THE BOOK OF ART

A Pictorial Encyclopedia of Painting, Drawing, and Sculpture

VOLUME 9

CHINESE AND JAPANESE ART

THE BOOK OF ART
A Pictorial Encyclopedia of Painting, Drawing, and Sculpture

CHINESE AND JAPANESE ART

By Michael Sullivan

Lecturer in Asian Art, School of Oriental and African Studies, University of London

NOTE TO THE READER

This volume, the ninth in the series, is arranged in sections of historical introduction, historical and biographical text, Color Plates, Monochrome Plates, and documentation of Influences and Developments, and is intended to provide the reader with a comprehensive survey of the development of Chinese and Japanese Art.

With the exception of this volume, and of the volumes entitled *Origins of Western Art* and *How to Look at Art*, which are more general in their scope and treatment, each of the books in the series is arranged in accordance with the following basic plan:

First, a historical introduction sets out the main lines of development within the period covered, with special reference to the major artists and the major works of art. This is followed by an illustrated biographical section outlining the life and work of every major artist and important minor artist. Next follow sections of Color Plates, Drawings, and Sculpture. A final section, entitled Influences and Developments, rounds off the volume by drawing together the main ideas and characteristics of schools and styles, and by exploring the internal and external influences that have made their impact on the development of the arts during the period concerned.

Throughout the series the location of every work of art is included in its caption. Every effort has been made to include also the size, medium, and date of each work represented in the plates. The reader will appreciate that the precise dating of some works of art is the subject of scholarly controversy; however, no dates have been included here unless they have the authority of qualified experts and art historians.

A list of basic reference books for further reading appears on page 16.

To avoid repetitive explanation of basic technical terms, an illustrated Glossary is provided in the volume entitled *How to Look at Art*. Also in that volume is an Index listing every artist mentioned throughout the series.

NOTE.—The terminal dates in the titles of some of the volumes are inevitably approximate. One volume will sometimes overlap with another. Some artists mentioned under French Art, for example, are also represented under the Impressionists, and the Post-Impressionists merge imperceptibly with the Moderns. In the ever-continuous process of Art it is difficult to contain schools or periods within precise boundaries.

Contents

LIST OF COLOR PLATES

JAPANESE

ACKNOWLEDGMENTS

The publishers and producers wish to express their gratitude to Professor James B. Cahill of the University of California and Professor Alexander Soper of New York University for reading the text, and to Mr. Lee Yim, London University, for the calligraphy for the names of Chinese and Japanese artists. They also thank the following museums, art galleries, collectors, photographers, and agencies who have courteously assisted them in obtaining the material for the illustrations reproduced in this volume:

The Abe Collection, Municipal Art Museum, Osaka, Japan
The Art Museum, Kobe, Japan
N. Asano Collection, Kanagawa, Japan
The Atami Museum, Shizuoka-ken, Japan
A. W. Bahr Collection, Metropolitan Museum of Art, New York
Major Geoffrey Barker Collection, Woking, England
Sir Alan and Lady Barlow, Wendover, England
The Benrido Company, Ltd., Kyoto, Japan
The Trustees of the British Museum, London
Avery Brundage Collection, M. H. de Young Memorial Museum, San Francisco, Calif.
The Byōdō-in, Uji, Japan
Chin Yüan Chai Collection, New York
Ch'en Ching-chao Collection, Singapore
Tan Tze Chor Collection, Singapore
The Cleveland Museum of Art, Cleveland, Ohio
John M. Crawford Jr. Collection, New York
The Daien-in, Mount Kōya, Wakayama, Japan
The Daigo-ji, Kyoto, Japan
The Daikaku-ji, Kyoto, Japan
The Daito-ji, Daisen-in, Kyoto, Japan
The Daitoku-ji, Daisen-in, Kyoto, Japan

Acknowledgments continued

The late Sir Percival David and Lady David Collection, London
C. A. Drenowatz Collection, Zurich
Jean-Pierre Dubosc Collection, Paris
The Fogg Art Museum, Cambridge, Mass.
John R. Freeman and Co., London
The Freer Gallery of Art, Smithsonian Institution, Washington, D. C.
Eugene Fuller Memorial Collection, Seattle Art Museum, Seattle, Wash.
Nomura Fumihide Collection, Kyoto, Japan
V. W. van Gogh Collection, Stedelijk Museum, Amsterdam
Mrs. Basil Gray, London
Kunizo Hara Collection, Kanagawa and Tokyo, Japan
The President and Fellows of Harvard College, Berenson Collection, Florence
The Henjokō-in, Wakayama, Japan
Umesawa Hikotaro Collection, Kanagawa, Japan
The Honolulu Academy of Arts, Honolulu, Hawaii
The Hōryū-ji, Nara, Japan
Hyogensha Company Ltd., Kyoto, Japan
The Imperial Household Collection, Tokyo
The Japan National Tourist Association, London and Tokyo
The Jingo-ji, Kyoto, Japan
The Juko-in, Kyoto, Japan
The Kangikō-ji, Kyoto, Japan
The Kennin-ji, Kyoto, Japan
The Kiyōshi-kōjin, Kobe, Japan
The Kojima-dera, Nara, Japan
The Kongō-ji, Kyoto, Japan
The Kōzan-ji, Kyoto, Japan
Zenshirō Kuriyama Collection, Tokyo
The Kuro-shoin, Kyoto, Japan
The Kyōō Gokoku-ji, Kyoto, Japan
Kyoto National Museum, Kyoto, Japan
Dr. Jacques Lacon, Paris
The Mansell Collection, London
Yasuo Matsudaira Collection, Tokyo
The Meigetsu-in, Kamakura, Japan
The Metropolitan Museum of Art, New York
James A. Michener Collection, Honolulu Academy of Arts, Hawaii
Mr. and Mrs. Severance A. Millikin Collection, Cleveland Museum of Art, Ohio
Takakimi Mitsui Collection, Tokyo
Mr. Motomichi Mōri, Yamaguchi, Japan
Hedda Morrison, North Borneo
The Municipal Art Museum, Osaka, Japan
N. Murayama Collection, Mikage, Japan
Musée Guimet, Paris
Musée de l'Impressionnisme, Paris
Museum of Art, Toledo, Ohio
Museum of Asiatic Art, Rijksmuseum, Amsterdam
Museum of Far Eastern Antiquities, Stockholm
Museum of Far Eastern Art, Cologne
Museum of Fine Arts, Boston, Mass.
Museum für Kunst und Gewerbe, Hamburg
Mr. Kinto Muto, Kobe, Japan
The Myōshin-ji, Reiun-in, Kyoto, Japan
Jansaku Nakamura Collection, Nara, Japan
Národni Gallery, Prague
The National Commission for the Protection of Cultural Properties, Tokyo
The Trustees of the National Gallery, London

The National Museum, Seoul, Korea
The National Museum, Tokyo
The National Palace Museum Collection, Taichung, Taiwan
The William Rockhill Nelson Gallery of Art and Mary Atkins Museum of Fine Arts, Kansas City, Mo.
The Nezu Art Museum, Tokyo
J. Nishimura Collection, Kyoto, Japan
Nü-wa-chai Collection, Munich
S. Ohara Collection, Kurashiki, Japan
Mokichi Okada Collection, National Museum, Tokyo
The Ohakura Shūkokan Museum, Tokyo
The Palace Museum, Peking
The Paul Klee Foundation, Kunstmuseum, Bern
Mr. and Mrs. A. Dean Perry Collection, Cleveland Museum of Art, Ohio
Philadelphia University Museum of Art, Philadelphia, Pa.
The Princeton University Art Museum, Princeton, N. J.
The Reihōkan Museum, Mount Kōya, Wakayama, Japan
The Reimeikai Foundation, Tokyo
The Royal Ontario Museum, Toronto, Canada
Sakamoto Photo Research Laboratories, Tokyo
Masa-aki Sasaki Collection, Tokyo
F. C. Schang Collection, New York
The School of Art, Tokyo
The Seattle Art Museum, Seattle, Wash.
The Seikadō Bunko Library, Tokyo
The Seikadō Collection, Tokyo
Arihiko Sekido Collection, Nagoya, Japan
The late Mrs. B. Z. Seligman, London
The Shosō-in Repository, Nara, Japan
The Shuko-kan Museum, Tokyo
Dr. Paul Singer Collection, Summit, N. J.
The late Sumitomo Kanichi Collection, Ōiso, Japan
Sung Tzu-ch'i Collection, Shanghai, China
Collection of H. M. the King of Sweden, Stockholm
The Szechwan Provincial Museum, Chengtu, China
Komakichi Tamura Collection, Osaka, Japan
The Tōdai-ji, Nara, Japan
The Tōfuku-ji, Kyoto, Japan
The Tokugawa Art Museum, Nagoya, Japan
H. Tozer Collection, London
University Museum, Tokyo
Dr. Franco Vannotti Collection, Lugano, Switzerland
The Victoria and Albert Museum (Crown Copyright), London
C. C. Wang Collection, New York
H. H. Weng Collection, New York
The Yakushi-ji, Nara, Japan
The Yale University Art Gallery, New Haven, Conn.
Yamato Bunkakan Museum, Nara, Japan
The Yoseido Gallery, Tokyo
Mme. Tseng Yu-ho Collection, Honolulu, Hawaii
M. H. de Young Memorial Museum, San Francisco, Calif.
The Zenrin-ji, Kyoto, Japan

ABBREVIATIONS

et al.	and elsewhere
in.	inches
B. M.	British Museum, London
Coll.	Collection
Gall.	Gallery
Mus.	Museum

Introduction

Chinese and Japanese Art

One way of writing the history of the art of a country or civilization is in terms of the life and principal works of the great masters. This method is perfectly feasible for presenting the history of European art because so much is known about the careers of the great painters, and many of their paintings survive. There are several reasons why it would not be a satisfactory approach to the art of the Far East.

In the first place, very little is known about the life and work of many great early masters of Chinese and Japanese painting. They lived many centuries ago, and all, or nearly all, of their paintings are lost. Ku K'ai-chih, for example, who might be called the father of Chinese figure painting (page 21), lived in the 4th century A.D., at about the time when the Roman Empire was tottering. It is not surprising that not a single original painting from his hand survives, although we have later versions of two of his most important scrolls (color plate 152, and page 22). Only one painting survives from the brush of Fan K'uan (color plate 162), who lived 50 years before William of Normandy conquered England in 1066. It is not known, and never will be known, who painted most of the great masterpieces of early Japanese painting. So a book based on the biographies of these painters and lists of their chief works would not take us very far.

A second reason for writing this book in the form of a continuous story is that a reader unfamiliar with Far Eastern history is apt to be bewildered by the names of dynasties and periods. When, for example, was the Ming Dynasty, and did it come before or after the Sung? Where, in relation to Chinese and Western history does the Ashikaga period of Japan belong? These periods and dynasties are important in the study of Chinese and Japanese art, and only a connected narrative can show them in proper historical relationship to each other and to Western history. In this connection, readers will find the chart on pages 276 and 277 helpful.

Thirdly, art cannot be fully appreciated except in relation to the culture in which it plays an important part. Someone who knew nothing of Christianity or of the Western humanistic tradition would be bewildered by Michelangelo's *Creation of Adam* in the Sistine Chapel. Similarly, to appreciate Buddhist art we should have some idea of what Buddhists believe; to understand the "literary" paintings of the Ming and Ch'ing Dynasties it is helpful to have some understanding of the ideals and the social position of the Chinese scholar-gentlemen who painted them. Above all, we must have a sense of the sweep of history, which only a connected story can provide.

People unfamiliar with the painting of the Far East often think of it as limited to a few traditional themes and styles. But a glance through the illustrations in this book will show that it is as richly varied as that of Europe. Subjects range from religion, history, legend, portraits, and figure compositions to landscapes, birds, flowers, and animals, while techniques vary from the heavy impasto of a wall-painting to the sensitive touch of ink and watercolor, which is as natural to the Chinese and Japanese painter as oil colors are to the Western artist. Even within this apparently restricted medium there is an enormous variety of techniques, from the fine, precise line drawing of the professionals and court painters at one extreme (color plate 162) to the "flung ink" of the expressionists (page 260) at the other. Again, the contrast between, say, the poetry and humor of an album leaf by Taiga (page 142) extolling

the pleasures of country life, and the cruelly brilliant war scrolls of the Kamakura period (color plate 214/5) is quite as striking as the contrast between an idyllic landscape by Claude Lorraine and a war scene by Goya.

Chinese civilization is not as old as that of the West, but it is the oldest of the still living cultures. Those of ancient Mesopotamia and Egypt decayed or were transformed almost beyond recognition, while Greece bestowed her civilization on Western Europe and ceased to build on it herself. But within the natural geographical entity that is China, development has been continuous and unbroken since the beginning of the historic period, about 1600 B.C. The language spoken and written in Peking today has developed naturally from that used at the Shang capital of Anyang 3,000 years ago. Never in Chinese history have the Chinese ceased to be conscious of their unbroken cultural tradition. At times, as in the 19th century, this sense of the past became a dead weight, preventing progress. But in the 20th century, under the impact of Western ideologies, science, and technology, China has gathered momentum, and is sweeping forward once more. Yet even in the surge of revolutionary fervor of the last 15 years, the past has not been forgotten, and today the Chinese are as deeply conscious of their cultural tradition as at any time in their history. As we shall see, this feeling for the past has had a great influence on the character and development of Chinese painting.

The Japanese also have a strong feeling for the past, which shows above all in the reverent care with which they have preserved their artistic heritage. But there are differences. Firstly, the history of Japanese civilization is much shorter than that of China—and this is reflected in the proportions of this book given to each. Secondly, the Japanese have inherited not one cultural tradition but two: their own, and that of China, which came flooding in as soon as permanent contact was established in the 6th and 7th centuries A.D. To understand Japanese art, therefore, we must see it in terms of this dual heritage.

The Japanese greatly admire Chinese culture, to which they owe so much. They modeled their government, their laws, and their social institutions on those of T'ang China; they borrowed Chinese writing, architecture, religion, and dress, adapting them to their own needs. In art, their debt to China can best be seen in the first forms and styles of Buddhist painting and sculpture, in the ink landscape-painting of the 14th and 15th centuries, and, to a lesser extent, in the influence of the later Chinese scholar painters.

Unique to the Japanese, on the other hand, are their all-pervading animistic religion Shintō, the Way of the Gods; a deep love of their own countryside; a superb tradition of craftsmanship; and a reverence for beauty unparalleled in the world. In art, the native Japanese spirit is expressed chiefly in the tradition of Yamato-e, the "Painting of Yamato," that is, of Japan. The contrast between the two traditions, which gives such fascination to the study of Japanese art, can be seen at once by comparing a pure example of Yamato-e, such as the detail of the handscroll illustrating the Tale of Genji (color plate 220) with an ink landscape by Sō-ami (color plate 222) painted in the Chinese manner.

The differences between Chinese and pure Japanese painting are not merely a matter of style; they are the expression of two very different cultural traditions. If there is such a thing as a "typical" Chinese painter, he is almost certainly something of a scholar and poet, perhaps a busy civil servant, who paints in his spare time. His painting is therefore that of an amateur, and painting is only one of several ways in which he may express himself, along with philosophical discussion, poetry, music, and calligraphy. He is a *wen-jen*, that is a man of letters, and hence a member of the most honored and respected class of Chinese society.

By contrast, the "typical" Japanese painter is a professional. He is a man of the people, and certainly no scholar. His subject matter is taken from the life around him or from the epics and novels of his national past. His style, composition, and use of color owe nothing whatever to Chinese art.

The Chinese amateur often makes a virtue of his amateurishness, and deliberately avoids any technical polish that might hint at professionalism. He and his friends may load the painting with poems and inscriptions that proclaim its literary and poetic content. The Japanese painter, on the contrary, prides himself on his craftsmanship. He is primarily concerned with picture-making, to which he bends the utmost of his skill, and

his pictures seldom carry inscriptions. While the painting of the Chinese scholar-amateur speaks as much to the intellect as to the senses, that of the Japanese painter appeals first and foremost to the eye.

The Chinese painter is concerned with nature in its eternal, unchanging aspect. Actions and momentary events seldom interest him. His landscapes, birds, and flowers are a distillation of the accumulated experience of generations of painters. His ideal subject is the scholar in a landscape, conveying the ideal of serenity and detachment from worldly affairs. The ideal of the Japanese artist, on the other hand, is often the Samurai, the knight errant imbued with loyalty and courage. The Japanese painter's brush, like the sword of the Samurai, finds fulfillment in swift action, creating moments of intense drama such as the magnificent war scrolls of the 13th century. These scrolls show a power to translate action into pictorial terms that has been reborn in the Japanese cinema today. The Chinese scholar painter would have turned in horror from such themes. To him the chief purpose of painting is to cleanse the mind and elevate the spirit.

Another difference between Chinese and Japanese painting lies in the kind of abstraction, or stylization, that each achieves. No good painting is completely realistic. Always nature is transformed by the creative imagination of the artist into something else that is not trees and hills, nor yet ink and silk, but a different kind of reality. Japanese art is more realistic than that of China, partly because the Japanese painter is more interested in things in themselves than is the Chinese, and partly because he sees them directly without the interposition of a philosophical attitude. If he stylizes his forms, it is likely to be because as a craftsman he prefers stylized shapes that lend themselves more easily to decoration.

The Chinese painter, on the other hand, is imbued with a philosophical attitude. He cannot see nature or man except in terms of his all-embracing philosophical outlook. They take their place in a total scheme of things and it is this total scheme, rather than individual places, people, or things, that he finds significant. Very few of the Chinese landscapes in this book depict actual places. The portraits do not record the features of a subject, but rather reveal his spirit. Everything the Chinese painter sees is passed through the filter of his philosophical attitude, and only the pure essence remains. What he presents may excite us, but it will never startle or shock. Originality, which counts for so much in Western art, has for him no virtue in itself. What matters most is his ability to convey his understanding of the unity and life of all things, which he sees manifest above all in the beauty of nature.

If this is the case, it might be argued that all Chinese paintings are very much the same. But this is to reckon without the individual painter. For the Chinese, and to some extent the Japanese, believe, as we do in the West, that the painting is a revelation of the creative personality of the artist. The theme may have been painted before, but it is the quality of the performance that counts. The closest parallel in the West would be not in art, but in music. The Oriental painter is like the pianist who plays a Beethoven sonata. It has been played a thousand times before, but what makes his performance memorable is not his technique (though that must be perfect), certainly not the originality of his interpretation, but his understanding of Beethoven's music. Only a great artist could plumb the depths of Beethoven's mind. Likewise only a great painter could fathom the mystery of nature.

The standard by which the Chinese or Japanese connoisseur judges a painting is the quality of the brushwork, which is the equivalent of the touch of the pianist. The brushwork of a master painter is vigorous and sensitive, rhythmic and harmonious, and at the same time very personal. Like his handwriting, it reveals both his education and his character. That is why the art of calligraphy occupies so honored a place in the culture of China and Japan.

An important aspect of the training of the Chinese and Japanese painter is the copying of the work of his teacher and of earlier masters. So expert are many of these copies that only an eye trained in the subtleties of brushwork can recognize the difference—as, for instance, a trained ear could spot the difference between interpretations of a Beethoven sonata by two great pianists. Many of these copies were made from reputable motives, not only technical training but the desire of the painter, before the days of photography, to have a replica of a work he admired. There are also vast

numbers of forgeries, made deliberately to deceive. They cannot be detected by X-ray or the analysis of pigments as can often be done with Western paintings, because the materials have remained virtually the same for many hundreds of years. Often the only guide is our sensitivity to the quality of the brushwork. In some cases even the expert cannot be certain; that is why a number of paintings in this book are labeled "anonymous," or merely "attributed to" a certain master.

Many Chinese paintings carry a good deal of "documentation" in the form of inscriptions and seals. If a painting has been in one of the imperial collections, such as that of the emperor Ch'ien-lung (reigned 1736-96), or in one of the great private collections such as that of Hsiang Yüan-pien (1525 - about 1602) or Liang Ch'ing-piao (1620-91), it would bear the appropriate seals and be recorded in the catalog of the collection. Although such documentation is invaluable in tracing the history of a painting, it still does not prove that it is genuine. Like the painting itself, signatures, seals, and inscriptions can be forged, although the quality of the brushwork is very difficult to imitate exactly. Though Japanese paintings generally carry much less documentation than do Chinese scrolls, the problem of detecting forgeries is just as great.

While there are differences of subject matter, technique, and feeling between Chinese and Japanese painting, those between Far Eastern and Western painting are much more fundamental.

If there were such a thing as a typical Western painter, it would be such a man as Rubens or Rembrandt. His chief subject matter is the human figure, clothed or nude. His pictures are surrounded by a heavy frame that defines the observer's viewpoint. Within the frame, the figures and other forms are organized into a composition that has been worked out through a long series of studies of individual figures and trial sketches of the whole design, until the painter has arrived at a solution to the formal problems he has set himself. He aims at a complete realization of his idea. His forms are solid and sculptural. Color plays an important part in the design. The fall of light from a single source creates highlights and shadows, intensifies the modeling and heightens the dramatic effect. The position of the viewer is clearly defined by scientific perspective. Often the ostensible subject is little more than an excuse, or rather a starting point, for the creation of a picture in which all these complex factors are interwoven into a unique creation.

By contrast, the chief theme of the Chinese and Japanese painter is nature, in which man takes his appropriately insignificant place. The human figure has little interest for the Chinese painter, and he never paints the nude human body. The life, tensions, and ever-changing forms of the Western nude are satisfied for the Chinese painter in the supremely difficult art of bamboo painting. The Chinese painting is not built up through trial sketches, but conceived in its essentials, whole in the artist's mind, before his brush touches silk or paper. No correction or over-painting is possible. Color is restrained and naturalistic, or omitted altogether. The painter deliberately seeks to avoid a single viewpoint, so the painting has no frame. Instead of one-point perspective, a scroll reveals a progressive series of views and vistas linked together into a harmonious composition. At each point as the eye moves vertically up a hanging scroll, or horizontally along a handscroll, the perspective is correct for that particular point. This is sometimes called continuous, or multi-point, perspective. So we do not stand back from a Chinese landscape painting to admire the composition. This, though often beautiful, is not the subject of the picture. Instead the painter invites us to explore it, to join the group waiting for the ferry to take them across the lake, to wander up the mountain path, to pause to gaze out at some breath-taking view, and finally to lose ourselves in the heart of the mountains, or in the infinity of distance that opens out before us. His landscape is to be explored, not only in space, but also in time. It is not necessary for the Chinese painter to fill every corner of the picture-space. To do so would be to make something complete. The aim of the Chinese painter is not to achieve a final statement about nature, but to liberate the imagination by hinting at vast depths and distances that are beyond the power of any artist to define or depict.

Other points of difference between Western and Far Eastern painting are discussed in the text and in the final section of this book. Only one will be mentioned here, because it is so conspicuous: that is the custom in China, and to a lesser extent in Japan, of writing on a painting.

This is never done in Western art because it would destroy the illusion of reality that the Western painter aims to create, as well as introducing an unmanageable element into the composition.

Some of the earliest Chinese paintings were illustrations to poems and other writings, and in these (color plate 152, for example) the text precedes or follows the painting, or runs along beneath it. Painters began to sign their works, very inconspicuously, about the 10th century. Gradually the signature became more prominent. By the Yüan Dynasty it had become very common, especially among the scholar-painters, to write poems and inscriptions on paintings. That on the landscape by Wen Cheng-ming, for example (color plate 185) tells of the sadness of friends parting; that on the Shih-ch'i (color plate 198) describes how the painter climbed a mountain at sunset and the views he saw on the way; the poem above Kenzan's flower baskets (page 137) sings of the innocent charm of the wild flowers in the misty autumn fields. The message written above Ch'i Pai-shih's wine-pot (color plate 203) is brief and cheerful: "The thing for prolonging life is wine!" While the painter's own inscription underlines the theme of the painting, or describes the occasion on which it was painted—often in the company of friends and with the wine flowing freely—additional inscriptions added over the years by admirers might describe their joy in seeing a long-famous masterpiece in the home of a friend, or contain critical and appreciative comments. Thus the writing and the painting form an aesthetic whole, the one reinforcing the other, and are united not only by their common theme and sentiments, but also by the vital rhythms of the brush, which painting and calligraphy share in common.

The habit of writing on a painting is an aspect of the very intellectual attitude of the Chinese educated class to art in general. The Chinese were the first to write a systematic history of painting. This was the *Li-tai ming-hua chi*, "Record of Famous Painters of Successive Dynasties," completed by the scholar and connoisseur Chang Yen-yüan in 847 A.D. It antedates by a little over 700 years the first European history of painting, Giorgio Vasari's "Lives of the Most Eminent Painters, Sculptors and Architects" first published in 1550. The *Ming-hua chi* was followed in about the year 1070 by Kuo Jo-hsü's

T'u-hua chien wen chih, "Record of Things Seen and Heard Regarding Painting," which brings the story up to the Northern Sung Dynasty. Thereafter there were no more systematic histories until modern times, but a vast amount of historical, biographical, and critical information is contained in essays and studies by painters and scholars.

The Chinese were also thinking about the nature of creative art at a very early stage. A rhapsodic poem on literature, written about the year 300 A.D., contains a profound and passionate description of the creative ecstasy and agony of the poet. Just two centuries later a portrait painter named Hsieh Ho drew up a list of earlier artists in order of merit, prefacing the list with a short essay in which he set out the principles upon which his classification had been made. These, the celebrated Six Principles of Hsieh Ho, were so concise yet so all-embracing that they remained the cornerstone of nearly all later theorizing about art in China.

The Six Principles may be summarized as follows: Spirit consonance and life-motion; the bone method in the use of the brush; conformity to the object to give likeness; correct color; care in composition; and transmission of the tradition by making copies. Of these, the first is both the most obscure and the most important. It holds that there is in nature an energy or spirit (*ch'i*) that gives life to all things, and to which the painter must attune himself so as to be able to impart this life to his paintings. Later theorists, notably the Zen mystics and scholar painters, held that the *ch'i* was a force within the painter himself. But all painters and critics throughout Chinese history have held that this mysterious energy, whether external or internal, or both, is the essential quality, lacking which the forms of a painting are without life or meaning.

The transmission of this energy to paper or silk is accomplished through the second of Hsieh Ho's principles, the "bone-like" structural strength of the brush-stroke, common to painting and calligraphy. The third, fourth, and fifth precepts explain themselves: they seemed particularly important in Hsieh Ho's time, when painters were still struggling with the basic problems of representational art. The sixth principle was important not only in giving the painter technical training and a rich pictorial "vocabulary," but also in preserving and

handing on the great tradition of which every painter felt himself to be in a sense a custodian.

The *ch'i* was held to be present in all living things— human figures, animals, birds, and flowers, but above all in mountains and water, trees and rocks. One of the most famous writings on landscape painting is a collection of notes and comments compiled by Kuo Jo-hsü from the sayings and teachings of his father, the great landscape painter Kuo Hsi (color plate 166). Why, asks Kuo Hsi at the beginning of the essay, does the gentleman take delight in landscapes? Kuo answers by saying that, as a member of the educated class, the gentleman is bound by his Confucian sense of duty to take office in the administration, and so cannot spend his life in retirement in the country as he would no doubt prefer to do. For such a man, the contemplation, or rather exploration, of a landscape scroll alone or in company with his friends is a substitute for wandering in the mountains.

Kuo Hsi also gives valuable technical hints to the landscape painter, and offers a number of quotations from poems which contain themes or suggestions for landscape paintings; such lines as these, for example:

> With a few creakings of the long oars,
> I depart from the shore;
> With a few drippings of the water clock,
> I pass cities and mountains.

Or,

> Clouds wait brooding for snow and hang heavily
> over the earth;
> The wail of autumn is unbroken as the wild geese
> sweep over the sky.

Or,

> Heavy with rain the spring flood rushes rapidly
> through the night;
> Not a soul on the bank; a solitary ferry lies
> aslant the water.

It is not difficult to see how such lines could open up to the landscape painter limitless vistas of time and space, and inspire landscapes like those illustrated in color plate 168/9 and on page 237.

Among the many scholars and critics who have enriched the literature on Chinese painting were the eccentric Mi Fu (page 47), who wrote extensively on connoisseurship, and his intimate friend, the poet Su Tung-p'o, who has left an illuminating treatise on the philosophy of bamboo painting. Li K'an in the 14th century wrote a more orthodox treatise on the same subject (see page 75). The letters and notes of the Yüan and Ming scholar painters were also voluminous, the more important being the writings of the painter and critic Tung Ch'i-ch'ang (1555-1636), whose exposition of the theory of the Northern and Southern schools of landscape painting (see pages 41 and 86) had an immense influence upon the outlook and style of the scholar painters of the late Ming and Ch'ing Dynasties. In direct contrast to his scholarly orthodoxy, the early Ch'ing painter Shih-t'ao (page 93 and color plate 199), wrote an essay in which he proclaimed a philosophy of extreme individualism in art.

Japanese art history is not so rich in the literature of connoisseurship and scholarly criticism as that of China. But that is not to say that the Japanese were not interested in aesthetics. On the contrary, probably no other race on earth is so acutely aware of pictorial and natural beauty as the Japanese, and none has brought the art of enjoying beauty to such a pitch of conscious refinement. The Japanese are deeply receptive to beauty in nature, to the world in miniature that is the Japanese garden, to the poignant impermanence of the cherry blossom. In recent centuries this worship of beauty has come to be centered increasingly on that unique Japanese institution, the tea ceremony (*cha-no-yu*).

Tea drinking had first become fashionable among the Chinese gentry in the T'ang Dynasty, when it was the custom to accompany it with philosophical discussion and the enjoyment and composing of poems and paintings. Tea was introduced into Japan in the Ashikaga period, along with Zen Buddhism and the ink painting of the Southern Sung Zen masters and academicians. Gradually it became subtly entwined with the ancient Japanese nature cult. At the same time the Japanese tendency toward self-discipline and self-abnegation turned what had been an informal pastime into a ritual. Under the influence of great "tea masters" such as Sen Rikyū (see pages 120 and 272) the ritual became formalized into different "schools," the rules of which are still studied and practiced today by any Japanese who wishes to be considered cultivated.

For the tea ceremony a special room or pavilion is

built, either as part of the house or in a secluded corner of the garden. The materials are plain and natural, the atmosphere of the room suggestive of quiet and restraint. The implements for making tea are chosen for their simplicity and natural beauty. Every movement of the host as he prepares tea for his guests is carefully studied even to the precise number of swirls of the bamboo whisk, and the exact angle at which the ladle is set down.

In an unadorned recess in one wall of the room, the *toko-no-ma*, there hangs a painting or a scroll of calligraphy (*kakemono*) appropriate to the season or to the company present. Beneath it stands a flower arrangement (*ikebana*). The mood of the small group kneeling in the room is one of repose. Their attention is given to the movements of the host and the objects he uses, to the work of art hanging in the *toko-no-ma*, and to the flower arrangement, all of which stimulate appropriate thoughts and comments.

To the Japanese, trained in the philosophy and discipline of the tea ceremony, the work of art, isolated in the recess of the *toko-no-ma*, acquires almost the significance of a religious icon. It becomes imbued with a special power that fills the room, and the viewer kneels before it almost as a worshiper. In this special sense the Japanese have a more selfless and reverent appreciation of beauty than any other race. But under the special conditions in which works of art are displayed it is very difficult for the viewer to react to them spontaneously. By contrast, the Chinese approach to art and to nature is relaxed and much more natural. A Chinese connoisseur has his preferences and dislikes, just as an educated Westerner can say with perfect freedom that he does not care for Picasso, or Flemish painting. This would be less easy for a Japanese. The very fact that an object is classifiable as a "work of art" gives it a special significance, which may not have very much to do with its intrinsic beauty. The dullest pottery bowl used in the tea ceremony, the most uninspired landscape by a minor artist of the Kanō School, would be regarded by the majority with reverence simply because it is a work of art or is connected with the tea ceremony. So for many Japanese the tea ceremony and the appreciation of natural and man-made beauty is very largely a matter of convention, and only people of unusual independence of mind are able to react to these things in a wholly natural and spontaneous way. Nevertheless "teaism," as it has been called, enshrines the best in Japanese culture. As Langdon Warner once wrote, "In spite of occasional perversion of its very principles, no other custom in Japan can illustrate so perfectly the sensitive side of Japanese nature, and no other force, unless that of Zen Buddhism which is close to it, has been so powerful to inculcate simplicity, directness, and self-restraint—in short, discriminating taste."

Because the Japanese have such reverence for works of art, they have preserved them much better than have the Chinese. The Chinese have, until the last 15 years, been very careless about them. Temples and palaces have been repeatedly destroyed; the imperial collection has gone up in flames time and time again; and not a few masterpieces of painting have been buried with their owners. What has mattered to the Chinese has been not so much the individual object—something which is almost sacred to the Japanese—but the tradition to which it belonged, and the ideas and ideals that it expressed. So long as these were kept alive, it mattered less that any particular work of art should survive. To the Chinese, the great masters of the T'ang and Sung Dynasties live today, not in their surviving works, of which there are few or none, but in the work of all those painters who have derived inspiration from them and have handed on their style. So it is not altogether surprising that today the greatest collection of T'ang decorative arts, and many of the earliest surviving masterpieces of Chinese painting outside the imperial collection, are to be found, not in China, but in Japan.

SOME BOOKS FOR FURTHER READING

Tokyo National Museum, *Pageant of Japanese Art*, 6 vols., Tokyo, 1952.

O. Sirén, *Chinese Painting, Leading Masters and Principles*, 7 vols., London, 1956 and 1958.

P. C. Swann, *An Introduction to the Arts of Japan*, Oxford, 1958.

Y. Yashiro, *2000 Years of Japanese Art*, London, 1958.

M. Sullivan, *Chinese Art in the Twentieth Century*, Berkeley and Los Angeles, and London, 1959.

S. E. Lee, *Chinese Landscape Painting*, Cleveland, 1960.

J. B. Cahill, *Chinese Painting*, New York, 1960.

L. Sickmann and A. C. Soper, *The Art and Architecture of China* (Pelican History of Art), London, 1960.

R. T. Paine and A. C. Soper, *The Art and Architecture of Japan*, (Pelican History of Art), London, 1960.

T. Akiyama, *Japanese Painting*, New York, 1961.

M. Sullivan, *An Introduction to Chinese Art*, Berkeley and Los Angeles, and London, 1961.

S. E. Lee, *A History of Far Eastern Art*, London, 1964.

Chinese Art

Chapter I
THE BEGINNING OF CHINESE ART

(A) Drawing of Painted Pottery Vessel from Ma-ch'ang, Neolithic period, about 1700-1300 B.C. *Kansu Province, China*

The Neolithic period

It is often thought that Chinese civilization is of immense antiquity, far older than that of Egypt or Mesopotamia. But in fact China did not begin to emerge from the darkness of prehistory until the middle of the second millennium B.C. Before that time the most advanced of China's communities were still living in the Stone Age. Some of the red pottery of the Neolithic period (about 3000 - about 1600 B.C.) found in northern and northwest China is decorated with plant forms (A), birds, animals, and human figures. Drawn in black pigment with a flexible brush, they give the first hint of the free and sensitive brush handling that, many centuries later, became one of the most striking qualities of Chinese painting.

The Shang Dynasty (about 1600-1027 B.C.)

Much more is known about the art of the Bronze Age, beginning with the Shang Dynasty. Excavations at the late Shang capital, Anyang, have shown that the tombs of the Shang kings were lined with timber beams, leather hangings, and matting painted in several colors with monster masks and other stylized animal motifs. These motifs are very like those that decorate ritual bronze vessels of the Shang Dynasty (B, C, and p. 18A), and were also found carved in wood and bone. They were the main elements, part magical and protective, part purely decorative, of Shang art.

Scarcely any traces of actual painting survive from this period, though some of the early writing consisted of pictograms (picture symbols). They were inscribed on sacrificial bronzes and scratched on the "oracle bones" used for divination. Here are some of these pictograms with their modern equivalents:

(B) Long-tailed Bird: rubbing from Bronze Vessel (Shang Dynasty) *Washington, D. C., Freer Gall. of Art*

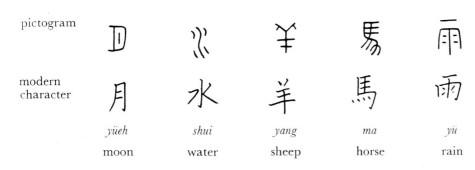

pictogram				
modern character				
yüeh	*shui*	*yang*	*ma*	*yü*
moon	water	sheep	horse	rain

(C) T'ao-t'ieh Mask (half): rubbing from Ping Shou Bronze Vessel (Shang Dynasty) *Washington, D. C., Freer Gall. of Art*

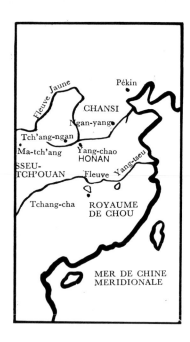

Map of Ancient China

More complex characters, called ideograms (idea symbols), were formed by combining different pictograms:

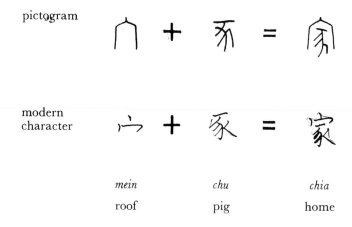

| | | mein | chu | chia |
| | | roof | pig | home |

A further stage in the development of the written language of China came with the phonogram (speech symbol), a composite character one element of which gave the meaning, the other the pronunciation. As time went on the pictographic element became less and less important. Nevertheless many modern characters started as pictures, and the Chinese traditionally believe that writing and drawing have a common source. In early legends both are given a divine or miraculous origin. It is this belief in the essential unity of the two arts that makes it possible for a Chinese painter to write on a picture (color plates 152 and 178, for example), and for collectors to feel that the writing, far from spoiling the work, adds to its beauty, meaning, and value.

The Chou Dynasty (1027-249 B.C.) and Warring States (about 421-221 B.C.)

During the early centuries of the Chou Dynasty there was a decline from the high standards of late Shang art. No paintings or painted objects of this period have yet been unearthed and scarcely any information about its pictorial art can be gleaned from the classical literature. Toward the end of the Chou Dynasty, however, during the period of conflict known as the Warring States, Chinese culture once more made rapid advances. The newly independent feudal states were developing regional traditions in the arts, a middle class was coming into being, and art patronage was spreading beyond the ruling house to new local aristocracies and wealthy merchant and landowning families.

The art of Honan province, as it survives in the decoration of inlaid bronze vessels (A) and mirrors, had a new richness and sense of movement, but remained — so far as we know — almost entirely abstract. The earliest examples of true pictorial art come chiefly from the area of central China dominated by the kingdom of Ch'u. Bronze vessels unearthed from Ch'u tombs in and around the modern city of Changsha are engraved with lively and realistic scenes of fighting, hunting, fishing,

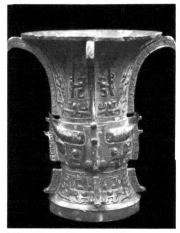

(A) Bronze Ceremonial Vessel,
1027-249 B.C.
Cleveland, Ohio, Mus. of Art,
Gift of Howard Hollis and Co.

harvesting, and other rites as yet unidentified. The oldest painting on silk yet discovered in China (page 253), representing a woman standing in profile, with a phoenix and a dragon, was excavated at Changsha from a Ch'u grave of about the 4th century B.C. Other Ch'u graves yielded boxes and trays decorated with figures, horses, and charming rudimentary landscapes painted in lacquer. Some examples of this early pictorial art are illustrated in (B) and on pages 252 and 253.

The Ch'in and Han Dynasties (221 B.C. - 220 A.D.)

China's scattered feudal states were united for the first time under the brief and tyrannical Ch'in Dynasty (221-206 B.C.). Under the Han Dynasty (206 B.C. - 220 A.D.) the new nation consolidated her power, extended her frontiers in all directions, made contact with India across central Asia, and established colonies in Korea and Annam. The Han emperors, at least in theory, were orthodox upholders of the state cult of Confucianism. But like the masses of the people, they were steeped in the magic and superstition that formed the popular aspect of the Taoist religion. Confucianism inspired pictures of legendary emperors, virtuous ministers, and filial sons of antiquity, which were painted on the walls of palaces and ancestral shrines to serve as inspiration to the living. The themes of popular Taoism, on the other hand, were illustrated by pictures of fairies and spirits (C), of the legendary Mount K'un-lun beyond the western horizon, or of P'eng-lai, the magical islands that rise out of the eastern seas. The artists who executed these wall paintings belonged to a corps of craftsmen that formed part of the tightly organized Han bureaucracy. None of their names is known. The palaces, halls, and shrines in which they worked have long since crumbled to dust, and all that survive are vivid descriptions of their paintings in Han poetry.

It is to this period that the first art collectors and connoisseurs belong. Later they played a vital part in Chinese cultural life, but even then, under the emperor

(C) A Celestial Game of *Liu-po*: rubbing of a stone tomb-slab from Hsinchin (Han Dynasty) *Chengtu, Szechwan University Mus.*

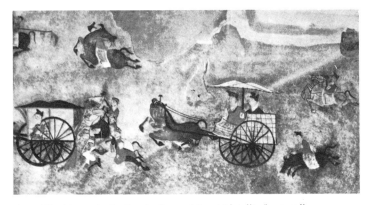

(D) The Guests Arrive for the Funeral Feast (detail): from wall painting in tomb (Han Dynasty) *Liao-yang, Manchuria*

(E) Scene of Dragon and Mountains (detail): from wall painting in Ts'ao-yüan-ts'un tomb (Han Dynasty) *Shansi Province, China*

(A) Painted and Lacquered Basket
(detail): from Lolang
1st century A.D.
Seoul, Korea, National Mus.

(B) Fu-sang Tree: stone rubbing
from Tomb Shrine of Wu Liang
(Han Dynasty)
Shantung Province, China, Chia-hsiang

Ming (reigned 58-76 A.D.), we are told, "the art of the whole realm was assembled like clouds." However, Ming's palace and all its treasures perished in the uprising that heralded the end of the Han Dynasty. It was perhaps the first imperial art collection and the first recorded instance of such a collection being destroyed at the fall of a dynasty.

Han texts often refer to paintings on silk scrolls. These were chiefly illustrated editions of the classics, or collections of folklore and of descriptive and narrative poems. None of them has survived. On the other hand, figures of officials and attendants, hunting scenes, chariots, and mythical beings have been found painted on the walls of underground Han tombs in several places, notably at Wang-tu in Hopei and at Liao-yang in Manchuria (page 19D). The most interesting of these wall paintings decorate a tomb unearthed in 1959 at Ts'ao-yüan-ts'un in Shansi (page 19E). The arched ceiling is painted with a dragon and a tiger among clouds and stars, but most remarkable is the mountain scene at the lower corner of the east wall. With its suggestion of mist and distance, this is technically the most advanced fragment of Han landscape painting yet discovered.

Clues to both the style and the subject matter of Han painting can also be found in small-scale decorative pictures on tiles, bronzes, and lacquer. Among the most famous of these are the figures of filial sons of antiquity that adorn a lacquered basket (A) found at Lolang in Korea in the 1st-century grave of a Chinese settler, and the swiftly sketched figures on tomb tiles now in the Museum of Fine Arts, Boston, and the Cleveland Museum of Art, Ohio. A detail from one Boston tile is shown in color plate 151: the single plane in which the figures are standing and the rather awkward drawing of their heads are two features typical of Han art, but the feeling of life and movement that is conveyed by the sensitive sweep of the artist's brush can be found in Chinese figure painting of every period.

Stone engravings and molded brick reliefs found in tombs, and in the shrines that stood before the tombs, give further clues to Han mural art. The engraved stones of North China, such as those from the tombs of the Wu family (B) at Chia-hsiang in Shantung (1st-2nd centuries A.D.), throw strong emphasis upon the ponderous, yet lively, silhouettes of the figures. Those from stone tombs in Honan are full of wild movement. The most pictorially advanced are the molded bricks with scenes of hunting and harvesting (page 264) and of the local salt industry that have been unearthed from Han Dynasty graves in Szechwan. Here for the first time is found a true feeling for space and continuous depth, combined with a down-to-earth realism. These brick reliefs are as far removed in style as they are in distance from the Confucian formality of the Shantung stone engravings.

The Three Kingdoms (220-265 A.D.) and The Six Dynasties (265-581 A.D.)

The fall of the Han Dynasty was followed by a period of more than 300 years during which China was fragmented. The north fell into the hands of a succession of barbarian tribes. Of these the chief were the Toba Turks, who occupied a large area for nearly two centuries, while they were gradually absorbed and civilized by their Chinese subjects. Meanwhile, central and southern China were

ruled from Nanking by a series of short-lived native dynasties and petty kingdoms.

During this period of social instability and political chaos the Confucian system of government founded by the Han emperors broke down. People pinned their faith instead on Taoist magic or on the promise of eternal peace offered by the Buddhists. Yet this very instability set arts and letters free from allegiance to the tradition of Han orthodoxy. Painting at last became a fine art, practiced by masters whose names and works are recorded. Their new consciousness of the power of the artist's imagination gave birth to a tradition of critical and theoretical writing on art, which began with an essay, the "Classified Record of Painters of Former Times," by the 5th-century painter Hsieh Ho.

Although these writings show that painters were becoming aware of the potentialities of their art, their actual methods and techniques were still very simple. Landscape painters, for example, were still wrestling with the problems of how to suggest depth and recession convincingly (for painters seem to have made little or no advance on the realism of the Han tomb paintings referred to above), and how to achieve the correct scale relationship between figures and landscape. Artists were still unable to decorate a large area with a single unified composition (see page 260). They treated it either as a series of panoramic handscrolls laid out one above the other, or as a series of "space cells," whereby groups of figures were enclosed within cells of rocks and trees, like stage settings, the separate cells being linked together in a continuous landscape.

One of the first Chinese painters of whom much is known was Tai K'uei (died 395 A.D.), who lived and worked in the southern capital, Nanking. His combination of talents—as musician, writer, painter, and sculptor—is unique in Chinese history, for sculpture was generally considered a craft rather than an art, and therefore not a proper occupation for a scholar and gentleman. By his varied gifts Tai K'uei, with his talented son Tai Po, not only raised sculpture to a level of prestige it never attained before or after, but succeeded in imposing upon it something of the fluid, linear rhythm that derived from the movement of the brush in the Chinese painter's hand. Despite several marked changes in style in later centuries, Chinese sculpture never quite lost this linear quality. None of Tai K'uei's works survive, but the unity of style and feeling that has ever since characterized painting and sculpture in China (c, d) must have been at least partly due to him, and to his great contemporary Ku K'ai-chih.

Ku K'ai-chih (about 345-406) served for many years at the imperial court in Nanking. He was a Taoist eccentric who, according to his official biography, "excelled as a wit, as a painter, and as a fool." His eccentricity, which he cultivated deliberately, enabled him to move unharmed through the maze of intrigue that marked court life under the Chin Dynasty (265-420; one of the Six Dynasties), and to escape punishment after rashly transferring his allegiance to a usurper. Also a poet, Ku K'ai-chih has left a rhapsodic poem on Thunder and Lightning that shows that he viewed natural phenomena with the eye of a painter. The language of the poem conjures up visions of Western painters such as Salvator Rosa or William Turner at their most romantic. At this period in Chinese history, however, the vocabulary of the poet was far richer and more expressive than the reper-

(C) Ladies Going for a Stroll: painted brick relief from tomb in T'eng-hsien, 6th century
Honan Province, China

TAI KUEI

TAI PO

KU K'AI-CHIH

(D) One of the Seven Sages: rubbing from molded brick relief in tomb at Nanking, about 525 A.D.
Kiangsu Province, China

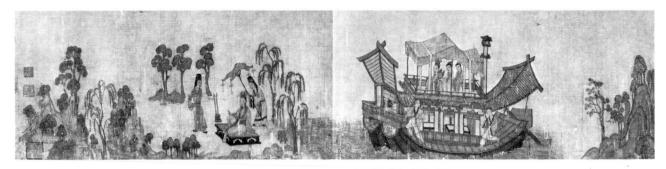

(A) After Ku K‘ai-chih
Lo Shen Fu Scroll (12th-century copy)
Washington, D. C., Freer Gall. of Art

toire of the painter. Ku K‘ai-chih simply would not have had the means to translate such a vision into painting.

Later copies of two of Ku K‘ai-chih's paintings have survived. Of one, a scroll illustrating the "Lo Shen Fu" ("Rhapsodic Poem on the Lo River Fairy"), there are Sung Dynasty versions in the Freer Gallery, Washington (A); the Palace Museum, Peking; and the Liao-ning Museum, Mukden. Of the other, Ku K‘ai-chih's scroll illustrating a poem by Tso Ssu (3rd century), "The Admonitions of the Instructress to the Court Ladies," there is a late T‘ang or 10th-century version in the British Museum, London. In this important scroll each of the admonitions is illustrated by a separate picture, all linked together by the text. The dictum that "men and women know how to adorn their persons, but few know how to embellish their souls" is illustrated by a charming domestic scene (color plate 152) in which an elegant young lady, seated before a bronze mirror on a stand, is having

(B) The Story of the Filial Ts‘ai Shun
(detail): from an engraved stone
sarcophagus, 520-550 A.D.
Kansas City, Mo.,
William Rockhill Nelson Gall. of Art

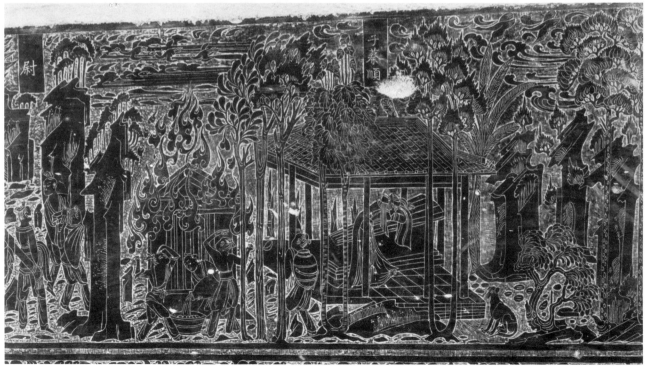

her long hair combed by a maid; on the right, a handsome young gentleman is attending to his own coiffure. The slim figures are drawn with a fairylike elegance in a brush line of great delicacy. There is no ground-line: depth is suggested simply by the placing of the figures and articles of toilet. The story of the Lo River maiden is told rather differently. Instead of scenes separated by sections of text, the action takes place in a continuous landscape setting, in which the same figures reappear several times as successive incidents in the story are related. This technique of "continuous narration" is thought to have been introduced from India.

Several of the characteristics of Six Dynasties painting that have been mentioned—the picture area divided into space cells, the slender, linear style of the figures, the inability of painters as yet to achieve a convincing scale between figures and landscape—are demonstrated in a pair of engraved stone slabs. These beautifully engraved stones, executed in North China between 520 and 550 to form the sides of a coffin, illustrate stories of six paragons of filial piety. Illustration (B) shows the story of the filial Ts'ai Shun, who refused to quit his mother's coffin even though the nearby storehouse was ablaze. The scene is enclosed within a ring of mountains like the wings of a stage setting. Although depth in the foreground is convincingly suggested, there is no middle distance, the eye being carried straight back to the mountains and clouds on the horizon. The scale is still quite false, the flat, stylized mountains remote from reality. But in spite of these and other signs of an archaic landscape style, the scene is drawn with great elegance. There is a wonderful feeling of the life of nature in the swaying trees, scudding clouds, and birds fleeing panic-stricken from the flames. The panels, probably copied from the line drawings of an accomplished artist, give some hint of what secular scroll painting in 6th-century China must have been like.

Chapter II
BUDDHIST PAINTING

Buddhism is believed to have reached China from India during the 1st century A.D. At first it was merely a little-known foreign religion, forced to compete with the rich collection of native myths, superstitions, and nature cults that is generally called "popular Taoism." But as the social and political confusion of the Three Kingdoms and Six Dynasties deepened, more and more men turned to the new faith, which seemed to offer not only a logical explanation of their sufferings, but the hope, and the means, of finding release from them. It was only after a thousand years on Chinese soil that Buddhism was finally absorbed into the total body of Chinese beliefs. Nevertheless, in the early centuries after its introduction, millions were converted to it and much of the country's energy and material wealth was spent on the construction and decoration of Buddhist temples and monasteries (C). In carrying out this enormous task, Chinese painters and sculptors were obliged first to copy, and later to adapt, an art that in content, style, and technique was entirely foreign to them. This chapter considers how they responded to the challenge.

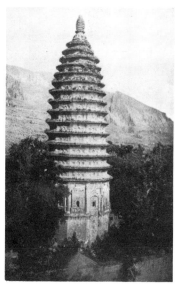

(C) Stone Pagoda of Sung-yüeh-ssu on Mount Sung, about 520 A.D. *Honan Province, China*

The Buddhist faith

Buddhism was founded by Gautama Shākyamuni, known as the Buddha (Enlightened One), who was born to a princely house in North India about 567 B.C. Although shielded by his father from all contact with the outside world, the young prince succeeded in escaping from the palace and in seeing with his own eyes the pains and miseries that beset humanity. This experience, the so-called Four Encounters, drove him to seek a path by which man might find release from pain and from the endless cycle of rebirths in this world to which *karma*, the inexorable law of cause and effect, condemns him. After years of fruitless study and ascetic practices Shākyamuni finally attained Enlightenment, while seated in deep meditation beneath a fig tree at Bodhgayā. The answer that came to him then is expressed in the Four Noble Truths: all existence is suffering; the cause of suffering is craving, desire, attachment; there is an end to suffering, because desire can be suppressed; there is a way of suppression through the Noble Eightfold Path. This last was an ethical code governing personal conduct, belief, and meditation.

After the Enlightenment the Buddha spent many years wandering about India, preaching and gathering disciples until his death at the age of 80. The main events in his life and ministry most frequently represented in Buddhist art are the Conception, Birth, Life in the Palace, Four Encounters, Asceticism, Temptation, Enlightenment, First Preaching, Miracles, and Death.

The doctrine of the Buddha at first spread through India only slowly. Its development was much more rapid when King Ashōka (reigned 272-232 B.C.) made it his state religion and filled the land with temples, monasteries, and stupas (mounds containing relics of the Buddha and his saints). In the early form of Buddhism, known as the Hinayāna (Lesser Vehicle), the Buddha was looked upon as no more than a great spiritual leader. Salvation was only for those men who were prepared to retire into monastic life. But the popular craving for a doctrine that would bring salvation for all, and the need for a deity to whom devotion and prayer could be directed, gradually gave rise to the schools of the Mahāyāna (Greater Vehicle). In this tradition Shākyamuni was deified and in time came to be seen as but one of a myriad Buddhas ruling in a pantheon as rich and complex as that of Hinduism.

In course of time the higher forms of the Buddhas came to be regarded as purely metaphysical forces, and worshipers began to feel the need for deities less remote and unapproachable. Thus there came into existence the *bodhisattvas*, beings destined for enlightenment, who intercede for men with God. The bodhisattvas most often represented in Buddhist art are Maitreya (A), who will come to earth in the next cycle as the Buddha; Manjushrī, the embodiment of divine wisdom; and Avalokiteshvara, the Lord who Looks Down in Mercy, known to the Chinese as Kuanyin. Around this shining galaxy of Buddhas and bodhisattvas gradually accrued a host of lesser deities and angels, some of whom were borrowed from the pantheon of popular Hinduism. The rich complexity of the later Mahāyāna pantheon is perfectly illustrated in huge Buddhist wall paintings at Tunhuang, which depict the paradises of the four quarters of the world (see pages 28 and 285).

(A) Maitreya Bodhisattva,
early 6th century
Boston, Mass., Mus. of Fine Arts

24

From India Buddhism spread northwestward into Gandhāra and Afghanistan. There it came into contact with the art of the Roman Near East, which had considerable influence on the development of Buddhist painting and sculpture. From Afghanistan, Buddhism spread into Central Asia, then eastward along the caravan routes to north and south of the Tarim basin, reaching China in the 1st century A.D. The path it took from India across Central Asia to China and Japan is illustrated on pages 282 and 283.

In China, very little Buddhist art of the Han Dynasty remains, except for a handful of stone reliefs and mirrors, whose decoration includes Buddhist figures. The great period of expansion in Chinese Buddhist art was from the 3rd century onward. The barbarian conquerors of North China adopted Buddhism as an act of policy, because they themselves were foreigners and hence were excluded from the native Confucian rites and beliefs. Missionaries and pilgrims returning from India brought with them paintings and replicas of famous images, which were copied as faithfully as possible by Chinese painters and sculptors. Working in a new and unfamiliar idiom, they frequently failed to understand what they were copying. Chinese Buddhist art of the 4th and 5th centuries is therefore often clumsy, though it has a certain naive charm (see page 284).

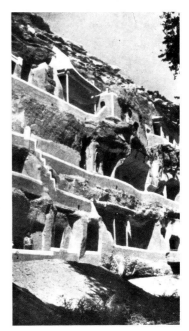

(B) View of Tunhuang Caves
Kansu Province, China

Cave shrines: sculpture and paintings

The progress of Buddhism into China was marked by the excavation of cave temples along the pilgrim route. In China the farthest to the west was Tunhuang, where from the middle of the 4th century onward over 480 cave chapels were carved out of the friable rock (B), after the Indian and Central Asian model; their walls were plastered, and adorned with paintings. Hardly less important paintings and sculpture decorate spectacular cliff sites at Mai-chi-shan (C) and P'ing-ling-ssu in southern Kansu. The sandstone of Yunkang in Shansi and the hard gray limestone of Lungmen in Honan were also carved with important sculpture in relief. All over China Buddhist temples were built, and their walls adorned with frescoes. The first climax of enthusiasm was reached under the Emperor Wu of the southern Liang Dynasty (502-557; one of the Six Dynasties); another climax came in the 8th century. However, later rebuilding, neglect, and the systematic persecution of 843-845 took heavy toll on the buildings. Today only a very few late T'ang temples survive, and so far as is known none of them contains early frescoes.

During his exploration of the Tunhuang caves in 1907, Sir Aurel Stein was shown a secret storehouse crammed with rolls of manuscripts and paintings on silk, paper, and hemp cloth, some of which bore dates between 406 and 1056. He removed a large part of this hoard to London and Delhi. Most of the scrolls since discovered at Tunhuang are now in Paris or Peking. Taken together, the wall paintings and painted scrolls of Tunhuang present a unique and continuous record of nearly a thousand years of Buddhist painting in China.

The paintings on the walls of the earlier caves at Tunhuang depict chiefly the Buddha and his attendant bodhisattvas, and incidents in his life or previous lives

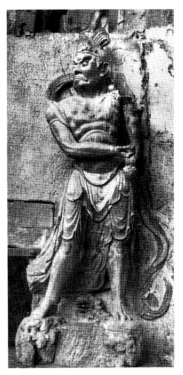

(C) Guardian Deity at Entrance to a Cave-shrine, 11th-12th century
Kansu Province, China, Mai-chi-shan

(the so-called *Jātakas*). Sometimes by forming a background to the principal Buddha figures, which are modeled in high relief and painted, these paintings give a unity of theme, color, and texture to the whole cave. A detail of the dado running around the lower part of cave 257 (about 500 A.D.), reproduced on page 253, illustrates the story of the Buddha incarnate in a golden gazelle. After rescuing the king of Benares from drowning (lower left), the gazelle is betrayed by the king to the hunters, but in turn shames him for his ingratitude. The style of the painting reveals a complex mixture of influences. The figure of the kneeling king derives from an Indian prototype, though his swirling scarves are typically Chinese. The flat, heraldic treatment of the deer and the flower-strewed ground are Near Eastern in origin. The landscape, too, is mixed: the sense of space and distance and the wavelike rhythm of the mountains are Chinese, but their decorative disposition in contrasting colors probably comes from western Asia.

In cave 428 (520-530) the Jātakas cover the whole wall (A). But the painter was as yet unable to weave the incidents together into one unified composition. Instead, the stories are told in long horizontal strips, like a series of handscrolls laid out flat one above the other, while separate incidents are enclosed in space cells formed by hills, as on the sarcophagus in Kansas City, Missouri (page 22). Toward the end of the 6th century these separate bands began to break down and mountains started to thrust their way up into the register above, creating the chaotic designs on the ceilings of the Tunhuang caves 419 and 420, which belong to the Sui Dynasty (581-618). Early in the T'ang Dynasty (618-906) compositions began to clarify. In cave 217 (about 700 A.D.) a single panorama covers the whole wall (page 260). Even here a relic of the old space-cell system survives, for successive incidents in the story are illustrated in separate parts of the landscape. In these paintings the development toward a more convincing representation of the natural world was purely Chinese, owing nothing to any influence from India or the Near East.

(A) Jātaka Scenes (detail): from wall painting in Tunhuang Cave 428 about 520-530 A.D.
Kansu Province, China

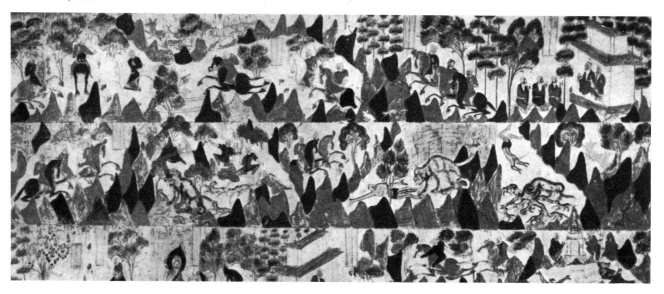

Styles of Buddhist figure painting

Figure painting in Chinese Buddhist art followed an altogether different path. While landscapes could be left to the free exercise of the Chinese painter's imagination and experience, figures had to resemble as closely as possible the icons brought from the holy places of Buddhism in India. Thus, in the earlier caves of the Northern Wei Dynasty (386-535) the paintings of Buddhas and attendant deities, like the earlier stone sculpture at Yunkang and early votive bronzes, were often crude copies of Indian or Central Asian models. The foreign conventions used in rendering anatomy and drapery, with shading and highlights to suggest roundness and plasticity, were not always properly understood (D).

Selected examples (page 284) show how the Buddha image was born in India by a fusion of native Indian and provincial Roman stylistic ideals; how it spread to Central Asia, where Buddhist art came in contact with the flat, heraldic, decorative art of Sassanian Persia; and how this mixed style, or series of styles, reached China, to be modified in its turn by the Chinese aesthetic tradition.

It must be remembered that Tunhuang, though it supplies almost all surviving examples of Six Dynasties Buddhist painting, was a frontier area, and that most of its artists were journeyman monks. The main developments in painting were taking place well within China, notably in and around the southern capital of Nanking. There Ku K'ai-chih and Tai K'uei were developing a style of figure painting that was purely Chinese. Their figures (to judge from copies of Ku's scrolls and some tomb decorations) were tall, slender, and rather flat, the supple grace of their movements being accentuated by trailing scarves. By the end of the 5th century this abstract, linear style had wrought a complete change in Buddhist painting and sculpture (B, C). The new type of Buddha, abstract, ethereal, two-dimensional, like the figure of Christ in French Romanesque sculpture, can be seen in the earlier cave reliefs at Lungmen, and in the gilt-bronze Buddha figures and stone steles of the first half of the 6th century. It is represented in painting by the type of Buddha figure in cave 249 (p. 284) at Tunhuang. This change to a

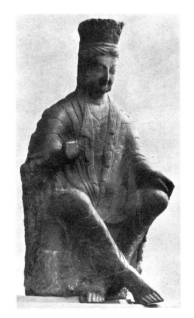

(B) Bodhisattva: from Yunkang,
early 6th century
New York, Met. Mus. of Art

(C) Flying Apsaras: stone rubbing from relief
in Lungmen Cave, mid-6th century
Honan Province, China

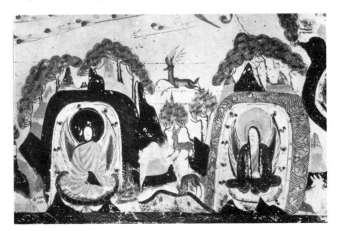

(D) Buddhas Meditating in Mountain Caves (detail): from the
ceiling of Tunhuang Cave 285, mid-6th century
Kansu Province, China

Chinese, linear manner took place at a time when contact with India by way of Central Asia was becoming increasingly difficult owing to fresh barbarian incursions across the pilgrim route. (See pages 282 and 283).

The renewal of Indian influence

Toward the end of the 6th century another equally momentous stylistic change took place. As surviving monuments in this new style are nearly all in North China, it is generally assumed that it originated under the barbarian dynasties of Northern Ch'i (550-577) and Northern Chou (557-581) and that it was the result of Indian influences once more reaching China across Central Asia. But in fact that route was still blocked. The northern barbarians, having settled on Chinese soil, were looking southward to Nanking for their culture, rather than westward to India. Chinese architects, painters, and sculptors were traveling to the north, bringing with them the latest stylistic trends from the southern court at Nanking.

The Buddhist painting and sculpture of "free" China under the southern dynasties of Sung (420-479) and Liang (502-557) has almost all disappeared. But these courts had been in diplomatic contact with the Hinduized kingdoms of Southeast Asia, notably with Champa (part of modern Vietnam) and Funan (modern Cambodia). Many Buddhist images and paintings in the local versions of the Indian Gupta style (A) were sent from Southeast Asia as gifts to Nanking. Although none of these Southeast Asian originals has survived in Central China, a remarkable hoard of Buddhist images discovered in 1956 in the ruins of a temple at Chengtu in Szechwan, all dating from the 6th and 7th centuries, shows the influence of the Indianized art of Funan and Champa. It is reasonable to suppose that the style had reached Chengtu by traveling up-river from Nanking, and that it was also carried northward to influence the sculpture of the Northern Ch'i and Northern Chou Dynasties, and the late 6th-century painting at Tunhuang.

In this new style the flat, linear treatment of the figure was replaced by a new Indian fullness and plasticity (see pages 284 and 285). The body swelled out again, its solidity subtly emphasized by clinging folds of drapery and by the contrast in texture provided by the addition of jewelry. In the late 6th century the figure was still static and rigidly frontal, but in the 7th it turned and moved in space, reflecting not only a truer understanding of Indian sculptural ideals, but also the energy and confidence of Chinese culture in the T'ang Dynasty.

After the founding of the T'ang Dynasty in 618 and the re-establishment of peace in Central Asia, land communication with India was once more possible. The renewal of direct Indian influence is clearly reflected in the wall paintings at Tunhuang.

Buddhist painting in the T'ang Dynasty (618-906)

The change in style of Chinese Buddhist art in the 6th and early 7th centuries was accompanied by a change in content. The old favorite subjects—the life and previous lives of the Buddha, and the perils from which Avalokiteshvara saves mankind—began to give way to more complex themes reflecting the popularity of

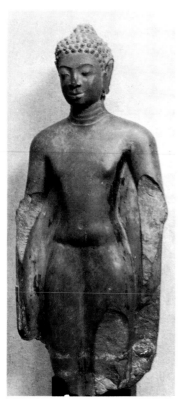

(A) Buddha, 6th-7th century (Siamese, Mon-Gupta style)
Seattle, Wash., Art Mus.,
Thomas D. Stimson Memorial Collection

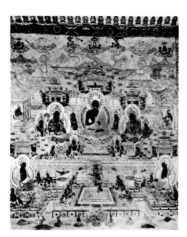

(B) Western Paradise of Amitābha (detail): wall painting from Tunhuang Cave 139, late 8th century
Kansu Province, China

28

two key texts in later Mahāyāna Buddhism. One was the "Lotus Sūtra" (the Sūtras are the Buddhist scriptures), a lengthy book expounding the eternal existence and infinite power of the Buddha; the other was called "Sukhāvatī-vyūha" ("Description of the Land of Bliss"). The illustrations to the former include parables and miracles, such as the miraculous appearance of the stupa containing the Buddha of the previous cycle, Prabhūtaratna. Those inspired by the latter text include elaborate compositions illustrating the pleasures of the four paradises beyond the horizon, notably the western paradise of Amitābha with its luxuriant trees, its pavilions and refreshing streams, its musicians, singers, and dancers who perform for the delight of the myriad beings clustered around the radiant figure of Amitābha (B).

None of the paradise scenes from the great temples of the T'ang capitals (Loyang and Changan) has survived. But a detail of a silk scroll from the Tunhuang hoard discovered by Sir Aurel Stein is shown in color plate 153. It illustrates the paradise of Bhaishajyaguru, and gives some idea of the complexity of design, richness of color, and over-all mastery with which Chinese painters at last succeeded in expressing Indian sculptural form in the language of the Chinese brush. The most perfect series of paradise paintings was until recently to be found not in China but in Japan, around the walls of the Kondō (Golden Hall) of the Hōryū-ji monastery temple in Nara. A detail of one of the bodhisattvas attendant on the Buddha Amitābha is illustrated in color plate 205. Unfortunately the Kondō paintings were almost completely destroyed by fire in January, 1949 (See page 101).

Also among the treasures recovered from Tunhuang by Sir Aurel Stein is the fragment of painted silk (color plate 154). It depicts the courtiers (here transformed into young Chinese gentlemen) who searched the countryside for the young prince Siddhārta (Shākyamuni; see page 24) after he escaped from his father's palace. The decorative way in which the plants are spaced out is a mark of Near Eastern influence; but the full curves of the horsemen, and their rich coloring, are typical of Chinese painting of the T'ang Dynasty, and the way they are partly hidden behind the hill is an ancient convention of Chinese landscapists.

Foreign techniques in T'ang painting

Chang Sèng-yu (early 6th century), the most famous court painter under the southern Liang Dynasty, had been especially noted for his power to suggest modeling in the Indian manner by "arbitrary shading," that is, without indicating a source of light or using cast shadows. He was also much admired for his "flowers in relief," painted with so thick an impasto that they actually seemed to stand out from the temple wall. The T'ang artist Wei-ch'ih I-seng (7th century), a descendant (perhaps the son) of an immigrant from Khotan in Central Asia, also practiced a realistic style of flower painting. But he was especially noted for his foreign manner of painting figures (c), the lines of his drapery being "tight and strong like bending iron or coiled wire."

No original from the hand of either of these masters survives. But a detail of what may well be an accurate copy of one of Wei-ch'ih I-seng's works, by the 11th-

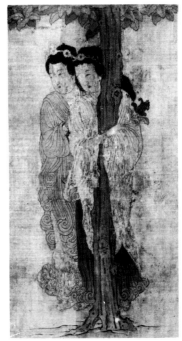

(C) After WEI-CH'IH I-SENG
Two Girls Standing beside a Tree: handscroll (detail)
Florence, Berenson Coll., by permission of the President and Fellows of Harvard College

CHANG SENG-YU
張僧繇

WEI-CH'IH I-SENG
尉遲乙僧

CH'EN YUNG-CHIH
陳用志

century painter Ch'en Yung-chih, is illustrated in color plate 155. It depicts the Buddha Shākyamuni walking in the garden of the Jetavana monastery, his headquarters during the later years of his ministry. The Indian features of the Buddha, the tight, wirelike lines of the drapery, the rich, luxuriant foliage of the blossoming tree, the flower-strewed rocks painted with a thick pigment to produce an effect almost of flowers in relief—all suggest a blending of foreign techniques with a refinement of drawing that is purely Chinese. The use of gold to outline the rocks was a technique often employed by Chinese court painters to give their landscapes added richness and splendor.

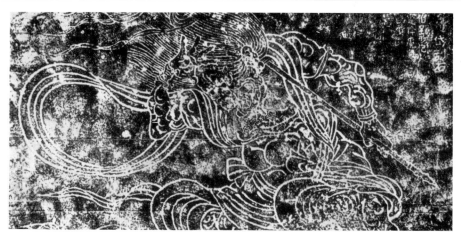

(A) After Wu Tao-tzu
Demon (detail): rubbing from stone engraving, early 8th century

Wu Tao-tzu and his legacy

The greatest master of Buddhist painting, and reputedly the greatest figure painter in Chinese history, was Wu Tao-tzu (A), or Wu Tao-hsüan (about 700-760). He occupies a position in T'ang painting roughly comparable to that of Michelangelo in Renaissance Italy. The T'ang art historian Chang Yen-yüan states in his "Record of Famous Painters of Successive Dynasties" (preface dated 847) that Wu Tao-tzu painted more than 300 frescoes in the temples of Loyang and Changan. He was not a great colorist. Indeed he generally left the coloring to his assistants, if it was to be added at all. His genius lay rather in the wonderful sweep, power, and sureness of his brush line, likened by his contemporaries to the speed and skill of an expert swordsman. It lay, too, in the endless invention of his designs, and in his power to suggest both movement and solid, three-dimensional form by the modulation, in direction and thickness, of his brush line alone. A 12th-century writer who had seen only copies of his work said that Wu's figures reminded him of sculpture. Several of Wu's pupils became sculptors, one because he thought sculpture "an easier craft" than painting.

(B) Style of Wu Tao-tzu
The Sage Vimalakīrti: Debating with Sāmantabhadra (detail): from Tunhuang Cave 103 (T'ang Dynasty)
Kansu Province, China,

Not a single line from Wu Tao-tzu's own brush survives, but hints of his style can be seen in many details from the later caves at Tunhuang (B), and in the Japanese ink study of a bodhisattva preserved in the Shōsō-in at Nara (page 244). His power as a designer of large-scale figure compositions was handed down through the centuries, chiefly by anonymous painters of religious and ceremonial subjects

on the walls of temples, palaces, and ancestral shrines (C), and in wood-engravings (D).

The climax of imperial patronage of Buddhism came during the glorious half century when the T'ang emperor Hsüan-tsung (reigned 713-756) was on the throne, and a galaxy of famous painters, led by Wu Tao-tzu, were vying with each other in the creation of religious scrolls and wall paintings. But after the great rebellion of 756 (see page 33), court patronage of the arts declined, while Buddhism itself was soon to come under attack from both the Confucianists and the Taoists as a foreign and "un-Chinese" religion whose service was impoverishing the state. In a series of decrees issued between 843 and 845, all foreign religions were proscribed. Hundreds of temples were pulled down or converted to other uses and tens of thousands of monks and nuns secularized. The destruction of Buddhist wall paintings and the melting down of precious icons was carried out so thoroughly that very little except small, easily portable scrolls and images survived. Although the decrees against Buddhism were relaxed after a few years, it never regained its pre-eminent position in Chinese life. Nevertheless wealthy citizens, who often managed to combine a modicum of Buddhist piety with observance of Confucian rites and Taoist superstitions, have continued to build temples and pagodas up to modern times. Some of the finest existing buildings were erected in the 12th and 14th centuries.

A Sung Dynasty painting of Sāmantabhadra

One of the best surviving Buddhist paintings of the Sung period (960-1279) is a small hanging scroll depicting the bodhisattva Sāmantabhadra (Chinese: P'u-hsien), reproduced in color plate 156. The bodhisattva, who both symbolizes the

(C) Buddhist Wall painting (detail): from Yung-lo-kung, 14th century
Shansi Province, China, Yung-ch'i-hsien

WU TAO-TZU

(D) Diamond Sūtra (detail): wood-block print from handscroll, 868
London, B. M.

31

majesty of Buddhist law and fulfills the role of protector of the "historical" Buddha Shākyamuni, is represented seated on a lotus on the back of his white, six-tusked elephant (itself an emblem of the Law), with a dark-skinned, curly-headed Indian groom standing at his side. The slightly sideways pose of the bodhisattva is due partly to the fact that the painting originally formed the left panel of a triptych, in which it was balanced by Manjushrī on the right, with Shākyamuni in the center; and partly to the fondness for asymmetry found in painting of the Sung period as a whole (see page 260). This conception of the bodhisattva is not a profoundly spiritual one. Yet the small figure has a calm, sumptuous dignity that, conveyed through largeness of design, delicacy of drawing, and rich, glowing color, perfectly expresses the refined tastes of Buddhism's aristocratic patrons in the 12th and 13th centuries.

Chapter III
COURTLY FIGURE PAINTING: T'ANG, FIVE DYNASTIES, AND NORTHERN SUNG PERIODS

Court patronage in the T'ang Dynasty (618-906)

The first half of the T'ang dynasty was one of the most brilliant periods in Chinese history. The empire had expanded into Central Asia, and monks were once more taking the pilgrim road to India (E). The streets of the twin

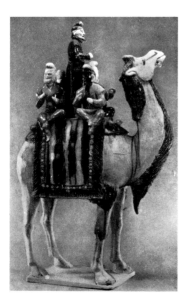

(A) Bactrian Camel with a Traveling Orchestra on its Back (T'ang Dynasty) *China, Private Coll.*

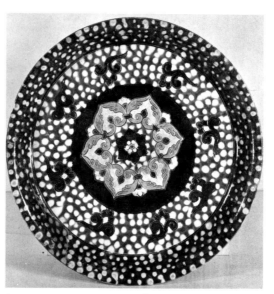

(B) Stoneware Dish with Three-colored Enameled Glaze (T'ang Dynasty) *Cleveland, Ohio, Mus. of Art, coll. Mr. and Mrs. Severence A. Millikin*

(C) Ewer: pottery with mottled cream and green glazes (T'ang Dynasty) *Toronto, Royal Ontario Mus.*

capitals, Loyang and Changan, were thronged with foreigners, whose jutting noses and curly hair were often caricatured in the pottery tomb figurines of the period. T'ang confidence and energy were reflected in the vital, ample forms of T'ang Dynasty painting and sculpture, in the ease with which foreign styles and techniques were assimilated, and in the love of color and rich floral decoration that appears in T'ang arts and crafts (A, B, C, D).

Imperial patronage, beginning with the second T'ang emperor, T'ai-tsung (reigned 627-650), reached a climax of liberal extravagance under Hsüan-tsung (reigned 713-756), better known as Ming-huang, the Brilliant Emperor. So absorbed did Ming-huang become in music and the arts—he had no less than eight orchestras, a theater, and a ballet school at the palace—that a treacherous general, An Lu-shan, was able to seize the capital in 756 and put him to flight. Although An Lu-shan was crushed and the dynasty restored, the rebellion brought to an end the glittering patronage of the T'ang court. The dynasty survived for another 150 years, but it never recaptured the brilliance of its heyday under Ming-huang.

Yen Li-pen

A great figure in early T'ang painting was Yen Li-pen, active at court between 630 and 673. He rose to be president of the Board of Works and in 668 became one of the two ministers of state. There was nothing unusual in this. From the T'ang Dynasty onward, painting, calligraphy, and scholarship were more and more closely connected. Many prominent painters were also scholars and, because they were scholars, their Confucian sense of duty obliged them to take public office.

Among Yen Li-pen's duties as painter to the emperor were those of recording important events and depicting the great figures of the past, the virtuous emperors and loyal ministers, as an inspiration to the living. Color plate 157 is a detail from what is possibly his only surviving work, a handscroll depicting 13 emperors from the Han to the Sui Dynasty, now in the Museum of Fine Arts, Boston. The first half of the scroll is a later restoration. The section illustrated shows the emperor Hsüan of the Southern Ch'en Dynasty (557-589; one of the Six Dynasties) being carried on a litter, attended by palace officials. The emperor is drawn larger than his attendants to emphasize his importance—a charming archaism. Shading is used in a purely arbitrary way to model the emperor's robe, but elsewhere solid

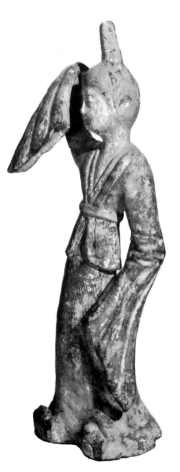

(D) Pottery Dancing Girl
(T'ang Dynasty)
Wendover, England, coll. Sir Alan and Lady Barlow

(E) The pilgrim Hsüan-tsang on his Way to India (detail): wall painting in Tunhuang Cave 103, 8th century
Kansu Province, China

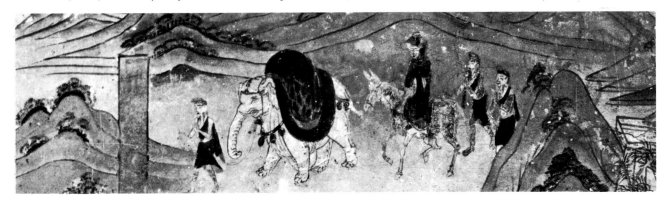

閻
立
本

張
萱

周
昉

form is suggested entirely by the subtle modulation of the brush line, whose gentle, sweeping rhythms also convey a sense of forward movement. With sly humor the painter has caught the lively attitude of the bearers, contrasting it with the serene, contemplative mien of this pious emperor and the grave deportment of his ministers. There is no means of knowing whether this is a true likeness of the emperor, but it is a perfect expression of the Chinese ideal of imperial dignity.

Chang Hsüan and Chou Fang

Although no originals survive from the hand of either of the 8th-century masters Chang Hsüan and Chou Fang, there are early copies of their work that give a good idea of the style of court figure painting in their time (A). Color plate 158 illustrates part of the scroll of Ladies Playing Double Sixes (a kind of backgammon) attributed to Chou Fang, a court painter active about 780 to 810 and famous for his pictures of palace women. The ample forms of the ladies and their girl attendants are evoked, as in the Yen Li-pen handscroll, simply by an almost hair-thin brush line. Color is reduced to a minimum; the delicate flesh tints have now all but disappeared, leaving exposed the white underpaint. We should note not only the delicacy with which the artist has delineated the volumes of the figures, whose fashionable plumpness presents a striking contrast to the ideal of feminine beauty expressed in the Six Dynasties by Ku K'ai-chih (color plate 152), but also how subtly he suggests the absorption of the women in the gentle drama of the game. It is a quiet, enclosed world that he presents, too precious and remote to survive contact with life beyond the palace walls.

Something of this quietness and restraint is also expressed in the handscroll of Ladies Preparing Newly-woven Silk (color plate 159), after an original by Chang Hsüan (active 710-745). The copy is attributed to an emperor of the Northern

(A) Attributed to CHOU FANG
Ladies Playing Double Sixes:
handscroll, 8th century
Washington, D. C., Freer Gall. of Art

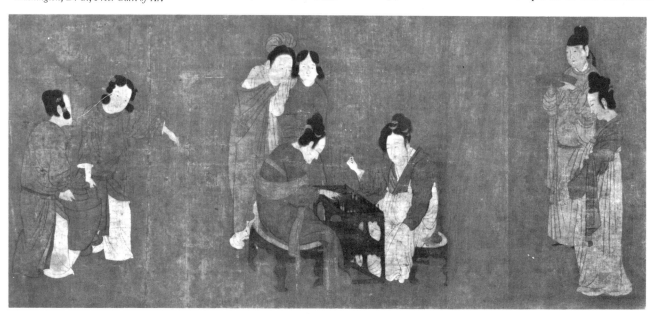

Sung Dynasty, Hui-tsung (reigned 1101-25), who was himself an accomplished painter. But whether it is actually by him or by a member of his academy, it is now impossible to tell. By contrast with the static composition of the Chou Fang, this scroll is full of subtle movement. Two ladies pound the silk, while one rests and another rolls up her sleeves. They are talking together, and we can almost hear their conversation and the dull thud of their pounding. As is usual in Chinese figure compositions, there is no ground or background. These, unless essential to the theme, can be taken for granted. The figures are thus united not by their setting, as they would be in a Western interior scene, but by their absorption in their task and in each other.

Painters of horses

The cavalry had been a vitally important branch of the imperial army since the Han Dynasty, and the possession of horses had become a symbol of wealth and prestige. Court painters were often called upon to paint the horses in the imperial stables. Yen Li-pen, for example, painted "portraits" of the six favorite chargers of the emperor T'ai-tsung, which were later carved as stone reliefs for the emperor's tomb (B)—another instance of the link between painting and sculpture. Copies of a number of T'ang horse paintings have survived. One of those most likely to be an original (at least in part; the hindquarters are a later restoration) is the fiery steed Shining Light of the Night (c). This horse was Ming-huang's favorite, and the artist, Han Kan, the most famous T'ang specialist in this genre. Han Kan has caught perfectly the nervous toss of the horse's head and the startled glint in its eye. The overlapping contours and arbitrary shading give a suggestion, not wholly accurate, of solid form. Nevertheless the artist, as always in Chinese painting, is not so much concerned with volume as with life and movement, which he expresses through the rhythm and direction of the lines.

 HAN KAN

(B) After YEN LI-PEN A Charger and his Groom: stone relief from the Tomb of Emperor T'ai-tsung (T'ang Dynasty) *Philadelphia, Pa., University Mus.*

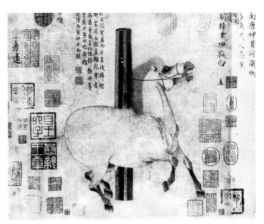

(c) HAN KAN Shining Light of the Night: handscroll (T'ang Dynasty)
London, coll. the late Sir Percival David and Lady David

35

Figure painting at the Southern T'ang court (937-975)

CHAO KAN

The long twilight of the T'ang Dynasty produced no painter comparable with the great masters of the 8th century. The style of court painting then, so far as can be judged, seems to have been a somewhat overblown continuation of the manner of Chang Hsüan and Chou Fang. When in 906 the T'ang Dynasty finally collapsed, China was once more divided. During the succeeding period of the Five Dynasties (907-960), the court of the petty kingdom of Former Shu (in modern Szechwan) became a haven of refuge for officials, scholars, and painters who had fled from the northern capitals. Later, Li Hou-chu (937-978), "Emperor" of the kingdom of Southern T'ang, and himself a poet, gathered around him at Nanking a group of painters, who sought to recapture the lost glories of the T'ang Dynasty in an atmosphere of remarkable artistic freedom. There Chao Kan painted a panorama of a riverside at first snowfall that has survived in the Palace Museum collection, Taiwan. In this scroll (A) the travelers and fishermen huddled against a biting wind, the bare mudbanks, and bent and spiky reeds, are drawn with lively realism. Falling snow is rendered by the simple device of flicking white paint from the brush on to the silk. The scroll has a sardonic humor unique in the annals of Chinese court painting.

KU HUNG-CHUNG

In contrast, Ku Hung-chung painted for the emperor a handscroll depicting the night revels of the licentious minister Han Hsi-tsai. Surviving in an excellent Sung copy (B), the scroll is chiefly remarkable for the manner in which the artist has clothed the highly suggestive detail in a pictorial language of the utmost decorum.

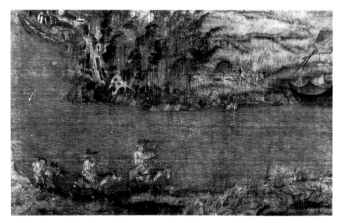

(A)　CHAO KAN　Early Snow on the River (detail): handscroll
(Southern T'ang Dynasty)
Taichung, Taiwan, National Palace Mus.

(B)　After KU HUNG-CHUNG　The Night Revels of
Han Hsi-tsai (detail): handscroll (Sung copy)
Peking, Palace Mus.

Imperial patronage under the Northern Sung Dynasty (960-1127)

The tradition of imperial patronage of painting was continued by the Sung emperors. By this time the Imperial Painting Academy, first established by Ming-huang of the T'ang dynasty, and placed on a firm basis by Li Hou-chu at Nanking, had become an important organization at court. Senior members of the academy

had a rank equal to that of ministers and were permitted to remain seated in the presence of the emperor. But the status accorded them, while it brought their profession into high repute, was a mixed blessing. It imposed upon academicians the obligation to depict an ideally perfect world in which the sardonic realism of Chao Kan's *Early Snow on the River* or the scandalous subject matter of the Ku Hung-chung handscroll would have been quite unthinkable. This growing conventionalism reached its height under the Northern Sung emperor Hui-tsung, for whom every picture painted in the academy studios had to be pure in form and lofty in sentiment. Even when the theme was tragic or dramatic, it was transformed into something noble and refined.

The limits to which the late Northern Sung academy painters were able to go in depicting a dramatic theme are shown in a detail (color plate 160) from *Breaking the Balustrade*. This scroll (c) by an anonymous master of the early 12th century illustrates an incident in Han history, when a loyal magistrate, Chu Yün, denounced a traitorous marquis in the emperor's presence. The angry emperor decreed that Chu Yün be executed, but the magistrate clung to the balustrade insisting that he be cut to pieces there and then, as another loyal subject had once died. Moved by his courage and by the pleas of a general, the emperor spared him and ordered that the broken balustrade be preserved as a memorial to his loyalty. The actors in the scene are here subtly characterized. On the left is the loyal magistrate held by the bodyguard; the general is in the center; the furious emperor is seated to the right, and the scheming, obsequious marquis stands beside him. The drawing is fine and precise, the color warm and seductive. It is only when we examine the picture closely that we become aware how intense is the drama that is being enacted. Remarkable also, and typically Chinese, is the manner in which the picture is composed. Pictorially speaking, the general in the foreground is completely isolated. Yet this lonely figure is related to the other actors in the drama by the tension that flashes like an electric current between them, uniting them with a force far more subtle than the formal unity that holds together a Western composition.

(c) ANONYMOUS Breaking the Balustrade: hanging scroll (detail) early 12th century
Taichung, Taiwan, National Palace Mus.

The deer paintings

Court painters were charged with the task of painting screens and wall panels to decorate the endless apartments of the palace. A few paintings and fragments of paintings of this type have survived, and were later mounted as hanging scrolls. Most of them are decorative flower paintings. Of exceptional beauty are two panels that have been preserved in the Palace Museum collection, Taiwan, *Deer in an Autumn Forest* (page 234) and *Deer among Red Maples* (d). The emphasis on the silhouettes of the deer, and the colorful composition completely filling the picture-space have suggested to some authorities the influence of Persian art. Attention has also been drawn to similar wall paintings in a Liao Dynasty tomb in Manchuria. But Persian influence at this early period would be hard to account for, while it is more likely that China influenced Liao painting than that the reverse occurred. These two lovely compositions are rare examples of the decorative court painting of the early Northern Sung Dynasty.

(d) ANONYMOUS Deer among Red Maples (detail) 10th century
Taichung, Taiwan, National Palace Mus.

Li Lung-mien

LI LUNG-MIEN

李龍眠

FAN-LUNG

梵隆

Beside the careful, precise, and colorful figure painting practiced in the Sung academy, another tradition was developing that was in time to become much more important. This was the painting of the scholars. Some were gentlemen of independent means and habits like Mi Fu (see page 47). Others were officials who painted in their spare time. Many were at the same time collectors and connoisseurs with a profound knowledge of literature, art, and antiquities. When they painted they preferred, like the calligrapher, to express themselves in ink line on paper rather than in color on silk, which they considered to be more suitable to the academician and professional. Li Kung-lin (1040-1106), or Li Lung-mien as he preferred to be called, served as an official for 30 years, "but never, even for a day," his biography records, "did he forget the mountains and forests." This devotion to nature was typical of the scholar painter. Nevertheless, Li Lung-mien is chiefly known as a figure painter who used the pure ink line (*pai-miao* or *pai-hua*) in the tradition handed down from Wu Tao-tzu. According to his official biography, although his style was that of Wu, in his "genius" he was like Wang Wei (see page 42). This means that he brought to the art of figure painting not only Wu's skill with brush and ink, but also the pure, lofty ideals of the poet painter Wang Wei. Today a number of figure paintings in ink line in Li Lung-mien's manner exist, though none can be attributed to him with absolute certainty. The scroll of Arhats, or Lohans (Buddhist saints), in a landscape (A) is attributed to his 12th-century follower Fan-lung. But its dry, scrubby brushwork, its air of cool serenity, and its highly individualistic rendering of both figures and tree trunks are all typical of Li Lung-mien himself. They provide a striking contrast, in both technique and spirit, to the academic ideals of figure painting exemplified in *Breaking the Balustrade*.

(A) Attributed to FAN-LUNG Buddhist Saints in a Landscape
(detail): handscroll, 12th century
Washington, D. C., Freer Gall. of Art

Chapter IV
LANDSCAPE PAINTING REACHES MATURITY

The earliest Chinese paintings of which we have any knowledge were almost all figure compositions of one kind or another. After the Han Dynasty, as painters increased their skill and broadened their scope, they began to provide their figures with landscape settings. Gradually the landscape became more and more important (B), until, in the T'ang Dynasty, the natural shift of emphasis from figures in landscape settings to landscapes with figures was made. By the 11th century the human figures in Chinese paintings had shrunk to a size that truly reflected the Chinese view of man's relative insignificance in the scheme of things.

(B) T'ang Style Landscape (detail): lacquer on a wooden box, 8th century
Nara, Japan, Shōsō-in Repository

Li Ssu-hsün and Li Chao-tao

The two painters Li Ssu-hsün (651-716) and Li Chao-tao (active about 670-730), father and son, are traditionally considered the founders of a colorful, decorative style of landscape painting known as *ch'ing-lü-pai* (blue, green, and white), or *chin-pi shan-shui* (gold and blue-green), which became the basis for what might be called the palace style of the T'ang Dynasty. Its place in the Chinese tradition is set out in the historical chart on pages 274 and 275. The origins of the style in fact go back to the Six Dynasties and even earlier, when painting was often referred to as *tan-ch'ing* (red and blue), indicating that a technique based on strong contrasting colors already existed at that time.

Li Ssu-hsün, after a checkered political career, was given the honorary title of General. He and his son Li Chao-tao are often referred to by Chinese art historians as Big and Little General Li, though the latter never held military rank, not even an honorary one. None of their work survives, and the literary descriptions of their style, crediting them with having painted in the *ch'ing-lü-pai* manner, were written centuries after their death. If this traditional view is accepted it seems probable that Li Chao-tao, whose style was presumably more advanced than that of his father, painted somewhat in the manner of a hanging scroll on silk in the Palace Museum collection, Taiwan, of which the present title is *Emperor Ming-huang's Journey to Shu* (color plate 161, and page 40A). Whether it actually depicts that emperor's tragic flight from the rebel An Lu-shan (see page 33), or merely a summer outing in the imperial park, it is now impossible to say. If the subject is the imperial flight of 756, it cannot be by Li Chao-tao, who had been dead for more than 25 years when the event took place. But while the author of this picture, its date of execution, and even its subject remain a mystery, the picture itself is a magnificent example of the brilliant courtly style of the mid-T'ang period. In some respects it is archaic. The exaggerated height and angularity of the mountains, the lack of a middle ground, the decorative clouds, the precisely outlined trees, all seem to derive from the Six Dynasties style as it is shown on the early stone sarcophagus illustrated on page 22. These decorative archaisms survived in one school of courtly

LI SSU-HSÜN

LI CHAO-TAO

39

and professional landscape painting until the Ch'ing Dynasty. The handscroll illustrated in color plate 171, attributed to a Sung artist but probably painted in the Ming Dynasty, is a typical late example of this style.

(A) ANONYMOUS Emperor Ming-huang's Journey to Shu (detail): hanging scroll, probably 12th century
Taichung, Taiwan, National Palace Mus.

(B) ANONYMOUS (from TUNHUANG) The Simultaneous Births: silk banner (detail)
London, B. M.

Specialists

During the first half of the T'ang Dynasty, painters made considerable progress toward solving the technical problems that had earlier defeated them. One painter, for example, was noted for his power to depict depth and distance convincingly, another for his suggestion of relief, another for the way in which he could convey an idea of color by the use of ink tone only. Then, too, painters were acquiring a reputation in one or another specialized branch of the art. One might be expert in the precise drawing of architecture, using a ruler in the *chieh-hua* (boundary-line) method, others in painting bamboo or pine trees, or cattle and farmhouse scenes, which were depicted with close accuracy. None of their work survives, but hints of both their subject matter and their styles are often to be found in the naturalistic paintings in the corners and side panels of the Buddhist wall paintings and in silk banners (B, and color plate 154) from Tunhuang.

The birth of two traditions

On pages 274 and 275 there is a chart showing how the main streams of Chinese landscape painting have developed from the T'ang Dynasty to the present day. The precise, colorful palace school runs along the top. Below this the literary

tradition is divided broadly into two main streams, which Chinese painters and critics in recent centuries have come to call the Northern and the Southern schools. Below this again is shown the tradition of the independents and individualists, who claimed to belong to no school at all.

Chinese critics decide whether a particular painter belongs in the Northern or Southern school chiefly on the basis of his style. If his ink landscapes have a firm structure, if his line tends to be rather hard, angular, and abrupt, if his rhythms tend to be jerky, and if he exploits dramatic contrasts of line and tone, he is classed as a Northern painter. The great Northern masters include Li Ch'eng, Fan K'uan (color plate 162, and c), Kuo Hsi (color plate 166), and Li T'ang (page 236) in the Northern Sung Dynasty; Ma Yüan (color plate 167) and Hsia Kuei (page 54) in the Southern Sung; T'ang Ti (color plate 180) in the Yüan; and Tai Chin (page 76) in the Ming Dynasty.

The painters of the Southern school avoided the striking effects of the Northern landscapists. Their vision was broad, their contours rounded, their line relaxed. In place of the dramatic contrasts of the northerners they explored the mysterious depths of nature in mist and cloud. The traditional founders of the Southern school were Tung Yüan and Chü-jan (color plate 163, and D). Its great exponents in the 11th century were Mi Fu and his son Mi Yu-jen (pages 47 and 238). The style went out of fashion during the Southern Sung Dynasty, but was revived by the scholar painters of the Yüan Dynasty, notably by Huang Kung-wang (page 238), and has continued to flourish among amateurs up to the present day.

Although the terms "Northern" and "Southern" were not applied to painters until the 16th century, the division into two traditions seems to have crystallized as early as the 10th, when it was based on the differences between two regional schools: the one, centered in the Northern Sung capital, Kaifeng, depicted the hard, bleak landscape of North China; the other, centered in Nanking, found a natural style to depict the rounded hills and misty atmosphere of the Yangtze valley. In time, however, the two schools lost all contact with their regional origins. Because of its possibilities for technical brilliance and startling effects, the Northern style became more and more the special province of the academicians and professionals. The more relaxed and spontaneous brushwork of the Southern school, on the other hand, became the natural mode of expression of the scholars and poets. Some later painters liked to combine elements from both schools.

During the Ming Dynasty, this division of landscape painting into two schools was given a special interpretation by the painter and critic Tung Ch'i-ch'ang (1559-1636), who saw in it a clear explanation of the split between the despised professionals on the one hand, and the amateurs and scholars, such as himself, on the other. He traced the origins of the Northern school back to the decorative courtly style of Li Ssu-hsün and Li Chao-tao, while he held that the Southern school originated in the monochrome ink landscapes of the great 8th-century poet and scholar Wang Wei. In fact Tung Ch'i-ch'ang's application of this theory to individual painters, based on the painter's social position rather than his style, is full of inconsistencies. For instance, he calls Li Ch'eng and Fan K'uan Southern, because they were scholars and amateurs, but relegates Li T'ang, whose style was

(c) FAN K'UAN Traveling Among Mountains and Streams (detail): hanging scroll, 11th century
Taichung, Taiwan, National Palace Mus.

(D) Attributed to CHÜ-JAN Seeking the Way in the Autumn Mountains (detail) 10th century
Taichung, Taiwan, National Palace Mus.

41

directly derived from Fan K'uan's, to the Northern school, because he was a member of the imperial academy. In this book the terms "Northern" and "Southern" refer to the two traditions of Chinese landscape *style*, and not to the special social interpretation put upon them by Tung Ch'i-ch'ang and his followers.

Wang Wei

WANG WEI 王維

CHANG TSAO 張璪

Since the time of Tung Ch'i-ch'ang, Wang Wei (699-759) has stood in the history of Chinese landscape painting as the symbolic founder of the tradition of scholarly painting, which is called *wen-jen-hua*, the painting of the *wen-jen*, or literati. Actually, he was by no means the first amateur landscape painter, and it is doubtful whether he did in fact paint in the monochrome ink-wash technique (*shui-mo*) of later scholar painters, as Tung Ch'i-ch'ang claimed that he did. Several early sources say, on the contrary, that he painted in color. There were other more independent and original T'ang painters, such as Chang Tsao, who are said to have made bold use of monochrome ink washes in their landscapes, but who have not attained Wang Wei's special position in the eyes of later literati.

For Wang Wei was not only a great poet and scholar, but also a man of noble character and profound feeling. To the critics of the Ming and Ch'ing Dynasties, who believed that the purpose of landscape painting was not primarily to depict nature but to express oneself, he was the ideal type of painter because he was the

(A) After WANG WEI View of Wang-ch'uan (detail):
handscroll (Ming Dynasty)
Seattle, Wash., Art Mus.

(B) Style of WANG WEI Riverside under Snow:
handscroll (detail) 9th or 10th century
Present location unknown

42

ideal type of man. His landscapes, they claimed, must therefore have been the expression of the highest Confucian virtues. Later copies of several of his paintings, notably a long panorama depicting his country estate, have been handed down (A). But they are so various in style and technique that they give little hint as to what the originals must have looked like. Perhaps his style is reflected most nearly in the *Riverside under Snow* (B) by an anonymous follower of the 9th or 10th century. The deeply poetic mood of this winter scene, the restrained naturalism of the drawing, the emphasis upon ink tone rather than outline and color, and the complete lack of decorative mannerism, all bring the viewer closer to nature than he has yet come in any landscape, and closer to the feelings of the painter himself.

The 10th century

The long stagnation of T'ang culture after the An Lu-shan rebellion of 756 was broken at last—in 906, when the dynasty fell, and China sank into the period of political chaos dignified by the name of the Five Dynasties. But, as before in Chinese history, political and social confusion stimulated a brilliant flowering of arts and letters, and it was during these turbulent years that landscape became the supreme art of the Chinese painter.

Before the end of the T'ang Dynasty, painters were already experimenting with an ink line of varying thickness and accent, and some had produced pictures as wildly eccentric (if literary descriptions are to be believed) as those of any modern Action Painter in the West (see page 295). Although these eccentrics founded no school, they must have influenced more orthodox painters, encouraging them to enlarge their range of brush techniques. It was at this time that painters began to "break" their ink line and wash (*p'o-mo*) by means of texture-strokes (*ts'un*) and dots (*tien*). As their vocabulary of *ts'un* and *tien* increased (see pages 254 and 255), their landscapes acquired a new richness of texture that brought them closer to nature than ever before. At last the viewer could almost imagine that he was standing before a real scene. Truth to nature was to remain the chief aim of landscape painters to the end of the Northern Sung Dynasty.

The great masters of the early and middle years of the 10th century were Ching Hao, Li Ch'eng, and Kuan T'ung (C). An essay on landscape painting attributed to Ching Hao, the "Pi-fa Chi" (literally: "Record of Brush Methods"), sets out the ideals of these painters. He stresses the need to study nature, so that all its infinite forms and moods can be accurately represented, but he insists that more important than mere accuracy is the animating spirit (*ch'i*), without which the forms have no significance. It is unlikely that any original works by these three masters have come down to us, but their styles are described in early literature and survive in good copies from the Northern Sung period.

Fan K'uan

The tradition of these great Northern masters is preserved above all in a magnificent hanging scroll of the early 11th century, *Traveling among Mountains and Streams*

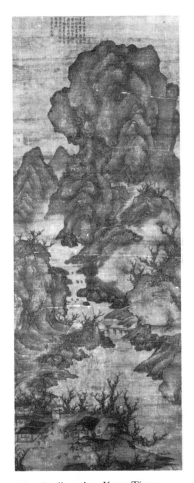

(C) Attributed to KUAN T'UNG
Travelers in the Mountains:
hanging scroll, 10th century
Taichung, Taiwan, National Palace Mus.

 CHING HAO

 KUAN T'UNG

 LI CH'ENG

FAN K'UAN

by Li Ch'eng's pupil, the Northern Sung master Fan K'uan. The whole of this simple but monumental composition is illustrated on page 261, a detail in color plate 162. A huge cliff face plunges down to a river bed. At its foot a jagged escarpment rises, silhouetted against the mists, with a temple half hidden among the trees. In the foreground two drovers with their mules emerge from the wood, dwarfed to insignificance by the precipice that towers above them. By means of the strong angular outlines, and a masterly use of short, "raindrop" *ts'un*, Fan K'uan has given the painting a wonderfully rich texture, while he conveys an almost super-human sense of the living reality of nature, by the power and concentration with which each leaf, each branch and fold in the rocks is delineated. So direct is his vision, so devoid of any hint of mannerism his style, that as we explore this land-scape we can almost hear the wind as it sighs in the pines, the shouts of the muleteers and the thunder of the waterfall. As the 11th-century critic Liu Tao-ch'un said of him, "They are real rocks and ancient trees that thrust themselves up, alive under his brush. One finds in him a spirit-consonance (*ch'i-yün*) that goes beyond the surface of things, and an indifference to ornamental beauty."

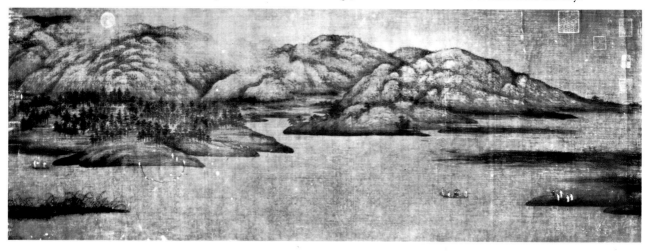

(A) Attributed to TUNG YÜAN
Views Along the Hsiao and Hsiang
Rivers: handscroll
(detail) late 10th century
Peking. Palace Mus.

TUNG YÜAN

CHÜ-JAN

Painters of the southern scene

Meantime, in Nanking, which as we saw in the previous chapter was a flourishing artistic center in the 10th century, a very different tradition of landscape painting had been developing. In contrast to the hard grandeur of the northern scene, the mountains of the province of Chekiang are low, rounded, and tree-covered; lakes and rivers abound, and the atmosphere is suffused with misty sunlight. This scenery demanded not the taut, angular brushwork of a Li Ch'eng or a Fan K'uan, but a manner altogether freer and wetter. The great masters of this Southern school are Tung Yüan (906-960) (A), who had the sinecure post of Superintendent of Parks under the cultivated emperor of the Southern T'ang Dynasty, Li Hou-chu (see page 36), and his pupil, the monk and painter Chü-jan, who went to live in a monastery in Kaifeng in 975 after the establishment of the Sung Dynasty, and the subsequent fall of the Southern T'ang. The style of their brushwork was loose and

relaxed; they placed less emphasis on outline and contour than did the Northern painters; rather than use the short, angular brush-strokes of the northerners, they drew hills with long, trailing, "hemp-fiber" *ts'un*, grouping boulders like "lumps of alum" on their crests. The contrast between the Northern and Southern styles becomes very clear if we compare the Fan K'uan in color plate 162, with the *Thick Forests and Serried Peaks* (color plate 163) attributed to Chü-jan.

It is unlikely that the latter is an original; in some respects it is too advanced for the 10th century, and it points rather to the 14th-century revival of Chü-jan's style. But this painting has many of the qualities associated with him: the relaxed brushwork, the long, loose, hemp-fiber *ts'un*, the groups of rocks on the hilltops, the rich, dense foliage and heavy, moisture-laden atmosphere of the southern scene. The path that leads up the side of the gorge carries not only the viewer's eye, but also his spirit, deep into the heart of the mountains. The painter is telling us that it is there—perhaps in the temple whose roofs can be seen farther up the valley—that we shall find the clue to the meaning of existence. Chü-jan, who was a Buddhist monk, was especially noted for his power to suggest not only pictorial, but also spiritual, depth in his landscapes (B).

Northern masters of the 11th century

It would be impossible to overemphasize the influence of these two groups of painters (Li Ch'eng, Ching Hao, and Fan K'uan on the one hand, Tung Yüan and Chü-jan on the other) upon the subsequent history of Chinese painting. Apart from the individualists and independents who appeared from time to time, almost every Chinese landscape painter up to modern times has considered himself to be a follower of one tradition or the other, or has consciously combined elements of both in an eclectic style.

In the 11th century the Northern tradition of Li Ch'eng and Fan K'uan was brilliantly developed by Kuo Hsi (1020-1090), a northerner from Honan, who became an instructor in the Northern Sung Imperial Painting Academy and was noted for his large-scale screens, and for his panoramas painted on the palace walls. He was also the author of a celebrated essay on landscape painting in which he discussed themes suitable for painting, gave much practical technical advice, and extolled the value of the art as a means of cleansing and ennobling the mind—a traditionally Confucian concept. Among the surviving paintings attributed to him, and the work most likely to be an original from his hand, is the great *Early Spring*, dated 1072 (color plate 166). The design of this large picture, in contrast with the static, centralized Fan K'uan compositions, is complex and restless, the sweeping S-curve of the central column of rocks being balanced and supported by a subtle interplay of lesser masses. The outline is still important; brilliant use is made of dark accents, and of the sharp, arresting silhouette of rocks and trees against the mist, while the painter's mastery of depth (both visual and atmospheric) opens up new dimensions of seeing and feeling. Again in contrast to Fan K'uan, who as it were chops out the shapes of his rocks with short, stubby texture-strokes, Kuo Hsi models his forms in soft transparent washes of graded ink, accentuating their mass

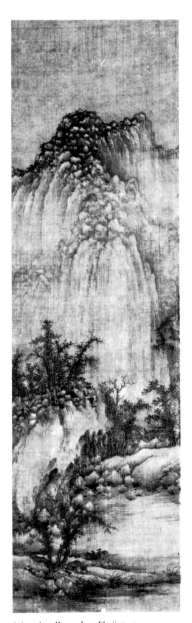

(B) Attributed to Chü-jan
A Buddhist Monastery in the Mountains: hanging scroll, late 10th century
Cleveland, Ohio, Mus. of Art

Kuo Hsi

YEN WEN-KUEI 燕文貴

with arbitrary but dramatically effective highlights and shadows. This painting is a triumphant vindication of Kuo Hsi's ideal that a landscape painting should have the power to arouse in the viewer the same kind of feelings that he would have were he to wander in a real landscape. This deliberate play upon the emotions of the viewer, which Kuo Hsi himself kept rigorously under control, was later exploited for its own sake by some of his followers, who mistook brilliance of effect for depth of feeling. Hints of it are to be found even in so accomplished a painter as the Southern Sung academician Hsia Kuei (see page 54). It became more obvious still in the work of the Ming painters of the Che school (see page 76), whom Tung Ch'i-ch'ang naturally placed in his Northern school.

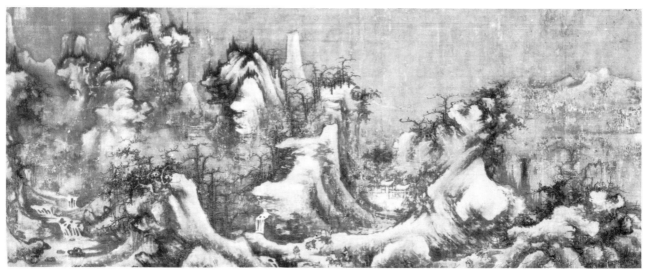

(A) KUO HSI Winter Landscape
(detail): handscroll, 11th century
Toledo, Ohio, Mus. of Art

KAO K'O-MING 高克明

HSÜ TAO-NING 許道寧

Although Kuo Hsi (A) was the dominating figure among the Northern painters of the 11th century, pictures by, or attributed to, several other important 11th-century masters in this tradition have survived. Hsü Tao-ning, who began life as a pharmacist and only later became a professional painter of large-scale panoramas, was often commissioned to paint wall and screen landscapes for the houses of the rich. Yen Wen-kuei started by selling his pictures in the streets. He was noticed, and commissioned to paint landscapes on temple walls, and eventually rose to be Painter in Attendance at the Northern Sung court and a member of the Imperial Painting Academy. His friend Kao K'o-ming was another Northern Sung academician who executed frescoes on imperial order.

All the wall decorations of these and other Sung artists disappeared with the destruction of the buildings that housed them. But several of their scrolls have survived, including a short handscroll attributed to Kao K'o-ming, *Streams and Hills under Fresh Snow* (color plate 164/5). The painter's accuracy of observation, and his choice of the horizontal, handscroll format for this picture make anyone who looks at it feel himself to be actually wandering along a river bank. A warmly dressed gentleman greeting his visitor, and a solitary fisherman are the only signs of life in a bleak, silent landscape that perfectly evokes the mood of a North

China winter. This is a fine example of the poetry and the realism of Northern Sung landscape painting, though it is perhaps rather too advanced technically for the date it bears (1035).

The Southern tradition in the 11th century

During the 11th century the poetic ideals of Wang Wei and the broad, relaxed, Southern brush style of Tung Yüan and Chü-jan came together in the person of Mi Fu (1052-1109), a northerner by birth, who held a variety of administrative posts at the Northern Sung capital. Mi Fu (or Mi Fei, as he came later to be called) was not only a painter but also a scholar, an incisive critic, and a collector of ancient paintings. He was something of an eccentric; he steeped himself in the past, went about in the costume of the T'ang Dynasty, and often painted pictures in antique styles. But he is chiefly known as the reputed inventor of a loose, free manner of painting landscapes in monochrome ink, in which the forms of the mountains are defined, not by the conventional brush line, but by graded washes reinforced along the contour by blobs of ink (the "Mi-dot") laid on with the flat of the brush. Because his technique dispensed with the brushstroke, which was the very foundation of traditional painting, it was considered highly unorthodox—so much so, in fact, that the emperor Hui-tsung (reigned 1101-25), himself a painter of exquisite conventional pictures, would have none of Mi Fu's work in the imperial collection. The style laid itself open to easy imitation, however, and it was handed down by later generations of painters who could never have seen an original work by Mi Fu himself (B).

Mi Fu's son Mi Yu-jen (1086-1165) was the first to develop his father's style, and several landscapes attributed to him have survived. Typical, in its loose handling of wet ink washes, is the handscroll dated 1130 in the Cleveland Museum of Art, Ohio (page 238). This picture stands at the crossroads between the broad, monumental concepts of the Northern Sung painters and the more lyrical and poetic masters of the Southern Sung Dynasty, whose work is discussed in the next chapter.

Painters of bamboo

Mi Fu, though not himself noted as a poet, was a leading member of an eminent circle of literary men at the capital who held that landscape painting, indeed painting in general, was not primarily a means of representing nature, but merely one of several possible ways in which the cultivated gentleman might express himself. Free self-expression was likely to be hindered rather than helped by too close and accurate a rendering of natural forms or too careful attention to technique: these could be left to the professionals and academicians. In their landscape painting, Mi Fu and his friends did not reject nature altogether. However unconventional their forms, the cloudy mountains and mountainous clouds of a Mi Yu-jen vividly suggest the mysterious life of nature, the very *ch'i* (life-breath) or *shen* (spirit) that had been enshrined centuries before in the First Principle of Hsieh Ho, and in the writings of Ku K'ai-chih (see pages 21 and 22).

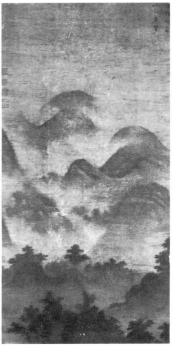

(B) After Mi Fu Misty Landscape: hanging scroll, 14th century? *Washington, D. C., Freer Gall. of Art*

Mi Fu

米
芾

Mi Yu-jen

米
友
仁

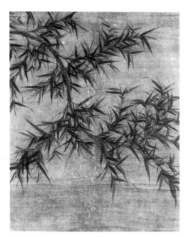

But the spirit now depicted was not only that of nature, but equally—and, as time went on, increasingly—that of the painter himself. When these men sought a medium for pure, abstract self-expression, they turned to calligraphy. Mi Fu and his friend the great poet Su Tung-p'o were masters of this supremely difficult art. In the swift, spontaneous movement of the brush, in the balance of ink line and empty space on the page, in the content of the passage itself, they found a unique union of vitality, form, and meaning, the perfect expression of the energy, intelligence and nobility of mind of the ideal Confucian gentleman.

Hardly less abstract than pure calligraphy was the art of bamboo painting. The scholars, often persecuted for their intellectual independence, saw in the pliant strength of the bamboo, which can be bent but not broken, a symbol of their own ideals and role in society. In bamboo painting, moreover, the range of ink tone, the subtle yet instinctive spacing, the springing vitality and infinite variety of the brush line, are those also of the calligrapher. Added to this is the painter's power to suggest the life and movement of the bamboo itself.

The greatest Northern Sung master of the bamboo was Wen T'ung (died 1079), but it is doubtful whether any of his works have survived (A). One of the finest early bamboo paintings is the hanging scroll *Bamboo and Withered Tree* (page 240), a free study by Mi Fu's nephew Wang T'ing-yün (1151-1202). Painted, like most of the works of the scholars, in loose ink washes on paper, it is so relaxed and spontaneous, so free from any technical mannerism that, in words from a poem written at the end of the scroll by a later critic:

"One feels, unrolling it, a fondness,
As if seeing the man himself."

Not, be it noted, seeing the bamboo itself, but seeing through the visible forms on the paper to the heart of the painter. Here is expressed in brief the whole philosophy of the *wen-jen-hua*, the painting of the scholars, which was from this time on to take an ever more dominant place in the history of Chinese painting. It is most fitting that these lines should have been attached to a painting of bamboo.

Painting under the Chin Tartars

Wang T'ing-yün was a member of the Han-lin academy of scholars under the Chin Tartars, who had conquered and occupied North China in 1125. The descent of the Tartars was a disaster from which the Sung Dynasty barely recovered. The capital was sacked and the countless art treasures accumulated by the emperor Hui-tsung and his predecessors were destroyed or scattered. In 1127 the emperor himself was carried off a prisoner to the remote northeast, where he died eight years later. The remnants of the royal house fled to the south, eventually to establish a new capital under a new emperor at Hangchow.

The leading figure in the Northern academy before the Tartar occupation was Li T'ang, the master of a powerful landscape style based on the tradition of Fan K'uan and Kuo Hsi. His work and his enormous influence on painters of the Southern Sung academy are discussed in the next chapter. But not all painters fled, like Li T'ang, to the south from the invading Tartars. Some remained behind, to

carry on his manner through the 12th and 13th centuries. They were cut off from developments in Hangchow and their style seems, from paintings identifiable as being of the Chin period, to have reflected their increasing isolation, becoming more and more mechanical and conventionalized. But these northern painters, who include Wu Yüan-chih (B), Yang Shih-hsien, and Li Shan, are important in that they preserved the manner of Li T'ang with little change until the day when, under the Mongols, the imperial court was once more established in the north.

YANG SHIH-HSIEN

LI SHAN

The Tung Yüan tradition in the Southern Sung Dynasty (1127-1279)

Painters at the Hangchow academy also carried on the officially favored style of Li T'ang. Meanwhile the Southern landscape tradition of Tung Yüan (C), Chü-jan, and the two Mi was kept alive during the 12th and 13th centuries by a number of painters outside the academy. One of them was Chiang Ts'an (page 50A), whose one known landscape handscroll, of which there are versions in Peking

CHIANG TS'AN

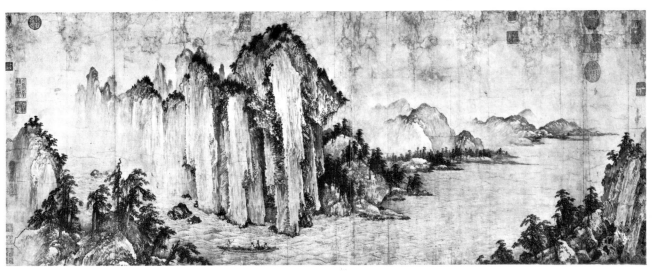

(C) ANONYMOUS Clear Weather in the Valley: handscroll (detail)
probably 12th century
Boston, Mass., Mus. of Fine Arts

(B) Attributed to WU YÜAN-CHIH
The Red Cliff: handscroll,
12th century
Taichung, Taiwan, National Palace Mus.

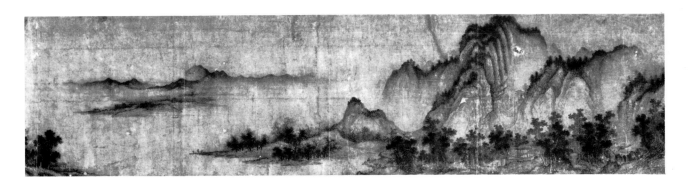

49

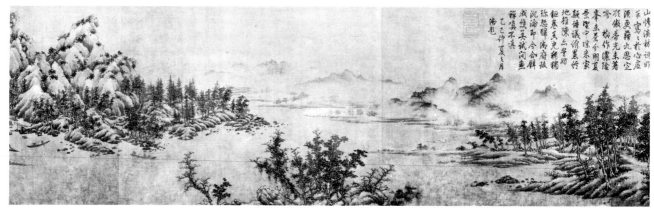

(A) CHIANG TS'AN Verdant
Mountains: handscroll (detail)
*Kansas City, Mo., William Rockhill
Nelson Gall. of Art*

CHANG TSE-TUAN

張
擇
端

(B) Attributed to LI CH'ENG
Buddhist Temple amid Clearing
Mountain Peaks (detail) about 940-967
*Kansas City, Mo.,
William Rockhill Nelson Gall. of Art*

and Kansas City, Missouri, shows a masterly development of the relaxed Chü-jan manner. The painters of some of the greatest of these Southern landscapes are not known, chiefly because they were not in favor at court. The handscroll *Clear Weather in the Valley* (color plate 168/9, and page 49c) in the Museum of Fine Arts, Boston, has been attributed to Tung Yüan by no less an authority than the great Ming critic Tung Ch'i-ch'ang. Yet the technique is too advanced, the sense of depth too subtle, for what is known of Tung Yüan's style and period. It seems probable that it was painted by some unknown southern master during the 12th century. It has been suggested that it might be the work of a northern painter who stayed behind under the Chin. But this is essentially a southern scene. The rounded, tree-clad hills, the moist, sunlit warmth of the atmosphere, above all the profoundly poetic, even romantic, vision of the artist, so different from the austerity of Fan K'uan and Li T'ang, all suggest a painter working in the lower Yangtze Valley, which from now on was the main center of landscape painting in the Southern tradition. Whoever its author, the Boston scroll is without doubt one of the greatest masterpieces of Sung landscape painting in the Western world.

Equally beautiful is *Traveling on the Hsiao and Hsiang Rivers in a Dream*, by an unknown twelfth-century master, of which a detail is shown on page 237. The monumental piling up of the mountain masses and the continuous depth into the river valley are in the spirit of Northern Sung, but the light, soft ink tones and the dreamlike blurring of the contours, influenced perhaps by Mi Yu-jen, suggest the romantic manner of the Southern Sung.

Chang Tse-tuan and the climax of realism

It will be remembered that the Six Principles of painting of the 5th-century theorist Hsieh Ho included truth to the forms and colors of nature (see page 13). In his day, when painters were still struggling with elementary technical problems, truth to nature was thought to be of the first importance; and since Hsieh Ho's time, artists had continued to strive for ever greater realism. In paintings attributed to Li Ch'eng (B), Fan K'uan, and Kuan T'ung, natural forms—trees

and rocks, figures and animals, farmhouses and temples, river boats and water-wheels—are not drawn direct from life, but are depicted so realistically that we feel as if we were looking at a real scene.

The climax of this tradition of realism may be seen in a remarkable handscroll (page 265) that illustrates preparations for the Ch'ing-ming festival (May 5) taking place along the river outside the northern capital, Kaifeng. The scroll is the work of the early 12th-century scholar painter Chang Tse-tuan, about whom almost nothing is known. In one detail a river boat, its mast lowered, is about to pass under a bridge. All is panic and confusion. Amid shouts of warning from all sides, the boatmen are frantically trying to prevent a collision with another boat coming downstream. Not only has the painter drawn the boat and its tackle, and every detail of the buildings (c), bridge, and figures with scrupulous accuracy and directness, but he has actually caught in mid-air the rope being thrown from the bridge, an example of photographic, split-second realism without parallel in the history of Chinese painting. Elsewhere in the scroll the curving sides of the junks are shaded to give them a convincing roundness and solidity (D).

Another striking departure in this scroll from the general practice of the Chinese painter is in the treatment of the interior of the restaurant in the foreground. It would be usual to show the whole of the interior with figures and furniture complete, even if this required some optical distortion. The Chinese artist is generally concerned to depict what he knows to be there rather than what would actually be visible from any particular viewpoint. Compare, for example, the typical treatment of the interior of a pavilion in the landscape by the Ming painter Wen Po-jen illustrated in color plate 186. By contrast, Chang Tse-tuan has not hesitated, in the interest of visual accuracy, to cut off with the line of the roof the heads of people sitting at the back of the room.

After the flight of the court to the South in 1126, this kind of realism soon faded, and did not appear again in Chinese painting until the twentieth century.

(c) CHANG TSE-TUAN
The City Gate: from the
Ch'ing-ming Festival Scroll,
about 1120
Peking, Palace Mus.

(D) CHANG TSE-TUAN
Boat: from the Ch'ing-ming
Festival Scroll, about 1120
Peking, Palace Mus.

Chapter V
THE SOUTHERN SUNG ACADEMY

After a decade of wandering, the refugee Sung court was finally established at Hangchow in the southern province of Chekiang. This delectable city, with its temples and pagodas, groves and mountains mirrored in the still waters of the West Lake, was and still is one of the famous beauty spots of China. There, in what they believed was only their temporary capital, men forgot the loyal armies on the frontier still heroically striving to stem the barbarian tide. Courtiers and officials gathered once more around the emperor; the ceremonies and arts of the old court at Kaifeng were scrupulously revived and fervently clung to; and life, for the upper

classes at least, became more refined than ever before. The Imperial Painting Academy was re-established under the first emperor, Kao-tsung (reigned 1127-62), himself a distinguished calligrapher and a connoisseur second only to Hui-tsung, his unfortunate predecessor. The kind of painting that Kao-tsung and his successors favored was a perfect reflection of the delicacy of taste, the nostalgia for past glories, and the ever-deepening desire for escape from the realities of life, that characterized the outlook of the Hangchow elite during the Southern Sung.

Li T'ang

In the early years of the Southern Sung Dynasty the academy was dominated by the figure of Li T'ang, then a very old man. He was born in the north before 1050, and had risen at the Northern Sung court to be Painter in Attendance and recipient of the coveted Golden Girdle. Stylistically, Li T'ang stood in direct line of descent from the Northern painter Fan K'uan. A contemporary wrote of his landscapes that "they are firmly painted with richly flowing ink in a free, straight, and abbreviated manner." His most characteristic technique was the *ta fu-p'i ts'un-fa* (literally: big ax-cut texture-stroke method), a free development from the raindrop and "small ax-cut" *ts'un* of the Northern masters of the early Sung Dynasty. With this terse, powerful brush technique for the painting of rocks and mountains, Li T'ang combined a masterly use of washes so as to suggest roundness by means of light and shade, a technique that had been developed by Kuo Hsi.

Li T'ang's modeling in light and shade, his ax-cut *ts'un* and firm, dense texture may be seen in a large landscape, *Whispering Pines in the Mountains* (page 236), in the Palace Museum collection, Taiwan. On a distant pinnacle is his signature and the date, 1124, one year before the Chin Tartars fell upon the northern capital and drove the old painter and many others into the mountains. This magnificent painting is today much darkened, so that the contrast between the grays and browns of the rocks, and the mineral green of the dense pine trees is lost. But no darkening can conceal the nobility of the design, truly in the spirit of Fan K'uan, or the concentrated power of Li T'ang's brushwork.

(A) Attributed to LI T'ANG
A Myriad Trees on Strange Peaks: fan, early 12th century
Taichung, Taiwan, National Palace Mus.

The lovely fan painting *A Myriad Trees on Strange Peaks* (A) has also been attributed to Li T'ang. It represents perhaps a late phase of his work, for the placing of the main foreground mass of mountains to one side, and the subtle suggestion of mists welling up from the valley below were conventions more characteristic of the Southern than of the Northern Sung academy.

The style of the Southern Sung academy

Some of Li T'ang's immediate followers at the Hangchow academy, such as the robber-turned-painter Hsiao Chao, seem to have retained something of his vigor of expression. But as time went on, the Southern Sung court retreated farther and farther into its world of exquisite dreams. Gradually painters transformed the style that Li T'ang had created into something more lyrical and romantic, chiefly by combining his ax-cut texture-stroke with a new subtlety in the manipulation of ink

tone. At the Southern Sung academy the type of design that he initiated was developed, sometimes to the point of artificiality and exaggeration, in the so-called "side-horned" or "one-corner" composition. In this the landscape occupies the foreground to one side or the other, the rest of the picture space being empty except for a suggestion of atmosphere and mist, with perhaps a hazy view of distant mountains. By means of this convention, artists were able to depict views that must have been very familiar to people gazing out across the West Lake from Hangchow (B). At the same time the vaguely melancholy atmosphere of these pictures was perfectly in accord with the mood of the times.

The Ma-Hsia school

The leading academicians of the late 12th and early 13th centuries who gave fullest expression to these techniques were Ma Yüan, his son Ma Lin, and Hsia Kuei. As these men were neither scholars nor high officials, they find no place in the dynastic history, nor in the writings of the literati. Consequently little is known about their lives. Ma Yüan, descendant of a long line of minor professional painters, became Painter in Attendance under the emperor Kuang-tsung (reigned 1190-94), received the Golden Girdle under his successor, Ning-tsung, and was still at work when Li-tsung ascended the throne in 1225.

Ma Yüan is chiefly famous for his ink landscapes on silk, which were enormously admired at court and imitated by academicians and professionals of widely varying talent (C). His fan painting *Bare Willows and Distant Mountains* (color plate 167), is one of the loveliest and most surely genuine of many such works attributed to him. The ax-cut *ts'un* on the distant ridge and the firm drawing of the tree trunks both recall Li T'ang, but the poetic vision is Ma Yüan's own. The painting is not too obviously a one-corner composition, but is in every other respect typical of Ma Yüan's period. The atmosphere of the lake shore as the evening air cools is suggested by mist hanging in the distant trees; the first hint of spring, by the tremulous droop of the bare willow branches silhouetted against the sky; silence and loneliness, by the solitary fisherman returning to his cottage at the water's edge. If the painting were not marred by the outrageous placing of the seals of a famous Ming collector, we should see better how subtly the painter carries the eye back beyond the trees to where the edge of the hills is lost in the evening mist.

Some of the technical devices used with great restraint in this fan by Ma Yüan began as it were to come out into the open in an album leaf by his son Ma Lin, *The Fragrance of Spring—Clearing after Rain* (color plate 170), in the Palace Museum collection, Taiwan. Again the arrangement is not typical of the period, being composed of an intricately woven and subtly balanced lattice of tree trunks and branches, living and dead, silhouetted against the mist. The composition seems to drift away in all directions. Nevertheless, the viewer's eye is ever drawn back to the center to try to penetrate through the trees to the place where the stream loses itself in the distance. No fisherman or contemplative scholar invites him to share the melancholy beauty of the scene. Although spring is coming, the despairing gestures of the outflung branches evoke an unutterable sadness. The twisted plum

(B) LI SUNG The Hangchow Bore in Moonlight: fan, 13th century
Taichung, Taiwan, National Palace Mus.

(C) MA YÜAN
Playing the Lute in Moonlight: hanging scroll, early 13th century
Taichung, Taiwan, National Palace Mus.

MA YÜAN

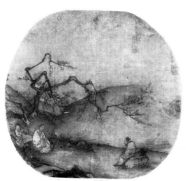

(A) MA YÜAN Sages under a
Spreading Plum Tree: fan,
late 12th-early 13th century
Boston, Mass., Mus. of Fine Arts

HSIA KUEI

夏珪趙伯駒

CHAO PO-CHÜ

(B) HSIA KUEI Pure and Remote
View of Streams and Mountains:
handscroll (detail) 13th century
Taichung, Taiwan, National Palace Mus.

tree bowed over the water in the foreground puts out few buds; it is old, with not
many more springs left for it to flower. Thus, perhaps, Ma Lin himself must have
felt amid the sad beauties of Hangchow, as the Sung Dynasty and its too-
exquisite culture slowly crumbled away.

Hsia Kuei, whose name is always coupled with that of Ma Yüan (A) as co-founder
of the "Ma-Hsia" school of landscape painting, was a prominent academician in the
early years of the 13th century, receiving the Golden Girdle under Ning-tsung. At
his best he was a more vigorous and daring painter than Ma Yüan. His long hand-
scroll, *Pure and Remote View of Streams and Mountains* (B), is without doubt the greatest
surviving work in the whole Ma-Hsia school. Indeed, it seems in some respects to
stand somewhat outside the tradition. The fact that it is painted on paper, the
medium of the scholar rather than the academician, gives the ink a tone of unusual
brilliance. The fire and energy of Hsia Kuei's brush is sustained throughout the
scroll's great length of over 32 feet with scarcely a hint of that technical mannerism
that often mars lesser works in the Ma-Hsia style. The modeling of rocks in broad,
powerful ax-cut *ts'un*, and the expression of their solid mass in terms of vivid high-
lights and dark areas, owe much to Li T'ang and Kuo Hsi. But the barely con-
trolled violence and freedom of Hsia Kuei's brushwork, and his dramatic balan-
cing of mass against apparent emptiness, bring him closer to the 13th-century Zen
expressionists (see pages 62 and 63; color plate 176), than to anything in the Sung
academy tradition.

It is hard to resist the impact of the brilliant play of Hsia Kuei's brush: the
spectacular contrasts, and the sharp, sudden accents of his rocks and trees. Later
Chinese painters in the scholarly tradition were profoundly mistrustful of these
qualities, and the critic Tung Ch'i-ch'ang placed the painters of the Ma-Hsia
tradition in his despised "Northern" school not only because they were profes-
sionals, but also because they often exploited the power of the brush for its own sake,
and not for the quality of the ideas that it might convey. As a result, although the
court continued through subsequent dynasties to favor the Ma-Hsia style, it was

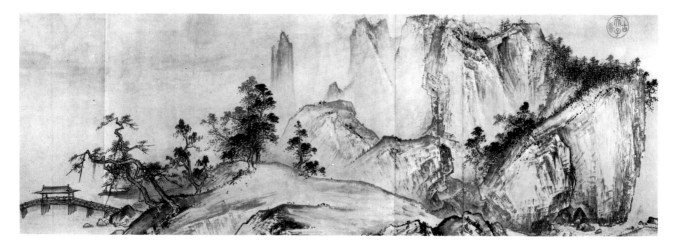

completely neglected by critics and private collectors, and few paintings by the artists of the Ma-Hsia school remained in private hands in China. However, the very qualities most mistrusted by Chinese literati were those that appealed most readily to Japanese connoisseurs, who had not had the benefit of a Chinese classical education. How the landscapes of Ma Yüan and Hsia Kuei found their way to Japan, and their influence upon Japanese ink painting, is a story that belongs to the Japanese section of this book.

Archaism

The intellectual sophistication of the Sung elite showed itself in an attitude of mind that was not only inward but also backward looking. The present seemed so unreal and the future so uncertain that men tended to absorb themselves in the past. The ancient rituals of the Chou Dynasty were revived and their utensils in bronze and jade were scrupulously copied. Almost every scholar was an antiquarian; some were amateur archaeologists, and it is said that the emperor Hui-tsung even sent scholars to find the source of the ritual bronzes of the Shang and Chou Dynasties, which he was acquiring and recording in the catalogs of his vast collection.

So it is natural that many court painters also turned their eyes to the past, and that they sought to revive and preserve the styles of antiquity. The chief of these painters was Chao Po-chü (early 12th century), who, like Li T'ang, was a prominent member of Hui-tsung's academy in the north, and like him followed the court to Hangchow. There he was employed on large-scale decorative schemes for the palace. He was also noted for charming, intimate fans and handscrolls depicting scenes in the inner apartments of the palace (D), or re-creating famous incidents in antiquity, which he treated with just that mixture of realism and fancy most calculated to appeal to court taste. His most distinguished surviving work is in Peking, a long landscape panorama in the traditional courtly *ch'ing-lü-pai* (blue, green, and white) manner (C).

Many scrolls in the *ch'ing-lü-pai*, or *chin-pi shan-shui* (gold and blue-green), style in Western collections are attributed to Chao Po-chü. One of the best of these, though certainly from the hand of a later copyist, is a long handscroll in the Museum of Fine Arts, Boston, depicting the imagined entry of the first Han emperor into Kuanchung, the Ch'in capital, in 206 B.C. (color plate 171). The brushwork is rather finicky and stiff, but the color is rich and gay, and the army as it winds through the mountains with its fluttering pennants has the air of some medieval pageant. It is unlikely that Chao Po-chü himself would have made his mountains so patently artificial as these, or that he would have applied his azurite blues and malachite greens quite so liberally. *The Entry of the First Han Emperor into Kuanchung* is important not as an example of the style of Chao Po-chü, but because it shows what professional painters of this period thought the ancient court style was like. Indeed, in the history of Chinese painting the traditional conception of the style of an early master, however inaccurate it might be, often takes on a life and validity of its own and may in time, when all originals are lost, come to replace the original.

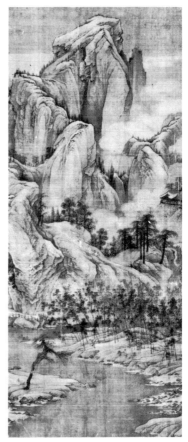

(C) CHAO PO-CHÜ
Rocky Mountains along a River in Autumn (detail): handscroll, 12th century
Peking, Palace Mus.

(D) Attributed to CHAO PO-CHÜ
The Han Palace: fan, 12th century
Taichung, Taiwan, National Palace Mus.

Figure painters

Wealthy Sung patrons liked nothing better than to contemplate pictures in which their own enclosed, comfortable world was reflected in miniature. Some painters accordingly specialized in depicting the easy, gentle life of the inner apartments of the palace and great mansions. One such was Su Han-ch'en (A), who was particularly noted for his quiet studies of elegant ladies at their toilet, and of sleek children playing amid the puppies and peonies of a palace garden. A fan decorated by the late Southern Sung academician Li Sung (color plate 172) is equally typical of this class of painting. Characteristically, the subject is taken from the life of the T'ang court in its heyday: the emperor Ming-huang on horseback amid his courtiers and attendants, watching a cockfight. It is signed on the square pillar just to left of center: "Painted by Li Sung of Ch'ien-t'ang, Painter in Attendance through three reigns." It was evidently executed shortly after 1225. The diagonal composition, the intimacy of the scene, the delicacy of the drawing, the romantic evocation of golden days long past—all are typical of court painting during the last century of the Sung Dynasty.

Birds and flowers

In the catalog of the painting collection of the emperor Hui-tsung, the eighth of ten categories of paintings was *hua-niao*, flower and bird painting. The earliest known Chinese example is to be found on the side of a pottery grave jar (B) of the 2nd or 3rd century A.D., in the collection of Dr. Paul Singer of New Jersey. But it seems to be an isolated example. The art of flower painting had scarcely developed at all in China when the introduction of Buddhism created a demand for painters who could execute elaborate flowered canopies over Buddhas and bodhisattvas, and depict the flower-strewn paradises described in the Sūtras (Buddhist scriptures). Strange foreign techniques were often employed, to the wonder and amazement of Chinese worshipers. From the temples the art of flower painting spread to palaces and mansions, where it formed an effective decoration for walls, screens, and furniture generally.

In the 10th century, Huang Ch'üan in Szechwan and Hsü Hsi in Nanking were both famous flower painters, though for quite different techniques. According to early accounts, Huang Ch'üan (c) applied his colors direct in thin washes without a strong outline—a technique called *mo-ku-hua* (literally: boneless painting); Hsü Hsi (D), on the other hand, drew his outlines firmly in ink and then filled them in with color. In general, later flower painters in the academic tradition are said to have based their techniques on the more decorative manner of Huang Ch'üan, while amateurs claimed to follow Hsü Hsi because the basis of his art was the ink line, the natural means of expression of the scholar and calligrapher. But in any event, beginning with Huang's son Huang Chü-ts'ai, they all borrowed their techniques freely from both schools, and the two traditions are not clearly defined.

A handscroll in the Moore Collection at Yale University (c, and color plate 174) is attributed to Huang Ch'üan. It bears an inscription referring to its having

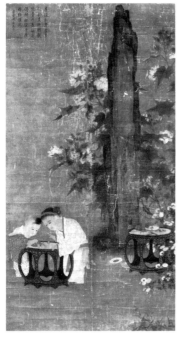

(A) Su Han-ch'en
Children at Play: hanging scroll
Taichung, Taiwan, National Palace Mus.

(B) Birds on a Flowering Branch: decoration on pottery grave jar, 2nd or 3rd century A.D.
Summit, N. J., coll. Dr. Paul Singer

been recorded and selected by the Interior Treasury of Painting of the imperial palace in 1032. The painting has been so severely damaged, and so clumsily restored that it is now impossible to tell whether or not it goes back to the 10th century and Huang Ch'üan, though a careful examination of the underlying ink drawing suggests that it may well be a work of the Sung Dynasty. The static design, the open spacing, the broad banks painted in mineral blue without the aid of *ts'un*, the flowers painted in a thick impasto that almost gives an effect of relief (compare those in Ch'en Yung-chih's copy of Wei-ch'ih I-seng, color plate 155) —these features all suggest that under the clumsy retouching lie the remains of a fine early example of the Huang Ch'üan style.

The sumptuous formality of the Yale scroll remained the ideal for decorative bird and flower painting throughout later centuries. But at the same time another more lively and naturalistic tradition was developing. A large hanging scroll in the Palace Museum collection, Taiwan, depicts two magpies teasing a hare (page 58 A). Dated 1061, it bears the signature of Ts'ui Po, a brilliant and wayward member of the Imperial Painting Academy, whose freedom with the brush (according to the notice on him in the emperor Hui-tsung's catalog of paintings) brought about a reaction against the decorative stiffness of the style of Huang Ch'üan. The artist has caught miraculously the atmosphere of oncoming winter, presenting it not as a set of conventional forms in frozen, colorful immobility, but as something that *happens* in nature. The air is full of tumult: the magpies shriek their insults, while the cold wind rattles the dry bamboo and seeks to tear from an old branch the few dead and dying leaves that still cling to it.

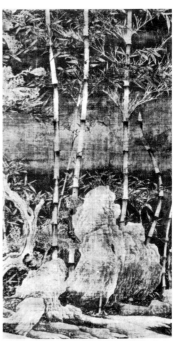

(D) Attributed to HSÜ HSI
Bamboos in the Snow: hanging scroll, 10th century
Peking, Palace Mus.

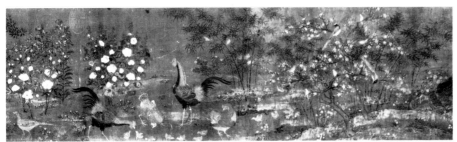

(C) Attributed to HUANG CH'ÜAN An Assembly of Birds on a Willow Bank: handscroll (probably Sung Dynasty)
New Haven, Conn., Yale University Art Gall., Gift of Mrs. William H. Moore

Bird and flowers painting under Hui-tsung, and after

The compilers of the catalog of paintings in the collection of Hui-tsung (reigned 1101-25), the painter emperor of the Northern Sung Dynasty, remarked somewhat tartly that Ts'ui Po "showed an excessive reliance on his own wit." That such a verdict could have been passed is symptomatic of the change that had come over imperial patronage under Hui-tsung. In the previous century Ts'ui Po had dared to refuse an appointment in the imperial academy, and had been accorded special privileges that prompted him to even greater feats. Under Hui-tsung all that was changed.

57

The emperor himself painted birds and flowers in a flawlessly accurate technique and demanded the same of his academicians. He would give them set themes to test their observation and would criticize the most trivial mistake. When he himself painted a picture they hastened obsequiously to copy it. As a special mark of his favor he would add his own abbreviated signature and perhaps an inscription, in his superbly elegant handwriting, to any of their paintings that particularly pleased him. Among his favorites was Li An-chung, a specialist in painting quail, who was later awarded the Golden Girdle under the emperor Kao-tsung at Hangchow. After the informal relationship that had hitherto existed between emperor and painter, Hui-tsung's aesthetic dictatorship can only have had a stultifying effect upon court painting, putting a premium on craftsmanship and conventional ideas at the expense of genuine feeling.

It is now difficult, if not impossible, to separate the surviving paintings by Hui-tsung himself from those of his academicians that he obligingly signed. One famous painting generally believed to be from the imperial hand is the *Five-colored Parakeet on a Branch of Apricot Blossom* (c) in the Museum of Fine Arts, Boston. The inscription, certainly by the emperor himself, describes the bird in poem and prose as a lovable guest in the garden, a visitor from the south. In contrast to the living vision of Ts'ui Po, Hui-tsung's conception is quite static. Although the parakeet is

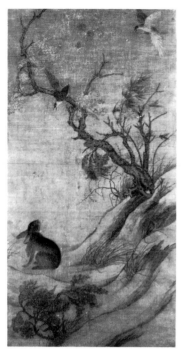

(A) Ts'ui Po Two Magpies Teasing a Hare: hanging scroll, 1061 *Taichung, Taiwan, National Palace Mus.*

Li An-chung 李安忠

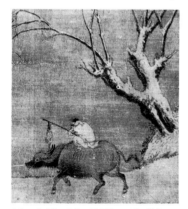

(B) Li Ti Man Riding a Buffalo in the Snow (detail): album leaf, 12th century *Osaka, Japan, Municipal Art Mus.*

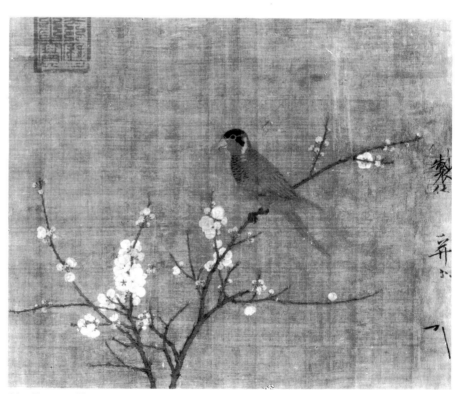

(C) Emperor Hui-tsung Five-colored Parakeet on a Branch of Apricot Blossom: handscroll (detail) early 12th century *Boston, Mass., Mus. of Fine Arts*

58

observed with minute accuracy, what Hui-tsung has achieved is not realism, still less naturalism, but a vision of nature frozen in timeless perfection. The bird is poised in an airless void without depth or atmosphere; no breeze lifts its feathers, no sound escapes from its beak. With such an example before them court painters of later times had no longer any incentive to look at nature itself, for Hui-tsung and his circle had created for them a world more perfect and flawless than nature ever achieved.

Some bird and flower painters of the Southern Sung academy, however, succeeded in their exquisite pictures in transcending the conventional limits (D). Although unsigned, the lovely fan painting *Birds Quarreling on a Blossoming Quince* (color plate 173) is believed to be by Lin Ch'un, a prominent member of the Southern Sung academy during the later years of the 12th century. He is said to have based his style on that of the early Northern Sung flower painter Chao Ch'ang, who was one of the first to make intimate close-up studies of nature. Despite the minute precision and subtly sophisticated one-corner balance of *Birds Quarreling on a Blossoming Quince*, the artist has contrived to bring back some of the life and movement of the work of Ts'ui Po. The chattering birds, the tremulous, delicate leaf forms, and the soft colors give the picture a seductive charm absent from Hui-tsung's stiffly accurate renderings.

Painters of animals

A number of artists in Hui-tsung's Northern Sung academy were experts in painting animals, which formed the seventh category in the catalog of his collection. The early 12th-century master Li Ti, for example, was not only an accomplished flower painter; he was noted also for his paintings of the water buffalo, that slow, patient beast whose ponderous form had become to the Chinese city dweller a symbol of the peace and tranquillity of country life. Li Ti's most beautiful paintings of this kind are probably a pair of album leaves in the Osaka Municipal Art Museum, Japan, depicting two farmers, the one leading his buffalo, the other riding his homeward through the snow on a winter evening (B). A number of other buffalo paintings of the Sung dynasty have survived, many of which are attributed, though with less reason, to Li Ti.

The melancholy parody of human nature to be seen in the faces of monkeys provided another theme popular with Sung academicians. The most famous monkey painter was Mao Sung (early 12th century), surviving examples of whose work show both masterly technique and humorous insight into simian character. His son Mao I specialized in painting dogs and cats, rendering them with the utmost refinement of technique as the charming playthings of the aristocracy. Scrolls attributed to him give an intimate glimpse into the courtyards and gardens of Hangchow.

Horses as a subject for painting seem to have appealed less to the Sung emperors, who preferred gentler themes than the T'ang emperors. Nevertheless, Sung horse painters usually modeled their style on the T'ang masters, and one of them, Ch'en Chü-chung (active about 1200), was said in his day to be "a Han Kan

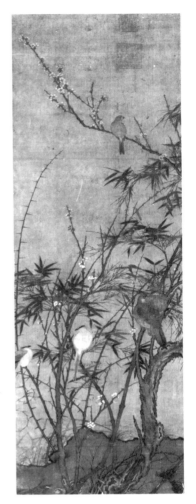

(D) ANONYMOUS
Birds in a Thicket of Bamboo and Prunus (detail): hanging scroll
Taichung, Taiwan, National Palace Mus.

LIN CH'UN 林椿 MAO I 毛益

LI TI 李迪 MAO SUNG 毛松

(A) CH'EN CHÜ-CHUNG
Wen-chi's Return to China (detail):
handscroll, about 1200
Taichung, Taiwan, National Palace Mus.

CH'EN CHÜ-CHUNG

reborn." Surviving pictures attributed to him are mostly scenes of Mongol horse-men, or illustrations to the story of Wen-chi (A), a lady of the Han Dynasty who spent 12 years as a prisoner of the barbarian Hsiung-nu tribe. The horse, indeed, was always a northern subject. It became very popular in North China under the Chin Tartars, and later under the Mongols. The album leaf showing a Mongol soldier escorting a Chinese woman with her two children (color plate 175) was probably painted by a Chinese artist working for the Chin Tartar court in the 12th or early 13th century. While his rendering of the faces is not particularly distin-guished, the horses themselves have a solidity of form and vigor of movement very different from the suave refinement displayed at the same period by horse painters of the Southern Sung academy.

Chapter VI
ZEN PAINTING

(B) LIANG K'AI
Strolling on a Marshy Bank: fan,
13th century
New York, coll. John M. Crawford Jr.

The Buddhist sect known in China as Ch'an, in Japan as Zen, was the only branch of the Buddhist faith to have a profound and lasting influence upon pain-ting. The doctrine, brought to China in the 6th century by an Indian monk named Bodhidharma, was different from that of all other sects in its total denial of the value of temples, images, scriptures, ritual, even doctrine itself, as aids to the attainment of enlightenment. Bodhidharma, the First Patriarch, taught that the Buddha was to be found, if at all, in a man's own inner soul; from realization of the truth within oneself, one might reach awareness of the "Buddha essence" that is in all things, animate and inanimate.

After Bodhidharma, Zen Buddhism split into two rival schools. The "Northern" school, founded by another Indian monk, Buddhapriya, claimed that the truth could be attained through the conventional path of discipline and study; the "Southern," of which the chief champion was the Fifth Patriarch, Hui-neng, denied the validity of all such aids, insisting that illumination came suddenly of itself to the mind empty of all intellectual dross. The Northern school became

fashionable and corrupt, but the Southern retained the pure teaching of Bodhidharma and Hui-neng, and came to be a source of profound inspiration to painters, particularly to those in the scholarly tradition. It was the distinction between the Northern, "gradual" and the Southern, "sudden" schools of Zen Buddhism that provided the Ming critic Tung Ch'i-ch'ang with his apt and convenient labels — "Northern" and "Southern" — for the two traditions of landscape painting described in chapter IV (see page 40).

The T'ang eccentrics

During the first half of the T'ang Dynasty, when society was still welded firmly together, Zen Buddhism made little headway in China except among eccentrics. But after 756 the gradual decay of T'ang institutions, together with the persecution of orthodox Buddhism that culminated in the decrees of 845 (see page 31), drove men of independent mind to seek spiritual truth through more unconventional paths, and Zen flourished. At the same time certain artists, finding that orthodox methods no longer met their needs, were experimenting with techniques as wild and eccentric as those of any modern abstract expressionists. The flash of Zen illumination, impossible to communicate in words, could be made manifest in the spontaneous gesture of the painter's brush. Each picture by these masters was a revelation of the inner self, meaningful in the very act of painting. One master, it is recorded, would spatter the silk with a toss of his ink-soaked hair; another spilled ink in pools upon the floor, dragged an assistant sitting on a sheet round and round over it, then with deft touches of the brush turned the blobs and smears thus created into mountains and forests.

Unhappily, none of these creations has survived. Contemporary critics viewed them with dismay, condemning them partly on the ground that the brushstroke, the very foundation of painting, played little or no part in their making, and partly because they flouted two ideals that figured prominently in the Six Principles of Hsieh Ho: truth to nature and subservience to old models. These wild painters, therefore, could not be judged by conventional standards. For them the critics coined the term "*i-p'in*," meaning the unrestrained, or untrammeled, class. Whether they were placed above or below the three classes of orthodox painters (divine, marvelous, competent), or outside them altogether, depended upon the outlook of the critic. It is not clear to what extent painters of the *i-p'in* category were actually Buddhists, nor does it greatly matter. Zen adherents, who were anything but doctrinaire, claimed that any painter who expressed his moments of illumination with absolute spontaneity was acting in the true spirit of Zen (B, C, D).

Zen painters in Chengtu

By the 9th century the city of Chengtu, or Shu as it was anciently known, in the far western province of Szechwan, had become one of the chief centers of Zen painting. Nanking was another. Chengtu, especially, was a haven of peace, prosperity, and liberal patronage of the arts, to which many scholars, officials, painters, and

(C) LIANG K'AI
Shākyamuni Leaving his Mountain Retreat (detail)
13th century
Formerly Count Sakai Coll.

(D) Attributed to MU-CH'I
Tiger (detail): hanging scroll, 13th century
Cleveland, Ohio, Mus. of Art

61

WU TSUNG-YÜAN　武宗元

KUAN-HSIU　貫休

SHIH K'O　石恪

poets drifted during the chaotic years preceding the fall of the T'ang Dynasty in 906. Favorite subjects of the Zen painters in Chengtu (who included Wu Tsung-yüan, Kuan-hsiu, and Shih K'o) were the Arhats, or Lohan, the saints of Indian Buddhism (A). They delighted to draw, with a mixture of spiritual insight and caricature, the outlandishly prominent features of these imagined Indians. Their work was too grotesque to find many admirers in China. But some of their paintings found their way to Japan, where they were treasured and endlessly copied in Zen monasteries.

It is doubtful, however, whether any of the works that have been attributed to Kuan-hsiu and Shih K'o, now in Japan, are originals. Probably the closest approximation to these early Chinese masters that exists today is a pair of pictures of Zen patriarchs harmonizing their minds (that is, meditating), in the National Museum, Tokyo, one of which is illustrated on page 235. It has been attributed to Shih K'o, but the signature and inscription are forged, and it is unlikely that the painting is earlier than the 13th century. Nevertheless, it holds the essentials of his style. The meditating patriarch leans upon a tiger, which is fast asleep—or perhaps meditating too. The technique agrees with early records, which describe how Shih K'o would touch in the visible parts of a body with deft, precise brush lines, and how he would indicate the robes and all else with jerky, rough movements of the brush that bore no relation to conventional brush strokes. Color, which would gratify the senses, and visual accuracy, which would appeal to the intellect, are both avoided. The painter here is not merely depicting an old priest leaning on a tiger, but is attempting to portray a state of mental and spiritual concentration, unity, and repose.

Zen painting during the Southern Sung Dynasty

The Zen adept's solitary search for truth seemed less desirable, or necessary, during the late 10th and 11th centuries, when Sung culture was flowering in its first vigor. But after the flight to the south in 1127, conditions were similar to those during the decaying years of the late T'ang Dynasty. Zen monasteries, nestling in the mountains around the West Lake at the southern capital of Hangchow, became a haven of refuge for weary scholars and disillusioned officials. Painters, too, would leave the dusty city behind them to wander up the hillsides in search of peace and inspiration. In its belief in the necessity for communion with nature, Zen found common ground with philosophical Taoism, and there is little doubt that Zen ideals are reflected even in the monochrome landscapes of academicians such as Ma Yüan and Hsia Kuei—most vividly, perhaps, in the latter's great handscroll of which a part is illustrated on page 54.

In the early years of the 13th century the chief source of Zen influence in southern China was undoubtedly Mu-ch'i (B), a Zen priest from the far southwest of China who had come to Hangchow in 1215 and restored its ancient monastery of Liu-t'ung-ssu. He was still living in 1269. He was not only a great propagator of Zen but also a painter of genius. A critic wrote of him after his death that "he played with ink in a rough and vulgar manner and did not follow the rules of the

ancients." As this view was shared by later Chinese connoisseurs, it is not surprising that Mu-ch'i has been completely neglected in China, and that most of his surviving paintings found their way to Zen monasteries in Japan. His influence in Japan was indeed enormous. Shortly after his death a Japanese monk named Moku-an visited the monastery of Liu-t'ung-ssu at Hangchow, where he studied and imitated Mu-ch'i's style so thoroughly that the abbot presented him with the master's brushes and seals. Although Moku-an died in China, later Japanese pilgrims to Hangchow took home with them as many of Mu-ch'i's and Moku-an's paintings as they could find. It is now extremely difficult to distinguish genuine works of Mu-ch'i from those of Moku-an and other Japanese imitators.

Mu-ch'i did not restrict himself to any particular subject, for to the Zen adept all nature is one, and the "Buddha essence" is present in all things equally. Whether Mu-ch'i's theme was a bird pecking at its feathers on a pine branch, a *bodhisattva* in glory, or a great panorama of mountains and rivers, his attitude and means were the same. In color plate 176 is illustrated part of his handscroll *Scenes of the Hsaio and Hsiang Rivers*, in the Nezu Museum in Tokyo. This scroll is unusual among Zen works only in the addition of slight color. The ink is applied in broad washes in the tradition of Mi Yu-jen; there are no texture-strokes, and the few accents are picked out sparingly by means of ink dots touched in with the tip of the brush. The mist from which the forms of mountains and trees emerge, and into which they blend, has a triple function: first and most obvious, it evokes the atmosphere of a lakeside in the evening; secondly, and on a deeper level, it is the visible manifestation of the *ch'i*, or life-breath, that in the belief of the Chinese mystic animates nature; thirdly, and as a peculiarly Zen extension of this idea, the mist as expressed in the loose, wet brushwork gives to all the forms an undifferentiated unity of texture, thus proclaiming the Zen belief in the essential oneness of all things.

Liang K'ai

One of the painters at the Southern Sung court who heard the message of Mu-ch'i was Liang K'ai, who during the opening years of the 13th century was in such favor as an orthodox exponent of the academy style that he was made Painter in Attendance and awarded the Golden Girdle. But, we are told, he hung the girdle up on the wall of the academy and retired from the court. He seems to have spent the rest of his life in the company of other Zen enthusiasts in the monasteries around Hangchow. Although none of his pictures is dated, it is generally assumed that the more orthodox ones belong to his early years at the academy, the expressionistic ones to the latter part of his life. Yet even in his most advanced works Liang K'ai never completely lost the precision of technique given him by his early training (pages 60 B and 61 C). His famous portrait of the T'ang poet Li Po (C) shows how brilliantly he could blend precision (in the poet's profile) with the loose, apparently careless brushwork with which Zen painters generally indicated robes. Here is the same combination of care and carelessness that we found in Shih K'o. Whether or not this resembles Li Po is unimportant. In evoking the ecstatic awareness of a great poet, Liang K'ai achieved more than a mere formal likeness.

MU-CH'I

牧
谿

LIANG K'AI

梁
楷

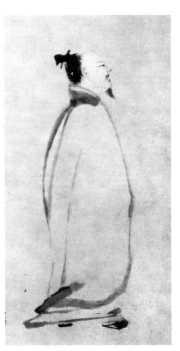

(C) LIANG K'AI
Portrait of Li Po, 13th century
Tokyo, Commission for the Protection of Cultural Properties

TS'AO PU-HSING

After the fall of the Southern Sung Dynasty, Zen painting gradually ceased to be a distinct, identifiable tradition in China. The decline of Buddhism, and the absorption into Taoism and Neo-Confucianism of those elements of it that Chinese intellectuals found most acceptable, robbed Zen painting of any reason for a separate existence. Yet the emphasis placed by Zen Buddhism upon communion with nature, and upon directness and spontaneity of expression has continued to inspire original and independent Chinese painters up to modern times.

Dragon painting

Although not strictly a branch of Zen art, the painting of dragons was popular at the same period and close to it both in spirit and technique. The dragon, that wholly playful yet somewhat terrifying creature, which brings the rain at the proper season and is so potent a source of benevolent energy that it has become a metaphor for the emperor himself, has been a popular subject in Chinese art since antiquity. The works of early dragon painters such as Ts'ao Pu-hsing (about 222-277 A.D.) are of course all lost, but fine paintings of the dragon entwined with a serpent (when they are shown together, they are a symbol, in ancient Chinese cosmology, for the north) can still be seen on the walls of 6th- and 7th-century tombs near Pyongyang in northern Korea (A). The style of these tomb paintings is essentially Chinese.

The climax of dragon painting in China was in the late 12th and the 13th centuries, when Zen ink painting was also at its height. Indeed, the dragon might be said to be the equivalent in terms of popular Taoist mythology of the more lofty and insubstantial concepts of Zen idealists. When artists came to paint this wonderful beast they gave him the head of a bull, the horns of a deer, the body of a snake, and the talons of the fabulous *p'eng* bird. Like truth to the Zen adept, the dragon is

(A) Dragon: from wall painting, 7th century
North Korea, Pyongyang Tombs

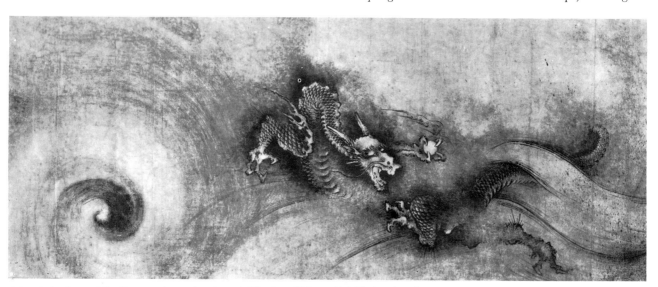

(B) CH'EN JUNG Nine Dragons Appearing through Clouds and Waves (detail): handscroll, 1244
Boston, Mass., Mus. of Fine Arts

64

never wholly revealed. Just when he seems to come within our grasp, he slithers behind a rock, soars into the clouds, or plunges into the deep.

According to tradition the greatest Chinese painter of dragons was Ch'en Jung, who, after passing his government examinations in 1235, had a long and distinguished career in the civil service. A 13th-century critic relates that when drunk, Ch'en Jung would give great shouts, whip off his cap and, using it as a brush, smear and spatter ink on to the paper after the manner of the T'ang eccentrics. From the mists and clouds thus created he would make his dragons appear, form emerging out of formlessness. Among scores of dragon paintings attributed to him, the finest, and the one most likely to be from his hand, is the famous handscroll *Nine Dragons Appearing through Clouds and Waves*, signed and dated 1244. The details of this dramatic work shows Ch'en Jung's technique: the mists and clouds smeared and spattered, perhaps with his cap; the dragons drawn with firm strokes; the rocks modeled in ax-cut *ts'un*, a technique derived from Li T'ang (B, and page 235).

CH'EN JUNG

Chapter VII
THE YÜAN DYNASTY: REACTION
AND WITHDRAWAL

The Mongol conquest

Although the Yüan Dynasty (1280-1368) lasted less than a century and its Mongol rulers were almost totally indifferent to art, it was a crucial period in the history of Chinese painting. After conquering the Near East and half of Europe in the 12th century, the Mongols had turned their armies eastward once more in the 13th. The cities and peoples of central Asia that resisted them were obliterated. In 1215 their swift cavalry descended upon the Chin Tartars, who had established a dynasty in North China after driving out the Sung emperors. The Chinese, eager to see the destruction of their old enemy, allied themselves with the Mongols.

But no sooner had the Chin Tartars been swept away than the Mongols turned upon the Chinese. The Southern Sung generals put up a heroic resistance and might well have repelled them. But after 30 years of fighting, the Sung armies were defeated as much by corruption and intrigue in the court at Hangchow as by the invaders. By 1287 the Mongol Khan Kublai had conquered all China. He established his capital at Peking, the city of "Khanbaluc" whose wonders are vividly described in the writings of the great Venetian traveler Marco Polo.

The Mongols profoundly mistrusted their Chinese subjects, treating them as third-class citizens. The Confucian intelligentsia they trusted least of all, grading them ninth in the ten grades of social classes, next above beggars. This scholarly elite, trained and conditioned only for loyal service to a native emperor ruling under the mandate of heaven, shrank from serving a barbarian despot. It was better, they felt, to retire altogether from public life, to wait and hope for the restoration of

a Chinese dynasty. But the Mongol rulers, for all their distrust, badly needed the services of the Chinese intellectuals in the government, and after initial hesitation made some efforts to attract them to the capital. Those who succumbed to the temptation were condemned by later Chinese scholars as collaborators, whereas those who chose withdrawal and poverty became their heroes.

With the fall of the Sung Dynasty the court hierarchy had collapsed and the Imperial Painting Academy was no more. The honored rank of Painter in Attendance was abolished and the Golden Girdle, the goal of every academician, became no more than a memory. At first the only painters required at the Mongol court were skilled craftsmen who could decorate palaces and Lamaist temples, and illustrate the exploits of the Mongols on horseback, in war and in the chase. This was the age of the horse painters.

(A) JEN JEN-FA Three Horses and Four Grooms (detail): handscroll, 14th century
Cleveland, Ohio, Mus. of Art

Among members of the intelligentsia who were eventually persuaded to enter the service of Kublai Khan were a few painters of great ability. The versatile Chao Meng-fu (1254-1322), a distant descendant of the first Sung emperor, rose to be secretary of the Board of War and president of the Han-lin College of Scholars. Jen Jen-fa (about 1290 - about 1350) became vice-president of the River Conservation Bureau, the landscapist Kao K'o-kung (about 1245 - after 1310) president of the Board of Justice. But though high in government service, these men were not professional painters nor members of any academy. They were officials who painted in their spare time, and are thus to be considered as in the amateur tradition.

Ch'ien Hsüan

The collapse of the Southern Sung Dynasty had put an end to a long period of slow inner decay. By the end of the dynasty the academy was already dying. In one direction, the followers of Ma Yüan and Hsia Kuei had carried the style of mono-

(B) CH'IEN-HSÜAN Flowers:
album leaf, 13th century
Washington, D. C., Freer Gall. of Art

66

chrome ink painting as far as romanticism and mannerism could take it. In the other, beyond the expressionistic ink-play of Mu-ch'i and Liang K'ai, lay utter formlessness. Clearly, painting could go no farther along either path.

Painters in the capital during the Yüan Dynasty received no encouragement from the emperor to express their own ideas or develop their art along new lines. Rather, they were induced to look backward and, most of all, to re-create the glories of the T'ang Dynasty, when Ming-huang and his mistress Yang Kuei-fei had gone riding and hunting in the imperial park, and Han Kan had painted "portraits" of the emperor's favorite chargers. The foremost of the horse painters of the Yüan Dynasty was Jen Jen-fa (A), though Chao Meng-fu, by virtue of his pre-eminent position generally in the cultural life of the capital in the early 14th century, is also credited with having been an expert horse painter.

Ch'ien Hsüan (1235-1301), Chao Meng-fu's teacher, grew up under the old regime and was about to enter government service when the Southern Sung Dynasty was overthrown. Thereupon he "clenched his teeth and did not join the crowd," remaining in seclusion in southern China, where he devoted the rest of his life to painting. As a painter he was thoroughly eclectic. He steeped himself in the styles of past ages. For his figures he is said to have imitated Li Lung-mien, for his birds and flowers (B, C) Chao Ch'ang, while his blue-and-green landscapes were done after the manner of Chao Po-chü (color plate 177). Thus, like other backward-looking painters of the early Yüan period, Ch'ien Hsüan took as his models the vigorous and colorful styles of the Northern Sung Dynasty and earlier. He would have nothing to do with the romantic ink painting of the Southern Sung academy, which he thought mannered and effete. Color plate 179 and (D) illustrate a handscroll by Ch'ien Hsüan, depicting Yang Kuei-fei mounting her horse for a riding excursion with Ming-huang. Another version of this composition, attributed to the 10th-century court painter Chou Wen-chü has recently been discovered in China. It is possible that both are based on a lost design by Han Kan, the famous horse painter of the T'ang Dynasty. The Ch'ien Hsüan scroll is an exquisitely cool and passionless commentary on a style of painting that had been forgotten for centuries, a nostalgic reminder of the time long past when China had been proud, prosperous, and independent.

(C) CH'IEN HSÜAN
Sparrow on an Apple Branch,
13th century
Princeton, N. J., University Art Mus.

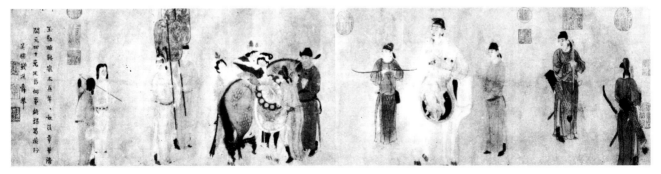

(D) CH'IEN HSÜAN Yang Kuei-fei Mounting a Horse: handscroll, 1295
Washington, D. C., Freer Gall. of Art, Smithsonian Institution

Chao Meng-fu

CHAO MENG-CHIEN 趙孟堅

CHAO MENG-FU 趙孟頫

KUAN TAO-SHENG 管道昇

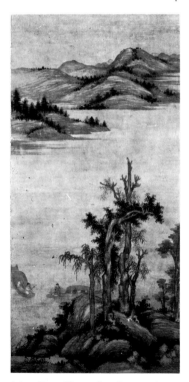

(A) CHAO YUNG Landscape with Scholar Fisherman: hanging scroll, early 14th century
Cleveland, Ohio, Mus. of Art, coll. Mr. and Mrs. Dean Perry

Chao Meng-fu (1254-1322), unlike his teacher Ch'ien Hsüan, responded to inducements offered by Kublai Khan and went north to Peking, where he entered on a brilliant official career. He also served as a provincial governor. His fame rests partly upon his scholarship, partly upon his calligraphy, and partly upon his paintings of horses, which were executed in a very careful technique (B). Later critics condemned him for his willingness to serve the alien dynasty. Because they felt that he was in some way tainted, some of them refused to accord him the status of a scholar and gentleman. Yet he clearly thought of himself as in the amateur tradition. He admired Mi Fu and tried, unsuccessfully, to complete a damaged scroll by that great master of the *wen-jen-hua*. The picture has not survived, but illustrated in color plate 178 is a detail from Chao Meng-fu's short handscroll *Autumn Colors on the Ch'iao and Hua Mountains*, which is a fascinating revelation of his dual personality as a painter. On the one hand the rather artificial colors, and the clear separation of the trees and precisely drawn leaves are evocative of the antique blue-and-green style (see color plate 161, for example) then being revived at the Yüan court. On the other hand the ink drawing, the apparent awkwardness and naiveté of the composition, the choice of paper rather than silk, and the deliberate lack of charm, are the hallmarks of the painting of the scholar and amateur. In Chao Meng-fu himself the conflict between these roles was never quite resolved. But by his strong personality, his influential position in the capital, and his skill and wide learning as a painter, he was to have an immense influence upon the artists of the 14th century.

Chao Meng-fu claimed, with some justice, that "every member of my family is a

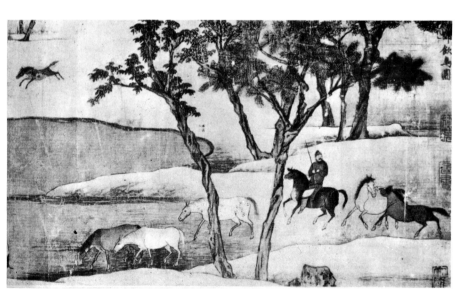

(B) CHAO MENG-FU Leading Horses to Water (detail): handscroll, late 13th century
Peking, Palace Mus.

skillful painter or calligrapher." His wife Kuan Tao-sheng, who specialized in bamboos, is the most famous woman painter in Chinese history. His uncle Chao Meng-chien, his son Chao Yung (A), and grandson Chao Lin all won fame in a variety of subjects and techniques, though they were to some extent overshadowed by the immense prestige of Chao Meng-fu himself.

Chu Te-jun and T'ang Ti

A number of early Yüan landscape painters working under the influence of Chao Meng-fu revived the Northern Sung style, especially that of Kuo Hsi. Among them were Chu Te-jun (1294-1365) and T'ang Ti (1296-1340). The latter, like Chao Meng-fu, was a scholar and amateur painter, who also executed commissions for the Mongol emperors. In his large *Fishermen Returning along a Frosty Bank* (color plate 180), he has combined elements of Kuo Hsi—in the writhing trees with "crab's-claw" branches and the modeling of rocks in wet ink washes—with a minute, archaistic precision in the drawing of the leaves and human figures. He thus created a rather coldly decorative effect that is not at all in the spirit of Kuo Hsi. Such pictures are important in the history of Chinese painting, however, because their eclecticism prepared the ground for the decorative court painting of the Ming and Ch'ing Dynasties.

Ts'ao Chih-po and Sheng Mou

As one moves farther away from the circle of Chao Meng-fu and other artists who lived and worked in the Yüan capital, styles of painting become progressively easier and more relaxed. In color plate 181 is a small study, *A Pavilion near Old Pines*, by Ts'ao Chih-po (1272-1355). He was a southerner who served for some time in a government college, but later retired to a life of painting, study, and Taoist meditation in Kiangsu. At first glance this picture seems, like that of T'ang Ti, to have been inspired by Li Ch'eng and Kuo Hsi. But although Ts'ao Chih-po's way of drawing pine trees and his emphasis on the silhouette are in the Kuo Hsi manner, his brushwork is relaxed, the atmosphere calm and poetic. Later in life he came even closer to the true Southern tradition. On a snowscape (c) in the Palace Museum collection, Taiwan, painted when he was 78, his friend Huang Kung-wang wrote that "his brushwork and ideas have an antique blandness, inheriting the atmosphere of Wang Wei." *A Pavilion near Old Pines* is a relatively early painting, yet even here the old pine trees have an intimate air much closer to the spirit of Wang Wei than to the brilliant technical performance of T'ang Ti.

Something of the same breadth of conception and looseness of execution is present in the album leaf attributed to Sheng Mou (active about 1330-60), color plate 182. Sheng Mou's teacher was the son of an official in the Southern Sung academy at Hangchow. His choice of silk rather than paper, careful grading of ink tones, and the sharp-edged distant mountains, all show the influence of Ma Yüan. But the breadth of treatment, the heaving masses of the foreground hills, the loose

CHU TE-JUN 朱德潤

趙雍 CHAO YUNG

趙麟 CHAO LIN

TS'AO CHIH-PO 曹知白

T'ANG TI 唐棣

盛懋 SHENG MOU

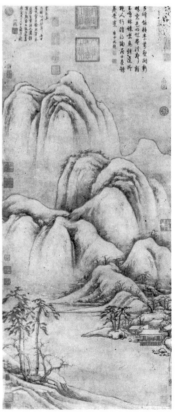

(c) Ts'AO CHIH-PO Clearing after Snow on the Mountain Peaks: hanging scroll, 1350
Taichung, Taiwan, National Palace Mus.

69

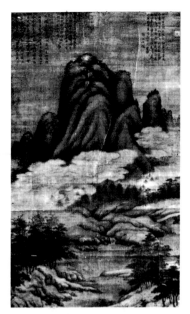

(A) Attributed to KAO K'O-KUNG
Verdant Peaks above the Clouds:
hanging scroll, 1299
Taichung, Taiwan, National Palace Mus.

KAO K'O-KUNG　高克恭

drawing of the foliage, and the use of "tangled hemp-fiber" texture-strokes suggest that he was also influenced by the style of Tung Yüan and Chü-jan. Sheng Mou's great popularity in his lifetime lay precisely in his successful blend of the techniques of the academic and literary schools.

Kao K'o-kung

In varying degrees, Chao Meng-fu, Ts'ao Chih-po, and Sheng Mou all revived the ideals of the great masters of the 10th and 11th centuries, especially those of Tung Yüan and Kuo Hsi. Yet their interest in the scholarly tradition was always colored by a deliberate archaism. Even in Ts'ao Chih-po it was not wholly spontaneous. In Kao K'o-kung (about 1245 - after 1310), on the other hand, the literary tradition found a sincere and whole-hearted champion. As we have seen, Kao-K'o-kung had a distinguished official career under the Mongols, but as a painter remained the untainted inheritor of the style and spirit of the Sung literati. Although it is difficult to separate his works from those of his followers and imitators, it appears that in his ink landscapes he was above all a disciple of Mi Fu.

An important landscape (A) attributed to Kao K'o-kung has a monumental design and relaxed brushwork reminiscent of Tung Yüan: the flat dots outlining the distant hills are a tribute to Mi Fu, and the rather careful disposition of trees in the foreground hints at the scholarly interest in archaic styles that he and Mi Fu had in common. The Palace Museum collection in Taiwan contains a number of paintings of this kind that are attributed to Kao K'o-kung. This one, which bears an inscription dated 1299 by his friend the celebrated landscapist and bamboo painter Li K'an (see page 75), is one of the two or three most likely to be authentic. In spite of the mists and liberal use of wet ink, it has an underlying firmness of structure missing from the many imitations of his style.

The Four Great Masters of the Yüan Dynasty

Later Chinese critics gave the name "The Four Great Masters" to Huang Kung-wang, Wu Chen, Ni Tsan, and Wang Meng. Rather than serve an alien regime after the Mongol conquest, all four chose seclusion in the south, where they kept the lamp of Confucian ethics and scholarship burning, setting an example in both their work and their private lives that later became the ideal of the scholar painters of the Ming and Ch'ing Dynasties. In painting, they all (with the partial exception of Wang Meng) took as their models Tung Yüan and Chü-jan rather than Li Ch'eng and Kuo Hsi. They cultivated a deliberate plainness, or blandness, of brushwork, studiously avoiding the technical refinements, the appeal of color, and the spectacular ink contrasts indulged in by their contemporaries in the capital. They no longer troubled to make their forms outwardly true to nature, as had Fan K'uan and Kuo Hsi, or to evoke a poetic or nostalgic mood, as had Ma Yüan and Hsia Kuei. So at first their painting has little appeal. In fact, it is not meant to "appeal" in the usual sense. Spare, cool, relaxed, it evokes a feeling of detachment and serenity.

Huang Kung-wang

HUANG KUNG-WANG

Huang Kung-wang (1269-1354) was a native of Chekiang. Like most men of his class he was trained for government service. But he soon quit, to spend the rest of his long, peaceful life as a *yin-shih*, a retired scholar, in the Wu district of Chekiang, talking, drinking, writing, and painting in company with Taoists, Buddhists, and other so-called recluses like himself. According to his contemporaries his heart was warm and generous, his understanding of history and philosophy profound.

It is fortunate that his masterpiece, which had a greater influence and was more often copied than any other painting in the literary tradition, has survived in the Palace Museum collection in Taiwan (B). Only the opening section is missing. The scroll, of which the central part is illustrated on pages 238 and 255, was inspired by the hills and valleys of the Fu-ch'un mountains, a famous beauty spot near Hang-chow. In his inscription at the end, Huang Kung-wang relates how one day (he was already 79) he sketched out the whole design in a single surge of inspiration, and how thereafter he carried the scroll with him for three years, adding to it whenever the mood took him until at last he felt he need do no more.

The details illustrated show how Huang Kung-wang lightly sketched in the forms of mountains and trees, gradually adding accents, darkening the ink, enrich-ing the texture, yet miraculously retaining the freshness of the original conception and preserving the feeling of hazy sunlit atmosphere that floods the scene. He did not hesitate to correct a contour, or paint trees over it, for he did not feel himself bound by the conventional rules and techniques. Nothing is studied or premedit-ated. Huang's understanding of Tung Yüan was instinctive. Above all, through the heroic scale of the scroll and the easy, expansive movement of his brush there shines the spirit of Huang Kung-wang himself. This revelation of the personality behind the picture, as much as its style, became the ideal of all later painters in the schol-arly tradition.

Wu Chen

Wu Chen (1280-1354), the second oldest of the Four Great Masters, spent the whole of his quiet life in southern China. For some years he lived next door to the clever and popular Sheng Mou (color plate 182). It is said that his wife scolded him one day for his lack of success as compared with his neighbor, but that he merely replied: "It will not be so after 20 years." Certainly Sheng Mou was never so popular as in his lifetime, while Wu Chen's cool, quiet, unassuming landscapes only gradually began to draw the admiration they deserved (page 72 A). In his handscroll of fishermen (C) Wu Chen does not attempt to depict the anything-but-ideal life of men who make their living by fishing, but rather to suggest the peace and contentment of the scholar who has withdrawn from the "dusty world" into communion with nature. The soft ink tones, the bland, luminous atmosphere, even the sweeping wavelike shapes of the mountains all suggest that mood of utter tranquillity in which the thoughts of the philosopher and poet rise to the surface of the mind.

HUANG KUNG-WANG

(B) HUANG KUNG-WANG
Dwelling in the Fu-ch'un
Mountains (detail): handscroll, 1350
Taichung, Taiwan, National Palace Mus.

WU CHEN

(C) WU CHEN Fishermen:
handscroll (detail) 1352
Washington, D. C., Freer Gall. of Art

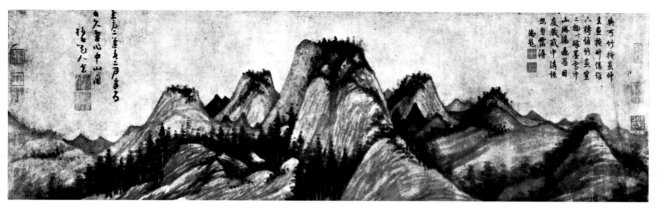

(A) Wu Chen A Mountain among Mountains: handscroll, early 14th century
Taichung, Taiwan, National Palace Mus.

Ni Tsan

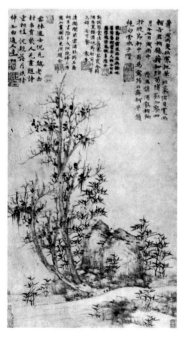

(B) Ni Tsan
Pines and Rocks: hanging scroll,
14th century
New York, C. C. Wang Coll.

Ni Tsan

To later literary painters Ni Tsan (1301-74) represented the acme of scholarly purity and restraint. Born into a wealthy Kiangsu family, he became a noted collector and antiquarian. Shortly before the fall of the Yüan Dynasty, however, he distributed all his property among his relatives and left his home to spend the rest of his life as a wanderer. He painted only when he felt inclined. Like Wu Chen, he never sold his pictures, but would give them away to people who really appreciated them. His landscapes are remarkable for their narrow range (he used virtually the same composition over and over again), for a detachment and serenity even greater than that of Wu Chen, and for their dry, fastidious brushwork. Ni Tsan used ink, later critics said, "as sparingly as if it were gold."

His *Jung-hsi Studio* (1372) is illustrated on page 239. In his inscription on the upper part of the picture the artist explains that the studio belonged to a doctor friend, for whom the picture was painted. But it is not an attempt to depict the doctor's studio itself. The conventional, empty pavilion was placed in the picture merely as a hint that this quiet spot was occasionally visited by the doctor and his friends. It was not difficult for later scholar painters, who enormously admired Ni Tsan's style, to imitate his compositions and techniques. But none ever equaled the calm clarity of his ideas or the cool, chaste touch of his brush (B).

Wang Meng

The fourth great Yüan master was Wang Meng (about 1309-85), a nephew of Chao Meng-fu. He differed from the other three in several important respects. Unlike them, he served for some years in the administration, though not in the capital, Peking. Toward the end of his life he was the innocent victim of political intrigue, and he died of cold and hunger in prison. Nor was he a great scholar, poet, or calligrapher, and it may seem surprising that later literati valued him so highly. But he was a passionate and single-minded painter, whose integrity in the pursuit of his aims inspired Ni Tsan to say that "there has been no one equal to him for a

hundred years." Wang Meng did not have the lofty detachment of Huang Kung-wang or Ni Tsan. Each of his pictures is an attempt to explore anew the forms and shapes of living nature, and to evolve the techniques to express what he felt. His style was to some extent inspired by Tung Yüan, his careful brushwork by the archaism of his famous uncle Chao Meng-fu. Uniquely his, however, are the tortuous shapes and dense texture of his landscapes (D), which reveal a spirit as restless in the search for form in nature as that of Cézanne. Yet in a painting such as that illustrated in color plate 179, Wang Meng has succeeded in conveying a sense of the tranquillity of the retired country life.

王蒙 WANG MENG

Fang Ts'ung-i

That withdrawal from the affairs of the world did not necessarily bring peace to the painter is shown by the highly individualistic works of Fang Ts'ung-i, or Fang Fang-hu (active in the mid-14th century), who spent most of his obscure life as a Taoist priest in a temple on Lung-hu-shan in Kiangsi. His powerful landscape *Immortal Mountains and Luminous Woods*, painted for a fellow Taoist in 1365, is illustrated on page 239. Its dark, heavy ink and loose brushwork show that Fang Ts'ung-i was influenced by Mi Fu and Kao K'o-kung, but its restless movement and dramatic contrasts suggest that he was striving to find expression for the Taoist's awareness of the mysterious forces that underlie and animate the visible forms of nature. Perhaps, too, they are an indirect reflection of the turbulent state of the country during the years immediately preceding the downfall of the Yüan Dynasty.

方從義 FANG TS'UNG-I

Bamboo painting

The increasing withdrawal of the scholar class during the Yüan Dynasty was reflected in the revival of bamboo painting. For, as explained in an earlier chapter, the bamboo was both a symbol of the pliant but unbreakable spirit of the true Confucian gentleman, and, as a subject for painting, closest to the art of calli-

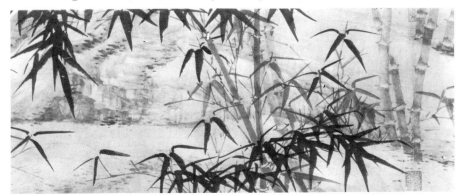

(C) WANG FU Ten Thousand Bamboos along a River in Autumn (detail): handscroll, 1410
Washington, D. C., Freer Gall. of Art

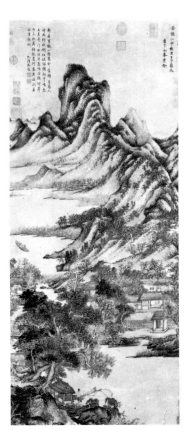

(D) WANG MENG
Thatched Lodge in Autumn Hills:
hanging scroll, 14th century
Taichung, Taiwan, National Palace Mus.

73

graphy. Some scholar painters developed a deep attachment to the beautiful plant, whose ever-changing forms responded so naturally to the movement of the brush (page 73 c). On one of his bamboo paintings Wu Chen wrote: "Tender are the flowers of spring, willows swaying softly in the wind; but these gentlemen alone (that is to say, the bamboos in his garden) will remain the friends of winter's cold." He never tired of watching the patterns woven by their shadows on the ground and on his paper windows.

Wu Chen and other scholarly painters tended to emphasize the life and movement of the bamboo in terms of the vigorous brushstrokes of the calligrapher. They were concerned less with the actual appearance of the bamboo than with its spirit, to which they felt themselves so much akin. Thus their bamboo paintings and those of such men as Ku An (first half of the 14th century) and K'o Chiu-ssu (1312-65) go beyond the formal appearance of the plant. The latter painter was a favorite of the Yüan emperor Wen (reigned 1330-33), but the jealousy of rivals drove him from court to retirement in Kiangsu, where he became a friend of Ni Tsan. His *Bamboo and Chrysanthemum* (A), although painted for a high Mongol official, is no mere academy piece. The exquisite balance of the main stalk swaying in the wind, the trembling spearpoints of the leaves, the loose, relaxed treatment of the rocks all reveal the sensibility of a cultivated amateur.

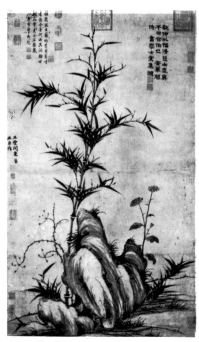

(A) K'o Chiu-ssu
Bamboo and Chrysanthemum,
14th century
Taichung, Taiwan, National Palace Mus.

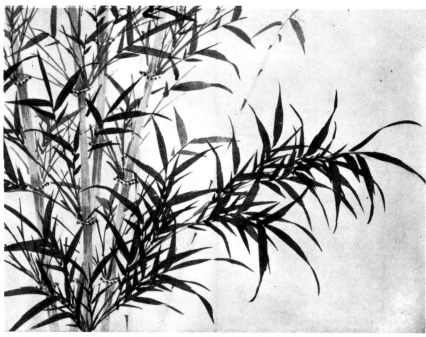

(B) Li K'an Ink Bamboo (detail): handscroll, early 14th century
Kansas City, Mo., William Rockhill Nelson Gall. of Art, Nelson Fund

Li K'an

The bamboo painting of the scholars was often of a kind called *hsi-mo* (playing with ink). Li K'an (1245-1320), on the other hand, brought to the art the science and discipline that also characterized his successful career in government service. Busy as he was, he relates how he gradually became more and more absorbed in the history and art of bamboo painting, until finally he obtained imperial permission to retire and spend the rest of his life in his favorite pursuit. He is chiefly noted for his three-volume "Systematic Treatise on Bamboo," in which, after an historical account of the art up to his time, he gives detailed and methodical instruction on how to paint bamboo. His insistence on the need for strict brush discipline, combined with his implied preference for painting bamboo in color, and his recommendation that paintings should be based on a preliminary charcoal sketch, suggests that his approach was more cautious and academic than that of the literati. This supposition is borne out by Li K'an's handscroll *Ink Bamboo* (B), of which one half is in the Palace Museum, Peking, the other in the Rockhill Nelson Gallery, Kansas City, Missouri. Although faultlessly executed, with careful attention to the articulation of the plants, the spacing of the leaves, and the subtle gradation of ink tone, the scroll somehow lacks the *ch'i*, or life-breath, of the less perfectly painted but more natural works of literati such as K'o Chiu-ssu.

After the Yüan Dynasty, bamboo painting remained popular with scholars, and provided an exercise both for professionals and amateurs, men and women, who looked upon painting as a polite accomplishment for their leisure hours.

Chapter VIII
TRENDS IN MING PAINTING

The Ming Dynasty (1368-1644)

In 1368 the tottering Yüan Dynasty collapsed and the last Mongol emperor was driven out of Peking to take refuge in the northern wastes. A new dynasty, the Ming (Brilliant), was established with its capital at Nanking. In 1421 the third Ming emperor, Yung-lo, moved his seat of government back to the old Yüan capital, Peking, which he enlarged and adorned with walls, gates, and palaces much larger and more splendid than any built by the Yüan rulers. The magnificent palace complex (c) there today, the Forbidden City, was largely his creation.

The first Ming emperor, who rose to power from peasant stock by means of banditry, summoned painters to Nanking from all over China. Although he gave them military ranks (to distinguish them from civil officials), and allotted them studios in the palace grounds, there was no official painting academy as there had been under the Sung Dynasty. The emperor treated his painters with the brutality he meted out to all his subjects, and several were executed for trivial breaches of the regulations. Their chief task was to decorate the screens and walls of the palace

(c) The Imperial Palace, Peking
(*Photo by Hedda Morrison*)

with colorful landscapes, bird-and-flower compositions, and historical subjects.

In the course of the 15th century imperial patronage became more humane and enlightened. The cultivated emperor Hsüan-tsung, or Hsüan-te, was himself a painter, and during his brief reign (1427-35) something of the old liberal atmosphere of the early Sung court was recaptured. His chief painter in attendance was Pien Wen-chin, who was noted for large, detailed bird-and-flower compositions in which he revived the Sung academy style. In the work of Pien Wen-chin's school, however, the poetic subtlety of Sung painting was replaced by a more superficial and colorful splendor. In landscape, 15th-century palace painters such as Ni Tuan and Li Tsai likewise transformed the monochrome ink style of Ma Yüan and Hsia Kuei into something more obviously effective as wall decoration.

The Che school

During the Yüan Dynasty many scholar painters had withdrawn to relative seclusion in the province of Chekiang in southern China, where they revived the old Southern tradition of Tung Yüan, Chü-jan, and Mi Fu (see chapter VII). But this was not the only trend of landscape painting in the south under the Yüan Dynasty. Among the professionals of Chekiang the style of the Southern Sung academy, always much easier for the layman to appreciate, as it is for Westerners today, continued to be popular right into the Ming Dynasty. The Chekiang professionals formed no school, and the fact that Chinese historians speak of a Che (kiang) school is due largely to the talent of one man, Tai Chin.

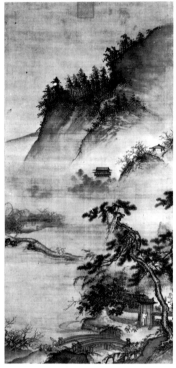

(A) TAI CHIN
Returning Late from a Spring Outing: hanging scroll, 15th century
Taichung, Taiwan, National Palace Mus.

(B) TAI CHIN Autumn River Landscape with Fishing Boats: handscroll (detail) 15th century
Washington, D. C., Freer Gall. of Art

TAI CHIN

Tai Chin (1388-1462) was one of the most gifted artists under the Ming emperor Hsüan-tsung. But he was proud and independent, and when one day he showed the emperor a landscape containing the figure of a fisherman in a red coat ("a color proper only for courtiers at imperial audiences"), he was forbidden to paint any more. Under the first Ming emperor he would have been put to death for such an offense, but Hsüan-tsung allowed him to leave the court. He retired to Chekiang, where he spent the rest of his life trying to support himself by painting. He died in poverty in 1462.

Tai Chin's work varies greatly in quality, and is seldom dated. His most academic pictures, such as the large, carefully composed *Returning Late from a Spring Outing* (A), probably belong to his period at the court in Peking; the freer and more individualistic works to his retirement in Chekiang. Tai Chin at his best, as in the scroll of Fishermen (B), has a spontaneity utterly different from the decorative formality of the contemporary palace school.

His chief follower, Wu Wei (1459-1508), departed still further from the palace style. A wild, uncouth character, he was twice summoned to the imperial court, where he would often stagger drunk and disheveled into the emperor's presence. That he was tolerated and even welcomed in the palace is some indication of the laxity of court life in the late 15th century. The style of his long handscroll *The Pleasures of the Fishing Village* (color plate 183) is an interesting mixture. Basically, the brushstrokes and composition derive from Hsia Kuei (compare, for instance, the detail from Hsia Kuei's great handscroll illustrated on page 54). But in *The Pleasures of the Fishing Village*, Wu Wei's individuality has broken down the formal discipline of the Ma-Hsia style. The ink is spattered and stabbed upon the paper in a manner that is almost a parody of the Sung academy technique, the color is gay, and the figures are drawn with lively humor.

At his best, Wu Wei has a boldness and freshness (C) that link him with literary painters such as Shen Chou (color plate 184) rather than with the academic

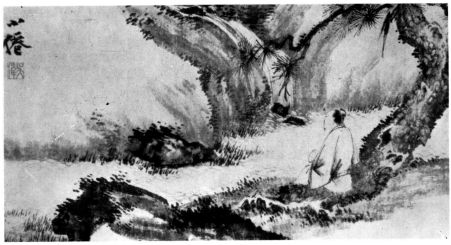

(C) WU WEI A Scholar under a Pine Gazing at a Waterfall: album leaf, 15th century
Stockholm, Mus. of Far Eastern Antiquities

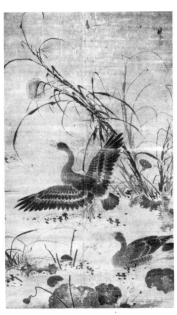

(D) LIN LIANG
Geese and Rushes (detail): hanging scroll, 15th century
Hamburg, Mus. für Kunst und Gewerbe

tradition. Beside him even Tai Chin seems a little formal. In fact Wu Wei should be classed as an individualist rather than as a member of the Che school, which consisted, if it had any cohesion at all, chiefly of obscure followers of Tai Chin.

Painters of figures, birds, and flowers

The Ming tradition of court painting is more typically represented by a host of decorators, known and anonymous, who found employment and even honor at the

LIN LIANG

LÜ CHI 呂紀

CHU TUAN 朱端

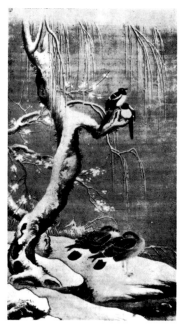

(A) LÜ CHI Geese beside a
Snowy Bank: hanging scroll
Taichung, Taiwan, National Palace Mus.

WANG FU 王紱

HSIA CH'ANG 夏昶

capital during the late 15th and early 16th centuries. One of the most admired was Lin Liang, who was called to Peking before 1444 and was still active in 1488. For the palace walls he painted colorful compositions of birds, flowers, and fruit. But few have survived, and he is best known today for his large studies of geese (page 77 D), eagles, and phoenixes in brilliant washes of monochrome ink. These spectacular pictures have an immediate appeal, and were among the first Chinese paintings to attract the attention of Western collectors.

By contrast with Lin Liang, the fame of his contemporary Lü Chi rests upon studies of birds (A) and flowers painted with meticulous precision in color. Lü Chi was a scholar and moralist who won high repute at court. But he employed numerous helpers in his workshop in the palace grounds, and many pictures bearing his name were done by his assistants. His chief pupil was Chu Tuan, a native of Chekiang famous in the Cheng-te era (1506-21) for his birds and flowers, and for landscapes in the manner of Northern Sung masters such as Fan K'uan and Kuo Hsi.

The Wu school

The name "Wu school" is given to the amateur, scholarly painters of the Ming Dynasty, who lived in the Wu-hsien district of Chekiang. This prosperous area, occupying roughly the triangle between Nanking, Shanghai, and Hangchow, had long been famed for its beautiful towns, waterways, and distant mountain views. During the Southern Sung Dynasty it became the focus of Chinese civilization, and during the Yüan period (see chapter VII) it remained the intellectual and artistic center of the scholars who refused to serve in the capital. By the 15th century, therefore, the Wu-hsien district already had a long history in the artistic activity of the gentleman class.

Early masters of the Wu school

The founder of the Wu school is often said to have been the Ming painter Shen Chou, whose life and work are discussed below. But although he was certainly its greatest ornament, the tradition of scholarly landscape painting in the Wu-hsien area had been unbroken since the Yüan Dynasty. Wang Fu (1362-1416), a native of the Wu district, seems to have imbibed the ideals of the Yüan literati before he took up an administrative post in the Ming capital. He also spent many years wandering through North China. He always remained a proud individualist, an amateur landscape painter inspired by Huang Kung-wang, Wang Meng, and Ni Tsan. He was also famous as a bamboo painter (page 73 C), and it was said of him that: "He had the spontaneity of Ni Tsan without his carelessness, and the strength of K'o Chiu-ssu without his impetuosity."

Wang Fu's follower Hsia Ch'ang (1388-1470) also held prominent official posts in Peking. Yet he is noted especially for the fluent, easy manner of his long hand-scrolls of bamboo and rocks. The earliest known dated example (1441) is in the collection of the Art Institute of Chicago, the latest (1464) in the Freer Gallery, Washington. Perhaps the chief contribution of both Wang Fu and Hsia Ch'ang

was that they transformed the lofty, austere manner of the great Yüan masters into a style more easily appreciated and practiced by amateurs, and thus helped to lay the foundation for the literary painting of the Ming and Ch'ing Dynasties.

Shen Chou

Like all men of his class Shen Chou (1427-1509), the greatest of the literary painters of the Wu school, was trained for the civil service. But, pleading the necessity to look after his aged mother, a request that the Confucian administration could hardly refuse, he retired to the country, to spend much of his long, peaceful life on the family estate near Su-chou. A man of deep scholarship, generous and humane, he was loved and respected in the neighborhood.

According to a Ming record, Shen Chou "followed in the footsteps of the old masters, from the Chin and T'ang down to the Sung and Yüan Dynasties, and came to know them all. In his landscapes he followed Tung Yüan, Huang Kung-wang, and Wu Chen." He also made a close study of the works of Ni Tsan, Wang Meng, and Wang Fu. But however intimately he studied these masters, his paintings were no mere imitations. He infused into all his pictures his own unmistakable "handwriting" and the warmth of his personality (B, C). A typical example of his reworking of old styles is a great landscape in the Ni Tsan manner in the Palace Museum collection, Taiwan (page 270). Although its composition and technique follow Ni Tsan closely, the mountains have expanded until they fill the picture space; the brushwork, if less sensitive, is broader and more relaxed than that of the austere Ni Tsan; and Shen Chou invites the viewer to share the beauty of the scene with a "staff-bearing wanderer" in the foreground, a concession to human appeal never found in Ni Tsan.

Shen Chou was a prolific painter. Probably more than 100 genuine works from his brush have survived, of which the earliest dated painting was done when he was already 37. A leaf from an album (color plate 184) is a characteristic work. It may well depict a view from Shen Chou's study window. The free yet firm drawing of trees and rocks shows his debt to Wu Chen. At the same time the soft, lyrical color,

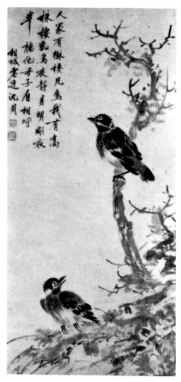

(B) SHEN CHOU Two Young Crows hanging scroll, 15th century
Stockholm, Mus. of Far Eastern Antiquities

SHEN CHOU

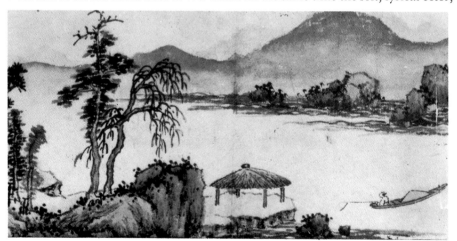

(C) SHEN CHOU Lone Fisherman: album painting (detail) 15th century
Boston, Mass., Mus. of Fine Arts

79

the naturalistic treatment of the fence and of the receding vegetable patch, and the artists's interest in the activity of the gardeners, all reveal a direct and human approach to the subject very different from the detachment of the Yüan literati.

Wen Cheng-ming

Shen Chou's most important pupil was Wen Cheng-ming (1470-1559), whose career as a painter falls into three main periods: his early years in Su-chou, when he was studying with Shen Chou; the years from about 1505 to 1530, during which he held a post in the Han-lin College of Scholars in Peking and had little time for painting; and the three remaining decades of his life, when he was once more living in retirement in Su-chou. Most of his surviving paintings belong to the third period. Like Shen Chou he was a man of refined and noble character, generous in giving away paintings to those who really appreciated them, resolute in his refusal to pay court to the rich and powerful.

Although he sometimes painted rocks, flowers, and bamboos in the manner of Wu Chen, and even experimented with the archaic blue-and-green technique, Wen Cheng-ming's most typical pictures are his landscape scrolls depicting the ideal life of the retired country gentleman (A). Some of these were painted in the firm, rich ink washes of his master, Shen Chou, others in an extremely refined, careful style enlivened with soft and delicate color. A delightful example of Wen Cheng-ming's "precise" style is the scroll *A Farewell Visit* (1531), illustrated in color plate 185. One of the two gentlemen seated under the trees is perhaps a scholar about to depart to some distant government post. Such were the hazards of an official career that the two friends could not know when they might meet again. Here they talk together for a last precious hour, their contentment in each other's company being delicately suggested by the artist's choice of style. The "precise" manner, which Wen Cheng-ming practiced to the end of his life, is in striking contrast to the "rough" style of many paintings of his later years. The latter is seen chiefly in his powerful ink studies of pine trees and junipers, whose gaunt, writhing

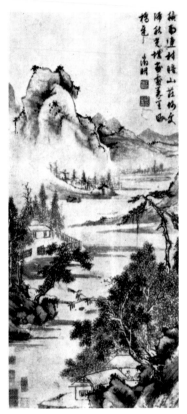

(A) WEN CHENG-MING
Mountain Landscape: hanging scroll, 16th century
Boston, Mass., Mus. of Fine Arts

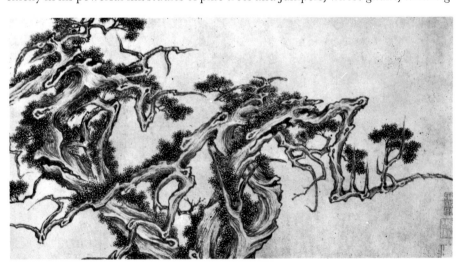

(B) WEN CHENG-MING
Seven Junipers (detail): handscroll, 1532
Honolulu, Hawaii, Academy of Arts

trunks growing in a landscape of bare rocks seem symbolical of the unconquerable spirit of the old scholar himself (B).

Followers of Wen Cheng-ming

There were many reasons why Wen Cheng-ming was the most influential painter of his day. His noble character and wide circle of friends made him an inspiration to young gentlemen, while his learning, the range of his styles and the brilliance of his technical accomplishment made him the ideal teacher and interpreter of the literary tradition. For a century or so after 1550 most Su-chou scholar painters, beginning with his son Wen Chia (1501-83) and his nephew Wen Po-jen (1502-80?), were influenced by him.

Wen Po-jen, the more gifted of the two, specialized in tall, narrow landscapes executed in a gentle, lyrical manner. This is seen in the landscape, dated 1561, of which the lower half is illustrated in color plate 186. Its light, feathery brushwork and fresh color show clearly the influence of his famous uncle. Like so many pictures in the Ming literary tradition, this charming work describes the quiet pleasures of the retired scholar in such a way that the viewer may readily identify himself with the contented gentleman, who here sits in a pavilion gazing at a stream, his books upon the table beside him. Wen Po-jen himself was a wild and quarrelsome character, heartily disliked in the Su-chou district. The fact that no trace of his ill nature appears in his paintings is an indication of the extent to which, among the literati in general, expression of feeling was controlled by discipline of style.

Chou Ch'en, T'ang Yin, and Ch'iu Ying

Chou Ch'en, T'ang Yin, and Ch'iu Ying occupy a position in mid-Ming painting somewhere between the Che school and the professionals on the one hand and the Wu school scholar painters on the other. They are sometimes called the Neo-academicians, and sometimes, because their styles were compounded from several sources, the Eclectics. Neither name is just or adequate, for all three were accomplished and original painters.

Chou Ch'en

Chou Ch'en (active about 1500-35) is said to have been the teacher of both T'ang Yin and Ch'iu Ying. The facts of his life are obscure, as he was not a member of the gentleman class and so received little attention from critics. Whereas Tai Chin and the Che school had sought inspiration in the romantic ink painting of the Southern Sung academy, Chou Ch'en modeled his style on that of Li T'ang, whose firm, tightly knit texture and masterly use of small ax-cut *ts'un* had been completely neglected since the early 12th century (C). A typical example of Chou Ch'en's "Li T'ang manner" is a carefully constructed handscroll (page 82B), which shows a white-robed scholar sitting under a tree beside a pool.

WEN CHIA

WEN PO-JEN

CHOU CH'EN

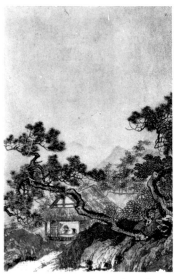

(C) CHOU CH'EN Dreaming of Immortality in a Thatched Cottage: handscroll (detail) 16th century
Washington. D. C., Freer Gall. of Art

81

Occasionally, Chou Ch'en broke free from the domination of the Li T'ang technique. In the landscape handscroll of which a section is illustrated in color plate 187, he makes a highly original use of ax-cut *ts'un*, building up boldly modeled rocks by means of repeated short chopping strokes of the brush. The technique is that of a craftsman rather than of a scholar painter, whose brushwork was always much closer to calligraphy. In this picture there is more than a hint of that mannerism and exaggeration that were to characterize much late Ming landscape painting (compare, for example, the late Ming handscroll by Wu Pin of which a detail is shown in color plate 191).

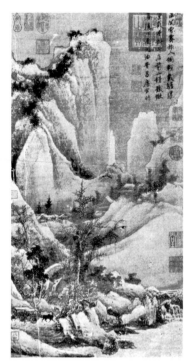

(A) T'ANG YIN Clearing after Snow in a Mountain Pass: hanging scroll, early 16th century
Taichung, Taiwan, National Palace Mus.

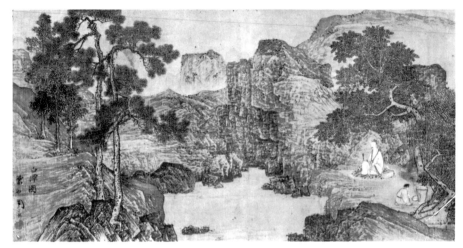

(B) CHOU CH'EN The Clear Lake: handscroll, early 16th century
Kansas City, Mo., William Rockhill Nelson Gall. of Art

T'ANG YIN

T'ang Yin

(C) T'ANG YIN Preparing Tea: handscroll, 1521
Stockholm, Mus. of Far Eastern Antiquities

T'ang Yin (1470-1523) was one of the most colorful personalities among Ming painters. Although he came of a humble family, his intellectual brilliance early marked him out for an official career. But while still in his twenties, he was involved in a scandal about cheating in the government examinations, and returned disgraced and penniless to his home in Su-chou. The humiliation hung over him for the rest of his relatively short life, but he never lost his old friends, among whom was the upright and disapproving Wen Cheng-ming. The doors to an official

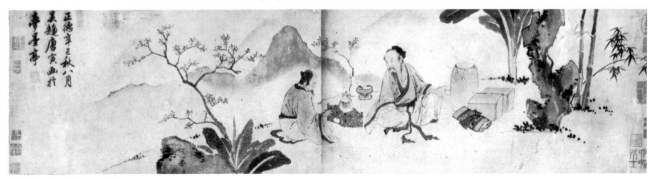

career being closed to him, T'ang Yin was forced to support his family by painting. This he did with such notable success that he had, it is said, to ask his friend and neighbor Chou Ch'en to help him fulfill his commissions by painting pictures for him to sign, a fact that probably accounts for the comparatively few surviving pictures bearing the signature of Chou Ch'en.

A characteristic work by T'ang Yin is a big hanging scroll, *Strolling across a Summer Stream*, in the Royal Ontario Museum, Toronto (color plate 188). Its craggy mountains, and monumental design were inspired by the great masters of the early Northern Sung Dynasty; the precise drawing of the trees and close-textured rocks was derived from Li T'ang by way of Chou Ch'en, and the decorative color also recalls the academic tradition. But the subject, a scholar in a landscape, belongs to the literary world on the edge of which T'ang Yin moved. Painted, perhaps as a concession to popular taste, on satin, this charming picture shows with what refinement and skill he could fuse together elements of diverse origin. He was also an expert painter of flowers (D), of beautiful women, and of figures in garden settings (C). He was widely appreciated in his own day, and his landscapes (A) and figure studies, especially his groups of elegant ladies, have been copied and imitated by a host of anonymous professionals up to recent times.

Ch'iu Ying

Ch'iu Ying (active about 1510-51) was, if anything, even more popular in his day than T'ang Yin as a painter of women and idealized scenes of the inner apartments of the imperial palace (E). While T'ang Yin could claim at least some scholarly attainments, Ch'iu Ying began as a painter's apprentice and was never anything but a professional. Yet the brilliance of his technique was matched by the elegance of his taste. Many of his larger paintings depict the scholar at ease in a landscape, and have the same combination of literary content and academic technique as that found in the work of T'ang Yin. Ch'iu Ying was also noted for landscapes in the archaic gold and blue-green style, and for studies of beautiful women inspired by the 8th-century court painters Chou Fang and Chang Hsüan. His pictures, like T'ang Yin's, were widely copied, with the result that there are far more good forgeries than originals in existence.

Ch'iu Ying's lovely scroll of *Narcissus and Flowering Apricots* (color plate 189), in the Freer Gallery, Washington, was painted in 1547 in the precise style known as *kung-pi-hua*. In its perfect craftsmanship, delicacy of touch, and quietness of mood the scroll recalls the ideal of flower painting as practiced at the Northern Sung academy under the emperor Hui-tsung. That it has been greatly admired can be seen from the number of seals it bears, which include those of the great Ming collector Hsiang Yüan-pien and, most numerous and conspicuous, those of the Ch'ing Dynasty emperor Ch'ien-lung (reigned 1736-96).

Other late Ming figure painters

Critical works on Ming and Ch'ing painting, written as they were by scholars, naturally placed greatest emphasis on the scholarly landscapists and paid little

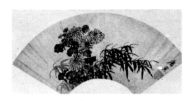

(D) T'ANG YIN
Chrysanthemums: fan
Lugano, coll. Dr. Franco Vannotti

丁雲鵬 TING YÜN-P'ENG

仇英 CH'IU YING

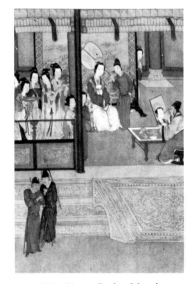

(E) CH'IU YING Spring Morning in the Han Palace (detail)
Taichung, Taiwan, National Palace Mus.

attention to figure painters. During the late Ming Dynasty, however, there were a number of gifted and original painters of figure subjects quite unlike the charming creations of T'ang Yin and Ch'iu Ying. For example, Ting Yün-p'eng (active about 1584-1638) was noted for pictures of Buddhist and Taoist personages (A), in which he not only revived the orthodox linear technique of the Sung master Li Lung-mien, but also captured some of the eccentricity of early Zen painters.

The tendency to look to the past became more and more characteristic of Chinese painting from this time onward. It was partly an expression of the social and cultural decay that set in as the Ming Dynasty drew to a close. Men thought wistfully of the great days of the T'ang and Sung Dynasties, and never tired of looking at paintings in which the heroic past was re-created. The gorgeously decorative blue, green, and white landscapes of the 12th-century court painter Chao Po-chü and his school were often copied or imitated. Typical of such copies is the Boston handscroll, *The Entry of the First Han Emperor into Kuanchung*, discussed in chapter V (see page 55 and color plate 171).

The greatest late Ming figure painter to draw upon archaic styles was Ch'en Hung-shou (1599-1652), who received an official appointment just before the fall of the Ming Dynasty, only to be taken prisoner in Nanking by the advancing Manchus. His life was spared and he was allowed to retire to his home in Chekiang, where he died soon after. The figure painters on whom he modeled his style were Ch'ien Hsüan and Li Lung-mien. Color plate 190, and (B) show details from Ch'en Hung-shou's handscroll depicting moments in the life of the 4th-century poet T'ao Yüan-ming, who described his return to his country home in one of the most famous poems in the Chinese language. In the color plate detail, the poet meditates, kneeling upon a palm leaf beside a rock on which repose his two fans, his brush, and his inkstone. Above him are written the relevant passages from the poem. In the slender figure and flowing drapery may be recognized an echo of the fluent line of Ku K'ai-chih, the poet's contemporary (color plate 152), while the drawing of the rock recalls the T'ang courtly style of landscape painting as it survives, for example, in the anonymous *Emperor Ming-huang's Journey to Shu* (color plate 161). But Ch'en Hung-shou was no mere revivalist. His was a highly original talent. In his hands archaic styles and techniques were not only brought back to life, but were transformed into something new.

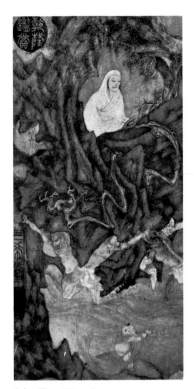

(A) TING YÜN-P'ENG
The Dragon King Paying
Homage to Kuanyin (detail):
hanging scroll, 17th century
Kansas City, Mo.,
William Rockhill Nelson Gall. of Art

(B) CH'EN HUNG-SHOU Scenes from
the Life of T'ao Yüan-ming (detail):
handscroll, 1650
Honolulu, Hawaii, Academy of Arts

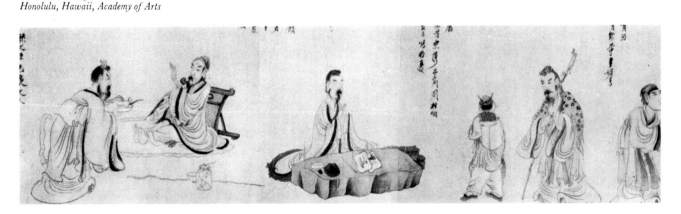

Late Ming painting

After a short period of firm and stable government in the latter part of the 15th century, the Ming regime had begun to sink slowly into decay. The emperors were mostly weak and dissipated, helpless in the hands of eunuchs who controlled both court and government. Brave scholars who dared to protest against the growing corruption of public life were beaten to death. The dynasty survived until 1644 through its own inertia, but the loyalty of the intelligentsia upon whom it depended for its existence was strained to breaking point. Many scholars retired altogether from public life or formed secret resistance groups such as the famous Tung-lin society. Although they were powerless to halt the decay of the dynasty, they took pride in the knowledge that they alone upheld the true Confucian ideals, while those who served at court were tainted with its corruption. As we shall see, this conviction among retired scholars that they were the true custodians of traditional culture had a profound influence upon the character of scholarly painting during the 16th and 17th centuries.

At the same time, the gradual breakdown of Ming society and the withdrawal of the scholars led to the fragmentation of the tradition of literary painting. The serene stability and acceptance of tradition that we found in Shen Chou (see page 79) was much rarer in the 16th century. There was everywhere a feeling of stress and uncertainty, a striving for originality that was the scholar's way of proclaiming his independence. Typical of this trend was the work of Hsü Wei (1521-93), whose explosive studies of bamboo were painted in a state of high intoxication, which made him truculent rather than gay.

Another independent master was Wu Pin (active about 1567-1617), whose most original works were his fantastically contorted ink landscapes. His delightfully detailed panorama, *Greeting the Spring* (color plate 191), in the Cleveland

CH'EN HUNG-SHOU

HSÜ WEI

SHENG MAO-YEH

CHANG JUI-T'U

SHAO MI

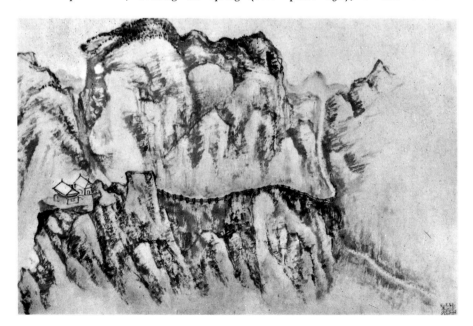

(c) SHAO MI Landscape: album leaf, 1638
Paris, coll. Jean-Pierre Dubosc

85

KU CHENG-I

CHAO TSO

SUN K'O-HUNG

TUNG CH'I-CH'ANG

顧正誼孫克弘董其昌

趙左

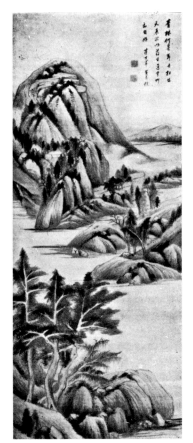

(A) TUNG CH'I-CH'ANG
Landscape: hanging scroll,
16th century
Munich, Nü-wa-chai Coll.

Museum of Art, Ohio, has much of tradition, even of archaism, in its precise drawing and gay color. Yet even here there are willful distortions, such as the fantastic rock overhanging the village on the left. Sheng Mao-yeh (active 1607-37), Chang Jui-t'u (active 1605-45), and Shao Mi (active 1620-60) (page 85 c) were other late Ming expressionists whose originality is only now becoming recognized.

Even a more professional painter like Lan Ying (about 1585 - after 1600), who came from Chekiang, is difficult to fit into any particular school. His panorama handscroll of the Fu-ch'un mountains (color plate 192) was inspired, like so many renderings of this subject, by the famous handscroll *Dwelling in the Fu-ch'un Mountains* (pages 238 and 255) of the Yüan scholar-painter Huang Kung-wang. But Lan Ying has added color, and the rather harshly angular forms of his mountains reveal the influence not merely of the Che school of his home province, but of the restless age in which he was living.

One of the groups of late Ming literati became known as the Hua-t'ing school, after the home town in Kiangsu of several of its most prominent members. These included Ku Cheng-i (late 16th century), who had a great influence on the painter critic Tung Ch'i-ch'ang; Sun K'o-hung (1532-1610), a lyrical and scholarly landscapist akin to Shen Chou; and Chao Tso (active about 1610-30).

In discussing the great Chinese Individualists of the late 17th century (see page 91), it is important to remember that the tradition of Individualism was already well established among the literati some decades before the fall of the Ming Dynasty in 1644.

Tung Ch'i-ch'ang

Of late Ming literati, none was more influential than Tung Ch'i-ch'ang (1559-1636). Painter, calligrapher, scholar, critic, and collector, he became the figure-head and spokesman for the intellectuals of his time. As a critic he is chiefly known for his exposition of the theory of Northern and Southern schools of landscape painting, outlined at the beginning of chapter IV. According to him, all scholar painters, bamboo painters, and painters of monochrome ink landscapes in a free style based on Tung Yüan and the masters of the Yüan Dynasty, belonged to a "Southern" tradition; professionals, court painters and decorators, and members of the Che school were contemptuously relegated to a "Northern" school. The theory gained wide acceptance among literati because it fitted their own ideals and prejudices. At the same time the suggestion of a "we" and a "they" group gave comfort and encouragement to scholars who felt that their talents were unwanted and unappreciated by the emperor.

Although Tung Ch'i-ch'ang himself did not invent this theory, but took it over and developed it from an idea of his friend Mo Shih-lung, such was his authority that for three centuries scholar painters continued to see the history of landscape painting through his eyes. They often painted in the manner of Tung Yüan or Huang Kung-wang, and it was Tung Ch'i-ch'ang's version of these styles that guided them. For many of them nature ceased to provide the inspiration. Painting became a branch of historical scholarship. It is often impossible to understand works

by these painters without knowing from whom, as it were, they are "quoting" and without recognizing the pictorial and stylistic allusions in each work.

The intensely intellectual character of such painting is best seen in the work of Tung Ch'i-ch'ang himself. His *Landscape with a Straw Hut* (page 241) was painted in 1597 for Ch'en Chi-ju, a young scholar whom he greatly admired. The forms of the mountains, with their long, hemp-fiber texture-strokes, derive from Huang Kung-wang, but there is a deliberate distortion in Tung Ch'i-ch'ang's painting that expresses the cool, intellectual passion of the scholar and theorist, rather than a poet's response to the natural world.

By now the literati made a positive virtue of absolute detachment from "things." If they painted rocks or trees it was not because they loved them for their own sake. They merely "borrowed" them, as they put it, as convenient forms in which, for the moment, to "lodge" their feelings. Their feelings had little or nothing to do with rocks or trees as such. It was possible for Tung Ch'i-ch'ang to load a painting with inscriptions without impairing its significance, because it was not a landscape in the accepted sense of the word. Instead, it was a manifesto of an art-historical theory, a declaration of the painter's detachment from things, and a document bearing witness to the ties that bound the scholarly elite together (A, B).

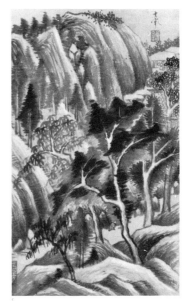

(B) TUNG CH'I-CH'ANG
Landscape: album leaf,
16th century
Lugano, coll. Dr. Franco Vannotti

Chapter IX
THE CH'ING DYNASTY

The Ch'ing court and its patronage

In 1644 the Ming Dynasty, by then in a precarious state, was overthrown by invading armies from Manchuria, who at once established a new dynasty, the Ch'ing. Peking (C) remained the capital. Conscious of being aliens on Chinese soil and aware of the fate that had befallen the Mongols, the Manchu rulers were anxious to secure the support of the Chinese intelligentsia, and to attract back into public service the numerous scholar officials who had prudently retired when the Ming Dynasty fell. In this they were successful. The Chinese official class served them loyally for nearly three centuries. In order to prevent any possibility of a conspiracy, however, the Manchus imposed upon educated Chinese a rigorous censorship and a tight control of thought. Many scholars in the imperial service were induced to adopt an extremely cautious and conservative attitude of mind, which is found reflected in their painting.

At the same time the early Ch'ing emperors were energetic patrons and collectors of art. In the Forbidden City at Peking, the emperor K'ang-hsi (reigned 1662-1723) established a Bureau of Painting that became known by the name of the old Sung Imperial Painting Academy, Hua-yüan, though it had none of the prestige and freedom of its predecessor. K'ang-hsi treated his senior painters like superior artisans, keeping them constantly busy as decorators, recorders of histor-

(C) The Temple of Heaven, Peking

87

ical events, and illustrators of encyclopedic works such as the "Keng-chih-t'u," a treatise, completed in 1696, on rice and silk culture.

The conservatism demanded of scholars was expected also of court painters. Yüan Chiang, court painter to the emperor Yung-cheng (reigned 1723-36), specialized in landscapes in the manner of the Northern Sung masters. So did his nephew Yüan Yao, employed by Ch'ien-lung (reigned 1736-96). Yüan Yao's *Traveling in the Mountains in Autumn* (color plate 193) shows how boldly they could adapt the typical S-curve composition and twisting rocks of Kuo Hsi (color plate 166), adding color and much realistic detail to produce a picture that was not only unmistakably in the Kuo Hsi tradition, but also decorative and interesting to look at. Scholar painters, of course, would have heartily condemned so crude and mannered a reference to the style of the great Sung landscapist.

The decorative style favored at court found another master in Shen Ch'üan (A), or Shen Nan-p'in. Although never actually a court painter, he is worthy of mention as having spent the years from 1731 to 1733 in Nagasaki at the invitation of a rich Japanese art patron. His delicate flower paintings had considerable influence on Japanese artists, who assumed, quite wrongly, that they were typical examples of the Chinese literary style.

European influence on Ch'ing court painting

Europeans penetrated into the Far East early in the 16th century. Hard on the heels of the first Spanish and Portuguese raiding parties came Catholic missionaries, among whom the Jesuits were outstanding for their success in winning the confidence of the ruling class wherever they went. This they achieved by offering to China, for the greater glory of the Church, the skills and sciences of which Europe was master. Devotional engravings brought to Peking in 1601 by the Italian Jesuit missionary Matteo Ricci caused a great stir among the few who saw them. Painters at court were astonished at the power of Western artists to suggest solid form and depth by means of shading and linear perspective. But although some of these engravings were imitated by painters and decorators into whose hands they fell (B) —even the critic Tung Ch'i-ch'ang is said to have copied them—they had no influence whatever upon the mainstream of Chinese painting.

When the reign of K'ang-hsi began in 1662, the Jesuits were well entrenched in Peking, teaching astronomy and mathematics, engineering and architecture to a receptive audience of scholars at court. The Italian Jesuit painter Giuseppe Castiglione (1688-1768), also known by his Chinese name Lang Shih-ning, arrived in Peking in 1715 and was soon established with several assistants in a studio in the palace grounds. There he painted realistic portraits of the emperor Ch'ien-lung, who was very pleased with them. In a number of highly detailed scrolls illustrating the emperor's travels, campaigns, and court ceremony, he cleverly combined the Chinese format, medium, and certain landscape conventions, with Western perspective, shading, and realistic drawing. These brilliant exercises in synthetic craftsmanship were greatly admired at court. Nevertheless, one of Castiglione's most adept pupils, the court painter and official Tsou I-kuei (1686-1766), while

praising Western painting for its realism, condemned it for its lack of "brush manner." The brushstroke is the very foundation of Chinese painting. In Tsou I-kuei's opinion, men who ignored this and worked entirely in the Western style were not painters at all, but mere artisans.

The Chinese-European style of Castiglione and his followers was fashionable at court through the reign (1736-96) of Ch'ien-lung (see page 290 A), though after the abolition of the Jesuit order in China in 1773 and the withdrawal of the missionaries, it gradually faded away. It had no influence whatever upon the Chinese literati, and by the 19th century had ceased to be an important factor even in court painting.

Orthodox painters in the scholarly tradition

For all its reactionary outlook, the Ch'ing regime brought China peace and prosperity, in which the middle classes expanded and flourished. For educated men and women, painting and calligraphy became popular pastimes in which even an average performance, like that of a Western amateur pianist, could give pleasure to the artist and his friends. There was no longer a serious rivalry between the academic and the scholarly traditions in Chinese painting. The academic style had become completely fossilized and no new developments could be expected from that quarter. Instead, divisions began to appear within the literary tradition itself between, at one extreme, orthodox followers of the art philosophy and brush styles laid down by the late Ming critic Tung Ch'i-ch'ang, and, at the other, the Individualists and expressionists. Between these two poles lie the great majority of Ch'ing amateur painters.

Chinese critics have divided Ch'ing painters in general into groups, such as the Six Great Masters of the Ch'ing Dynasty, the Eight Masters of Nanking, and the Eight Yangchow Eccentrics. This is misleading if it suggests close-knit schools such as are found in the history of European and Japanese art. Except in the case of the Six Great Masters these men were very loosely associated, sometimes merely by the accident of living in the same town or district, and were not in the least conscious of belonging to any group. Nevertheless, the labels are convenient in helping us to pick our way through the scores of painters at work during the Ch'ing Dynasty.

Wang Shih-min

The stability imposed by the Manchus, and the willingness of conservative scholars to support them, provided ideal conditions for the doctrines of Tung Ch'i-ch'ang to take root. The Six Great Masters of orthodox literary painting of the early Ch'ing Dynasty were the so-called Four Wangs, Wu Li, and Yün Shou-p'ing. The first of the Four Wangs and the chief agent in the consolidation of Tung Ch'i-ch'ang's theories was Wang Shih-min (1592-1680), member of a prominent official family in Kiangsu and former student of Tung Ch'i-ch'ang himself (c). At the fall of the Ming Dynasty he retired to T'ai-ts'ang in Kiangsu, where he indulged his passion for painting, collecting, and connoisseurship. His models were Huang Kung-wang and Ni Tsan. Content to feel that he was handing on the great

(C) WANG SHIH-MIN
Landscape: hanging scroll, 1647
Lugano, coll. Dr. Franco Vannotti

王時敏 WANG SHIH-MIN

89

WANG CHIEN 王鑑

WANG LI 王翬

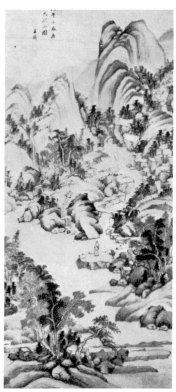

(A) WANG CHIEN Landscape: hanging scroll after Huang Kung-wang, 1666
Lugano, coll. Dr. Franco Vannotti

WANG YÜAN-CH'I 王原祁

Southern tradition as he had received it from Tung Ch'i-ch'ang, he had no desire to create anew. Yet he was an able painter, who fully grasped the grandeur and purity of the work of the Yüan recluses. His great series of landscapes in the manner of Huang Kung-wang, painted when he was in his seventies, are among the noblest achievements of the Ch'ing literati.

Wang Shih-min's close friend Wang Chien (1599-1660) was the second of the Four Wangs. He, too, studied Huang Kung-wang; but he interpreted the relaxed brushwork of the Yüan master in a very personal way (A).

Wang Hui

It is not always easy to separate the landscapes of Wang Chien from those of his pupil Wang Hui (1632-1717), the third of the Four Wangs. Wang Chien once introduced his student to the venerable Wang Shih-min, who remarked sadly: "I only regret that he was not old enough to meet Tung Ch'i-ch'ang." There is no doubt that Wang Hui was a faithful disciple. He spent a long, peaceful life turning out landscapes in the manner of Huang Kung-wang and other early masters. His scholarly allusions are sometimes very obscure. According to the artist's inscription the small landscape of 1680 (color plate 194) was done in the colored manner of the Sung painter Kan-feng-tzu. Where Wang Hui could have seen a landscape by that almost totally unknown painter of Buddhist figure subjects, he does not say. One is left to imagine that he may have heard the name mentioned by Wang Shih-min. The landscape illustrated, calm, scholarly, dispassionate, with its vague allusion to the Southern Sung style, is a typical example of the intellectual dryness of the more conservative literary painters of the Ch'ing Dynasty.

It is perhaps surprising that a creative painter was content to sacrifice his talent in this way. During the Ch'ing Dynasty, however, Chinese culture was in many ways at a standstill. Men looked not forward, but backward. The conviction of many philosophers and historians that society in the remote past had once been in an ideal state of order was shared by conservative painters, who believed that Tung Yüan, Mi Fu, and Huang Kung-wang had produced the perfect expression of the ideals of their class, and that nothing remained but to pay homage to their tradition and hand it on unsullied to later generations.

Wang Yüan-ch'i

The more gifted literati, however, took note of Tung Ch'i-ch'ang's insistence that it was the *spirit* of the old masters, and not merely their style that must be kept alive. "However easy it may be to make a close copy," he had written, "it is difficult to transmit the spirit. When Chü-jan, Huang Kung-wang, and Ni Tsan all studied Tung Yüan, they all followed the same model, yet they were not like one another. But when ordinary people make faithful copies they do not transmit anything to posterity."

The point is well illustrated by the landscapes of Wang Yüan-ch'i (1642-1715), the fourth of the Four Wangs. A grandson of Wang Shih-min, he rose to high rank

in the Ch'ing administration under the emperor K'ang-hsi, for whom he was the chief compiler of a huge encyclopedia of painting and calligraphy, published in 1708. The emperor often summoned him to paint, and would sit watching him for hours. Wang Yüan-ch'i was above all an admirer of Ni Tsan. Yet a comparison of a typical landscape by him (color plate 195) with a work by Ni Tsan (page 239), makes it clear that he was no mere copyist. He adopted Ni Tsan's horizontally divided composition, his dry brushwork, and his air of detachment, but there all similarity ends. For the Ni Tsan painting is subtly elusive and deeply poetic, while Wang Yüan-ch'i was obsessed with the organization of form in space. A contemporary described how he laboriously built up his compositions, pulling apart and reassembling his rocks and mountains into closely interlocked masses, until he attained the complete realization of his concept. In their careful construction and their concern with abstract form, his landscapes have been likened to those of Paul Cézanne.

Wu Li and Yün Shou-p'ing

The Four Wangs, along with the two painters Wu Li and Yün Shou-p'ing make up the Six Great Masters of the Ch'ing Dynasty. Wu Li (1632-1718) was a pupil of Wang Shih-min and Wang Chien, and a close friend of Wang Hui. His paintings reflect if anything an even purer understanding than theirs of the spirit of the Yüan recluses. To Western collectors, Wu Li's chief claim to fame is that he came under the influence of the Jesuits, was ordained priest, and spent his last 30 years as a Catholic missionary. Although his religious duties reduced his output of paintings, they in no way affected his pure, scholarly style. The album leaf after Wang Meng illustrated in color plate 196 is attributed to him. While its debt to Wang Meng is unmistakable, there are also hints in it of the quieter and more relaxed tone of Wu Chen, for whom Wu Li had great admiration.

Yün Shou-p'ing (1633-90), a painter of free and poetic landscapes (B), was another friend of Wang Hui. Feeling with excessive modesty that his own landscapes could never equal those of his friend, he turned to flower painting, for which he is chiefly known. His aim, he said, was to revive the "boneless" manner of the Sung painter Huang Ch'üan, and in this he was successful. He often worked in color in order to please his patrons, but himself preferred the "light and refined manner of the Sung masters," as he put it. The album leaf illustrated in color plate 197 shows with what freedom and delicacy he put new life into the old "boneless" technique.

The Ch'ing Individualists

Scholar painters who withdrew into private life at the beginning of the Ch'ing Dynasty, on the accession to power of the alien Manchus, might have been expected to take as their models the scholar painters of the Yüan Dynasty, who had become recluses under similar circumstances. That they did not, was chiefly because the style of the Yüan masters had already been appropriated by the

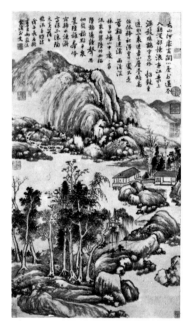

(B) YÜN SHOU-P'ING
Landscape: hanging scroll,
17th century
Taichung, Taiwan, National Palace Mus.

YÜN SHOU-P'ING

WU LI

91

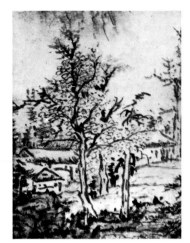

(A) SHIH-CH'I
Wooded Mountains at Dusk (detail):
hanging scroll, 1666
New York, coll. John M. Crawford Jr.

PA-TA SHAN-JEN 八大山人

SHIH-CH'I 石溪

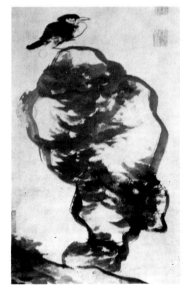

(B) PA-TA SHAN-JEN
Bird on a Rock, 1694
Paris, coll. Dr. Jacques Lacan

orthodox literati, many of whom were loyally serving the Manchus. If painting was to become a living art once more, the painter had clearly to free himself from the burden of theory and scholarship carried by the literati. He must use his art for the spontaneous expression of his own feelings. This the Ch'ing Individualists triumphantly accomplished, putting new life into the Chinese tradition.

Shih-ch'i

The earliest of the Ch'ing Individualists was Shih-ch'i, or K'un-ts'an (about 1610-93). He spent the greater part of his life in Buddhist monasteries in and around Nanking, rising eventually to the rank of abbot. Like many of the so-called recluses, he had a wide circle of friends among scholars of the Nanking region. But although he painted only in his spare time, painting was no mere relaxation for him; in the complex organization and rich, dense texture of his landscapes, is to be seen an extension of his strenuous spiritual life. Somewhere in the background of his large *Wooded Mountains at Dusk*, 1666 (color plate 198, and A) there is perhaps a hint of the close-knit compositions of Wang Meng, but if so, Shih-ch'i seems hardly aware of it. He appears rather to be trying to express some powerful inner feeling of his own. His scrubby brushwork makes no obvious appeal to the viewer. The long inscription, telling how he climbed the hill behind the monastery at sunset, and how deeply he was moved by the grandeur of the scene that unfolded before him, leaves no doubt that, far from being a scholarly commentary on Wang Meng, the picture is a translation into ink and color of what Cézanne, in a celebrated phrase, called *une sensation forte devant la nature.*

Pa-ta Shan-jen

A very different type of expressionist was Chu Ta (1625-1705). He gave himself many names, but is known chiefly by an odd Taoist appellation, Pa-ta Shan-jen, which he used after 1689. He was a distant descendant of the Ming imperial family. According to one account, he entered a Buddhist monastery near Nan-ch'ang in Kiangsi; another states that he married and had children. It is said that on the death of his congenitally dumb father he became dumb himself. Nevertheless he loved company and drink, and had many friends. In his later years his well known eccentricities bordered on madness. People who wanted works by him plied him with wine until he was completely drunk, and were rewarded with some of the most joyous and startling pictures in the history of Chinese painting.

Nearly all Pa-ta Shan-jen's works are swiftly sketched studies of flowers, angry little birds (B), or fish darting among fishlike rocks. Poised in empty space, and drawn with the fewest possible strokes in dark, rich ink, his small, lively creatures capture the very essence of living nature (page 242). Even his rocks seem to be alive. Occasionally he painted landscapes, beneath whose cryptic, abstract forms lies a deep feeling for the monumental compositions of the Northern Sung Dynasty.

Shih-t'ao

The third great Individualist was Chu Jo-chi (1641- about 1717), a distant relative of Pa-ta Shan-jen. Although generally known by one or the other of the names that he adopted as a monk, Shih-t'ao or Tao-chi, he was never in fact ordained, but moved freely about southeastern China and finally settled in Yangchow. He was not only a noted painter and calligrapher, but also a garden designer. His flair for "piling up stones," as he called it, is almost certainly to be seen reflected in some of his album landscape sketches.

Of all Ch'ing painters Shih-t'ao was the most philosophical in outlook and the most articulate. A collection of his scattered notes published after his death sets out his belief that the essence of painting lies in the *i-hua*, the one-stroke painting method. This hard, cryptic phrase embraces Shih-t'ao's awareness of the life and order of nature, and his power to convey this awareness by the free, unfettered exercise of his brush. "By one spontaneous movement of the hand," he wrote, "mountains, rivers, human beings, birds, animals, plants...... will assume form in accordance with their characteristics; they will be drawn as if alive and their meaning will be revealed."

A sense of the life and unity of nature breathes through every picture that Shih-t'ao painted, from the smallest album leaf (color plate 199), to his rare large hanging scrolls, such as the awe-inspiring vision of Mount Lu (c) in the Sumitomo collection. He seems always to have painted in a state of almost childlike ecstasy, derived partly from nature and partly from some deep well of purest inspiration within himself. In order to give expression to his feelings he not only flouted all the rules, but invented a new range of forms and techniques (D). He would apply pure color in washes of blue and pink, or dot it upon the surface of the paper like a 19th-century Pointillist.

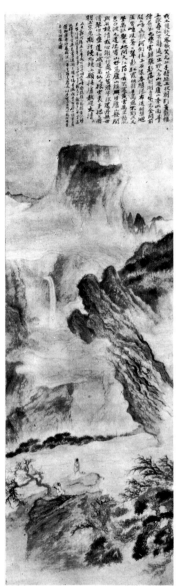

(C) SHIH-T'AO
Mount Lu: hanging scroll
Oiso, Japan, Sumitomo Coll.

SHIH-T'AO

(D) SHIH-T'AO Plantains after Rain:
album leaf, 17th century
China, Private Coll.

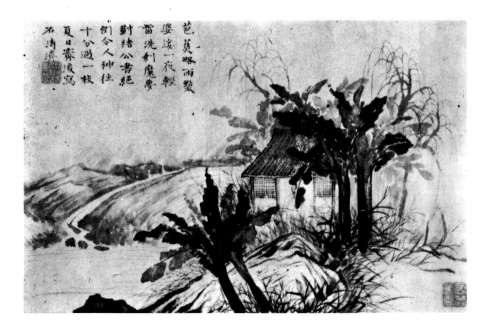

(A) ANONYMOUS
Kuanyin with Willow and Vase:
wood-block print from Tunhuang
London, B. M.

HSIAO YÜN-TS'UNG

CH'A SHIH-PIAO

MEI CH'ING

Kung Hsien

Just as orthodox Ch'ing masters took pride in upholding the Chinese tradition, so the Individualists proclaimed their independence from it. Shih-t'ao claimed to have rediscovered for himself the divine law of the "all-pervading unity." Kung Hsien (about 1620-89) said of himself that "there has been no one before me and there will be no one after me." Kung Hsien is traditionally classed as one of the Eight Masters of Nanking. But most of that group falls well within the literary tradition, while he stands apart from it. He spent his life in poverty as a recluse in the hills near Nanking. Although he greatly admired Tung Yüan, his somber landscapes lack the breadth and serenity of the 10th-century master.

Over Kung Hsien's landscape (page 243) there hangs an absolute silence. No wind stirs the branches, no scholar saunters down the path, the pavilion is untenanted. The stillness is partly an expression of Kung Hsien's brooding nature, and partly the result of his working almost entirely in graded ink tones, making scarcely any use of the brushstrokes that give life and movement to almost all Chinese painting. Although scholarly commentators criticized him for this, there can be no doubt that his landscapes have a strange and compelling power.

The color print

It is a little surprising to learn that Kung Hsien was an active teacher, who prepared for his students a handbook of instruction in the art of landscape painting. In 1679 one of his pupils, Wang Kai, produced a more ambitious handbook illustrated with woodcuts in color. This, the "Painting Manual of the Mustard Seed Garden," proved to be exactly what the growing army of amateur painters required. It was soon enlarged to cover the whole traditional repertory of the painter, and ran into many editions (see pages 256 and 257). Its arrival in Japan shortly before 1700 (see page 142) was a great stimulus to the development of the Japanese color print.

However, the "Mustard Seed Garden" was by no means the first Chinese book with wood-block illustrations. Wood blocks had been in use since the T'ang Dynasty for printing and illustrating Buddhist scriptures (A). By the Sung Dynasty, if not earlier, line prints were being colored by hand, and the Yüan period saw the first experiments in color printing. The picture of loquat fruit (color plate 200) is taken from a famous late Ming book, the "Treatise on the Paintings and Writings of the Ten Bamboo Studio," prepared by a group of Nanking painters between 1620 and 1630. It shows with what success Chinese craftsmen had achieved their aim of making a color print resemble a watercolor painting.

The painters of Anhui

Of the painters who worked in the province of Anhui during the Ch'ing Dynasty, at least four deserve mention: Hsiao Yün-ts'ung, Hung-jen, Ch'a Shih-piao, and the eccentric Mei Ch'ing (B). The most gifted was Hung-jen (1610-63). Born Chiang T'ao, he took the Buddhist name Hung-jen when he entered a monastery at the

fall of the Ming Dynasty. He was admired and loved for the purity of his heart and mind, qualities revealed in all his paintings. Not unnaturally he took as his example the great Yüan scholar painter Ni Tsan, but he absorbed the spirit of the master rather than his technique. Hung-jen drew his cool, spare landscapes (c) with a rigid economy of means, building up sheer rock faces with fine lines of almost geometrical precision, yet achieving a breadth and serenity of mood that recall Huang Kung-wang.

18th-century Individualists

The tradition of lyrical self-expression established by the Individualists of the 17th century continued to flourish during the 18th. There were no painters quite of the quality of Shih-ch'i or Shih-t'ao, but many minor masters produced scrolls and album leaves of great freshness and originality.

Kao Ch'i-p'ei (1672-1734), a native of Manchuria, rose to high office under the emperor K'ang-hsi. An amateur painter, he was chiefly noted for flowers, birds, figures, and landscapes in the painting of which he used his long, split fingernail instead of a brush. The resulting coarse and ragged quality of his "brushstrokes" may be seen in the landscape album leaf reproduced in color plate 201. More important than his peculiar technique, however, is the originality of his vision. In every leaf of this album he has swept aside accumulated layers of art scholarship to bring the viewer face to face with nature. Perhaps Kao Ch'i-p'ei strove a little too obviously after dramatic effect; but paintings such as his come as a refreshing contrast to the pedantry of the orthodox literary masters of his time.

The city of Yangchow, lying at the point where the Grand Canal meets the Yangtze River below Nanking, was by the beginning of the Ch'ing Dynasty a thriving center of trade. Its rich merchants were not especially cultivated as art patrons, though some had Shih-t'ao design gardens for them. Nevertheless they provided a prosperous milieu in which the arts could flourish. Among the Eight Eccentrics of Yangchow was Chin Nung (1687- after 1764), who, having begun to paint only when he was 50, worked in a deliberately awkward and amateur fashion. Others were his more accomplished but equally eccentric pupil Lo P'ing (1733-99) (D), and Hua Yen (1682-1765), noted for brilliant studies of birds and flowers in which his light, abbreviated brushwork omits all but the essentials (color plate 202).

(B) MEI CH'ING
Landscape: album leaf, 18th century
Cleveland, Ohio, Mus. of Art

 LO P'ING

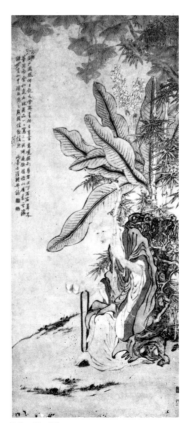

(D) LO P'ING
Buddhist Monk under a Hollow Tree: hanging scroll, 18th century
Cologne, Mus. of Far Eastern Art

(c) HUNG-JEN Landscape: album leaf, 17th century
Zurich, coll. C. A. Drenowatz

95

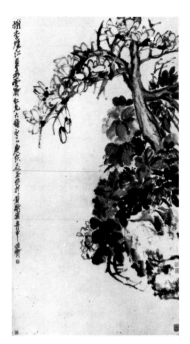

The 19th century

The Yangchow school was the last group of Ch'ing painters to make a significant contribution to tradition. By the beginning of the 19th century Ch'ing culture was so set in its forms and attitudes that it was almost impossible for a painter to break through the conventions and put Chinese art upon a new path. However, the gentleman painters of the 19th century, such as Tai Hsi (1801-60) and Wu Ch'ang-shih (1844-1927), had such masterly techniques and so thorough a knowledge of the old scholarly styles that they were borne along by the sheer momentum of the great tide of tradition that had built up behind them (A).

The 20th century

The Manchu rulers of the Ch'ing Dynasty resisted every effort to awaken the sleeping giant that was China, well knowing that reform would lead only to their own downfall. Moreover, Chinese painters were confident that their own tradition, however static, was far superior to the academic oil painting that was all the West then had to offer. But in 1911/12, when the Chinese Revolution finally took place and the Ch'ing Dynasty was overthrown, China's hostility to Western ideas was replaced, especially in coastal cities, by an eagerness to adopt Western ways of living, to write in the Chinese of colloquial speech instead of the classical style, and to develop modes of artistic expression more suited to a modern society.

In 1916, a Cantonese painter who had studied Western art in Tokyo started a movement to promote the painting of modern urban themes in the traditional Chinese ink medium (pages 290 and 291). Other painters returned from Japan to set up their studios in the French Concession of Shanghai, which became the center of China's cosmopolitan culture for the next three decades. In 1918, the end of the World War I made it possible for young artists to fulfill their dream of studying in Paris. After several years in France and Germany, Hsü Pei-hung (1895-1953) and Liu Hai-su (born 1895) returned to China as pioneers of the modern movement, and established art schools on the French pattern in Nanking and Shanghai·

(B) HUANG YUNG-YÜ
The Music Lesson: woodcut
London, Private Coll.

(C) Ch'i Pai-shih Painting
(Photo)

(D) P'AN JEN
They Also Live in the City:
woodcut, about 1946

Their painting, though in oils and in the Western style, was conservative. The Hangchow Academy under Lin Feng-mien (born 1901) became the center for a more experimental painting that was Chinese in feeling and modern in style (page 98 B).

At the same time more radical artists found, in the woodcut, a cheap and effective vehicle for denouncing the social abuses that plagued China during the earlier part of the 20th century. The woodcut movement was launched by the great writer Lu Hsün (1881-1936). Its inspiration was primarily Russian, but Chinese wood engravers, using a technique with a very ancient history in China (see page 94), soon surpassed their Russian models. The woodcut has since remained the chief medium for social and political propaganda (D). In the hands of a few artists, such as Huang Yung-yü (B), it has achieved a truly lyrical quality.

The double challenge of Western oil painting and Russian woodcuts acted as a stimulus to upholders of the Chinese tradition. In Shanghai the scholar painter Huang Pin-hung (1864-1955) revived the independent ideals of the Wu school literati (G). In Peking the venerable bearded figure of Ch'i Pai-shih (1863-1957) (c) seemed a reincarnation of the innocent genius of Pa-ta Shan-jen. Although for a short period Ch'i Pai-shih produced landscapes (E), he was noted chiefly for paintings of flowers, fruit, insects, and fishes, which he executed with the strength and spontaneity of a true Individualist. Painted when he was 88, his *Still-life with Wine Pot and Chrysanthemums* (color plate 203) is typical of his vigorous simplicity. The inscription reads: "The thing for prolonging life is wine!" When the Chinese People's Republic came to power in 1949, Ch'i Pai-shih was honored not only for his great age and humble origins—he was the son of a carpenter—but because he seemed to be the embodiment of the new vigor that has flowed into traditional painting since the beginning of the 20th century.

In 1937, when Japan invaded China and began to occupy the coastal cities, the modern movement changed its course. Painters and students were driven far into the interior. Cut off from Paris and deprived of oil paints, the modernists rediscovered

LIN FENG-MIEN 林風眠
HSÜ PEI-HUNG 徐悲鴻
HUANG PIN-HUNG 黃賓虹
黃永玉 HUANG YUNG-YÜ

(E) CH'I PAI-SHIH Landscape: album painting
Shanghai, coll. Sung Tzu-ch'i

(F) ZAO WOU-KI
Birds in the Branches, 1948
Location unknown

(G) HUANG PIN-HUNG
Landscape: hanging scroll, 1953
Singapore, coll. Ch'en Ching-chao

97

TSENG YU-HO 曾幼荷

CH'I PAI-SHIH 齊白石

CHAO WU-CHI 趙無極

LIU HAI-SU 劉海粟

LI K'O-JAN 李可染

their own land, and found new possibilities in the traditional ink medium. The work of this period often has a tentative, exploratory character, such as is to be seen in the early paintings of Chao Wu-chi, or Zao Wou-ki (born 1920), but it is unaffected and sincere. Zao Wou-ki (page 97 F), who first went to Paris in 1946, is one of the Chinese painters living abroad who are making a significant Chinese contribution to international modern art. Another is Tseng Yu-ho (A) now living in Honolulu.

The delightful sketch of two scholars in a wood reproduced in color plate 204 is by Li K'o-jan (born 1907), a modernist trained at the Hangchow Academy and active during World War II in painting propaganda pictures. Later he became a teacher at the Peking Academy. He has told how on his arrival in Peking after the war, he went to pay his respects to Ch'i Pai-shih; after looking through his Chinese style paintings for some time in silence, the old master remarked: "All my life I have admired above all the works of Pa-ta Shan-jen and Shih-t'ao. Now that I have seen your pictures I am sure that one day you will be their follower." That Li K'o-jan, who had spent the past six years as a realistic war artist, could express himself so naturally in the manner of the 17th-century Individualists shows how deep-rooted, and at the same time how vital, the Chinese tradition is in the 20th century.

In 1949 the establishment of the People's Republic gave both modern and traditional painters what they had never before known — security and prestige. On the other hand, the fact that they have been discouraged from painting pictures too far in advance of popular taste has put an end to experiment, except on a purely technical level. Yet contemporary art in China has been far from being monopolized by Socialist Realism, which, though useful for propaganda purposes, is nevertheless a foreign style (page 96 D). Since 1949 China has become intensely proud of her own cultural heritage. More care and resources are devoted today to the study and preservation of ancient monuments and works of art than at any previous period. China's profound sense of the meaning and value of history is ensuring that her art will surrender neither to the crudities of socialist propaganda, nor to the wilder excesses of some modern Western artists.

Japanese Art

Chapter I
THE BEGINNING OF JAPANESE ART

(A) Bronze Dōtaku Bell, probably 1st century A.D. *Tokyo, National Mus.*

Legendary contacts between China and Japan

It has been said that Japan is a child of the world's old age. It would be truer, perhaps, to say that while continental Asia and the Mediterranean world were creating their great classical cultures, Japan still slept. Before the Christian era her contacts with mainland Asia were intermittent and accidental. The Chinese believed that the islands that lay far out in the eastern sea must be P'eng-lai, the Blessed Isles of the Immortals, and the first Ch'in emperor, Shih-huang-ti (reigned 221-209 B.C.), is said to have sent a shipload of youths and girls to gather the elixir that grew on their hillsides. What became of this and other early expeditions is not known.

To the Japanese of that time China must have seemed just as legendary and remote. Certainly there are few remains dating from before the 1st century A.D. that point to any direct cultural contact, and no paintings at all.

Painting in prehistoric times

The most ancient remains of Japanese pictorial art yet discovered consist of painted decorations on pottery, and drawings cast in raised relief on the bronze bells (A) of the Middle Yayoi period (1st century A.D.). They depict men engaged in hunting (B), boating, rice husking (C), and other rural pursuits, and animals and birds, especially stags and waterfowl. In their shape and style of drawing, these bells are quite different from anything being produced in North China at the time, though they may have a remote connection with the bronze art of the Yangtze valley (Ch'u kingdom). The little scenes have a clarity of design and a precision of execution that were afterwards to be notable characteristics of Japanese art.

Slightly later are the paintings in tombs of the Tumulus period (about 250-550 A.D.), most of which have been found in that part of northern Kyūshū nearest to Korea. Of the 71 tombs discovered, the most important are the Ōtsuka (Royal Tomb) near Fukuoka, and the tomb in the village of Takehara, both dating from the 5th or early 6th century. The stone slabs lining the tombs were covered with a thin coating of clay, on which were painted men, horses, stylized plants, dragons, and the boats that bear away the souls of the dead. The colors—red, green, yellow, and black—are boldly, even crudely applied, and the designs show some affinity with the much more sophisticated tomb paintings of contemporary Korea.

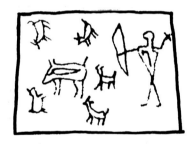

(B) Hunting Scene: drawing from relief on bronze Dōtaku Bell, probably 1st century A.D. *Tokyo, National Mus.*

(C) Rice Husking: drawing from relief on bronze Dōtaku Bell, probably 1st century A.D. *Tokyo, National Mus.*

99

(A) General view of the Hōryū-ji
Monastery, 7th century
Nara, Japan

(B) The Tiger Jātaka: from the
Tamamushi Shrine, probably 650-675
Nara, Japan, Hōryū-ji

The Asuka period, 552-645

The awakening of Japan to the civilization of mainland Asia came with dramatic suddenness. Buddhist missionaries from the Korean kingdom of Paekche may have reached Japan before the end of the 5th century, but the first recorded contact occurred in 538, when the ruler of Paekche sent to the emperor Kimmei a gift of *sūtras* (Buddhist scriptures) and a Buddhist image and a banner. At first there was much local opposition to the new religion, and a pagoda set up in 585 was torn down by the anti-foreign faction. But in 588 a group of monks and architects, with one painter, arrived from Korea, and very shortly afterwards, in what is today Ōsaka, the Shitennō-ji temple was erected. This is the earliest Buddhist temple in Japan of which the foundations survive. In 610 a painter from the Korean kingdom of Koguryo introduced into Japan the techniques of preparing painting materials.

Under the empress Suiko (593-628) Buddhism spread rapidly. Her regent, Shōtoku Taishi (592-622), doubtless inspired by the example of the great Indian Buddhist monarch Ashoka, established more than 40 religious foundations in and around the Japanese capital at Asuka, in the Nara region. Of these, Hōryū-ji (A), Daian-ji, and Hōrin-ji are the most renowned. Although their principal architects, sculptors, and painters were almost certainly Koreans, they were served by Japanese assistants, who brought to their work not only an eagerness to learn, but the high standards of craftsmanship for which Japan has since become famous. The Nara region was the focus of Buddhism in Japan from the beginning, and it has always remained so. It has since become also a place of pilgrimage for lovers of Buddhist art. Of the temples of T'ang China, very little survived the persecution of 845. Even less can be found in Korea. But the temples of Nara still stand, a veritable treasure house of the architecture, sculpture, and—until recently—painting of the most splendid period in the history of Buddhist art in the Far East.

Only two relics of Buddhist painting have been preserved from this first phase in Japan. One of them is the tapestry depicting the paradise of Miroku (Maitreya), sewed by court ladies in 622 as a pious deed to secure rest for the soul of Shōtoku Taishi. The names of the men who designed it are recorded; all were immigrants to Japan, probably Koreans. Today only fragments of it remain; even so, it shows how closely the pictorial art of the period was modeled on that of China.

The most important relic of Asuka style painting is the Tamamushi shrine, so called because its panels are bordered with gilt-bronze strips of open-work laid over the iridescent wing-covers of a beetle known as the jewel insect (*tamamushi*). The shrine (C), in the form of a miniature temple set on a high base, was probably made between 650 and 675. The door-panels are painted with figures of celestial guardians, the side doors with *bodhisattvas*; on the back is a stylized painting of the Vulture Peak. The four panels of the base show the holy Mount Meru, worshipers before a relic of the Buddha, and two stories from the Jātakas (B). The paintings are executed in clear, fluent line, in yellow, red, and green lacquer on a black ground. The technique is close to Western oil painting. The style, which may be called Sino-Korean, has a decorative flatness and lyrical charm that must have appealed strongly to contemporary Japanese taste.

The Nara period, 710-794

In 645 the emperor Kōtoku promulgated a series of decrees aimed at recasting his realm in the image of T'ang China, which was then approaching the zenith of its power and prestige in East Asia. Japan looked no longer to Korea for guidance. Government and the social order, the arts, dress, manners, and even language were to be modeled as closely as possible on those of China herself. The new capital laid out in 710 at Nara was a copy of the T'ang city of Ch'ang-an. The years known as the Nara period, from 710 to the removal of the capital to Kyoto in 794, mark the crest of this wave of Chinese influence. It is sometimes called the Tempyō period, though strictly speaking Tempyō covers only the years from 729 to 748. Other waves of Chinese art and culture washed later over the shores of Japan, but never in so overwhelming a flood as that which carried with it the brilliant civilization of the T'ang Dynasty.

The wall paintings in the Kondō at Hōryū-ji

By an edict of 701 a Bureau of Painting had been organized under the Ministry of Internal Affairs. It comprised four master painters, 60 ordinary painters, officials, and assistants. It was probably painters from this department who were responsible for the decoration of most of the palace and temple buildings that were raised in and around Nara during the 7th and 8th centuries. Their achievements most probably included the great series of wall paintings in the Kondō (Golden Hall) of Hōryū-ji in Nara (D).

The exact date of these paintings is uncertain, though most authorities place them between 680 and 710. They decorate the inner walls of the hall, and were intended for the edification of devotees making a ritual circumambulation around the icons on the central dais. Four large panels, each about ten feet high by eight feet six inches wide, depict the four paradises that, according to the doctrines popular in Japan at that time, lie beyond the boundaries of the world. On the east wall is probably the paradise of Shākyamuni, on the northeast that of Yakushi, Buddha of healing, and on the northwest that of Miroku (Maitreya); on the west is certainly the paradise of Amida (Amitābha) (E), whose cult was the most popular of all. Between them are eight vertical panels each containing a bodhisattva. The paradise is a purely formal arrangement, with the presiding deity on a lotus throne in the center beneath a canopy of flowers, and flanked by bodhisattvas and attendants (color plate 205). Noble, calm, austere, these belong to a timeless world far removed from the intensely human visions of a Western religious painter such as Fra Angelico. They are drawn on the dry plaster with a sweeping brush-line of marvelous fluency and subtlety; a hint of shading gives an effect of plastic solidity; color is restrained, but pigment is heaped up in a rich impasto in the rendering of flowers and jewelry. Some scholars have detected in these panels the influence of the Buddhist painting of central Asia. They are, however, essentially Chinese in style, though finer than any Buddhist painting of the period that has survived in China. After being preserved for over 1200 years, they were largely destroyed in a fire in 1949.

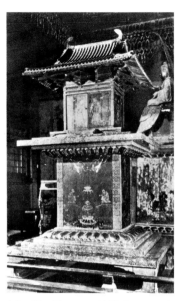

(C) The Tamamushi Shrine, probably 650-675
Nara, Japan, Hōryū-ji

(D) Interior view of the Kondō, 7th century
Nara, Japan, Hōryū-ji

(E) ANONYMOUS Paradise of Amida (detail) wall painting about 700
Nara, Japan, Hōryū-ji

Other Buddhist paintings of the Nara period

Of the many gorgeous painted banners that decorated the Buddhist temples of the Nara period almost nothing remains. Fragments of a *Paradise of Amida* woven in silk tapestry are preserved in the Taima-dera, a temple south of Nara. The most important of the surviving banners is the so-called Hokke-dō *mandara* (Mystic Diagram of the Preaching), depicting Shākyamuni preaching on the Vulture Peak. It was kept in the Hokke-dō of Tōdai-ji, the great temple at Nara, until the end of the 19th century, and is now one of the treasures of the Museum of Fine Arts, Boston. Although damaged, darkened, and heavily retouched, the figures of the deity and his attendants loom with an unearthly radiance against a background of forest-clad mountains (A), which provide valuable evidence for the study of T'ang landscape style. The fact that the mandara was painted on coarse hemp cloth than silk suggests that it was executed in Japan, and not in China.

The wealth of the Buddhist monasteries at Nara was due largely to the lavish patronage of the court, a patronage that inevitably had its effect upon Buddhist art. A striking illustration of this influence can be seen in a small banner preserved at Yakushi-ji (B). It depicts Kichijō-ten (Mahāshri), goddess of wealth and the incarnation of beauty, whose worship was ordered by the empress in an edict of 767. The graceful figure, clad in diaphanous robes and fluttering scarves picked out in gold, has a very worldly air, reflecting not so much Buddhist spirituality as the opulent type of female beauty created in China by the T'ang court painters Chang Hsüan and Chou Fang (see color plate 158).

The Ingakyō scrolls

In the absence of historical documents there is no means of knowing for certain by whom, or where, paintings such as the *Kichijō-ten* were executed. It is clear, on the other hand, that the scrolls of the illustrated " Scripture of Causes and Effects," or *Ingakyō*, were copied in Japan from a Chinese original. Four versions in Japanese collections were painted in the mid-8th century, a fifth probably half a century later; there are also fragments in several Western museums. The *Ingakyō* tells the story of the life, and previous lives, of the Buddha. The illustration runs above the text, reading, as do all Far Eastern scrolls, from right to left (color plate 206). Although the incidents belong to India of the 6th century B.C., they are set, like the Tunhuang paintings, in the "modern dress" of T'ang China; they are notable for their naive charm and clarity, and for the skill with which incident follows incident, the same figure appearing again and again in a continuous landscape panorama.

Paintings in the Shōsō-in Repository

Erected in 756, the treasury of the great temple at Tōdai-ji houses one of the largest and most ancient collections of arts and crafts in the world. On the death of the emperor Shōmu in that year, his pious empress presented the treasures of his court to the temple; these were placed in a huge timber storehouse, the Shōsō-in (D), where

they have remained in perfect condition, though with some losses and later additions. Among the 10,000 objects there are examples of T'ang style decorative art of superb quality, the like of which have not survived in China itself. The original inventory listed "one hundred screens." Of these only one painted specimen remains (c). On each of its six panels is depicted a handsome lady, plump after the fashion of the time, standing or sitting beneath a tree. This subject, popular in T'ang art, comes ultimately from the Near East, and is but one of many examples of western Asiatic influence in the art of the Shōsō-in.

Another precious relic in the Shōsō-in (see page 244) is a large square of hemp cloth on which a bodhisattva is freely sketched in ink, in a sweeping brush-line like that for which the T'ang master Wu Tao-tzu was famous. The modulated line expresses a sense of solid form close to that of some of the sculpture of this period: compare, for example, this figure with the voluptuous modeling of the Buddha in the North China caves at T'ien-lung-shan (page 285).

(c) Anonymous Lady Under a Tree (detail): screen panel, 8th century
Nara, Japan, Tōdai-ji, Shōsō-in Repository

(d) The Shōsō-in Repository, erected 756
Nara, Japan, Tōdai-ji

The Heian period, 794-1185

By the end of the 8th century the monasteries had amassed such wealth and power that it became essential, if the state was not to be run by monks, to remove the administration to a safe distance from Nara. Accordingly, a new capital was inaugurated in 794 at Kyoto, or Heian as it was then called. The late Heian period, from 901 until 1185, is often known as the Fujiwara period, after the powerful family who ruled Japan by the simple means of acting as regents to a succession of helpless, or compulsorily abdicated, emperors. In beautiful Heian, "City of Peace and Tranquillity," ringed with tree-clad hills, the spreading palaces with their bird-wing roofs and water-gardens became a world apart. There handsome princes and

exquisite women dallied in luxury, tasting all the delights of the intellect and the senses. Poetry and calligraphy, picnics and incense-smelling competitions, fashion and gossip flourished in a hot-house atmosphere that became more and more rarefied and artificial as time went on. The men upheld the learning and literature of the mainland, and thought it more dignified to write in Chinese. Their mistresses, less learned and less inhibited, wrote in their native tongue, and explored a new world of feeling that was purely Japanese and was, in time, to inspire the birth of a native tradition of painting, called Yamato-e (art of Yamato, i.e. of Japan). For a glimpse into the heart of this court culture we can do no better than read Arthur Waley's masterly translations of two works by court ladies of the period, the "Pillow-book" of Sei Shōnagon (A) and the romantic novel "The Tale of Genji."

Esoteric Buddhism: the mandaras

Although Buddhism saw its greatest expansion during the Nara period, a far larger number of religious paintings have survived from the Heian era. This is due chiefly to the popularity of two esoteric sects, Tendai and Shingon, that had been introduced from China at the beginning of the 9th century. The Tendai (Chinese: T'ien-t'ai) was established on Mount Hiei in 805 by the priest Saichō, called Dengyō Daishi, who taught an all-embracing system based on the text of the "Lotus Sūtra." The Shingon (Chinese: Chen-yen) was brought to Japan three years later by Kūkai, called Kōbō Daishi. Shingon held that every being is a manifestation of the divine wisdom, which is deified as the primordial Buddha Dai-nichi Nyōrai (Mahā-Vairōchana).

Both sects claimed that only priests could intercede with the deity, and both devised elaborate rituals, the formulas of which were known only to the priests. Hence the epithet "esoteric." Services were conducted with the aid of images, paintings, and *mandaras* (mystic diagrams), which illustrated the outward aspects of the doctrine.

The tenets of Shingon, indeed, could only be represented by mandaras, which were of two basic types: the Taizō-kai (World of Reason), the so-called matrix mandara of the material world, representing Dai-nichi Nyōrai seated in a circular aureole surrounded by the heavenly host (B); or the Kongō-kai (World of Wisdom), the diamond mandara of the spiritual world, in the form of a square divided into nine sections, each containing its assemblage of Buddhas. Although at first glance these mandaras seem too formalized to command attention as works of art, the best of them have a jewel-like beauty of form, line, and color that well illustrates the unique power of Buddhist art to give visible shape to metaphysical concepts.

Fierce forms of the Buddha

To the common worshiper, desiring wealth, position and heirs, Buddhist metaphysics were quite incomprehensible. Above all he wanted security, and it thrilled him most to contemplate the deities of wrathful aspect, the five Enlightened Kings (Myō-ō). Painted with meticulous realism, armed to the teeth and aureoled with

flames, the Myō-ō glowered down from the temple wall, threatening destruction not only to the enemies of the faith, but also to those of the worshiper himself. The deity was invoked in a midnight ceremony. Looming through the incense smoke in the flickering candle-light, he must have presented a terrifying spectacle.

In the oldest surviving painting of one of the Myō-ō, the *Yellow Fudō* preserved in the Tendai monastery at Mii-dera on Lake Biwa, the pose is rigidly frontal. Later representations, such as the set of five dated 1127 in the Tō-ji at Kyoto, and the *Myō-ō Seated on a Bull*, in Boston (c), show an increasingly lateral movement, which culminated in the "running Fudō" of the 13th century. A particularly ferocious form is illustrated on page 245. Drawn in vigorous ink line and showing Fudō adamant and glowering on a rocky shore, it was invoked at the end of the 13th century as a protection against the threatened Mongol invasion.

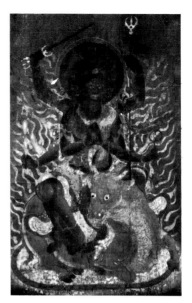

(c) ANONYMOUS
Myō-ō Seated on a Bull, 12th century
Boston, Mass., Mus. of Fine Arts

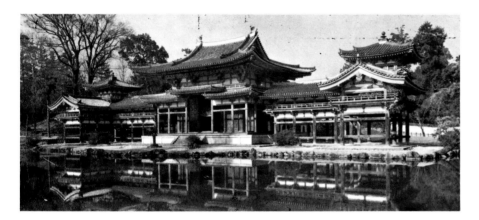

(D) View of Phoenix Hall,
commissioned 1053
Uji, Japan, Byōdō-in

Painting of the Amida sect

Neither the tortuous metaphysics of the esoteric sects nor the fearsome visions of the Enlightened Kings offered much comfort to men and women at the hour of death. This they sought in adoration of Amida (Amitābha), the Buddha who presides over the western paradise and into whose care and protection will pass the souls of all who so much as call upon his name. His cult, known in Japan as Jōdō, was spread from 985 on Mount Kōya by the monk Genshin, who taught a path to salvation by faith alone. The most famous surviving Amidist shrine, the Phoenix Hall of the Byōdō-in at Uji (D), was commissioned in 1053. The elegance of its pavilions, mirrored in the water, and the splendor of the paintings that cover its walls and doors are a perfect expression of the feminine refinement of Fujiwara religious art. The decorative scheme of these paintings is devoted chiefly to the nine aspects of Amida Raigō (literally: Amida Coming to Welcome), which depict the deity descending on clouds amid a throng of godlings and angels to receive the soul of the faithful and bear it up to paradise. Another somewhat later form, painted on

(A) ANONYMOUS Amida Yamagoshi,
13th century
Kyoto, Japan, Zenrin-ji

(B) ANONYMOUS
One of the Sixteen Rakan: from the
Raigō-ji Banner series, 11th century
Tokyo, National Mus.

a screen and set before the dying man, showed Amida Yamagoshi (Amida Crossing the Mountains), looming like a huge setting sun above the western horizon (A).

These representations of the Raigō, and other early compositions such as the superb vision of Amida's descent preserved in the Daien-in on Mount Kōya (color plate 213), are symmetrical after the fashion of the Chinese paradises, even though the Raigō itself is a purely Japanese invention. But as time went on there developed the " fast Raigō," in which the heavenly host swings down out of the sky toward the figure of the deceased in the lower right corner. The " fast Raigō," like the "running Fudō," dramatically expresses the urgent desire for comfort and protection that came over men and women during the turbulent years heralding the downfall of the Fujiwara regime.

Two masterpieces of Fujiwara Buddhist painting

The appeal of Fujiwara Buddhist art was often to the eye and the emotions rather than to the mind. Like the literature of the time, it expresses sentiments of the greatest delicacy in a language of extraordinary refinement, but it seldom plumbs the depths of religious experience. The supreme example of this emotional aestheticism is in the large silk panel of the Nirvana of the Buddha, dated 1086 and preserved on Mount Kōya, a composition too rich in detail to reproduce satisfactorily in color.

Instead, the *Shaka Nyōrai* from the Jingō-ji, Kyoto (color plate 207) has been chosen as equally typical of the period. Shākyamuni is here represented preaching from a high throne, clad in richly colored robes made the more splendid by the use of *kirikane*, a web of cut gold leaf laid óver the ground color. The drawing is delicate, modeling being suggested by barely perceptible shading. Even the band of light radiating from Shākyamuni's halo is set with flowers in gold—a typical Fujiwara extravagance. The total effect of this gorgeous banner is rather of some glittering jewel than of a religious icon.

Religious portraits

In ancient Japan, portrait painting in the Western sense was unknown. Such "portraits" as had been imported from China, as for example the famous set of five banners of patriarchs of the Shingon sect by the T'ang artist Li Chen, were more than mere likenesses of individuals; they were attempts to express the spiritual power of great religious leaders deep in meditation or engaged in lively theological dispute. The influence of these Chinese models can be seen in the vivid portrait by a Japanese artist of Kōbō Daishi's teacher, the priest Gonzō, who died in 827 (color plate 208). Although the picture we have today is an 11th-century copy, it reproduces the style of the 9th-century original quite faithfully.

In portraits of the later Fujiwara period this intensity of feeling was replaced by the same combination of decorative splendor and spiritual emptiness that marked the *Shaka Nyōrai* (color plate 207). More appealing among later 11th-century works are the pictures of 16 Rakan (Buddhist saints) from Raigō-ji, now in the

National Museum, Tokyo. Their faces are not caricatured or distorted as in so many Chinese versions, but treated naturalistically, and each figure is set in a delightful landscape that shows how the Japanese painter was already adapting the decorative T'ang style to his own instinctive needs (B).

Chapter II
YAMATO-E

(c) ANONYMOUS
Michizane in Exile (detail): from the Kitano-tenjin-engi handscroll, about 1219
Kyoto, Japan, Kitano Shrine

The discovery of Japan by Japanese artists

In 894 Sugawara no Michizane, a leading scholar and adviser on foreign affairs, was chosen to head yet another cultural mission to China. He petitioned the throne not merely to excuse him, but to stop sending such embassies altogether. The journey was dangerous, he pointed out, and China was in confusion. The downfall of the T'ang Dynasty was in fact imminent, and it seemed that there was nothing to be gained by further contact. Moreover Japan, for three centuries China's pupil, was at long last becoming aware of her own cultural identity. What she needed was not more Chinese civilization, but time to digest what she had already learned and the opportunity to make use of it in her own way. For the next three centuries Japan was virtually isolated from the mainland, and it was during this period that a truly national art came into being. This was the Yamato-e or literally, Art of Yamato, the area of central Honshū around Kyoto and Nara that the Japanese consider the heart of their civilization.

Just as in the Nara period the Japanese passion for the new and up-to-date had inspired people to be as Chinese as possible, so now did Chinese things and Chinese styles of painting and writing suddenly become old-fashioned. As we saw in the last chapter, it was the fiction and journals written by court ladies in their own language that first opened the way to a new freedom of expression. The poets followed their example, writing of the beauty of the land of Yamato as though they saw it now for the first time, as in a sense they did. Poems preserved in the " Ko-kinshū," an anthology of 922, praise themes that have come to be regarded as typically Japanese—waterfalls, plum trees in flower, and the ever-popular cherry blossom, a symbol to the Japanese of the poignant impermanence of all beautiful things.

KOSE NO KANAOKA

The Kose school

The earliest recorded picture of a purely Japanese scene, *Red Leaves Drifting down the River Tatsuta*, was painted between 866 and 876. A screen showing scenes from Japanese daily life was painted in 905. Between 868 and 872 Kose no Kanaoka, head of the Painting Bureau, painted for Michizane a view of the imperial garden, of which he was curator. His grandsons Kintada and Kinmochi con-

(A) ANONYMOUS Landscape (detail): from the Amida Raigō hanging scrolls, late 11th century
Wakayama, Japan, Mount Kōya, Daien-in

(B) ANONYMOUS The Poet Po Chü-i in a Landscape (detail): from the Tō-ji Screen, late 11th century
Kyoto, Japan, Kyōō Gokoku-ji

tinued the tradition, and the Kose school, as it came to be called, is looked upon as forming the core of the national tradition. At this time the old Painting Bureau was abolished, and under the new Painting Office artists enjoyed a much higher status at court. This important change, corresponding in some ways to the elevation of court painters in China to the level of an imperial academy under the Sung Dynasty, helps to account for the aristocratic character of the work of the Kose school.

Through the 9th century Chinese styles and themes in painting still predominated, but the change was coming. In a painting competition described in "The Tale of Genji," it is the Chinese work that is condemned as out-of-date and the Japanese scene, painted in the new native manner, that wins the prize. Hints of this new style can be seen in a set of panels depicting the life of Shōtoku Taishi, now in the Imperial Household Museum, but they are so heavily restored that little more than the original design survives. The landscape vignettes in the lower part of several of the Raigō paintings offer more reliable evidence, and some interesting contrasts. That in the lower left corner of the great *Amida Raigō* on Mount Kōya (color plate 213) is very much in the T'ang manner (A); but when we turn to the Raigō compositions on the doors of the Phoenix Hall at Uji, we encounter something entirely different. Here the T'ang style is simplified; hills are reduced in scale and suggested by broad washes; detail is suppressed; trees are stylized; color is cool, simple, and gay, and the brushstroke, the very foundation of Chinese landscape painting, has all but disappeared.

As time went on Kose school painters started other conventions that became characteristic of the new style, notably the cloud-band and the " house with the roof blown off." The clouds, laid in broad horizontal layers, served to obscure the horizon, to confine the scene to the foreground, to mask off unwanted parts and, especially when done in gold, to add to the decorative effect. The roofless house enables us to look down right into the rooms and to observe the human drama, or comedy, being enacted there.

The change to the new style was not achieved overnight, however, and there were always artists able to work in the old Chinese manner, or to combine the two. There has survived, for example, a description of a late 10th-century painting that was " Chinese" above a central band of water, Yamato-e below it. The famous Tō-ji landscape screen in Kyoto (B) is an interesting example of the fusion of the two styles or, rather, of an intermediate stage on the way toward pure Yamato-e. The subject, probably the poet Po Chü-i in a landscape receiving a visit before his house, is Chinese, as are the brush style and the basic structure of the scene; but the bland, flat coloring, the simplification of forms, and the scaling down of the landscape to human proportions are purely Japanese.

The narrative scrolls

The mansions of the emperor and the Fujiwara nobility were furnished with screens (*byōbu*) and sliding doors (*fusuma*) faced with paper, which offered ideal surfaces for decoration in the new style. But these were both fragile and inflam-

mable, and today the Tō-ji landscape screen mentioned above is almost the only example that has survived from that period. On the other hand over 100 sets of handscrolls (*e-maki*, or *e-makimono*) dating from the 12th to the 14th century have been handed down in temples or private collections. It is in these scrolls that we may study the development and wonderful variety of the Yamato-e.

The Japanese scholar Akiyama Terukazu has divided them into the following groups:

> 1. Secular scrolls of a purely artistic character. These include illustrated novels, written chiefly by court ladies; folk-tales and historical narratives; illustrations of poems and portraits of famous poets; and illustrations of "military" novels.

> 2. Secular scrolls serving a practical purpose, usually documentary. Among these are pictures of court ceremonies and of military campaigns and exploits.

> 3. Edifying scrolls of a religious nature. These begin with the Ingakyō scrolls discussed in the previous chapter, embrace the illustrations to *sūtras* (scriptures) and to the lives of great monks and religious leaders, and include moralizing scrolls that depict human afflictions and the horrors of hell. They are chiefly Buddhist, but there are a number of Shintō subjects among the later scrolls.

To these we might add:

> 4. Satirical scrolls and caricatures, some of which may have an edifying or admonitory purpose.

The Genji scrolls

One of the earliest and most beautiful of extant works in the first group is the series of scrolls illustrating "The Tale of Genji." Today there survive pictures from only four out of at least ten original scrolls illustrating 19 episodes in the novel (c). Beside each separate picture runs the text, written in a swift cursive hand of superb grace and elegance. The date of the scrolls is uncertain. It has been suggested that they were painted as a gift to the emperor or empress during the first half of the 12th century, or that they may possibly be the very set that is known to have been commissioned by the emperor in 1119. Whatever their origin, they reveal the

(c) ANONYMOUS The Tale of Genji (detail): from a handscroll, probably 12th century
Kyoto, Japan, Reimeikai Foundation

(A) Attributed to FUJIWARA NOBUZANE
One of the Thirty-six Poets:
handscroll (detail) 13th century
Washington, D. C., Freer Gall. of Art

FUJIWARA NOBUZANE

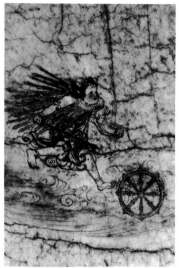

(B) ANONYMOUS Godling Flying down
from Heaven on a Cloud (detail): from
Myōren scroll, late 12th century
Nara, Japan, Chō-go Sonchi-ji

Yamato-e in all the freshness of its youth, when it still drew inspiration from the feminine, fairy-tale world of the Fujiwara court.

The detail illustrated in color plate 223 depicts a scene near the end of the book, in which the women attendants wait through the night, while beyond the screen to the right Genji's grandson Niou dallies with his new consort. Looking down into the room, the painter exploits the strong verticals of the screen, contrasting its firm lines and angles with the sweeping, voluminous curves of the girls' robes. The rich, glowing mineral colors, wonderfully mellowed by age, seem the more gorgeous by contrast to the jet black of the girls' hair, a feature often lovingly described in the literature of the time.

The technique is called *tsukuri*-e ("make-up" painting). In this the composition was first outlined in black; the mineral colors were then laid on in several thick coats, after which the main outlines were again sketched over in ink. Faces were drawn in a kind of shorthand called *hiki-me kagi-hana* (straight-line eyes and hooked-line noses) that gives little indication of character, emotion, or even sex. It is thought that this convention was invented by court ladies who wanted to illustrate their favorite novels but were not very good at drawing faces. This very featureless-ness had its advantages, for it made it easier for the aristocrats who pored over the pictures to identify themselves with the leading characters. At the same time it helped to create an atmosphere of unreality for these romantic tales.

The scroll of the Thirty-six Poets

Something of this fairy-tale quality survived in court painting even after the down-fall of the Fujiwara regime, notably in the scroll of the Thirty-six Poets, painted probably by Fujiwara Nobuzane (1176-1265?). The 36 poets were men and women of the Fujiwara era who were famous for their poems in the native tongue (A). Portraits of them became so popular at the time as to be given the special name *kasen-e* (immortal-poet pictures). The "portraits" in this scroll are not, of course, true likenesses, since the poets were all long dead when it was painted. Nevertheless the artist has attempted to go beyond the conventional *hiki-me kagi-hana* technique and suggest the features and character of each of them. The picture of the poetess Ko Ōgimi is illustrated in color plate 212. The gorgeous extravagance of her dress and the soft, warm colors are typical of Fujiwara court art; but sharp angles and dramatic contrasts provided by the rich black ink express the more virile taste of the succeeding Kamakura age.

Illustrated stories of monks and monasteries

The Genji scrolls are the supreme example of the abstract, decorative style of Fujiwara court art. However, by no means all the narrative scrolls of the next three centuries were inspired by courtly ideals, nor did they all make use of pic-torial conventions like the *hiki-me kagi-hana*. The scrolls illustrating the life-stories of famous priests have the same kind of realism that is encountered in the portraits discussed in the first chapter. An excellent example of this type is the set of three

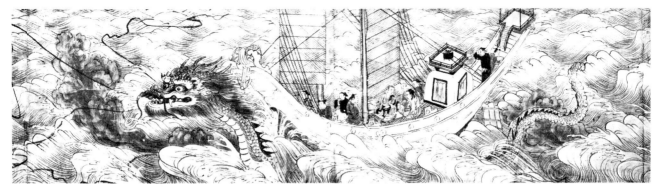

(C) ANONYMOUS Gishō on a
Ship Borne by a Dragon (detail):
from the Legends of the Kegon Sect,
13th century
Kyoto, Japan, Kōzan-ji

scrolls of stories about Mount Shigi, that illustrate legends of the monk Myōren, who restored a temple there in the early 10th century. One scroll tells the story of his magic rice-bowl, which flew about collecting food for its master, and of what happened to a rich farmer who neglected to fulfill his duty as patron; the second relates how Myōren cured the emperor from a great distance; the third how his aged sister was miraculously reunited with him after years of separation.

The contrast in treatment between these and the Genji scrolls is very striking. If the latter resemble stills from some gorgeous motion picture, the Myōren set are more like the film itself. The Genji scrolls are made up of separate set-pieces, composed in color; the action of the Myōren stories sweeps through a continuous landscape, the sense of movement being intensified by a masterful use of ink line in the Chinese manner (B); color is added only for greater realism. The figures are drawn with lively humor, verging on caricature. Yet it is evident, from the familiarity the artist shows in the second scroll with the inner apartments of the palace, that he must have been a professional attached to the court.

Other Buddhist handscrolls of the 12th and 13th centuries show how successfully the Chinese ink painting of the Sung Dynasty was incorporated into the now maturing Yamato-e. Most Chinese in technique are the scrolls, produced by artists attached to the Kōzan-ji near Kyoto, that tell the story, part fact, part legend, of the Korean leaders of the Kegon sect, Gishō (C) and Gengyō.

A more important set of scrolls, the so-called " Pictorial Biography of Ippen Shōnin," concerns the life of a leading figure in the popular Nembutsu movement, which taught salvation through faith in Amida. Of the three versions that survive, the best is the set of 12 scrolls painted on silk and now divided between the Kangikō-ji in Kyoto and the Tokyo National Museum. An inscription tells us that they were completed in 1299, ten years after the death of Ippen, and that the calligraphy was written by the priest Shōkai, the paintings executed by Hogen En-i (D).

A study of these scrolls suggests that Hogen En-i had actually accompanied Ippen in his 15 years of wandering through the length and breadth of Japan as a mendicant friar, which form their subject matter. For as Ippen passes through mountain scenery, farms, villages, and crowded cities, the artist presents a wonder-

 HOGEN EN-I

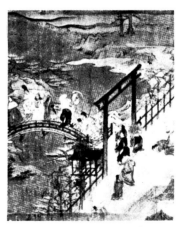

(D) HOGEN EN-I The Life of Ippen
(detail): handscroll, 1299
Kyoto, Japan, Kangikō-ji

fully vivid and accurate panorama of medieval Japan through the four seasons (color plate 209). The fact that the scrolls were painted on silk, always a luxury in Japan, suggests that they were commissioned by some very exalted person. Their style is chiefly notable for its successful fusion of native and Chinese elements: on the one hand a sense of life and character and a flair for decorative effect that are purely Japanese; on the other a lyricism and restraint in depicting nature and a mastery of pictorial depth that are inspired by Sung romantic landscape painting. Never again in the history of Japanese art was quite so perfect a balance achieved between the two traditions.

The Animal scrolls

By the 13th century the demand created by the esoteric cults Shingon and Tendai for the multiplication of images had bred a class of painter priests highly skilled at dashing off in a few moments a convincing icon in ink line, such as the menacing Fudō standing on a rock that we have already discussed (page 105; illustrated on page 245). It is easy to imagine one of these painters, more original and perhaps a little more irreverent than his fellows, occasionally giving rein to his talent for comedy and satire as a relief from the mechanical repetition of icons that was his chief occupation. Perhaps it was some such impulse that produced the four famous Animal scrolls that were painted at the Kōzan-ji in Kyoto, where they have remained to this day.

(A) ANONYMOUS
Monkey Worshiping a Frog: Animal scrolls (detail) 12th century
Kyoto, Japan, Kōzan-ji

The first two scrolls and part of the third, believed to date from the 12th century, show animals behaving as humans: playing (B), teasing each other, quarreling, and performing Buddhist ceremonies. Most of the third and the whole of the fourth, dating from the Kamakura period and by an inferior painter, depict various human activities, games, and recreations. Illustration (A) shows a detail from the first scroll, in which a Buddhist mass is being performed by monkeys and rabbits before a frog enthroned as the Buddha. No text accompanies these lively and amusing scenes, and their meaning has been much debated. Some scholars have suggested that a monk at the Kōzan-ji headquarters of the Shingon sect drew them to satirize the conduct of the monks of the rival Tendai temple of nearby Enryaku-ji. Whatever the artist's purpose, it is clear that he was not only a boisterous wit but also a master of the Chinese ink line. As these scrolls show, however, the Japanese artist was now using the line in a purely Japanese way. While the Chinese line is essentially calligraphic, that of the Japanese painter, who is at heart a realist, is primarily descriptive of the shape he is drawing.

(B) ANONYMOUS
Frog Throwing a Hare: Animal scrolls (detail) 12th century
Kyoto, Japan, Kōzan-ji

The Kamakura period, 1185-1392

The development of the narrative scrolls, which reached its climax in the second half of the 13th century, is a striking instance of the way in which art may reflect events in the political and social spheres. During the 12th century the Fujiwara court and nobility had withdrawn further and further into the fairy-tale world so

vividly depicted in the Genji scrolls. Meanwhile, beyond the walls of their palaces, powerful disruptive forces were at work. As the Fujiwara power declined, so did that of the feudal chieftains in the provinces increase. The Fujiwara sought to bribe them into submission with grants of land, but these merely increased their power and intensified the struggle between rival families.

By the middle of the 12th century two clans, the Taira and the Minamoto, had fought their way to supremacy. Now they turned on each other, and for 30 years the land was ravaged by civil war of unparalleled ferocity. Kyoto was laid waste, the great Tōdai-ji at Nara was destroyed, and the countryside was devastated by marauding armies. By 1185 the Minamoto, after many reverses, emerged triumphant over the Taira. They established their capital at Kamakura, south of Tokyo, as far removed as possible from the enervating influence of the Fujiwara court. The Shōgun (literally: Barbarian-subduing General), Minamoto no Yoritomo, organized his followers into a highly disciplined administration known as the *baku-fu*, or military headquarters. Many able men, denied advancement in the stifling atmosphere of Kyoto, came to join him at Kamakura. The officer class of *samurai* (literally: those who serve) formed a new elite who kept themselves rigidly apart both from the masses and from the court aristocracy, whom they despised, upholding a Spartan ideal of personal loyalty and self-discipline (c).

The epic literature of this period, such as the "Heike Monogatari," or "Heike Story," which describes the rise and fall of the Taira clan, is full of Homeric feats of courage, endurance, and loyalty. It is of little account to its admirers that the loyalty was often blind or inspired by greed and the bravery tarnished by the most revolting cruelty. It is a remarkable fact that the Taira Wars and, above all, the atrocities committed in the course of them, have inspired Japanese artists to some of their most brilliant performances.

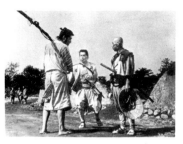

(c) Three Samurai: from the Japanese film "The Seven Samurai," 1954
Photo by Courtesy of the Japan National Tourist Association

The narrative scrolls

Not all the narrative scrolls deal with events in the Taira Wars, however. One of the earliest sets illustrates the story of Ban-Dainagon, or Tomo no Dainagon, the 9th-century Great Councilor who, in order to implicate his rival Minamoto Nobu, sets fire to the imperial gate and then blames Minamoto. Eventually the truth is discovered and Tomo is banished. The three scrolls, now in the Sakai Collection, Tokyo, were painted in the second half of the 12th century. They depict the fire at the gate, the panic within, and the confusion in the street outside. Their realism is tempered by a very delicate sense of line and color that makes them the most beautiful of all the war scrolls.

Less subtly painted but even more startling to the eye, and dating probably from three different periods within the 13th century, are the three scrolls that remain from a set illustrating the "Heiji Monogatari." This book describes the events of the winter of 1159-60, in which the Taira temporarily crushed the Minamoto. The "Heiji Monogatari" and other "military" novels of the period, such as the "Hogen" and "Heike Monogatari," are written in a direct, factual style utterly different from the gossamer subtleties of Fujiwara court literature. Similarly, the

cold realism of the pictures that these books inspired offers a striking contrast to the sumptuous abstractions of the Genji scrolls.

Color plate 214/5, (A), and (B) show details from the first of the Heiji Monogatari scrolls, now in the Museum of Fine Arts, Boston. The novel describes the marshaling of the forces of Taira and Minamoto and tells how a petty tyrant, the court noble Fujiwara no Nobuyori, sacked the palace of the retired emperor before turning to destroy his rival, the minister Shinzei. The text written on the Boston painting relates how Nobuyori bustled the ex-emperor off to safety, for his person was sacred; then he gave the order, and: " Soldiers blocked the palace on all four sides and set fire to it. Those who fled out they shot or hacked to death. Many jumped into the wells, hoping that they might save themselves. The ladies-in-waiting of high and low rank and the girls of the women's quarters, running out screaming and shouting, fell and lay prostrate, stepped on by the horses and trampled by the men. It was more than terrible. No one knows the number of persons who lost their lives."

The fearful spectacle is brought so vividly before our eyes that we seem to hear the crackle of the fire, the thunder of hoofs, the screams of the panic-stricken women. With consummate mastery the painter has created out of the swirling flames and smoke, the chaotic melee in the courtyard, and the hard, static lines of the palace buildings, a visual beauty that transcends the horrors of the scene itself. In the complexity of its design, the richness of its color and texture and the variation of its rhythm and tempo, this scroll has been aptly compared to a movement from a dramatic symphony.

From the slaughter of the war scrolls we turn to those that depict other calamities, real and imaginary, that beset the masses in those turbulent years. The mixture of satire and compassion that we often find in Japanese Buddhist art comes out clearly in a series of scrolls illustrating the afflictions of body and mind

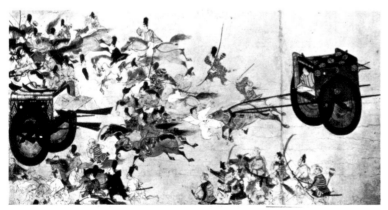

(A) ANONYMOUS The Burning of the Sanjō Palace (detail): from Heiji Monogatari scroll, mid-13th century
Boston, Mass., Mus. of Fine Arts

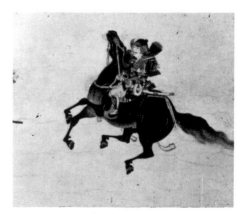

(B) ANONYMOUS Horseman: from the Burning of the Sanjō Palace, Heiji Monogatari scroll, mid-13th century
Boston, Mass., Mus. of Fine Arts

to which mankind is subject. These, the scrolls of Diseases, were painted about the year 1200. They illustrate, in swiftly sketched ink line and light wash, a wide variety of human ailments (c), from a hereditary black nose to hallucinations. They are remarkable not so much for their style, which, though lively, is relatively undistinguished, as for the insight they show into the lives of the poorer classes, a subject not touched on in the classical and aristocratic scrolls of the period. They show, too, how closely Buddhist art in that age of anxiety reflected the fears and sufferings of the common people, though the manner in which their afflictions are portrayed often verges on caricature.

(c) ANONYMOUS The Man with Loose Teeth: from the scrolls of Diseases, about 1200
Tokyo, Arihiko Sekido Coll.

Closely allied to these scrolls, though far more gruesome in content, are those depicting the Buddhist hells and the realm of the Hungry Ghosts, two of the six worlds into which, according to Buddhist belief, sentient beings may be reborn, and from which only rebirth in the western paradise can release them. Five scrolls of the series survive, of which three are originals of the late 12th century; the remaining two are copies. The most remarkable are those formerly in the Hara collection and now in the care of the Commission for the Protection of Cultural Properties, Tokyo. Painted with the purpose of frightening simple believers into the straight and narrow path, these depict the fearful torments that await the sinner in the next world. The lurid horrors of hell are realized by means of a dramatic contrast between the murky atmosphere and the rich, glowing color of the figures of demons and victims. Most striking of all is the Giant Cock (D) who tears to pieces those guilty of cruelty to others. His feathers end in flames and from his beak there darts a tongue of fire. The grandeur and awesomeness of the theme inspired the artists of these hell scrolls to one of the most extraordinary feats in the history of Japanese painting. In these and other scrolls, fire, whether it be the eternal fires of hell or those lit by Minamoto incendiaries in the streets of Kyoto, seems to be a symbol of the state of Japan in the 12th and 13th centuries.

It is a relief to turn from such horrors to a great scroll series of the 13th century, the Kitano-tenjin-engi *e-maki* (literally: scroll illustrating the Story of the Heavenly Being of Kitano). It tells the story of Sugawara no Michizane (845-903), the scholar and imperial adviser mentioned at the beginning of this chapter, who was exiled to Kyūshū at the instigation of the jealous Fujiwara. He died in his lonely post, but thereafter calamities fell upon the court, and he was posthumously reinstated and promoted in order that his spirit might be appeased. A shrine was raised to his memory in the Kitano district of Kyoto.

(D) ANONYMOUS The Hell of the Giant Cock (detail): from the Hell scrolls, 12th century
Tokyo, Commission for the Protection of Cultural Properties

The cult of Saint Michizane was very popular during the Kamakura period. Ten ancient scrolls illustrating his story exist. Of these the oldest and finest, still preserved at the Kitano shrine, dates from 1219 or shortly after (page 116 A). It relates his political career, his banishment, the later wanderings of his prophet, Priest Nichizō, in the six realms of transmigration, the founding of Michizane's shrine and the miracles performed there. Color plate 210 shows a detail from the scroll, in which the exiled minister is contemplating a robe that has been sent to him by the Emperor. The scrolls as a whole show a remarkable balance of dramatic storytelling and pageantry, realism and abstract decoration. The faces are those of real men; many details are taken straight from nature and the life of the

streets. Yet this realism is blended with a brilliant decorative use of architecture, landscape, and the dark accents provided by carts, weapons, or bulls, that weld each scroll into a complete pictorial unity.

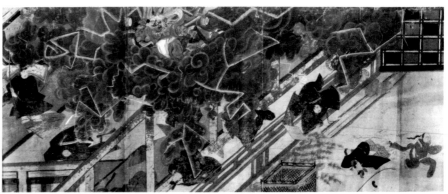

(A) ANONYMOUS Michizane's Ghost Sets Fire to the Gateway (detail): from the Kitano-tenjin-engi handscroll, about 1219
Kyoto, Japan, Kitano Shrine

FUJIWARA TAKANOBU

The scroll of Ten Famous Bulls

Color plate 216 illustrates a painting of a black bull that might be an enlarged detail from the Kitano-tenjin-engi series, but is in fact one of three remaining sections from a scroll of Ten Famous Bulls, painted about 1300. The two other surviving fragments are in Cleveland and Tokyo. The artist has concentrated throughout on essentials. The bulls are shown in silhouette, their massive bulk suggested by ample contours and subtle "negative shading," their vitality by delicacy of line and the startled expression in their eyes. The contained and disciplined power of their forms is a vivid expression of the aesthetic ideals of the Kamakura period.

Kamakura portraiture

We find an even more perfect expression of Kamakura ideals in the portrait of the great militarist Minamoto no Yoritomo (color plate 211). This is the work of Fujiwara Takanobu (1142-1205), Director of the Right Ward of the Capital, who is recorded as having been renowned as a portrait painter. It is one of five known portraits of the ex-emperor Gō-Shirakawa and his associates, painted by Fujiwara Takanobu for an imperial villa erected in 1188. They are preserved today in Jingō-ji, Kyoto. The purpose of the portrait of Minamoto was not merely to embody the ideals of the *samurai* class, but also to create the living presence of the man himself so that after death he could continue to give inspiration and strength to his followers. Thus in this picture the iron discipline exercised by Minamoto over his own fiery temper is perfectly matched by the painter's power to control the angular silhouette and dramatic contrasts of line and tone. The technique is as sharp and fine-drawn as the blade of a *samurai* sword (page 118 A).

(B) ANONYMOUS The Priest Jugen: wood sculpture, 13th century
Nara, Japan, Tōdai-ji

116

In the eyes of the Kamakura aristocracy, realism in portraiture was properly confined to depicting monks (B) and the lower classes. Many aristocrats must have been shocked by Fujiwara Takanobu's portraits, which were a revolutionary departure from the idealized heroes of the past to which they were accustomed. There is a strong romantic streak in the Japanese temperament that colors its religious outlook. We have seen it already in Fujiwara renderings of Shākyamuni and the Amida Raigō. Now it appears again in the lovely "portrait" of the great founder of the Shingon sect, Kōbō Daishi, as a child (C, and page 289). According to legend the boy had a dream in which he saw himself seated on an eight-petaled lotus, discussing Buddhist doctrine with various deities. The artist has represented him as a vision of touching beauty, wisdom, and innocence. Every detail of his hair, hands, and flowered dress is delineated with loving care and precision, with the aid of gold and silver paint. The sentiment that this painting evokes is typical of Fujiwara religious romanticism. But the technique, the emphasis on the silhouette, the angular forms of the robes, and the striking treatment of the jet-black hair all show how closely it is related in style to the portrait of Minamoto no Yoritomo. It can hardly have been painted much before the end of the 13th century.

(C) ANONYMOUS Kōbō Daishi as a Child (detail) late 13th century
Mikage, Japan, coll. N. Murayama

Dual Shintō and landscape painting

The creation of a national style in painting, the Yamato-e, was but one aspect of the maturing of Japanese culture that took place after the first great wave of Chinese influence subsided. During the Heian period the ancient Japanese religion, Shintō, the Way of the Gods, had yielded, as had Taoism during the Six Dynasties in China, before the power and prestige of Buddhism. But now, like other ancient Japanese institutions, it became strong enough to meet Buddhism on its own ground. This reconciliation took a number of different forms, according to the period and to the doctrines of the different Buddhist sects with which it was allied. Fusion with Shingon, for example, gave birth to Dual Shintō, in which local Shintō spirits were seen as manifestations of Buddhas and bodhisattvas, while Amaterasu, the ancient sun goddess, became an incarnation of Dai-nichi Nyōrai, the supreme deity of the Shingon sect. By such a synthesis it became possible for Shintō, which had hitherto had no religious art of its own, to provide painters with inspiration and subject matter.

The Kitano-tenjin-engi scrolls, particularly the later sections dealing with Michizane's shrine and the miracles performed there, may be regarded as examples of this new Dual Shintō art. Even more typical, perhaps, are pictures of shrines, mountains, and waterfalls famous for their beauty and for their ancient Shintō associations (D). The earliest and finest of such landscapes is the scroll in the Nezu Museum depicting the Nachi waterfall at Kumano, which in the 12th century became the center for Dual Shintō worship (page 245). The scroll, painted some time after 1300, shows the cascade as a great sheet of water descending vertically onto rocks at the foot of a cliff. Although there is a shrine among the trees, no human figure intrudes on the awesome spectacle; there is no strolling poet or scholar such as we should expect in a Chinese rendering of a comparable theme, and it is easy

(D) ANONYMOUS Mandara of the Three Mountains of Kumano, 13th century
Tokyo, National Mus.

to imagine the place haunted by its powerful *genius loci*, Hiryū Gongen. The great orange disc of the sun looming over the cliff-top has been interpreted as a symbol of Dai-nichi Nyōrai, in mystic union with the spirit of the waterfall. Thus the picture is more than a landscape; it is a mandara, in which both cosmic and natural forces are symbolized, though these here take the form not of the usual images of deities, but of mountains, water, and the sun. In Chinese landscape painting we find the same symbolism implied, if never so explicitly stated. From this time forward countless such pictures of shrines and famous beauty spots were painted in Japan and regarded as mandaras, but they never quite equaled the grandeur of the Nezu Museum scroll.

Chapter III
PAINTING IN MONOCHROME INK

The Ashikaga Shōgunate, 1392-1573

The problem that faced all Japanese governments until modern times was that none was ever strong enough to control the great clans and regional chiefs for more than a limited period. What kept them in power was less their own authority than the constant rivalry among their opponents. During the latter half of the 13th century the seductions of Kyoto court life had begun to work upon the military rulers at Kamakura, weakening their iron hold on Japan. In 1336 the powerful Ashikaga family put up a rival candidate to an emperor, who attempted to revive the power of the imperial house. There followed a long, bitter, and senseless struggle over the succession, a period known as the Namboku-chō (period of the Northern and Southern Courts), during which the Ashikaga Shōguns at Kyoto gathered strength until finally, in 1392, they were able to overthrow the rival regime. The era from 1392 to 1573, during which the Ashikaga family ruled as regents, is generally called the Ashikaga period. It is also known as the Muromachi period after the district in Kyoto where the palace of the Shōgun was situated.

In their struggle for power, and in their enjoyment of power once it was achieved, the Ashikaga Shōguns needed huge sums of money. This they gained partly by exactions from their supporters and partly by reviving the trade with China that had been brought to a standstill by the Mongol invasions of the late 13th century. About 1400 a government department was set up to control this trade, but the actual conduct of it, even to the fitting out of the trading fleets, was delegated to the great monasteries of Kyoto, and chiefly to those of the Zen sect.

Cultural ties with China renewed

An account of Zen has already been given in discussing Chinese painting of the late T'ang and the Southern Sung periods. Its influence on Japanese painting was

(A) ANONYMOUS Forging a Samurai Sword: from the scroll of Artisans, 16th century *Tokyo, Ōkakura Shūkokan Mus.*

to be far greater and more lasting. Zen was introduced into Japan during the 12th century by two monks, Min-an Eisai and Dōgen. Its emphasis upon self-discipline and swift action, its austerity and simplicity, at once struck a responsive chord in the military elite at Kamakura. In their eyes it had two additional virtues: it was the very antithesis of Fujiwara aestheticism and, above all, it was new. During the 13th century monks journeyed to China to study the doctrine, and on their return founded Zen monasteries, notably Enkaju-ji and Kenchō-ji at Kamakura and Tenryū-ji in Kyoto. There the nobles and *samurai* would gather, not merely to study Zen, but to steep themselves in the refined and scholarly atmosphere that these monasteries disseminated. For Zen was but one aspect of the culture of Southern Sung, and it was Sung culture as a whole that the upper ranks of Japanese society now sought to acquire, as eagerly as their forebears had modeled themselves on that of the T'ang.

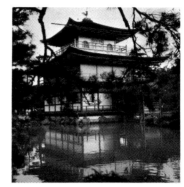
(B) The Golden Pavilion of Kinkaku-ji, 1397
Kyoto, Japan

One of the earliest, and certainly the most powerful, of patrons of Sung culture was the Shōgun Yoshimitsu, who ruled from 1367 to 1395. At the Golden Pavilion at Kyoto (B), to which he retired, he led the life of a monk, aesthete, and patron of the arts. Yoshimitsu liked to be carried about in a Chinese litter, wearing Chinese costume, and the nobles at court followed him in aping Chinese fashions.

The eighth Shōgun, Yoshimasa, who ruled from 1449 to 1474, tried to keep up this elegant and luxurious patronage, though with less authority and fewer resources. Under him, as the historian Sir George Sansom put it, "the Muromachi aesthetic reached and passed its fullest bloom, dropping its full-blown petals one by one as the 15th century drew to a close." The rule of Yoshimasa is curiously parallel to that of the Sung emperor Hui-tsung (see page 58), whose passion for the arts likewise blinded him to the dangers into which his country was drifting. For Hui-tsung the end was the Tartar invasion of 1125; for Yoshimasa, the Ōnin War of 1467 to 1477 that reduced Kyoto to ashes.

It might be expected that the paintings brought to Japan to enrich the great collections of Yoshimitsu and Yoshimasa would be in the contemporary Ming style. But this was not the case. The Zen monks who chiefly collected these pictures were not in the least interested in the works of the Yüan and Ming literati. Their contacts were with Zen monasteries. What they sought were paintings in monochrome ink by Chinese Zen masters such as Mu-ch'i and Liang K'ai, and it was of no importance to them that this style of painting had long gone out of fashion in China itself. A taste for paintings in monochrome ink was thus created among the aristocracy and military elite of Japan. Further purchasing expeditions sent by the Shōguns sought out secular landscapes in the same style, by Ma Yüan, Ma Lin, and Hsia Kuei. This explains why it is that many of the finest surviving works by painters of the Southern Sung academy are today to be found in Japan.

(c) Garden of the Abbot's Residence, early 17th century
Kyoto, Japan, Daisen-in, Daitoku-ji

Zen and art

The Japanese people found in Zen a teaching perfectly suited to their needs. The Zen doctrine that the " Buddha essence" is to be found in all things appealed to men who lived very close to nature; its denial of the usefulness of book-learning and

(A) Utensils for the Tea Ceremony
Photo by Courtesy of the Japan National Tourist Association

Chō Densu　北殿主

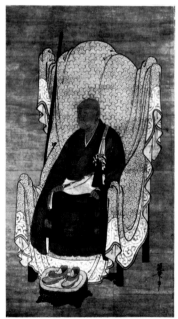

(B) Chō Densu　Portrait of Abbot Shō-ichi (detail)
Kyoto, Japan, Tōfuku-ji

metaphysics suited their unspeculative turn of mind, while its emphasis on quietism and self-discipline was in keeping with the national character. To contemplate in tranquillity a waterfall, a flower, a rock, was to cleanse the mind of all impurity and come close to the divine nature. To meditate upon a picture of such a subject achieved the same end. The Zen-inspired painting thus became itself an object of meditation, almost of worship. Hung in the *toko-no-ma*, a deep recess in one side of the main room in a house or temple, the painting took on the character of a religious icon, perfect in itself and isolated from the viewer, yet demanding his full concentration.

This aestheticism, this conscious absorption in natural beauty and in those man-made things that seemed to embody it, led to the development of that unique Japanese institution, the tea ceremony (A, and page 273), in which every action, every word spoken, every object used is justified only by its beauty, its simplicity, and its naturalness. It is one of the paradoxes of Japanese culture that the tea ceremony carried the worship of naturalism to such a pitch that it lost its spontaneity and became a cult. Yet in spite of this the aesthetics of the tea ceremony stimulated architects, craftsmen, and garden designers (page 119 c) to the creation of much that is enduringly beautiful in Japan.

The painter inspired by Zen ideals sought by his choice of subject matter to convey both the visual and the spiritual unity of all things in nature. The Zen emphasis upon discipline and restraint, and its distrust of sensuous appeal, led him to banish color from his paintings and to express himself purely in ink line and wash, a technique called *suiboku-ga* (Chinese: *shui-mo hua*), "water-ink" painting. Should he wish to suggest the sudden, irrational flash of illumination that comes to the Zen adept, he would paint in *haboku-ga* (Chinese: *p'o-mo hua*), splashed ink, as in the painting reproduced on page 260. But Zen painting was not merely a matter of technique. Any painting that, by its theme and treatment, helped to cleanse the mind and lead to awareness of eternal things could be said to embody Zen ideals.

Zen portraiture

Before discussing ink painting mention should be made of one kind of Zen painting that, for a definite purpose, used quite a different technique. An essential tenet of Zen doctrine is that illumination is attained by direct intuition aided by a stimulus that passes like an electric current from master to disciple. After years of study, bullying, and humiliation the pupil might, on graduation as it were, receive a portrait of his master that served as a diploma, certifying to his having attained enlightenment and to his right to wear the mantle of his teacher. These portraits, called *chin-zō*, were executed with reverent care, and the best of them are deeply penetrating studies not only of the physical appearance of the master, but also of his character, insight, and dignity. The greatest exponent of this type of portrait painting was Chō Densu (1352-1431), a professional painter attached to Tōfuku-ji, which today still treasures his masterpiece, the portrait of the "national master" of Zen teaching, Shō-ichi (B).

Masters of ink painting

One of the first Japanese painters in the new ink technique, *suiboku-ga*, was Moku-an, who went to China in the mid-14th century and settled in the monastery near Hangchow where Mu-ch'i had lived (see page 62). He modeled his style so closely on that of Mu-ch'i (color plate 176), to the extent even of using his seals, that their works are often hard to tell apart. Moku-an and other Japanese pioneers in ink painting confined themselves mainly to Zen subjects, but early in the 15th century the range was extended to include landscapes in the style of the Southern Sung academy.

Complete mastery of the *suiboku-ga* was achieved by Tenshō Shūbun (c), painter, sculptor, and administrator of the Sōkoku-ji in Kyoto, who was active between 1425 and 1450. His teacher was Jōsetsu, about whom very little is known. In 1423 Shūbun accompanied a Buddhist mission to Korea. As director of the Painting Office he was the first officially recognized practitioner of the new Chinese style. He was indeed a fortunate choice for the post, for the precision and refinement of his brushwork and the breadth of his vision set a standard that all his followers in ink painting strove to emulate. No certain work from his hand survives, but the very sensitive landscape, *Reading in a Hermitage in a Bamboo Grove* (page 246), has always been attributed to him, and must be very close to his style.

Sesshū and his followers

Shūbun's most famous pupil was Sesshū Tōyō (1420-1506). After serving his apprenticeship under Shūbun at the Sōkoku-ji, Sesshū went to China in 1468. There he soon came into contact with painters of the Che school, followers of Tai Chin (see page 76), who had put new life into the ink painting of the Southern Sung academic tradition. Sesshū also paid a visit to Peking, where he was greatly honored. He hoped to see and copy paintings by the Sung masters themselves. In this he was disappointed, and he records the general low level of the painting he encountered. Yet the year he spent in China was not wasted. The influence of the broad, painterly style of the Che school set him free from the too-perfect refinement of his master Shūbun and brought the latter's idealism down to earth. From Ming bird and flower compositions he acquired the power to design on a large scale that he later turned to effective use in his screen paintings.

Sesshū once painted a landscape in the Southern manner of Kao K'o-kung, but of the works of later Southern masters such as Shen Chou and Wen Cheng-ming, who were almost his exact contemporaries, he appears to have remained totally ignorant. This may seem surprising. But Sesshū had not seen their work in China, for the Ming literati formed an exclusive society to which no outsider, least of all a Japanese professional painter, could hope to gain admittance.

On his return to Japan in 1469 Sesshū went first to Kyūshū. Then, after three years of traveling through Japan, he settled in his own temple, the Unkoku-an in southern Honshū, where he remained until his death. His influence spread rapidly among his fellow painters, and very soon he had acquired an enormous reputation.

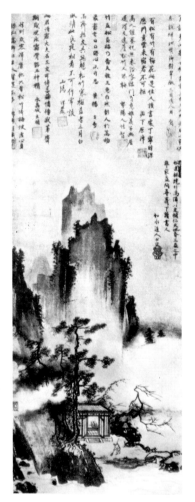

(c) Attributed to TENSHŌ SHŪBUN
Studio of the Three Worthies (detail): hanging scroll, 15th century
Tokyo, Seikadō Foundation

TENSHŌ SHŪBUN

天章周文

JŌSETSU

如拙

雪舟等楊

SESSHŪ TŌYŌ

For unlike Shūbun, who continued to paint in the Chinese manner all his life, Sesshū had by this time totally absorbed the technique and principles of the *suiboku-ga* and had succeeded in transforming it, by the sheer power of his artistic personality, into a Japanese style. He was also an accomplished exponent of *haboku-ga* (splashed-ink painting) and of portraiture in the Zen manner, and a master calligrapher (A).

Sesshū's greatest achievement of sustained composition is the long handscroll, painted in 1486, that depicts a landscape in transition through the seasons, from spring to winter (B, and page 263). Color plate 217 illustrates another winter scene, one of two surviving paintings from a set of the four seasons, now in the Tokyo National Museum. In this picture and its companion, *Autumn*, Sesshū shows a concentrated power of brushwork that brings us closer to Fan K'uan (color plate 162) than to any Japanese painter. The hard angularity of the line and the cold, bleak tones of the ink are highly evocative of the somber mood of winter. The debt to Hsia Kuei is also obvious. But this is no mere copy of Southern Sung painting. The densely packed composition, the reduction in scale, the pattern of line and tone that is strikingly decorative, however little Sesshū may consciously have desired it so, the shutting out of deep distance with mountains that form a backdrop, the heavy, dense lines—these are all essentially Japanese characteristics. The difference becomes very clear if we compare this painting with the Hsia Kuei handscroll illustrated on pages 54 and 254.

Other painters who, like Sesshū, were deeply influenced by Shūbun included Bunsei, Jasoku, and Sōtan, all active in Kyoto during the middle and later years of the 15th century. Although Sōtan succeeded his master as head of the Painting Office, no certain works from his hand have been identified. Jasoku and Bunsei were famous chiefly for their portraits of Zen priests, as for example the latter's magnificent *Yuima* (D). In an inscription on the upper half of the picture the abbot of Nanzen-ji explains that a Zen priest, on converting his father's house into a monastery, commissioned from Bunsei its main devotional image, the portrait of his father as Yuima (Vimalakīrti), the scholarly disciple of Shākyamuni. It is remarkable not only for its realization of intense spiritual and intellectual force, but also for the masterly way in which Bunsei has blended two quite different brush techniques: a nervous, calligraphic line in the drawing of the robes, and a cool precision in the rendering of facial details.

(A) SESSHŪ TŌYŌ Ink-Splash Landscape: hanging scroll, 15th century *Tokyo, National Mus.*

(B) SESSHŪ TŌYŌ Landscape (detail): handscroll, 1486 *Yamaguchi, Japan, coll. Motomichi Mōri*

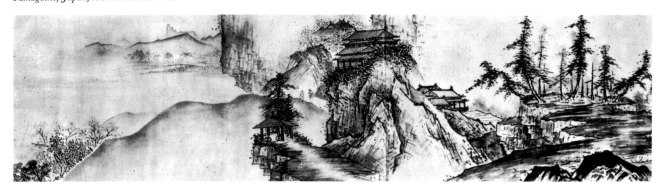

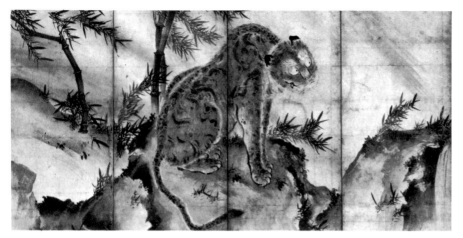

蛇
足

文
清

雪
村
周
繼

(C) SESSON SHŪKEI Tiger: from six-panel folding screen, mid-16th century
Cleveland, Ohio, Mus. of Art, Purchase from the J. H. Wade Fund

A striking example of the spread of Sesshū's influence across Japan can be seen in the career of Sesson Shūkei (about 1504 - after 1589), who was born in the far northeast of Japan and remained there all his life. Sesson had at his command a variety of ink subjects and styles (C). His most famous work is probably one of his smallest, an album painting of a fishing boat in a storm hurrying to the shelter of the shore (color plate 218). That Sesson in this remote area could have spent his life in studying ink paintings by Chinese and Japanese masters proves that by this time their works had been widely copied and circulated, and constitutes yet another instance of the speed with which new ideas and artistic styles gained currency in Japan.

The Ami family

The Japanese have always looked with respect upon the transmission of an art or skill from father to son. If a son with the necessary talent was wanting, the father would adopt a promising youngster to carry on the family name and tradition. Such artistic lineages, like the Kose family already mentioned, were to become an increasingly common feature of Japanese painting. One of the most famous is the Ami family: Nō-ami (1397-1471), his son Gei-ami (1431-85), and his grandson Sō-ami (died 1525). They were in succession official painters and art appraisers to three Shōguns, and compiled over the years the catalog of the Shōguns' collection of paintings, the "Notebook of the Shōgun's Art Secretary," a document of great value for the study of Chinese and Japanese ink painting of the period. It lists works—a number of which were clearly later copies—attributed to about 170 Chinese artists, from the Six Dynasties to the Ming period. Although it is evident from their name that the Ami family were Amidists, they all painted Zen subjects. Nō-ami was an enthusiastic admirer of Mu-ch'i, while Gei-ami had a somewhat harder style derived from Sesshū.

Of the three, Sō-ami was the most talented and influential. As a landscapist he

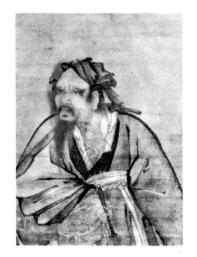

(D) BUNSEI Portrait of Yuima Koji: hanging scroll (detail) 1457
Osaka, Japan, Yamato Bunkakan Mus.

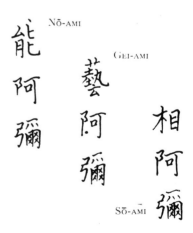

能
阿
彌

藝
阿
彌

相
阿
彌

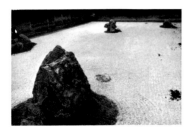

(A) SŌ-AMI The Stone Garden at Ryōan-ji (detail) early 16th century *Kyoto, Japan*

was notable for his mastery of the Southern style, at a time when most painters were practicing the Northern manner of Shūbun and Sesshū. His masterpiece, the sliding doors of the Daisen-in at Daitoku-ji, Kyoto (color plate 222), shows a breadth of vision remarkable in a Japanese painter. The moisture-laden atmosphere, the softly rounded contours, the long, loose lines, and the dots laid on with the side of the brush are derived not from the Southern Sung academicians, but from Kao K'o-kung, Mi Yu-jen and, ultimately, the first Southern masters, Tung Yüan and Chü-jan.

But Sō-ami was not merely a painter and critic. His fame in Japanese eyes rests equally firmly upon his contribution to the intricate ritual of the tea ceremony and its attendant arts, incense smelling, flower arrangement, and garden design, in all of which his precepts left a permanent mark upon Japanese cultivated taste. To him is attributed the famous stone garden at Ryōan-ji outside Kyoto (A), whose bare rocks, subtly disposed in a bed of carefully raked sand, suggest islands rising out of the sea. The art of garden designing was invented in China; but in Japan, like so much else that the Japanese imported from the mainland, it was elaborated and codified into a system or, rather, a number of schools, intimately related to landscape painting and inspired by Zen.

The Kanō school

The most remarkable art lineage in the history of painting is certainly that of the Kanō family, who supplied the leading painters to the Shōgunate for over 200 years from the end of the 15th century, and continued to uphold the "official style" for a century after that. The following table shows the chief members of this huge family in genealogical form, the numerals indicating the main line of artistic succession as accepted in Japan:

In addition to the artists named above, there were, up to the 19th century, scores of painters who were members, or claimed membership, of the Kanō school.

The key figures in the genealogy are Motonobu, who founded the school as a national branch of Chinese ink painting; Eitoku, who developed it into a brilliantly colored, decorative style in the Momoyama period; and Tannyū, who fossilized it as the official style of the Tokugawa academy.

When, in the late 19th century, Western scholars such as Ernest Fenollosa first began to study the history of Japanese painting, the Kanō school was still considered the "backbone" of the Japanese tradition. Large numbers of Kanō paintings, particularly by later artists, found their way into Western collections. Since Fenollosa's time this judgment has been radically revised, and it is now clear that much Kanō painting, especially of the last 200 years, is mannered, empty, and repetitive. Nevertheless in its first flush the school produced a group of painters of great vigor and originality.

The unique position of the Kanō school in the history of Japanese painting was due to several factors. First of all, the family became firmly entrenched as painters to the Shōguns and to the feudal lords in the provinces. The school therefore had the status of an official academy, with what amounted to regional branches. Secondly, it upheld the exact standards of the craftsman and professional that, until the arrival of Chinese literary painting in the 18th century, always held high prestige in Japan. Thirdly, while its techniques and conventional subject matter were usually Chinese, in all other respects—its emphasis upon craftsmanship, its clear-cut realism and precision of form, its lack of any scholarly or religious overtones—it was in perfect accord with the Japanese taste.

The founder of the school was Kanō Masanobu (about 1443 - about 1530), who succeeded Sōtan as director of the Painting Office (B, C). But it was his son Moto-

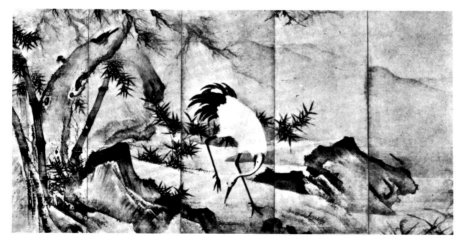

(B) KANŌ MASANOBU Landscape with Crane: from six-panel folding screen, early 16th century
Kyoto, Japan, Daitoku-ji

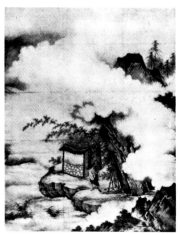

(C) KANŌ MASANOBU Chinese Priest under a Cliff (detail)
early 16th century
Tokyo, coll. Zenshiro Kuriyama

元
信 MOTONOBU

MITSUNOBU 光
信

nobu (1476-1559) who established the Kanō on firm foundations as the orthodox manner of ink painting in the Chinese style. Motonobu's marriage to the daughter of Tosa Mitsunobu (died 1522) was a key point in the school's development, for the Tosa school, which had traditionally furnished the painters to the court, was the inheritor of the Yamato-e tradition. Mitsunobu himself was famous for his brightly colored scrolls illustrating novels and epics (B). Motonobu's marriage, and further intermarriages between members of the Kanō and Tosa families (using the word "families" in its Japanese artistic significance rather than the genealogical sense), brought into Kanō painting the two things it initially lacked to make it a truly national style: Japanese subject matter and a rich, decorative use of color. A striking example of this union is the screen *Maple Viewers at Takao* (color plate 221) painted by Motonobu's son Hideyori. It is also important as a very early example of genre painting in the Kanō school.

A painter of enormous range and output, Motonobu was chiefly noted for his landscapes, birds, and flowers. With these he covered screens, sliding doors, and hanging scrolls in magnificent profusion (A). His most important commissions, executed with the aid of other members of his family, included the complete interior decoration of the fortified monastery of Hongan-ji at Osaka, and the sets of sliding doors at Daitoku-ji and Myōshin-ji in Kyoto, which have since been taken down and remounted as hanging scrolls. One of the latter, illustrated on page 280, shows the essentials of his style: the carefully balanced composition, the precise drawing derived from that of Ma Yüan and Hsia Kuei, the effective use of the decorative silhouette, the soft tonality, and the reduction of depth to two planes, foreground and background. In the interests of still greater decorative effect, later Kanō painters were to reduce the depth to a single foreground plane (page 281), thus cutting one of the last links with the Sung academy style, from which the Kanō school is ultimately derived.

(A) KANŌ MOTONOBU The Story of Hsiang-yen: screen, 16th century
Tokyo, National Mus.

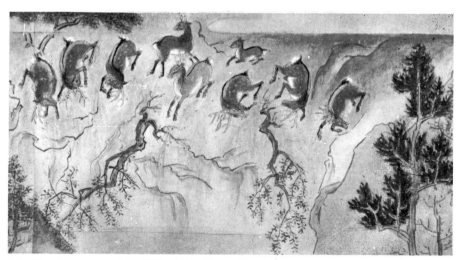

(B) TOSA MITSUNOBU Seisui-ji Engi (detail): handscroll, 16th century
Tokyo, National Mus.

Chapter IV

MOMOYAMA, 1573-1615:
THE AGE OF THE GREAT DECORATORS

(c) Ieyasu's Castle, 1594-1614
*Nagoya, Japan (Photo by Courtesy of the
Japan National Tourist Association)*

Screen painting

The Kanō style of large-scale decorative painting came into its own in the brief but hectic Momoyama period and the decades immediately following. To understand how it was that Japanese painting burst so suddenly into this rich, extravagant bloom, we need only glance at political events. During the first half of the 16th century the Ashikaga power had steadily declined and all over Japan the feudal lords were once more fighting among themselves. By 1568 Oda Nobunaga, in a campaign of terrible ruthlessness, had risen to power as *de facto* Shōgun. Two years after his murder in 1582, his general Hideyoshi, the " Napoleon of Japan," assumed power, and by 1590 completed the reunification of Japan that Nobunaga had begun. When Hideyoshi died in 1598 the struggle for power began once more, and it was not until 1615 that Tokugawa Ieyasu succeeded in crushing his rivals and making himself Shōgun. Then, for the first time in a century, Japan was at peace. The Tokugawa family ruled, on the whole securely and well, until the restoration of the imperial power in 1867.

Politically, the Momoyama period, so called after the site of Hideyoshi's last castle, lasted from 1573 to 1615. As a period in the history of Japanese art, however, it may be said to have extended for some years into the Tokugawa era. The three dictators, Nobunaga, Hideyoshi, and Ieyasu, demonstrated their power and wealth by the construction of castles and palaces of a magnificence hitherto unknown in Japan : Nobunaga at Azuchi (pillaged after his death) ; Hideyoshi at Osaka (destroyed in 1615), at Jūrakutei in Kyoto, and at Momoyama (dismantled at his death) ; Ieyasu at Nagoya (c) and Edo (now Tokyo). For the decoration of these buildings they called upon the services of bold and accomplished painters. Not for them the intimate subtleties of Zen ink painting. Themselves warriors and men of action—Hideyoshi started life as a servant in a village shrine—they demanded paintings that were realistic in content, clear-cut in form, rich in color, and huge enough in scale to cover the walls of halls in which several hundred *samurai* at a time might kneel in audience. Sometimes the folding screens were carried out into the parks for great picnics, and there is a story, a legend perhaps, that Hideyoshi was borne out to audience with the emperor along a road lined for 18 miles with screens taken from his Momoyama palace.

 Eitoku

Kanō Eitoku

The first member of the Kanō family to rise to this formidable challenge was Eitoku (1543-90). As a young pupil of Motonobu he painted in the restrained

127

(A) KANŌ EITOKU Crane: from sliding doors, 1566
Kyoto, Japan, Daitoku-ji, Jūkō-in

(B) KANŌ EITOKU Landscape with Flowers and Birch Tree (detail): from sliding doors, 1566
Kyoto, Japan, Daitoku-ji, Jūkō-in

Chinese manner, a beautiful example of his early work being the sliding doors decorated with cranes and pine trees that he executed for the Jūkō-in of Daitoku-ji in Kyoto (A, B). He was already famous when, at the age of 24, he met Nobunaga, who at once commissioned him to decorate the new castle at Azuchi.

In this great task, which took four years, Eitoku for the first time employed gold leaf for large areas of the ground and clouds. The use of gold was nothing new in Japanese art. It had been applied with great delicacy in Fujiwara Buddhist painting and in Yamato-e narrative handscrolls (color plate 210). But never had it been employed on such a scale or to such dazzling effect as now. It not only proclaimed the wealth of the patron, but fulfilled the practical purpose of reflecting light, and so illuminating the dark inner reaches of the huge audience halls. As the Momoyama decorators gained in confidence, its use spread to the whole of the background. The colors, to harmonize with it, had to be still further intensified, and the result was a scheme of interior decoration of pulsating splendor.

In addition to a host of lesser commissions, the dynamic Eitoku also decorated Hideyoshi's palace at Jūrakutei and his castle at Osaka, tasks that he accomplished with the aid of his brothers Sōshō and Naganobu, his sons Mitsunobu and Takanobu, and his adopted son Sanraku. Much of his work has perished, and of what survives little can be attributed to him with any certainty. But there can be no disputing his place as the true creator of the Momoyama style. He died of overwork at the age of 47.

TAKANOBU 孝信

Kanō Takanobu

The strength of the Chinese inspiration in the early work of the Kanō school is shown by a screen attributed to Eitoku's son Takanobu, now in the Seattle Art Museum. Its theme is the four enjoyments of the Chinese gentleman: painting (page 281), chess, music, and calligraphy. The chess-playing scene is shown in color plate 225. The subject, the perspective, and the drawing of the figures and of the rocky foreground are purely Chinese, being derived ultimately from the Ma-Hsia tradition as stylized by the Ming "academy." But the brittleness of the drawing,

the tendency toward broad, flat washes like that of the rock face behind the three chess players, the decorative use of clouds to mask off the top of the picture, and above all the rich color and gold-leaf background—all these features mark a further stage in the evolution of the Kanō school away from Chinese painting.

Kaihō Yūshō

Not all the great decorators of the Momoyama period were members of the Kanō family, though all felt its influence. Kaihō Yūshō (1533-1615), for example, while a Zen monk in Kyoto, was a pupil of Motonobu. Later he became a professional artist and tutor to an imperial prince. He probably assisted Eitoku in the decoration of the Jūrakutei palace for Hideyoshi.

Yūshō has left a magnificent series of screens, chiefly of flowers and flowering trees, such as the screen of peonies at Myōshin-ji, or that of plum trees, at Kennin-ji (c). In these his most notable contribution to the technique of screen painting is much in evidence. Hitherto, Kanō painters had tended to confine their bright colors chiefly to trees, flowers. and gold backgrounds, painting their rocks in monochrome ink in the old Chinese fashion. Yūshō, while preserving the ink base of his rocks, washes over them with a brilliant mineral green, thus completing the color harmony and heightening still further the decorative effect (D).

If the rich color could be stripped from one of Yūshō's big screen paintings, it would be seen that the underlying brushwork suggests the controlled fire and energy of the expert swordsman. This Yūshō in fact was. He shared with his pupil Niten, and the tea-master and designer Kōetsu, a passionate love of the military arts. This may seem a strange alliance of interests. But such men inspired by Zen ideals looked upon swordsmanship and even armed combat as an exercise in speed, skill, and self-discipline, aimed at the liberation of the spirit and the forgetting of self. The flash of the sword, the release of the arrow, the sweep of the brush are not means to an end, but ends in themselves. The meaning is in the act, as it is for modern "action painters" in the West. A brilliant example of this kind of swordplay with the brush is Niten's celebrated *Shrike on a Dead Branch* (page 249).

KAIHŌ YŪSHŌ

NITEN

(c) KAIHŌ YŪSHŌ Plum Tree (detail): sliding doors, 16th century *Kyoto, Japan, Kennin-ji*

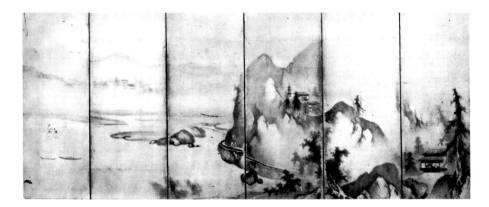

(D) KAIHŌ YŪSHŌ Landscape: six-panel folding screen, 1602 *Tokyo, National Mus.*

(A) HASEGAWA TŌHAKU Pine Trees and Grasses (detail): from a pair of screens, 16th century
Tokyo, National Mus.

HASEGAWA TŌHAKU 長谷川等伯

SANRAKU 山樂

(B) HASEGAWA TŌHAKU Pine Trees in the Mist (detail): from six-panel screen, 16th century
Tokyo, National Mus.

Hasegawa Tōhaku

Another screen painter trained in the Kanō studio was Hasegawa Tōhaku (1539-1610), who claimed to represent the "fifth artistic generation of Sesshū." His claim was contested by Unkoku Tōgan (1547-1618), the decorator of the Obai-in at Daitoku-ji. The case was carried to the courts and Tōgan won, a graphic instance of the absurd lengths to which Japanese painters carried their obsession with art lineages.

Of the two rivals, Tōhaku was the more versatile and original painter. His masterpiece in the colored style is the great sequence of paintings on sliding panels in the Chishaku-in, Kyoto, that Robert Paine has called "Perhaps the greatest examples of Momoyama art in strong color on a gold ground which have survived." They are notable not merely for their grandeur of design, but also for Tōhaku's characteristic use of liquid washes of color in combination with gold. He was equally a master of monochrome ink painting in the Zen manner (A). His screen of a pinewood in the mist (B) shows his debt to Sō-ami and, more remotely, to Mu-ch'i.

Kanō Sanraku

The last important representative of the Momoyama style was Kanō Sanraku (1559-1635). Hideyoshi discovered him as a boy and handed him over to Eitoku, whose favorite pupil and adopted son he became. Sanraku too was a highly versatile painter. Indeed versatility was an essential in these men, who were called upon to execute commissions in a wide variety of settings and subjects. For Hideyoshi Sanraku decorated the Momoyama castle, now destroyed. Color plate 219 shows one of a pair of sliding doors with peonies, which was part of his scheme for the Shin-den (Imperial Hall), also called the Hall of Peonies, in the Daikaku-ji in Kyoto. The quiet presentation, the carefully balanced composition, the harmonious color, all give these panels an air of stillness and repose much more suited for the decoration of a Buddhist temple than were the brilliant performances of Eitoku and Yūshō. There is also a hint of that stiffness and stylization that later became increasingly evident in painting of the Kanō school.

Sanraku remained loyal to Hideyoshi, and to Kyoto, all his life. When the capital moved to Edo he remained behind, and his followers took pride in upholding the original Kanō tradition of Kyoto, called Kyō-Kanō. But as Edo grew in wealth and power, Kyoto gradually became a cultural backwater, a treasure house of the art of the past, but no longer able itself to infuse new blood into the stream of Japanese painting.

Kanō Tannyū

The transfer of the capital to Edo, and Ieyasu's vast building program, put new life into the Kanō school there at a time when it might have seemed that no further achievements were possible. Three of Eitoku's grandsons, Tannyū (1602-74),

Naonobu (1607-50), and Yasunobu (1613-85), together established their studio in Edo, and this became the official academy under the Shōgunate.

The dominant personality was undoubtedly Tannyū. This dynamic and precocious youth had had an audience with the Shōgun at the age of ten, was made Painter in Attendance at 16, and was subsequently heaped with honors and court titles. He was extremely versatile. His works include countless scrolls and screens of Chinese subjects in the Chinese ink manner (c), while at Nikkō he illustrated the life of Ieyasu in a series of colored paintings in the Tosa style. He also did important work at Nagoya and Edo. His paintings for the great audience hall of the Momoyama palace were transferred to Nishihongan-ji when the palace was dismantled shortly after Hideyoshi's death.

Tannyū's most important commission was the decoration of the main halls of Ieyasu's palace of Nijō at Kyoto (D, E), which has been called the "Versailles of Japan." Here his chief themes were trees and birds, the most spectacular of all being an enormous pine tree, 46 feet long and 16 feet high, on the back wall of the fourth hall of the palace. While he was engaged on these colossal schemes there also flowed from his studio in Edo a constant stream of designs, based chiefly on plant forms, that were applied to textiles, lacquer, sword-guards, pottery, and embroidery throughout the length and breadth of Japan.

In spite of Tannyū's enormous prestige, the Kanō school had by this time explored all the possibilities that were inherent in the style. Although it continued to be the official school throughout the Tokugawa period, after Tannyū it had nothing fresh to contribute, and its influence became more and more deadening. It is in the reaction against Kanō that new developments in Japanese painting appear.

(c) KANŌ TANNYŪ Fishing with Cormorants (detail): from six-panel folding screen, 17th century *Tokyo, Okura Shuko-kan Mus.*

 TANNYŪ

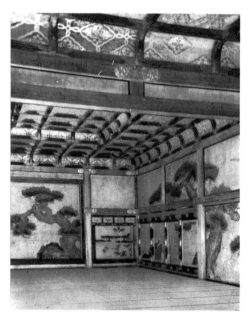

(D) Interior view of Nijō Palace, 17th century *Kyoto, Japan (Photo by Courtesy of the Japan National Tourist Association)*

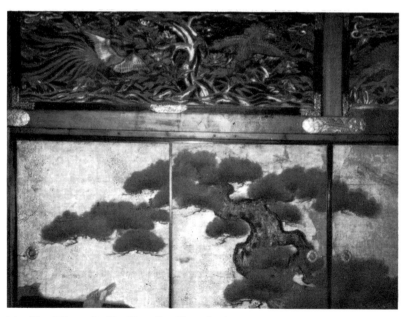

(E) KANŌ TANNYŪ Pine Tree (detail): wall painting in main hall of Nijō Palace, 17th century *Kyoto, Japan (Photo by Courtesy of the Japan National Tourist Association)*

Chapter V

ART UNDER THE TOKUGAWA

New cities and new classes

The history of Japanese art up to this point has been the history of the art of elites, and the forces that stimulated its production have been for the most part religious or political. These elites were the emperors and their courts, the regents and feudal lords, the military aristocracy, and the monastic communities. There was no middle-class taste or patronage, because there was no middle class. But the political upheavals of the 17th century, the increase in population, and the growth of the cities were bringing about profound changes in Japanese society. A merchant class was coming into being and the urban masses were gradually becoming articulate.

By the end of the 17th century the little marshy village of Edo had grown into a city. (In 1868 its name was changed to Tokyo.) To prevent the rise of local factions that had so often overthrown the government in the past, the Tokugawa Shōguns forced the *daimyō* (feudal lords) to spend half the year in the capital. They and their host of retainers flocked to the city. Too proud to work themselves, they brought employment to a growing class of merchants and artisans. Many *daimyō*, intoxicated with the delights of city life (A), spent far more than they could afford. They squeezed their peasants dry, and the latter in despair gave up farming and came to the cities too, thus further increasing their population. Then the *daimyō* borrowed money from the merchants, who soon had them at their mercy, though in law a bankrupt *daimyō* might still strike down a merchant with impunity. The breakdown of an agricultural economy caused the Shōguns to turn to overseas trade as a means of raising revenue. Most of this, however, went into the pockets of the merchants.

The Shōguns were well aware of the danger to the established order. By means of a penal code that severely restricted their movements, behavior, and even dress, they sought to keep down the rising tide of the new urban classes. But the forces now stirring were too strong for them. The change from a barter to a money economy, the impoverishment of the *daimyō*, the growth of the cities, the opening of Japan to contact with the outside world—these were but a few of the factors that were undermining the feudal structure and leading inevitably toward the eventual creation, in the 19th century, of a modern state.

The remarkable variety and vitality of the art of the Tokugawa or Edo period springs from the interaction and tension between this social restlessness on the one hand, and deeply engrained respect for tradition on the other. An artistically minded visitor to Edo in the 18th century might have been shown screens in which Sōtatsu and Kōrin had revived or transformed, though on a much smaller scale, the glories of Momoyama decorative art. He would certainly have seen countless imitations of the brushwork of Kanō Tannyū. A wealthy *daimyō* (if he could find

(A) HISHIKAWA MORONOBU Gay Life in Early Edo (detail): from six-panel screen, 17th century
Boston, Mass., Mus. of Fine Arts

one) might unroll for him a scroll of "The Tale of Genji" in the colorful Tosa style. He would be shown paintings in the manner of the Ming professional Shen Nan-p'in, or, if he moved in more cultivated circles, Ike-no-Taiga's response to the style of the Ming literati, which was just then coming into fashion. At the house of a rich merchant from Nagasaki he might be invited to admire a pair of screens painted in the European manner, while if he had frivolous tastes and spent an evening in the gay quarter, Yoshiwara, he would hardly come away without buying for a few coppers a sheaf of wood-block prints of popular actors, prostitutes, and tea-house waitresses.

Popular art

It will be noticed that in the course of his tour our imaginary visitor saw no recent masterpieces: no religious paintings of any significance, no narrative scrolls to match those of the 13th century, no flashes of Zen insight, no riot of decorative splendor such as adorned the Momoyama palaces and temples. Tokugawa art never touched the heights, for the old elites were in decline and the needs of the new patrons were more modest. They did not want to be instructed or inspired; they wanted an art that was both an expression of their own newly awakened self-confidence, and a source of entertainment that made it easier to bear the weight of petty restrictions imposed by the government upon their daily lives.

To meet this new need the artists of Edo and Osaka created the Ukiyo-e, the Art of the " Floating World." In it we find both Tosa and Kanō elements, for many of the new popular painters got their training in the Kanō studios and were patriotically imbued with the old tradition of Yamato-e. But the traditional schools could now offer them little more than technical training. The stimulus to the creation of a new style lay not in the studios but in the streets. Before we discuss this vital popular movement, however, we should glance briefly at the other schools that flourished under the Tokugawa.

 MITSUYOSHI

 MITSUNORI

 MITSUOKI

The Tosa school

The Tosa school, which formerly supplied richly decorative illustrated scrolls to the court at Kyoto, had sunk in prestige as the fortunes of the nobility who patronized it declined. By the 16th century the power of the great Momoyama decorators and the sheer number of the Kanō painters had overwhelmed it. The position of painter-in-chief to the emperor was given to a member of the Kanō family, and Tosa Mitsuyoshi was reduced to providing sketches for the Kanō painters to use in their screen paintings. Tosa Mitsunori gallantly upheld the ancient tradition with his illustrated scrolls, of which the Genji scroll, now in the Freer Gallery, Washington, is his best work (B). But the style had long gone out of fashion, even at court.

It took a painter of the ability of his son Mitsuoki (1617-91) to restore the Tosa family to its old position as Painters to the Throne. This title was given to Mitsuoki when he moved from Osaka to Kyoto in 1634. It was no accident that

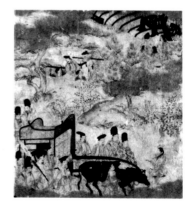

(B) TOSA MITSUNORI Barrier House Chapter (detail): from handscroll of "The Tale of Genji," 17th century
Washington, D. C., Freer Gall. of Art

133

(A) TOSA MITSUOKI Quail,
17th century
Tokyo, coll. Saburo Fujikura

TSUNENOBU 常信

NAGANOBU 長信

信

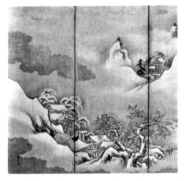

(B) KANŌ TSUNENOBU Landscapes of
the Four Seasons (detail): from
six-panel folding screen, 17th century
Boston, Mass., Mus. of Fine Arts

TAWARAYA SŌTATSU 俵屋宗達

he was strongly influenced by the prevailing fashion for Chinese ink painting. Indeed it is doubtful whether he would otherwise have received official recognition at all. He was also the first Tosa painter to follow the Chinese custom, already adopted by the Kanō school, of signing his work (A).

Mitsuoki is best known for his screen of Quails and Millet, a subject taken straight from the repertoire of the Southern Sung academy. His style is a curious mixture of the Chinese manner of the Kanō painters and the decorative simplification of the traditional Yamato-e. Even more than Kanō itself, the Tosa school, of which Mitsuoki was one of the last and least typical representatives, proved to be a dead end in Japanese painting.

The Kanō school

By the beginning of the Tokugawa period the subject matter, composition, and technique of Kanō painting was frozen by convention. Its interest for us is chiefly sociological. For there is some fascination in the study of an art organization that included hundreds of painters of varying merit, all members, or claiming to be members, of the same family and all acquiescing in a rigid tradition whereby the four principal families, called Palace Painters, had a monopoly of official commissions from the Shōgun; the 15 next in seniority, designated Outside Painters, catered for the aristocracy and the wealthy; the remaining Town Painters made what living they could.

Japanese historians have minutely chronicled the history of the Kanō school, recording that in the 17th century the leadership in Edo fell to the " Kobiki Street branch," headed by Tannyū's nephew Tsunenobu, instead of remaining with the main stream in another part of the city. But this is of little consequence for the history of Japanese painting. Tsunenobu (B), for all his astonishing skill with the brush, had nothing new to offer, any more than had his successors in the 18th and 19th centuries. The only significant Kanō painter of the 17th century was Eitoku's younger brother Naganobu (1577-1654). His importance lies in the fact that in a few of his works, most notably in the screens in the Hara collection that depict dancing at the cherry-blossom festival, he brings together with great success the discipline and precision of Kanō drawing and the movement and color of the new popular art (C).

Tawaraya Sōtatsu

The first great painter to impose his own personality upon the art of the 17th century was Sōtatsu. Very little is known about his career except that he was working in Kyoto between 1610 and 1640 and came of a wealthy family of cloth merchants, a fact that would automatically have put him beyond the reach of the professional Kanō organization. It is also believed that he ran a fan-painting shop and employed a number of assistants.

An important influence on his career was the distinguished amateur painter, poet, and potter Kōetsu (1558-1637). Kōetsu was to early 17th-century Kyoto what

Lorenzo de' Medici was to 15th-century Florence, a man of great wealth and standing, a friend of painters and poets. He was a confidant of the Shōgun Ieyasu, with whose help he founded an art colony outside Kyoto in order to try to put new life into the "classic" Tosa tradition, at that time moribund. He often collaborated with Sōtatsu, writing poems on scrolls that the painter then decorated with pictures of deer, vines, or flowers. These were done in washes of silver and gold, a technique that Sōtatsu himself invented (page 267).

Among Sōtatsu's most important works are sets of screens of the ever-popular "Tale of Genji", now in Tokyo and Kyoto, and screens of the Court Dancers and of the Wind and Thunder Gods (D), both in Kyoto. The spectacular *Waves Tossing in the Bay of Ise*, now in the Freer Gallery, Washington, is the finest of his works in a Western collection. He also executed many album paintings and fans, in which his astonishing inventiveness is given full rein. Color plate 220 illustrates a detail from one of a pair of screens in the Seikadō collection, Tokyo. The screen (page 136B) depicts the so-called Navigation Post scene from "The Tale of Genji," in which Prince Genji, while traveling, unexpectedly meets his former mistress, Lady Akashi. She is approaching in a boat. Genji has got down from his carriage and stands waiting, while his agitated followers wonder apprehensively what he will do when the lady steps ashore.

Nothing quite like this has been seen before in Japanese painting. Here is no Kanō mannerism, no trace of the niggardly refinement into which the Tosa school had sunk. Although the attitudes of the characters are lively, and the shore curves back to give an illusion of depth, it is not for their realism that Sōtatsu has exploited the shapes of the figures and the sweeping silhouette of the shoreline, but primarily for their decorative effect. Realism is employed only to the degree necessary for the viewer to identify the subject; having done so, he need think no more, but simply stand back and feast his eyes on the bold and sumptuous simplicity of shapes and colors, and the daring contrast between the broad masses of landscape and the jerky silhouettes of the figures. Shapes overlap and run into one another, lines cut across each other or run parallel; indeed every rule of good composition has been broken. This was clearly deliberate. For were the picture more perfectly composed, it would become static and lose all interest. The apparently awkward juxtapositions set up a tension between the shapes and colors that gives them life. It is not the life of nature. There could be no tree more naive, improbable, and "unlifelike," for instance, than the clumsy pine. Instead it is the kind of life that is hidden in a structure under stress. Genji's white face, for example, confronting the white curve of the shore and apparently in the same plane, seems to be both attracted to it and repelled from it by some hidden force, a force that we can see all over the picture, fusing and at the same time holding apart its elements. By the subtle and instinctive manipulation of this force Sōtatsu teases the eye of the viewer, riveting his interest.

The acute tensions in these formal relationships, so often uncongenial to Western, as to Chinese, taste, were nothing new in Japanese painting. They contributed greatly to the violent movement and drama of the Kamakura war scrolls, where they were used as an aid to dramatic story telling. But in Sōtatsu these

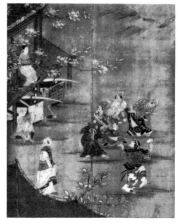

(c) KANŌ NAGANOBU Dancing at the Cherry-blossom Festival (detail): from six-panel folding screen, 17th century *Kanagawa, Japan, coll. Kunzo Hara*

HON-AMI KŌETSU

本
阿
彌
光
悦

(D) TAWARAYA SŌTATSU The Thunder God (detail): from a pair of two-panel folding screens, 17th century *Kyoto, Japan, Kennin-ji*

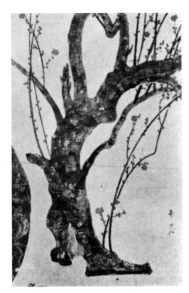

(A) OGATA KŌRIN Red Plum Tree (detail): from a pair of two-panel folding screens, late 17th century
Shizuoka-ken, Japan, Atami Mus.

OGATA KŌRIN 尾形光琳

(C) OGATA KENZAN Cake Tray with Signature and Two Seals, 17th century
Seattle, Wash., Art Mus., Eugene Fuller Memorial Coll.

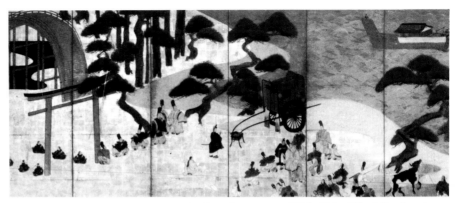

(B) TAWARAYA SŌTATSU The Navigation Post: from screen of "The Tale of Genji," early 17th century
Tokyo, Seikadō Coll.

tensions come out into the open, declaring themselves, in a sense, the real theme of the picture. From this time forward, they are more and more readily recognizable as a uniquely Japanese mode of pictorial expression. They play a crucial part in the aesthetics of the Ukiyo-e, the popular art of the 18th and 19th centuries.

Ogata Kōrin

After Sōtatsu's death his assistants continued to produce works in his style, and to stamp them with his seals and signature. Sōetsu, either his son or his younger brother (it is not known which), became head of the studio in 1639, but Sōtatsu's real successor was Ogata Kōrin (1658-1716). He was born, like Sōtatsu, into the wealthy merchant class. His great-grandfather had married a sister of Kōetsu; from her Kōrin inherited some of the latter's model-books. He was passionately addicted to the Nō drama and its decor. He was also wildly extravagant, and his defiance of the restrictions on the dress and behavior of commoners led to his exile from Kyoto to Edo in 1704. His years in Edo came close after the Genroku era (1688-1703), the climax of the hectic gaiety that marked the Tokugawa period in that city. Thus exile only fed his extravagant tastes. Returning to Kyoto in 1710, he did some of his finest works during the last six years of his life.

Kōrin's exuberance, his lavish use of color and gold, and his loose, free technique —a contrast to the clear, disciplined forms of Sōtatsu—were perfectly in keeping with the spirit of the age. His most famous works are the screens of Irises in the Nezu Museum, Tokyo, a gorgeous display of green and blue on a gold ground; the *White and Red Plum Trees*, in the Atami Museum (A); and the screens of Waves in the Metropolitan Museum, New York, and Museum of Fine Arts, Boston. The highly stylized treatment of water and plum blossoms in most of his screens set the pattern for designers in pottery, lacquer, and textiles. But on occasion Kōrin himself rose above being a mere decorator. The screen of Waves in New York (color plate 226) shows him inspired not by pattern making but by nature herself, though this is nature as seen through the eyes of the Southern Sung landscapists, whose ideals

he mastered in the course of his youthful studies of the Kanō style. And yet, for all its sense of living nature, this is a superbly decorative design. It is one of those rare moments in the history of Japanese art when the Chinese and the native aesthetic ideals come into perfect balance and accord.

Ogata Kenzan

Kōrin's younger brother Kenzan (1663-1743) was also an artist. Indeed recent research indicates that Kōrin was inspired to become a painter by his brother's example. Of the two, Kenzan's temperament was the quieter and more refined. Deeply imbued with Zen ideals, he was also a calligrapher and a distinguished potter (c), having learned the latter craft from the famous Kyoto potter Ninzei. Many of his pots were decorated by his brother. Kenzan led the life of a scholar and amateur, potting, painting, and savoring the subtle pleasures of the tea ceremony. His most famous painting, the *Flowers in Baskets* (D) in the Matsunaga Collection, is remarkable for an almost Chinese freedom of design and poetry of mood, a poetry that is heightened by the fragment of verse written by the artist in flowing calligraphy on the upper half of the picture. The signature, "Painted by Shisui Shinsei, an idler of Kyoto," shows that Kenzan was also influenced by the ideals of the Chinese scholar painters.

Sakai Hōitsu

Kōrin's immediate followers were imitators. A century passed before another talented painter appeared to continue in the brilliant decorative style that he and Sōtatsu originated. In fact Sakai Hōitsu (1761-1828) did more than this. A wealthy aristocrat and amateur painter, he felt it to be his mission in life to propagate the style of Kōrin by every means in his power. He not only painted a number of screens in Kōrin's style, but also published a collection of his seals entitled " One Hundred Masterpieces of Kōrin" (1810), and a book on the works of Kenzan.

Hōitsu's own masterwork, the pair of screens called *Summer Rain* (E) and *Autumn Wind*, in the care of the Commission for the Protection of Cultural Properties, Tokyo, is a very successful blend of the formalism of Kōrin and the naturalism and refinement of taste of the scholar painter. For Hōitsu was influenced even more than Kenzan had been by Chinese literary painting. Although the style of Sōtatsu and Kōrin has remained popular up to modern times, *Summer Rain* and *Autumn Wind* were the last important works of their school.

New influences: European art

We must now consider two powerful, utterly different influences that were injected into the stream of Japanese painting in the Edo period. One was European art, the other the Chinese painting of the Southern, or Literary school.

First contact between Japan and Europe was made accidentally in 1542, when three Portuguese sailors were shipwrecked on the coast of Kyūshu. Within seven years several more Portuguese ships had arrived, bringing with them the Jesuit

(D) OGATA KENZAN Flowers in Baskets: hanging scroll (detail): 17th century
Tokyo, National Mus., Matsunaga Coll.

OGATA KENZAN 尾形乾山

SAKAI HŌITSU 酒井抱一

(E) SAKAI HŌITSU Summer Rain (detail): from a pair of two-panel folding screens, early 19th century
Tokyo, Commission for the Protection of Cultural Properties

137

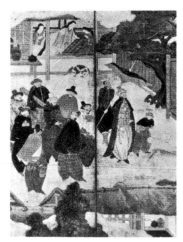

(A) ANONYMOUS Westerners in Japan (detail): from a pair of six-panel folding screens, 17th century
Tokyo, Commission for the Protection of Cultural Properties

(B) ANONYMOUS Henry IV on Horseback: from a pair of four-panel folding screens, 17th century
Tokyo, coll. Yasuo Matsudaira

missionaries who were the spearhead of Western cultural advance in East Asia. For 60 years the Portuguese prospered in Japan, first under the protection of Hideyoshi, later under his successor Ieyasu. Christianity became a fashionable craze among the aristocracy, while many thousands of their retainers and peasants were more sincerely converted. Before long the Portuguese were followed by the Spanish and then the Dutch. Competition for souls, and for trade, became fierce.

Ieyasu watched with growing uneasiness as the rival European powers carved out empires for themselves in the East. He realized that the spiritual conquest of the Jesuits would be, as it had been in the Philippines, merely a prelude to military conquest. He therefore began a suppression of Christianity that was carried on with far greater ruthlessness by his successor Hidetada, culminating in a massacre of Christians in 1638 and the total suppression of the foreign religion. In 1640 Hidetada finally slammed the doors to the outside world. From thenceforward until the arrival of Commodore Perry's squadron off Tokyo in 1854, no Japanese was permitted to leave the country, no seagoing ship was allowed to be built, and contact with the outside world was confined to the few Chinese and Dutch traders who were permitted under strict control to trade at Nagasaki.

Namban

It was a tragedy for Japan that she was forcibly sealed off from the outside world just at a time when her own culture most needed, and was most ready to receive, new stimulus from abroad. This seclusion partly accounts for the narrow, inverted character of Japanese art during the 18th and 19th centuries. How eager she was to learn can be seen in the speed and skill with which Japanese painters had studied, and mastered, the European techniques that entered Japan between the first arrival of Portuguese missionaries and the cutting of contact in 1640, a mere 80 years. Such Japanese paintings in the European style are called Namban (Painting of the Southern Barbarians), or simply Yōga (Foreign Painting).

The art brought by the Portuguese included oil paintings and engravings, of both Christian and secular subjects. A Jesuit art school was established at Nagasaki, and Japanese novices were trained as religious painters in Catholic seminaries scattered about the country (page 292). Although nearly all the Christian art of this period was destroyed in the persecution of the 1630's, a few icons were secretly kept by devout Christians. These were sometimes cleverly disguised, one example being the oil painting of St. Peter that stood for over 200 years, masquerading as Shākyamuni, on the altar of the Buddhist temple at Funabashi.

Japanese painters copied European secular subjects chiefly from engravings. There have survived, for example, a Japanese panorama of the battle of Lepanto (page 292) and a set of huge equestrian portraits of Western princes, one of which has been identified by a coat of arms as that of Henry IV of France (B). A work of particular charm, painted about 1610, is a pair of screens of Westerners playing their music (C), in the Okada Collection; so skillfully are they done that one hardly notices that several of the figures are copied from the same model. Indeed this figure appears in several screens, suggesting that only a very limited number of

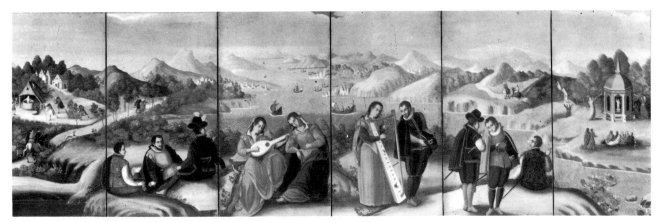

(c) ANONYMOUS Westerners Playing their Music: six-fold screen, 17th century
Tokyo, National Mus., coll. Mokichi Okada

Aōdō Denzen

Shiba Kōkan

Naizen

Odano Naotake

Maruyama Ōkyo

prints were available for the Japanese painter to work from. Aristocratic genre subjects such as that of the Okada Collection screens were especially popular with the more modern and "progressive" *daimyō*, who were eager to learn all they could about the Western way of life. Namban painting also included pictures of the Portuguese done in the Japanese manner, such as the big screens, Namban *byōbu*, showing in rich color and humorous detail the arrival of Portuguese ships at Nagasaki (A) or the peculiar features and costume of the foreign traders and missionaries. Some of the best of the Namban *byōbu* were done by members of the Kanō school, such as Naizen.

Although the proscription of Christianity put an end to Christian art in Japan, Western paintings and engravings continued to trickle into the country by way of Nagasaki. Their influence gradually spread. In 1720 the Shōgun authorized the import of Western books on all but religious subjects. Among these were treatises on botany, anatomy, and perspective, which convinced the Japanese that the foreign style they had been copying a century earlier did in fact correctly represent natural objects. Some artists even began to feel that their own traditional painting was not real art, because it was not true to nature. A group of 18th-century painters that included Naotake, Kōkan, and Denzen launched a movement to promote realistic art. It was so successful that it even influenced painters of the Nanga movement, such as Tani Bunchō and Watanabe Kazan (see page 143). Realism was thus not so much a distinct school in itself as an impulse that flowed into almost all the painting of the middle Tokugawa period, and gave it a new flavor.

The Maruyama-Shijō school

One of the most important 18th-century painters to feel this influence was Maruyama Ōkyo (1733-95). As a young pupil of a Kanō painter in Kyoto, Ōkyo one day saw a peep-show in the street. Its pictures were drawn and colored with

139

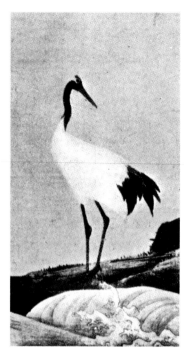

(A) MARUYAMA ŌKYO Cranes and
Waves (detail): from six-panel folding
screen, 18th century
Kyoto, Japan, Kongō-ji

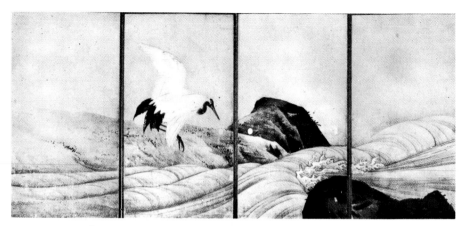

(B) MARUYAMA ŌKYO Cranes and Waves (detail): from six-panel folding screen, 18th century
Kyoto, Japan, Kongō-ji

Western perspective and chiaroscuro, which fascinated him. He rapidly learned
the technique and was commissioned to make more scenes for the peep-show.
Many of his sketchbooks, with their accurate drawings from nature, have been
preserved. Ōkyo was probably the first Japanese painter to make studies from the
nude (page 292). Soon he was applying realistic drawing and shading to big decora-
tive screens. To these novel techniques was added the influence of Chinese brush
painting that was coming into Japan, like Western art, by way of Nagasaki (A, B).

The result was a decorative style that was Kanō in theme, design, and basic
manner, but with elements of Chinese brushwork and Western realistic shading
and modeling. This brilliant eclecticism proved to be just what the taste of the new
wealthy class demanded. Ōkyo's major works, such as the great *Pine Trees in the Snow*
(page 248) in the Mitsui Collection, Tokyo, and the Hozu River screens in the Nishi-
mura Collection, were enormously admired, and set the style for a decorative realism
in Japanese screen painting that has remained fashionable up to modern times.

The tradition founded by Maruyama Ōkyo is generally called the Maruyama-
Shijō school, Shijō being the quarter of Kyoto where Ōkyo's follower Goshun
(1752-1811) lived. In point of temperament, Goshun stood in relation to Ōkyo
much as had Kenzan to Kōrin. Goshun was a poet and calligrapher, and a man of
more refined sensibility than Ōkyo, under whose influence he fell only late in life.

MATSUMURA GOSHUN

松
村
呉
春

(C) MATSUMURA GOSHUN
Landscape: from a pair of eight-panel
folding screens, 18th century
Tokyo, National Mus.

He had been a pupil of Buson, one of the first and most original painters in the Chinese literary manner. Goshun's most famous work, his pair of landscape screens (c) in the National Museum, Tokyo, combines the decorative realism of Ōkyo with the greater breadth of vision and subtlety of feeling inherent in the Chinese style. In general, the intimacy and refinement of Goshun's style was a perfect expression of the taste of Kyoto, in contrast to the more brilliant and colorful manner favored by Tokyo.

Nanga

The Nanga movement was an indirect result of the determination of the Tokugawa government to rule Japan not by military force, as their predecessors had, but on the model of the Chinese civil administration. The study of Confucian ideals in government, which the Tokugawa actively encouraged, led to a new awareness in Japan of the role of the intellectual in Chinese affairs, and hence to the study of the art of the scholar painters, which the Chinese call *wen-jen-hua*, the Japanese *bunjin-ga*, or Nanga (Southern Painting).

As we saw in a previous chapter, Japanese painters of the Ashikaga period had mastered the style of the Southern Sung academy, which the Chinese critic Tung Ch'i-ch'ang was to label the " Northern " school. But apart from one or two isolated examples, none had attempted to study or imitate the Chinese Southern school, traditionally founded by Wang Wei, which had been developed by Tung Yüan and Chü-jan in the 10th century and by Mi Fei and Su Tung-p'o in the 11th (see pages 44, 47, 238, and color plate 163). This style, after being excluded from the repertoire of the Southern Sung academy, was rediscovered by the Yüan literati, developed further by the Wu school in the Ming Dynasty, and by the 18th century was becoming, in some of its manifestations, almost as stereotyped as the art of the academicians themselves. Nevertheless the ideal of a style that expressed the lofty refinement and independence of the scholar had remained intact, and it was this ideal, as much as the style itself, that appealed to Japanese painters in the 18th century, although it is doubtful how many of them really understood it.

There is one significant difference, however, between the *wen-jen-hua* and the *bunjin-ga*, quite apart from the fact that the latter is derived from the former. While nearly all the Chinese scholar painters could with justice claim to be scholars and amateurs, their Japanese counterparts were drawn from a wide range of classes and occupations. Nankai and Gyokudō (color plate 224) were *samurai*; Ike-no-Taiga (D), one of the first leaders of the movement, made his living selling fans; Gyokusen was in the lacquer business, Mokubei a professional potter. Several were indeed poets. Buson, for example, was a master of the 17-syllable *haikai* as well as a professional painter. But none came to *bunjin-ga* as the natural expression of a scholarly temperament. To the Chinese it was, ideally at least, the symbol of a way of life, and its purity was its justification. To the Japanese painter it was more often a *style*, which might be blended with other styles, or arrived at after he had worked in the Tosa or Kanō schools. Nevertheless the *bunjin-ga* was an effective outlet for that poetic feeling always present in the Japanese temperament, and it

(D) IKE-NO-TAIGA Landscape with Building (detail): from a pair of six-panel folding screens, 18th century *Tokyo, National Mus.*

IKE-NO-TAIGA 池野大雅

YOSA BUSON 與謝蕪村

blew like a fresh wind over the surface of Japanese painting in the 18th century.

Several Chinese painters of little merit had settled in Nagasaki after the fall of the Ming Dynasty in 1644. Later others joined them, and Nagasaki became the new center for the study and dissemination of Chinese culture. The most notable Chinese visitor was the academic flower painter Shen Ch'üan, or Shen Nan-p'in, who lived in Nagasaki from 1731 to 1733 and had a number of followers. The Chinese literary style, however, was spread largely through the medium of albums and pattern-books, such as the "Painting Manual of the Mustard Seed Garden" (see pages 256 and 257), which had been published in 1679. The first copies must have reached Japan before the end of the 17th century, and a Japanese edition appeared in 1748. One of the first to study Chinese painting through these albums and pattern-books was Gion Nankai (1687-1761), a *samurai* and Confucian scholar of Wakayama, south of Osaka. His ink landscapes and those of his contemporary in Kyoto, Hyakusen (1697-1752), are inevitably stiff and heavy, for these artists could have seen no original Chinese literary paintings of any quality.

Ike-no-Taiga

A much more considerable figure in the Nanga movement was Ike-no-Taiga (1723-76), who began his career as a Tosa style artist in Kyoto. He first learned the Nanga from a Chinese album given him by Nankai, and from Ryū Rikyō, a rich *samurai* who made a study of Chinese painting based upon old pictures in Japanese collections. Taiga traveled widely, developing his painting as he developed his personality, in ever greater freedom. His inspiration in both was not only Confucianism but also Zen, which had never lost its hold on the Japanese mind as it had on the Chinese; Taiga's style was formed as much by Sung ink painting as by the *wen-jen-hua*. Yet by temperament he came closer to the latter, to the Chinese ideal of the scholar painter. Among his best works are his screen of Sages in Henjōkō-in on Mount Kōya, the screens of landscape on a gold ground (a feature that would have horrified a Chinese scholar painter) in the Tokyo National Museum, and a famous album, painted in friendly rivalry with Buson, in which he illustrated poems by Li Li-weng on The Ten Conveniences of Country Life (A).

Yosa Buson

Yosa Buson (1716-83) is generally linked with Taiga as one of the two greatest masters of the Nanga movement. Buson lived in Kyoto and seems to have been largely self-taught. Many of his most spontaneous paintings are small landscapes and nature studies called *haiga* after the short, evanescent 17-syllable poems, *haikai*, that inspired them (c). Buson's larger landscapes are more "correct" than Taiga's, and his brushwork less individual. The great attraction in his and Taiga's art was its naturalism, which came as a refreshing contrast to the technical sophistication of the Ōkyo school and the decorative realism of the Ukiyo-e (B). Among Buson's pupils was Goshun, who worked in the Nanga style from 1777 to 1787, before he came under the influence of the academic realism of Ōkyo.

(c) YOSA BUSON Snowy Landscape: handscroll, 18th century
Tokyo, Kinta-Muto Coll.

浦上玉堂　URAGAMI GYOKUDŌ

青木木米　AOKI MOKUBEI

谷文調

TANI BUNCHŌ

Later Nanga painters

Part of the charm of the work of Taiga and Buson lay in their imperfect knowledge of Chinese literary painting. Having seen few good examples, they were forced to develop their own pictorial vocabulary. The range of their brush technique was inevitably narrow, however, and repetition often led to mannerism. That these defects are gone from their successors was due partly to the greater number of good models reaching Japan after the middle of the 18th century, partly to the liberating influence of the Chinese Individualists, notably Shih-ch'i, Shih-t'ao, and Pa-ta Shan-jen (see pages 92 and 93, and color plates 198 and 199), whose paintings were then beginning to circulate among Nanga painters and connoisseurs.

Uragami Gyokudō (1745-1820) was a Kyoto *samurai* who resigned his commission in 1794 and retired, after the manner of the Chinese recluses, to a life of music, drinking, painting, calligraphy, and contemplation. His little album landscape in the Umesawa Collection, Kanagawa, is illustrated in color plate 224. It shows how close he came to the spirit and style of Shih-t'ao, though differing from him partly in the flatness from which Japanese painters could seldom escape, partly in the quality of his brushstroke, which seems to come closer to European than to Chinese drawing, and partly in the texture and pattern of color on the paper, which Gyokudō instinctively disposes for its decorative effect. Another member of Gyokudō's circle in Kyoto was Aoki Mokubei (1767-1883), a follower of Taiga who painted landscapes and flowers of great freshness and charm.

As the Nanga movement took root in Japan, it inevitably lost something of its original spontaneity and purity. While to Gyokudō and Mokubei it had been a natural mode of expression, to the Edo Nanga masters, such as Tani Bunchō (1765-1848) and his pupil Watanabe Kazan (1792-1841), it was often just one more style with which to experiment. Bunchō, for example, did not hesitate to combine in one landscape elements taken from the Nanga, Kanō, and Tosa schools; Kazan, especially in his portraits of his friends, combined Nanga with Western realism. This eclecticism brought them great popularity among the military aristocracy of Edo, but it carried them far from the true spirit of the Nanga.

Among the many hundreds of painters who were more or less inspired by Nanga

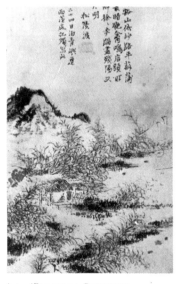

(D) TANOMURA CHIKUDEN
Landscape Sketch: album leaf, 1829
Osaka, Japan, coll. Komakichi Tamura

143

(A) TOMIOKA TESSAI The Zen
Master Feng-kan: hanging scroll,
late 19th century
Kōbe, Japan, Kiyōshi-kōjin

TANOMURA CHIKUDEN

NORO KAISEKI

能村竹田

野呂介石

富岡鐵齋

TOMIOKA TESSAI

ideals were Noro Kaiseki (1747-1828), like Mokubei a follower of Taiga; Bunchō's pupil Tanomura Chikuden (1777-1835) (page 143 D); and Tsubaki Chinzan (1801-54), who continued the style of Kazan. The movement lingered on through the 19th century, its character becoming more and more submerged in the eclecticism of the age. Late in the century, however, Nanga was vigorously revived by a group of painters and intellectuals who saw it as a symbol of the freedom that had finally found political expression in the Meiji restoration of 1868. The greatest figure in this revival was Tomioka Tessai (1836-1924), a powerful and original painter whose explosive brushwork caught the true flavor of the Chinese Individualists. In his figures, however, such as the vigorous study of the Zen master Feng-kan (A), there is an element of boisterous humour that is very Japanese.

Ukiyo-e

Although the Kanō, Namban, Nanga, and even Tosa schools all contributed to the rich tapestry of Tokugawa art, all were to a greater or lesser degree derivative from something else. The Kanō, Namban, and Nanga styles were of foreign inspiration, while the Tosa was a conscious keeping alive of the ancient tradition of the narrative handscroll. To the extent that they were original their originality lay in the novel blending of elements from two or three schools, such as we find in the work of Maruyama Ōkyo. The most lively art that flourished under the Tokugawa Shōguns, and by far the most original, was the Ukiyo-e, the Art of the " Floating World."

The artists of the Ukiyo-e claimed that they were reviving the true Yamato-e, in opposition to the foreign, academic Kanō that had dominated official painting for several centuries. If this were all they achieved, the Ukiyo-e would be of little interest. But they did far more than this. They created a new kind of art to reflect and to satisfy the needs of a new society.

In the early years of the Tokugawa period the patrons were the military, aristocratic class as before, and a few newly-rich merchants whose eyes were dazzled by the splendor of the great Momoyama screens and sliding doors. Nevertheless patrons no longer desired the old, conventional subjects of Japanese art: pine trees, flowers, or scenes from " The Tale of Genji." They wanted to carry into their houses the fashionable gatherings, pageantry, and festivals that went on around them. Some Kanō artists had treated these subjects as early as the 16th century. In 1574, for example, Eitoku painted a screen of life in Kyoto and its suburbs, and we have already referred to Kanō Naganobu's great screens, *Dancing at the Cherry-blossom Festival*, in the Hara Collection. By the 17th century, however, interest was already shifting away from these still purely aristocratic themes to the world of the rising common people.

Color plate 227 shows half of one of a pair of screens known as *Women Amusing Themselves* or, since they once belonged to the Matsu-ura family in northern Kyūshu, as the Matsu-ura *byōbu*. They were painted some time before 1650. The name of the artist is not known; it is clear, however, that he was not trained in the Kanō school. The screens show women and little girls engaged in various pastimes,

such as card playing, music, making-up, and smoking, introduced into Japan from Europe. Several of their dresses also reveal foreign influence. Screens depicting gorgeous dress materials were very fashionable at the time, partly as an echo of Momoyama grandeur that was beginning to filter down to the middle class, and partly as a symbol of the new-found prosperity. In the Matsu-ura screens the richness of Momoyama color is blended with a new realism of theme and feeling. Like others of the same kind, they represent a natural transition, both in subject matter and style, from the large-scale, colorful aristocratic art of the Momoyama period to the intimate, small-scale popular art of the 18th century, the true Ukiyo-e (B, C).

In the thriving city of Edo, the common man for the first time discovered both freedom and prosperity. The government, indeed, attempted by an endless stream of petty regulations to curtail his freedom, but these merely drove him to seek what compensation he could, and his energy found an outlet in the great variety of material and physical pleasures that the city had to offer. His moral code taught that, so long as he provided for his wife and family at home, what he did outside was his own affair. He took his pleasures where he found them, chiefly in the Yoshiwara, the gay quarter of the city. Here, a *samurai* could indulge in brawling, drinking, and licentiousness to a degree that would not have been tolerated elsewhere. The commoner might take no part in the ritual or ceremony of the aristocracy, but in the Yoshiwara he found a substitute in the beauty of the dancing girls, tea-house waitresses, and prostitutes, in their fashion parades, and in the rigid though no doubt playful etiquette by which they gave some dignity to their calling. The gaiety and extravagance of the "Floating World" of Edo reached its climax in the Genroku era (1688 - 1703). But the Yoshiwara continued to inspire artists of the Ukiyo-e until well into the 19th century.

The wood-block print

From the big screen decorated with a row of figures (color plate 227) it was a natural transition to the hanging scroll painted with a single figure. Kaigetsudō Andō (late 17th century), inspired by the sight of girls out walking in the Yoshiwara, created an ideal type of beauty, gorgeous in her dress, seductive in her pose,

KAIGETSUDŌ ANDŌ

懐
月
堂
安
慶

MORONOBU 師宣

KIYONOBU 清信

KIYOMASU 清倍

MASANOBU 政信

TOYONOBU 豐信

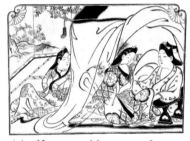

(A) HISHIKAWA MORONOBU Lover with Attendants: print, 17th century
Honolulu, Hawaii, Academy of Arts

(B) HISHIKAWA MORONOBU
Gay Life in Early Edo (detail):
from six-panel screen, 17th century
Boston, Mass. Mus. of Fine Arts

HARUNOBU 春信

highly stylized yet full of movement. The popularity of paintings of this sort was so great that means had to be found to reproduce them quickly and cheaply. Thus was evolved the Japanese color woodcut, the last great achievement of Japanese traditional art. Both the clear, sweeping, sharply accented lines of Kaigetsudō's paintings and their flat pattern of rich color lent themselves admirably to translation, in other hands, into the new medium.

As we saw in the first part of this book, the technique of wood-block printing had been developed in China in the T'ang Dynasty for the printing and illustrating of Buddhist *sūtras*. Color printing was invented in China in the 16th century or possibly earlier. We have already noted how Chinese painting manuals with woodblock illustrations in color were circulating in Japan among painters of the Nanga school. In the hands of the Ukiyo-e print designers the art of the wood-block developed along quite different lines.

The pioneers

The pioneer of wood-block printing in Edo was Hishikawa Moronobu (1618-94), who published no less than 130 different kinds of illustrated books, many of which depict the refined entertainments of the Yoshiwara. The fact that he called himself Yamato-eshi (Japanese Painter) shows that he considered himself to be in the direct tradition of the Yamato-e (B). Technically his prints were not revolutionary. Executed entirely without color, they consist of bold figure compositions in black on white, a technique called *sumi-zuri-e*, ink-printed picture. Even in so restricted a medium, however, his designs are remarkable for their freedom and for their power to suggest texture and color (A).

The *sumi-zuri-e* was developed by members of the Torii family: Kiyonobu (1644-1729); Kiyomasu (1694-1716?); and Kiyonobu II (1702-52) who had special contracts to supply posters and handbills for the popular Kabuki theater. Other early masters, such as Masanobu (1686-1764) and Toyonobu (1711-85), specialized in single figures of beautiful women.

By this time patrons, accustomed to the splendors of Kaigetsudō's paintings, were demanding color in their prints. It was therefore added afterwards by hand, at first in simple dabs of orange-red, *tan-e*. Later several colors were used, in a technique sometimes called *beni-e* after the rose-red (*beni*) that gave it its particularly attractive effect, sometimes *urushi-e*, from the brilliant "lacquer" gloss of the black. Kiyonobu II and Masanobu were the outstanding masters of the *urushi-e*. But even this is classed as "primitive" by the historians.

The full-color print

The final step in the evolution of the wood-block print, the perfecting of full-color printing with multiple blocks, was taken in 1765 when Suzuki Harunobu (1725-70) produced a *de luxe* edition of an almanac, its illustrations printed in seven or eight colors. So accurate was the register of the blocks and so fine the detail that this technique became known as *nishiki-e*, "brocade" painting. A popular edition

of Harunobu's almanac led to a huge demand for his work, which he met by increasing labor. In the few remaining years of his life he turned out over 600 prints, chiefly of the girls of the Yoshiwara, whom he portrayed with wonderful grace and charm (c). Typical of his style is the *Courtesan with Attendants* (color plate 228). This is clearly a morning scene, and Harunobu shows the lady in relaxed mood, as she watches her little maids playing with a dog. It is a precision of form and subtlety of color harmony that the woodcut achieved in the hands of a master. It has moreover a poignant tenderness of feeling, as if to suggest that the innocent pleasures of youth are as transient as the "Floating World" itself.

Less lyrical than those of Harunobu, but grander and more stately in design, are the woodcuts of Torii Kiyonaga (1752-1815), who was the first to spread his compositions over two or three sheets, each of which could be seen as a separate picture in itself. In his splendid *Snowy Morning in the Yoshiwara* a young aristocrat after a night of dissipation is composing, on the left, a poem suitable to the occasion, while behind him his favorite of the night before stands in graceful *déshabillé* (D). All in the room have turned to look at two fishes that another girl has brought in, their concentration subtly uniting the separate figures. This print shows well Kiyonaga's power to endow his figures with such grandeur and dignity that the realism of the scene is transcended.

We have room to mention only the greatest masters of the color print. Kitagawa Utamaro (1753-1806) began by following Kiyonaga, but soon created an ideal type of female beauty. He also invented the close-up, or "big face" (*ōkubi-e*), which he used with great effect in portraits of courtesans and tea-house waitresses. He explored the world of women with a profound understanding, and some of his prints are frankly erotic. But he also broadened the scope of color printing to include flowers, birds, insects, and seashells, observed with accuracy and insight. Utamaro was followed by Utagawa Toyokuni (1767-1825) and Tōshūsai Sharaku (late 18th century), both of whom were famous for their actor prints, the former for his standing figures, the latter for his powerful close-ups. Typical of Sharaku's striking and often humorous designs is his *Actors of the Kabuki Theater*, made in 1794 (color plate 229). It is one of a series of over 100 actor prints which he designed in a furious burst of energy in that single year, after which he sank into obscurity.

Masters of landscape

By the end of the 18th century these and a host of lesser print makers had thoroughly explored the world of the brothels, theaters, and tea houses of Edo. But the art of the color print was not yet exhausted. Some Ukiyo-e artists had already introduced landscapes into their work as settings or backgrounds for their figures, and several prints in Utamaro's seashell series, poetically named *Gifts of the Ebb Tide*, are almost pure landscapes. Now, however, landscape became the print makers' main theme.

The first great master of this new form was Katsushika Hokusai (1760-1849), the "old man mad about drawing," as he called himself. His art education included

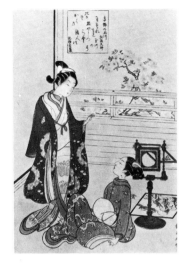

(C) SUZUKI HARUNOBU Boy, Girl, and Viewing Glass: color print, 18th century
New York, Metropolitan Mus. of Art

KIYONAGA

UTAMARO

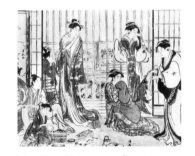

(D) TORII KIYONAGA Snowy Morning in the Yoshiwara (detail): color print, 18th century
London, B. M.

HOKUSAI

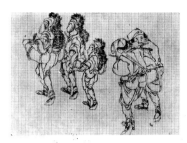

HIROSHIGE

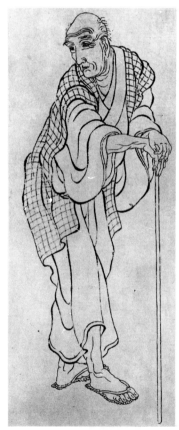

15 years doing actor prints and book illustrations, and studying the Tosa, Kanō, and Sōtatsu-Kōrin schools. Hokusai also studied Western landscape drawing. His first landscape prints were inspired by Dutch engravings, from which he acquired the single, low viewpoint, new in Oriental art, that makes his compositions so easy for the Western eye to appreciate. A draftsman of extraordinary power and fertility (A, B) he turned out a vast number of prints, strong in color and daringly modern in design. Some of these were published in sets, among them the scenes along the Tōkaidō (the highway from Tokyo to Kyoto) and the *Thirty-six* (actually 46) *Views of Mount Fuji*. In the print illustrated in color plate 230-2, Mount Fuji rises out of the mist behind a fisherman perched on a rock. The lines in his hand may hold either a net, or four cormorants that have dived out of sight beneath the waves. This print achieves its remarkable impact largely by contrasting the easy, sweeping lines of the mist and distant mountain with the short, jagged rhythms of the rocks and waves.

By the time he was 70 years old Hokusai's position as the supreme print maker of his day was being challenged by Andō Hiroshige (1797-1858). While Hokusai continually astonishes with the boldness of his invention, his colors are sometimes harsh and the exaggeration and distortion of his forms sometimes verges on expressionism. Hiroshige, while less original, was the more poetic landscapist, able to convey through the difficult medium of the print a sense of distance and atmosphere; his colors are truer to the subdued tones of the actual Japanese landscape than Hokusai's. Hiroshige's greatest work, the *Fifty-three Stages of the Tōkaidō*, (c) was published in 1853. This series was the last important achievement of the Ukiyo-e, for the modern world was already knocking at the gates of Japan.

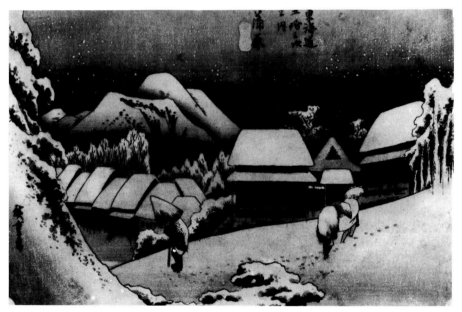

Modern times

In 1854 Commodore Perry's naval expedition dropped anchor in Tokyo Bay, and a new chapter opened in Japanese history (D). Japan's doors to the outside world, firmly closed since 1640, were flung open again. This time it was not the culture of China that flowed in, but that of the aggressive, industrial West. In their quick enthusiasm to catch up, after two centuries of isolation, many Japanese were ready to abandon their own culture forthwith. Painters and architects imitated Western styles with such readiness and skill that there was for a time a very real danger that their own traditional arts would perish through neglect; some people even started to destroy ancient works of art. Toward the end of the 19th century, however, chiefly through the influence of Okakura Kakuzō and the American Ernest Fenollosa, interest in the Japanese tradition began to revive. Since then, Japanese art, like that of China and India, has been enlivened by the interplay between rediscovered tradition, on the one hand, and the international modern movement on the other.

In 1888 Okakura established the Tokyo Academy of Art (now the Tokyo University of Art), in which the Kanō, Tosa, and Yamato-e styles were studied, practiced, and given a modern flavor. One of the most distinguished exponents of this modernized traditional art was Shimomura Kanzan (1873-1930), a pupil of two orthodox Kanō masters. He was noted expecially for huge screens in which he tempered the decorative style of the Momoyama period with a modern realism—a type of synthesis that holds a strong appeal for conservative Japanese taste (page 293).

In the 20th century Japan's enthusiasm for European art, which the influence of Fenollosa and Okakura had hitherto held in check, broke into full flood, and there emerged a host of talented oil painters, many of whom, trained in France, had so mastered the style of the French Post-Impressionists that their work was almost completely European. Among the older generation Yasui Sōtarō (born 1888) is outstanding. In more recent works by slightly younger painters, such as Kawaguchi Kigai (born 1892) and Wakita Kazu (born 1908), can be seen the influence of Bonnard, Matisse, and Picasso.

The fact that oils as a painting medium are not native to Japan makes it perhaps inevitable that Japanese oil painters follow closely their European models. The print makers, on the other hand, employ a medium—the wood-block—with a long history in the Far East, and one that, less than two centuries ago, reached its highest achievement in Japan itself. Thus it is by print makers that the most modern, original, and yet essentially Japanese, work is produced today.

The pioneer of the color-print revival was Yamamoto Kanae (1882-1946), who was trained as an engraver of Western style line-blocks for book and magazine illustration, and later spent several years in Europe. Although his own landscape and portrait prints are Western in style (page 293), his rediscovery of the medium opened the way for the next generation, who experimented freely with the infinite range of designs, colors, and textures that wood-block printing can produce. The most influential of these modernists were Onchi Kōshirō (1891-1955), who used natural forms such as leaves and feathers in his sensitive semi-abstract composi-

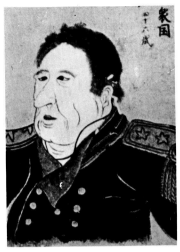

(D) ANONYMOUS Commodore Perry (detail): from six-panel Perry Expedition screen, 1854 *Tokyo, University Mus.*

YASUI SŌTARŌ

ONCHI KŌSHIRŌ

安井曽太郎

思地孝四郎

(E) HASHIMOTO OKIIE Stone Garden: wood-block print, 20th century

149

HASHIMOTO OKIIE

SAITŌ KIYOSHI

MUNAKATA SHIKŌ

橋本興家 齋藤清 棟方志功

tions; and Saitō Kiyoshi, born 1907 (color plate 232). Saitō is a highly professional print maker whose designs have become progressively more abstract, though his inspiration, like that of Hashimoto Okiie (born 1899), is often derived from the harmony and discipline of traditional Japanese architecture (B) and garden design (page 149E).

The move toward pure abstraction among Japanese print makers since the end of World War II has been one inevitable result of Japan's agile response to the latest trends in modern Western art. Munakata Shikō (born 1903), however, has obstinately refused to surrender to prevailing fashions. He started his career as an oil painter, but, as he said, "I wanted the universe at the tip of my brush, and I realized it never could be while I worked in a borrowed medium." Certainly there is some Western influence in his prints, notably that of Gauguin and Picasso; but in spirit and content his work is purely Japanese, his chief sources of inspiration being Zen Buddhism and the tempestuous Nanga painter Tessai (see page 144). Of his own bold print of the Buddhist Saint Kasen'en, Munakata said: "He looks exactly like my father. I like this print because of that, but it always reminds me of a scolding he once gave me." Like the great Chinese Individualists of the 17th century, Munakata founded no school. However, his inimitable genius is a vital factor in preserving the native spirit in Japanese art against a too-ready acceptance of new movements from abroad (A).

(A) MUNAKATA SHIKŌ
Kasen'en: wood-block print, 1939
Honolulu, James A. Michener Coll.

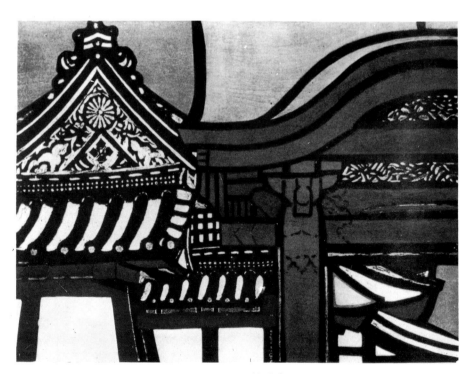

(B) HASHIMOTO OKIIE Gate and Retainers' Hall, Nijō Palace:
colored wood-block print, 1957
Honolulu, James A. Michener Coll.

Color Plates

ANONYMOUS Young Ladies Adorning Themselves with Jewels (detail) 2nd-3rd century A. D. *polychrome on hollow tile* $29\frac{1}{8} \times 94\frac{1}{2}$ *in.*
Boston, Mass., Museum of Fine Arts, Ross Collection

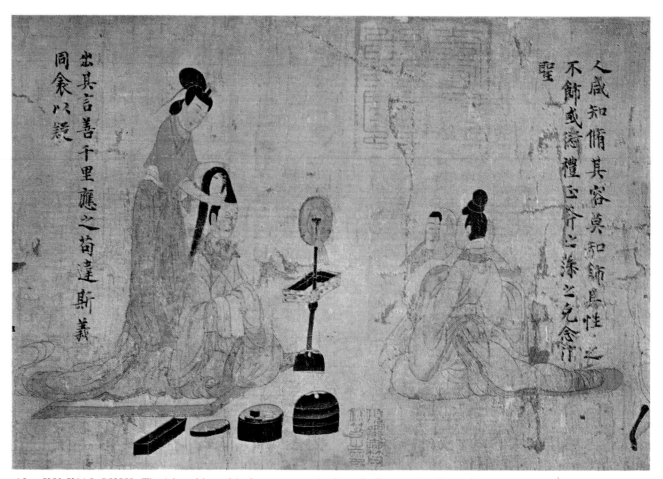

人咸知脩其容莫知飾其性性之
不飾或愆禮正斧之澡之免念作
聖

出其言善千里應之茍違斯義
同衾以疑

After KU K'AI-CHIH The Admonitions of the Instructress to the Court Ladies: handscroll (detail) 10th century?
ink and light colors on silk 9¾ × 137½ in.
London, British Museum

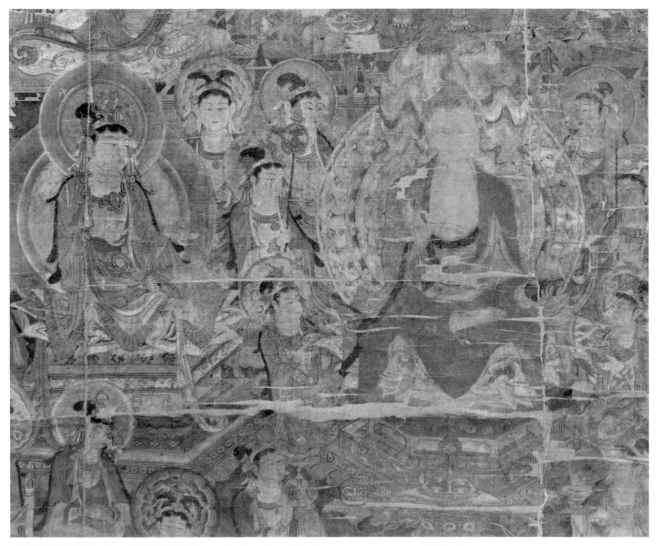

ANONYMOUS (from TUNHUANG) The Paradise of Bhaishajyaguru: hanging scroll (detail) early 10th century
ink and colors on silk 81 × 67 in.
London, British Museum

ANONYMOUS (from TUNHUANG) The Pursuit of the Messengers: fragment of a banner, late 9th-early 10th century
ink and colors on silk 5¾ × 7¾ in.
London, British Museum

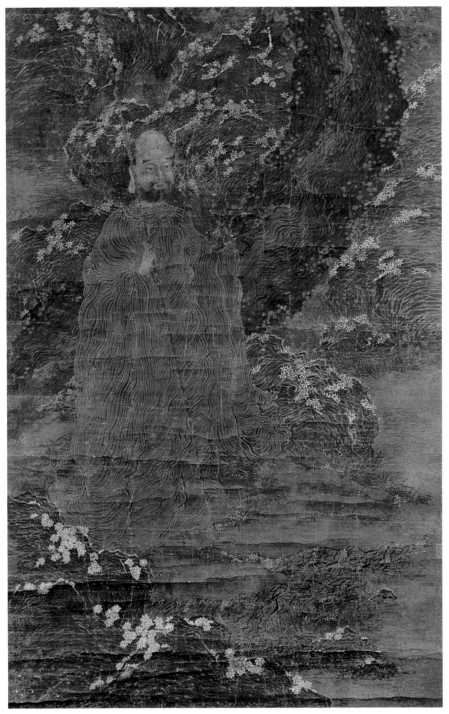

CH'EN YUNG-CHIH Buddha under a Mango Tree (detail): hanging scroll
after WEI-CH'IH I-SENG, about 1023 *ink and colors on paper 82¾ × 28 in.*
Boston, Mass., Museum of Fine Arts

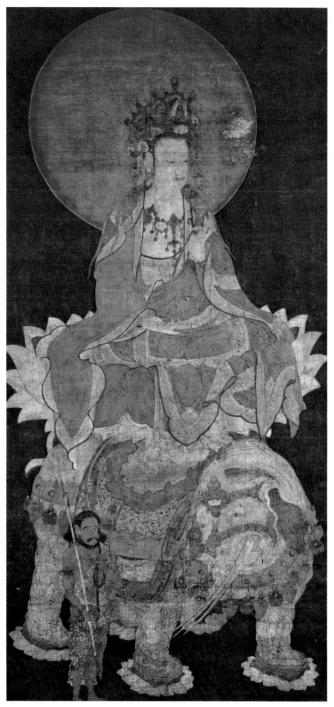

ANONYMOUS Sāmantabhadra and an Attendant: hanging scroll,
Southern Sung Dynasty (1127-1279) *ink and color on silk* 45¼ × 21¾ *in.*
Cleveland, Ohio, Museum of Art, Mr. and Mrs. William H. Marlatt Fund

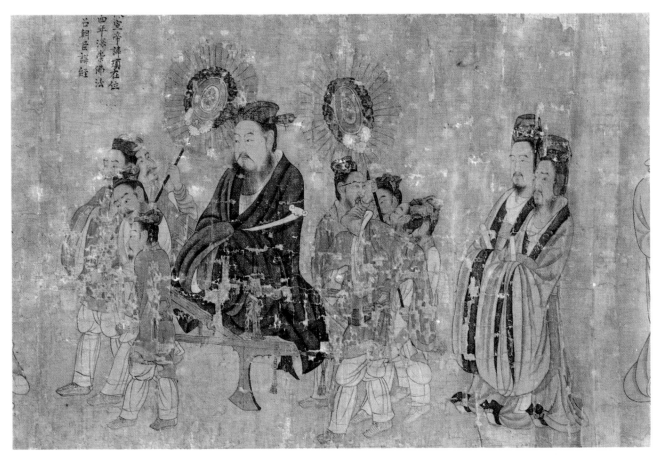

YEN LI-PEN Emperor Hsüan of the Ch'en Dynasty: from the handscroll of Portraits of the Thirteen Emperors, mid-7th century
ink and colors on silk 20¼ × 209 in.
Boston, Mass., Museum of Fine Arts

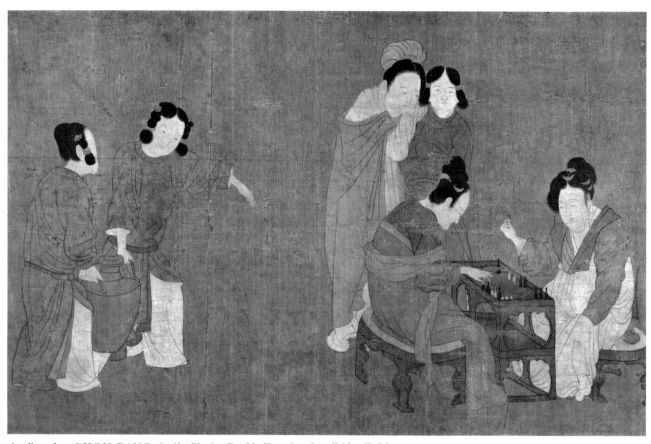

Attributed to CHOU FANG Ladies Playing Double Sixes: handscroll (detail) 8th century
ink and colors on silk height 12½ in.
Washington, D. C., Freer Gallery of Art, Smithsonian Institution

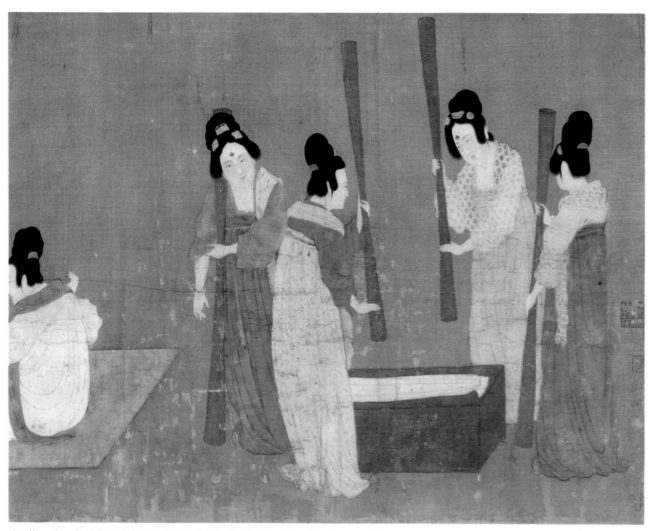

Attributed to EMPEROR HUI-TSUNG Ladies Preparing Newly-woven Silk (detail): handscroll after CHANG HSÜAN,
12th century *ink and colors on silk* *14⅝ × 57 in.*
Boston, Mass., Museum of Fine Arts

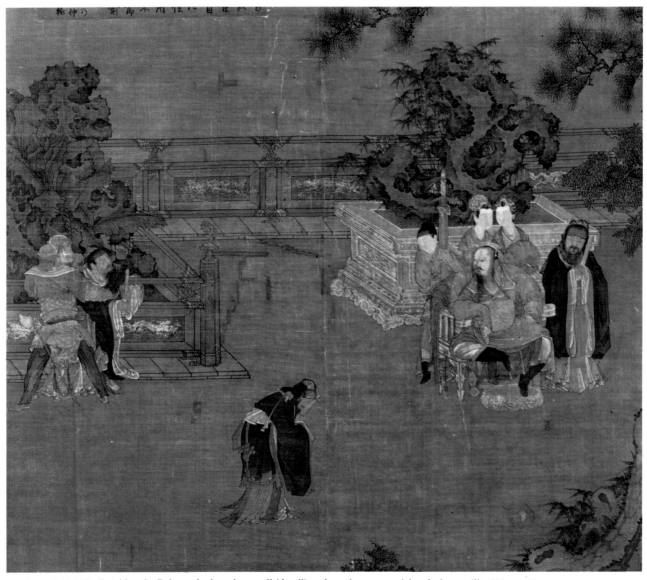

ANONYMOUS Breaking the Balustrade: hanging scroll (detail) early 12th century *ink and colors on silk* *68½ × 40¼ in.*
Taichung, Taiwan, National Palace Museum

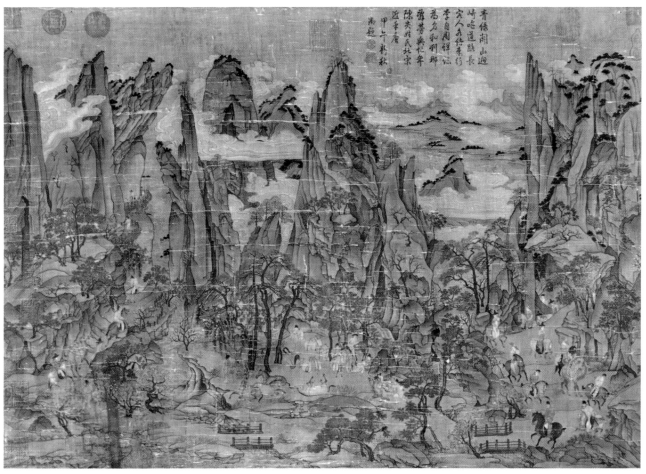

青綠湖山迴
婦嗁遠縣長
宴人夷伏束行
李自圉祥記
為名私明鄉
飛夢吳亿年
陳失作氏此宗
近甲午秋林
尚題

ANONYMOUS Emperor Ming-huang's Journey to Shu: hanging scroll, probably 12th century *ink and colors on silk 21¾ × 31 in.*
Taichung, Taiwan, National Palace Museum

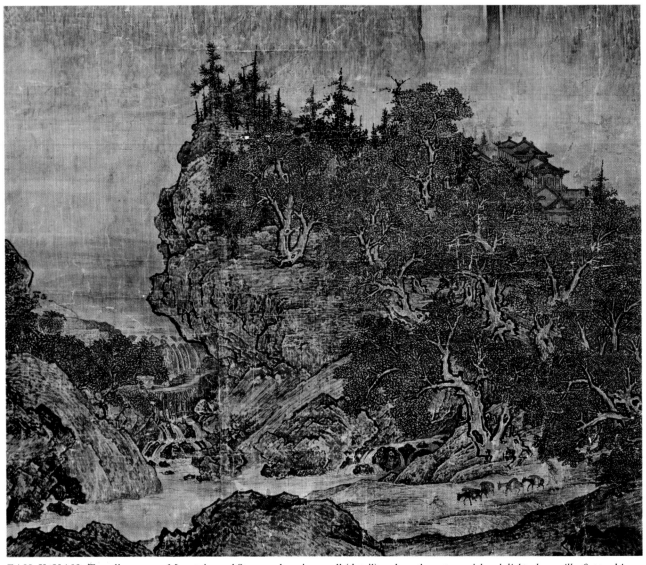

FAN K'UAN Traveling among Mountains and Streams: hanging scroll (detail) early 11th century *ink and slight color on silk 61 × 29¼ in.*
Taichung, Taiwan, National Palace Museum

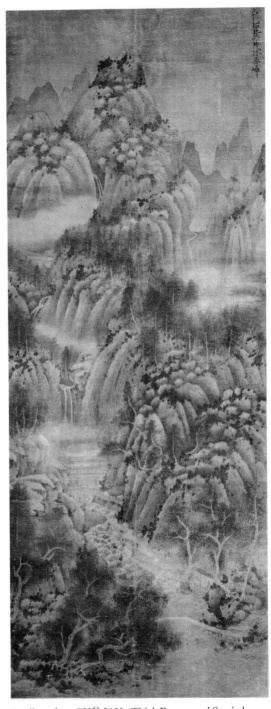

Attributed to CHÜ-JAN Thick Forests and Serried
Peaks: hanging scroll, probably 14th century
ink and colors on silk 73 × 29 in.
London, British Museum

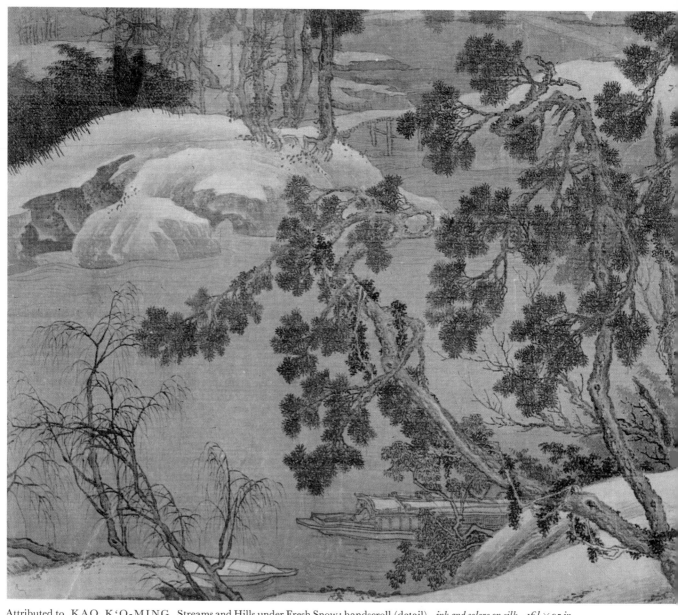

Attributed to KAO K'O-MING Streams and Hills under Fresh Snow: handscroll (detail) *ink and colors on silk 16⅜ × 95 in.*
New York, collection John M. Crawford Jr.

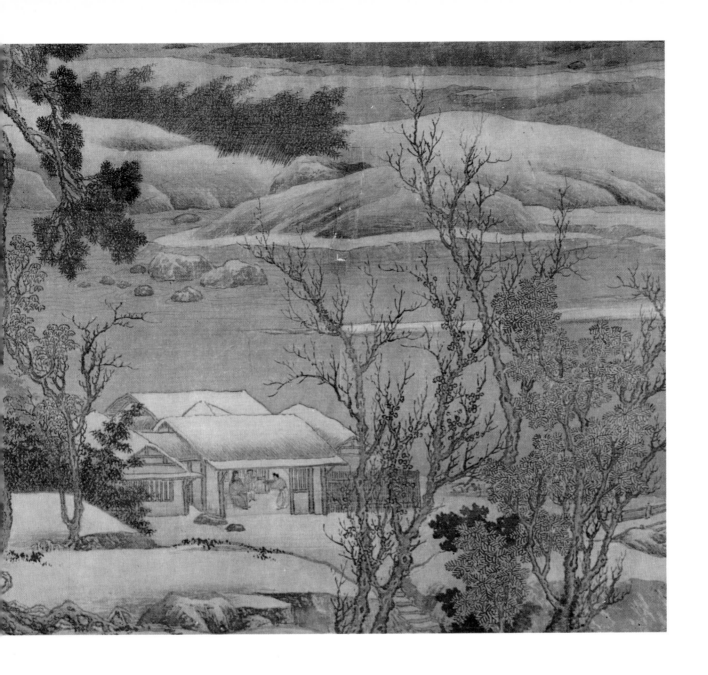

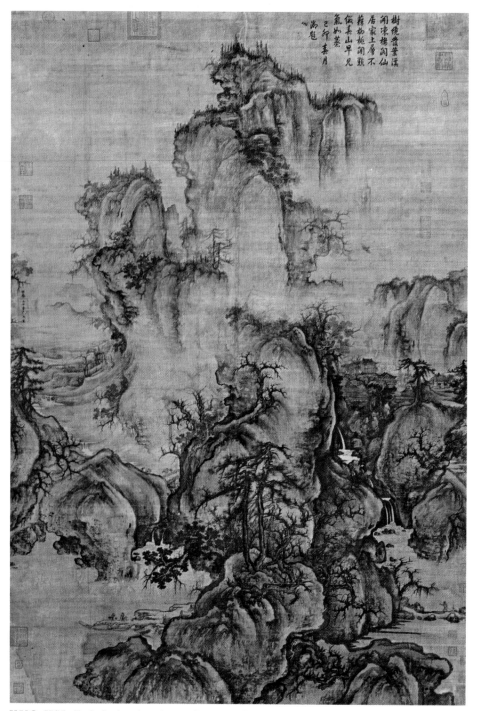

KUO HSI Early Spring: hanging scroll, 1072 ° *ink and light colors on silk* 62¼×42⅜ *in.*
Taichung, Taiwan, National Palace Museum

166

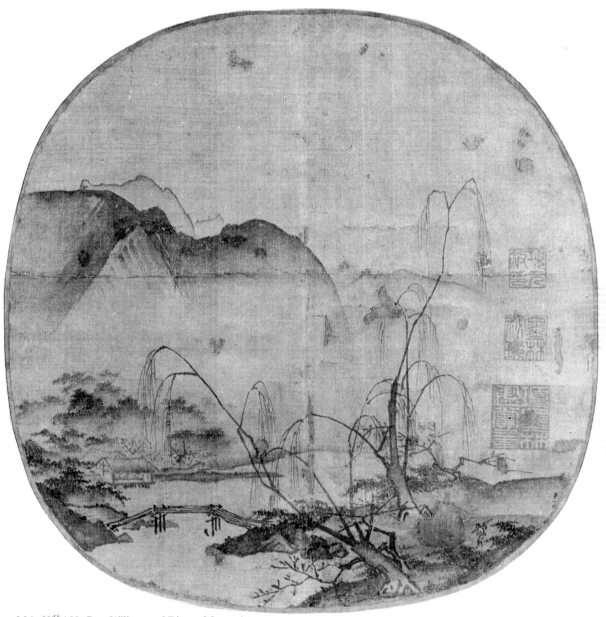

MA YÜAN Bare Willows and Distant Mountains: fan, early 13th century *ink and slight color on silk* $9\frac{3}{8} \times 9\frac{1}{4}$ *in.*
Boston, Mass., Museum of Fine Arts

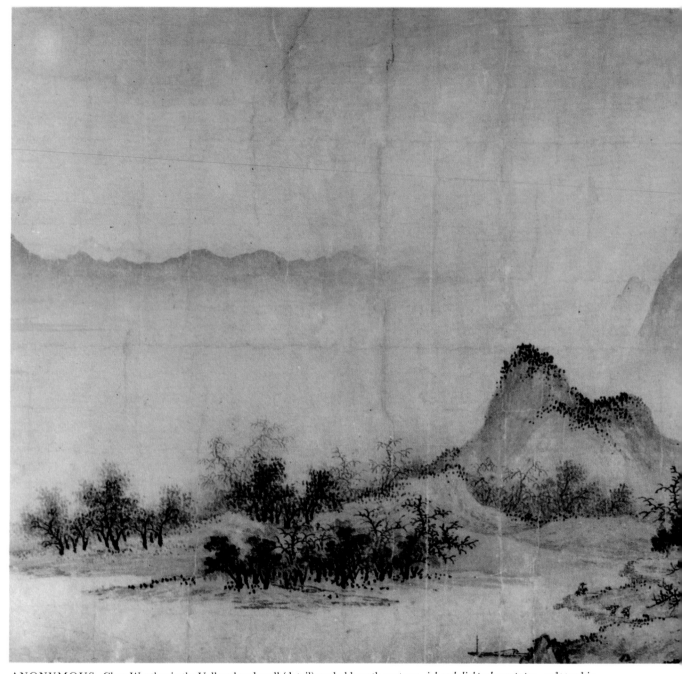

ANONYMOUS Clear Weather in the Valley: handscroll (detail) probably 12th century *ink and slight color on paper* *14¾×59⅜ in.*
Boston, Mass., Museum of Fine Arts

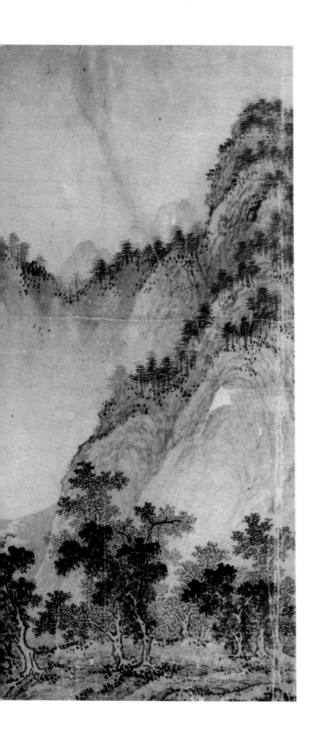

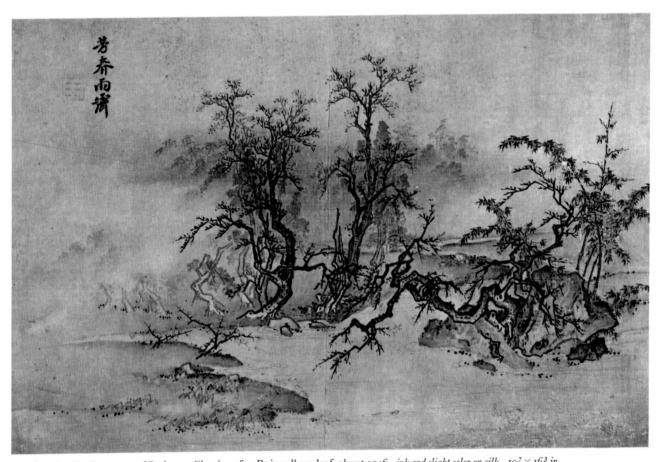

MA LIN The Fragrance of Spring — Clearing after Rain: album leaf, about 1246 *ink and slight color on silk* $10\frac{7}{8} \times 16\frac{3}{8}$ *in.*
Taichung, Taiwan, National Palace Museum

After CHAO PO-CHÜ The Entry of the First Han Emperor into Kuanchung: handscroll (detail) probably 16th century
ink and colors on silk 11¾ × 123¼ in.
Boston, Mass., Museum of Fine Arts

LI SUNG Emperor Ming-huang Watching a Cockfight: fan, after 1225 *ink and light colors on silk* 9¼ × 8¼ *in.*
Kansas City, Mo., William Rockhill Nelson Gallery of Art and Mary Atkins Museum of Fine Arts, Nelson Fund

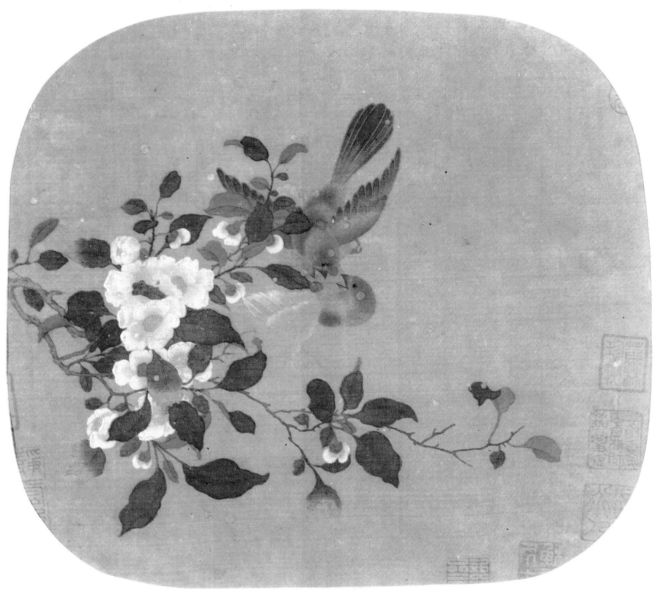

Attributed to LIN CH'UN Birds Quarreling on a Blossoming Quince: fan, 12th century *colors on silk* $9\frac{1}{4} \times 10\frac{1}{2}$ *in.*
Kansas City, Mo., William Rockhill Nelson Gallery of Art and Mary Atkins Museum of Fine Arts, Nelson Fund

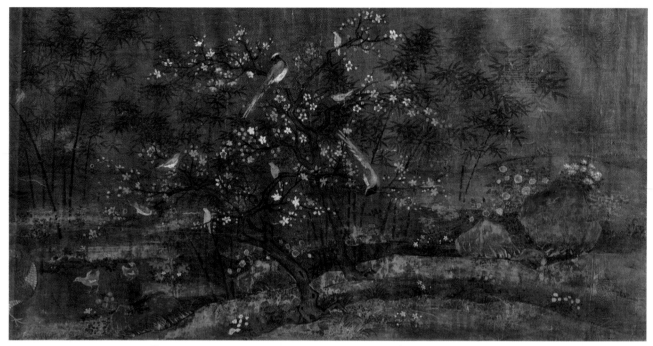

Attributed to HUANG CH'ÜAN An Assembly of Birds on a Willow Bank: handscroll (detail)
probably Sung Dynasty (960-1279) with later repainting *ink and colors on silk* *9 × 72⅜ in.*
New Haven, Conn., Yale University Art Gallery, Gift of Mrs. William H. Moore

ANONYMOUS Woman and Children on Horseback, with Mongol: album leaf, 12th or early 13th century
ink and colors on silk $9\frac{3}{4} \times 8\frac{7}{8}$ in.
Boston, Mass., Museum of Fine Arts

MU-CH'I Landscape (detail): from the handscroll of Scenes of the Hsiao and Hsiang Rivers, mid-13th century
ink and slight color on paper height 13 in.
Tokyo, Nezu Art Museum

CH'IEN HSÜAN Yang Kuei-fei Mounting a Horse: handscroll (detail) 1295 *ink and colors on paper* $11\frac{5}{8} \times 46\frac{3}{4}$ *in.*
Washington, D. C., Freer Gallery of Art, Smithsonian Institution

CHAO MENG-FU Autumn Colors on the Ch'iao and Hua Mountains: handscroll (detail) 1295 *ink and colors on paper 11¼ × 36¾ in.*
Taichung, Taiwan, National Palace Museum

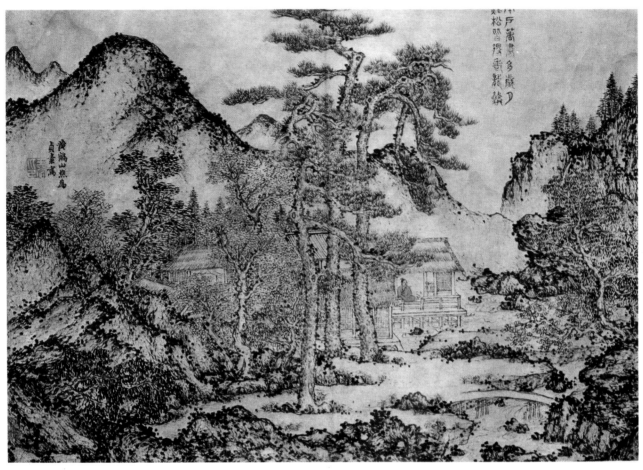

WANG MENG Scholar in a Pavilion under Trees: album leaf, mid-14th century *ink and slight color on paper 15⅝ × 22¼ in.*
Cleveland, Ohio, collection Mrs. A. Dean Perry

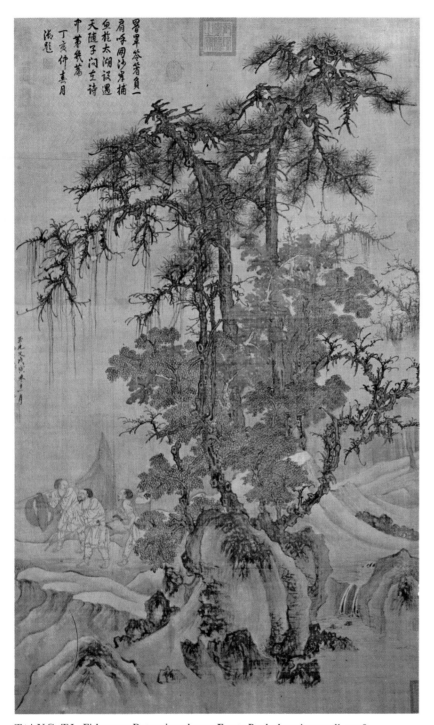

T'ANG TI Fishermen Returning along a Frosty Bank: hanging scroll, 1338
ink and colors on silk 56¾ × 35¼ in.
Taichung, Taiwan, National Palace Museum

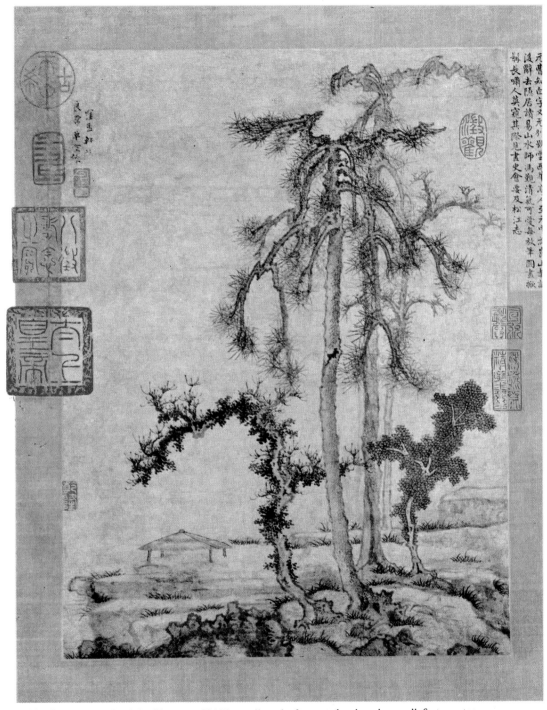

TS'AO CHIH-PO A Pavilion near Old Pines: album leaf mounted on hanging scroll, first quarter
of the 14th century *ink on paper 18⅞ × 14⅜ in.*
Paris, Musée Guimet

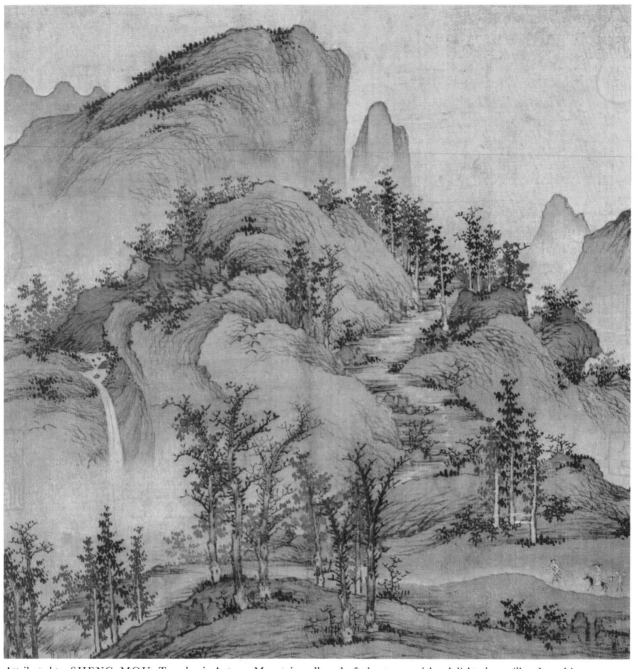

Attributed to SHENG MOU Travelers in Autumn Mountains: album leaf, about 1350 *ink and slight color on silk* $9\frac{3}{8} \times 10\frac{1}{2}$ *in.*
Cleveland, Ohio, Museum of Art, Mr. and Mrs. Severance A. Millikin Collection

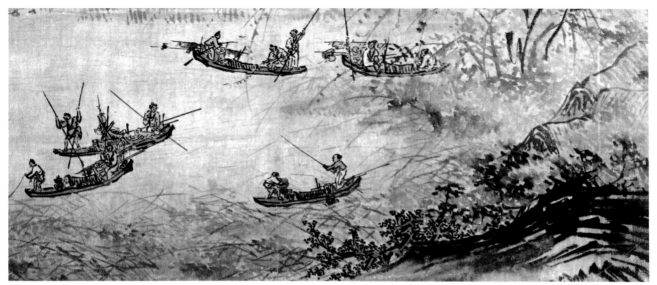

WU WEI The Pleasures of the Fishing Village: handscroll (detail) late 15th or early 16th century *ink and light colors on paper 10¾ × 100¼ in.*
Washington, D. C., collection Ching Yüan Chai

SHEN CHOU Gardening: album leaf, late 15th century *ink and colors on paper $15\frac{1}{4} \times 23\frac{3}{4}$ in.*
Kansas City, Mo., William Rockhill Nelson Gallery of Art and Mary Atkins Museum of Fine Arts, Nelson Fund

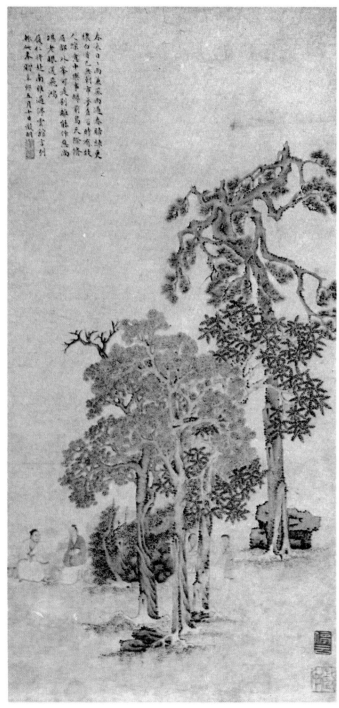

WEN CHENG-MING A Farewell Visit: hanging scroll, 1531
ink and light colors on paper $20\frac{5}{8} \times 10\frac{1}{8}$ in.
Lugano, Switzerland, collection Dr. Franco Vannotti

WEN PO-JEN Mountain Landscape: hanging scroll (detail) 1561
ink and colors on paper $50\frac{5}{8} \times 15\frac{1}{8}$ in.
Seattle, Wash., Art Museum, Eugene Fuller Memorial Collection

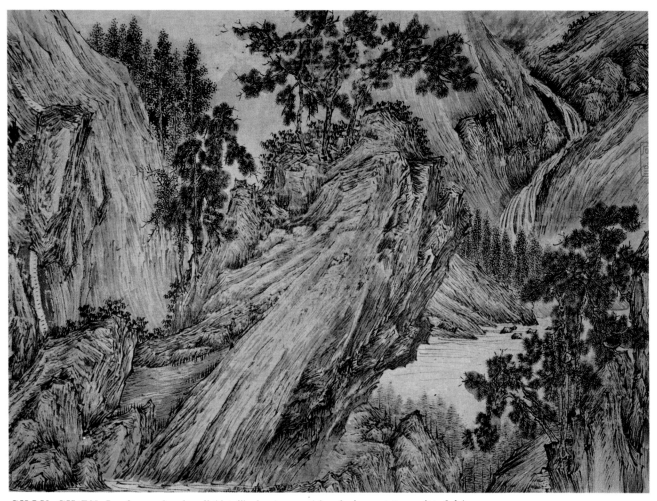

CHOU CH'EN Landscape: handscroll (detail) about 1500 *ink and colors on paper* $12\frac{1}{4} \times 165\frac{3}{8}$ *in.*
New York, collection W. H. C. Weng

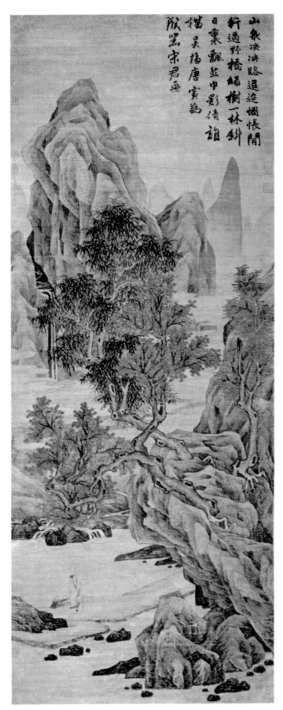

山象決決路迢迢倜悵間
行過野橋綠樹一林稀
日暮飄歸中影倩誰
描吳楊唐寅戲
成崙宋君画

T'ANG YIN Strolling across a Summer Stream:
hanging scroll, early 16th century
ink and slight colors on satin 53½ × 21⅜ in.
Toronto, Canada, Royal Ontario Museum

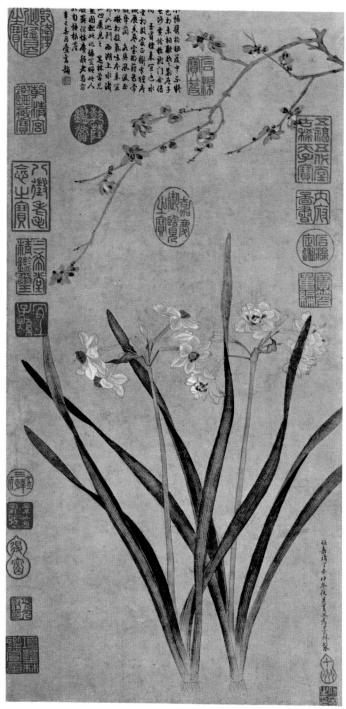

CH'IU YING Narcissus and Flowering Apricots: hanging
scroll, 1547 *ink and colors on paper 19¼ × 9⅝ in.*
Washington, D. C., Freer Gallery of Art, Smithsonian Institution

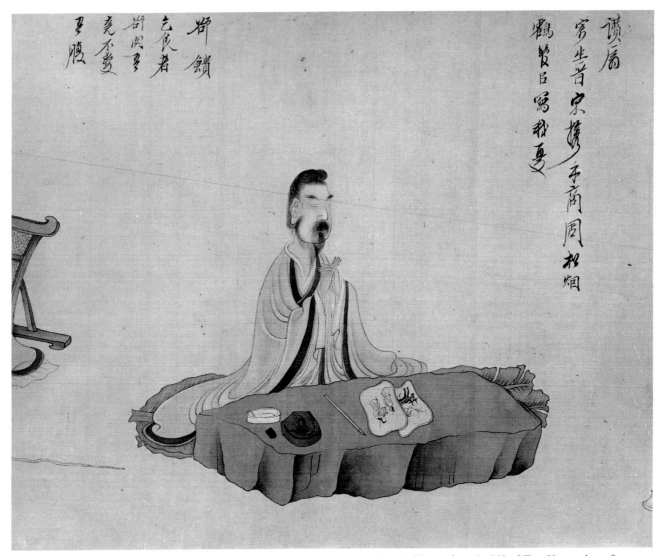

讚屬
寫坐昔宋撰平商周松烟
觀筆已寫稿夏

卻鑽
亢食者
齡兒多
竟不變
立腹

CH‘EN HUNG-SHOU The Poet T‘ao Yüan-ming Meditating: from the handscroll of Scenes from the Life of T‘ao Yüan-ming, 1650
ink and light colors on silk 12 × 121¼ in.
Honolulu, Hawaii, Academy of Arts

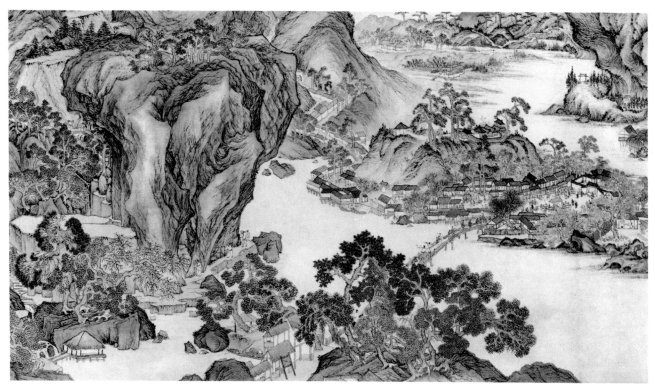

WU PIN Greeting the Spring: handscroll (detail) 1600 *ink and colors on paper* $13\frac{3}{4} \times 102$ *in.*
Cleveland, Ohio, Museum of Art, J. H. Wade Fund

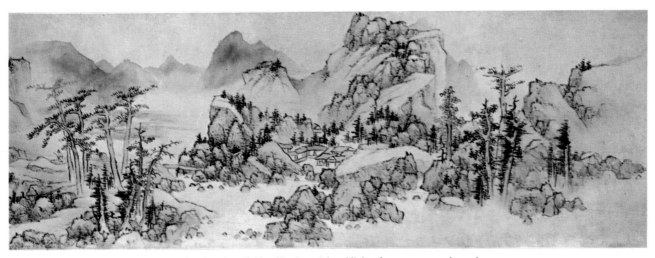

LAN YING The Fu-ch'un Mountains: handscroll (detail) 1650 *ink and light colors on paper 12¼ × 91 in.*
Zurich, collection C. A. Drenowatz

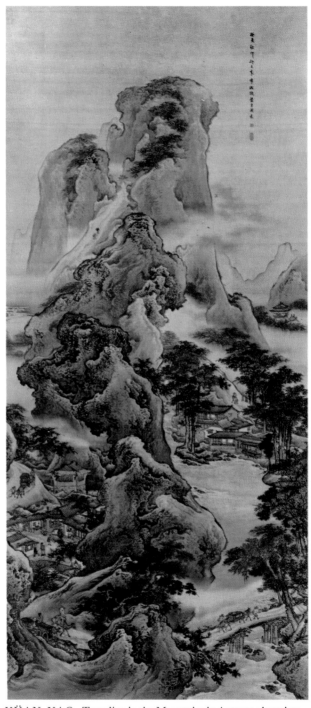

YÜAN YAO Traveling in the Mountains in Autumn: hanging scroll, 1742 *ink and colors on silk $81\frac{7}{8} \times 39$ in.*
Hamburg, Museum für Kunst und Gewerbe

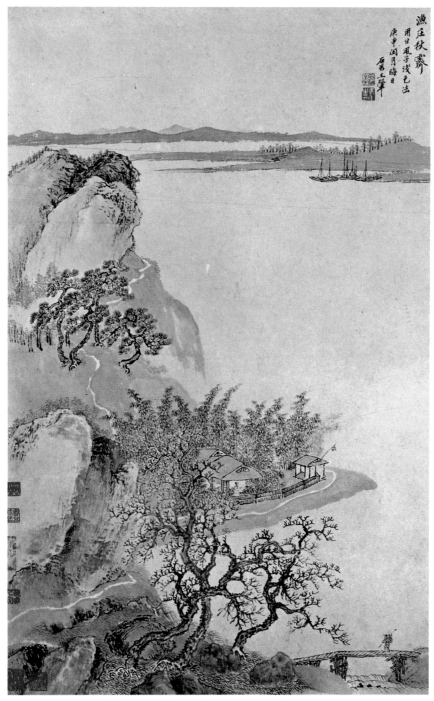

漁
莊
秋
霽

用
廿
風
子
淺
色
法

庚
申
閏
月
梅
日

石
谷
王
翬

WANG HUI Landscape: hanging scroll, 1680 *ink and colors on paper* $24\frac{1}{2} \times 15\frac{5}{8}$ *in.*
Honolulu, Hawaii, Academy of Arts

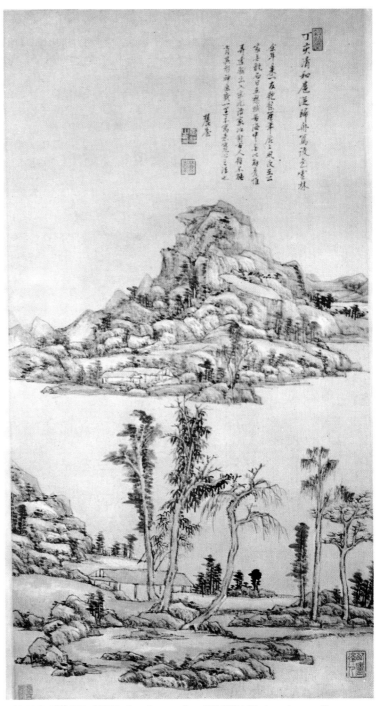

WANG YÜAN-CH‘I Landscape after NI TSAN: hanging scroll, 1707
ink and colors on paper *$31\frac{5}{8} \times 17\frac{1}{8}$ in.*
Cleveland, Ohio, Museum of Art, John L. Severance Fund

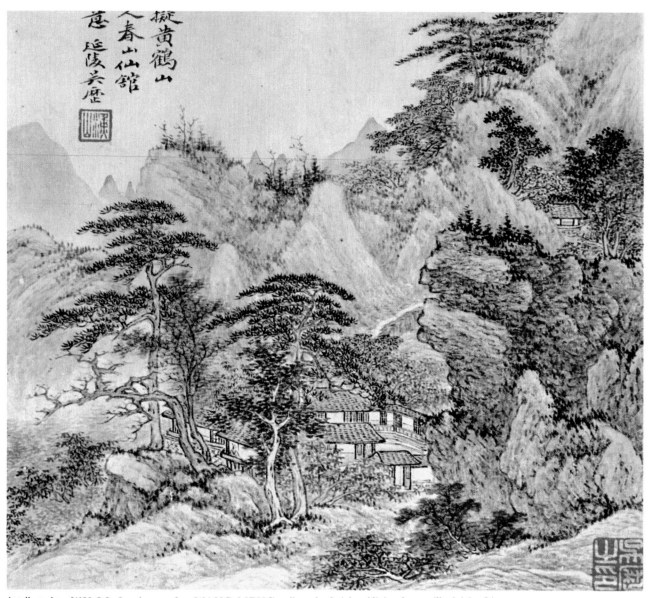

Attributed to WU LI Landscape after WANG MENG: album leaf *ink and light colors on silk* *height 7⅞ in.*
Osaka, Japan, Municipal Art Museum

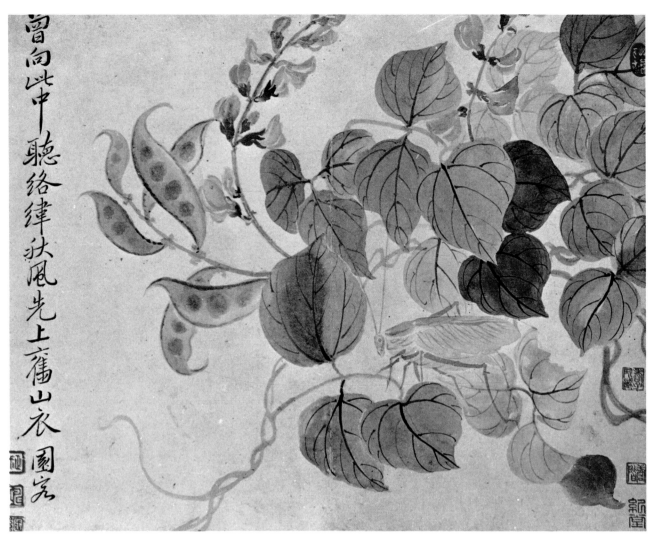

曾向此中聽絡緯秋風先上舊山衣 園客

YÜN SHOU-P'ING Flowers: album leaf, 17th century *ink and slight color on paper*
Honolulu, Hawaii, Academy of Arts

197

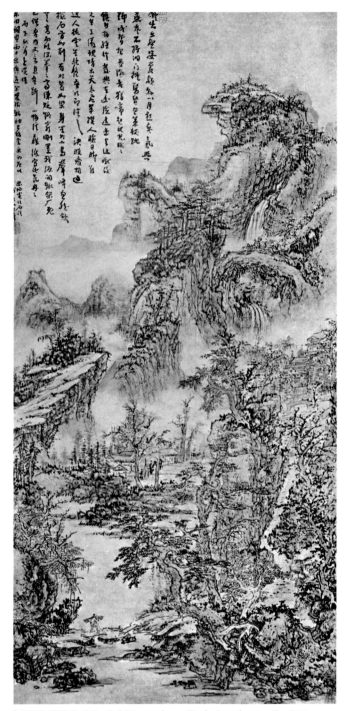

SHIH-CH'I Wooded Mountains at Dusk: hanging scroll, 1666
ink and light colors on paper 49 × 23⅝ in.
New York, collection John M. Crawford Jr.

198

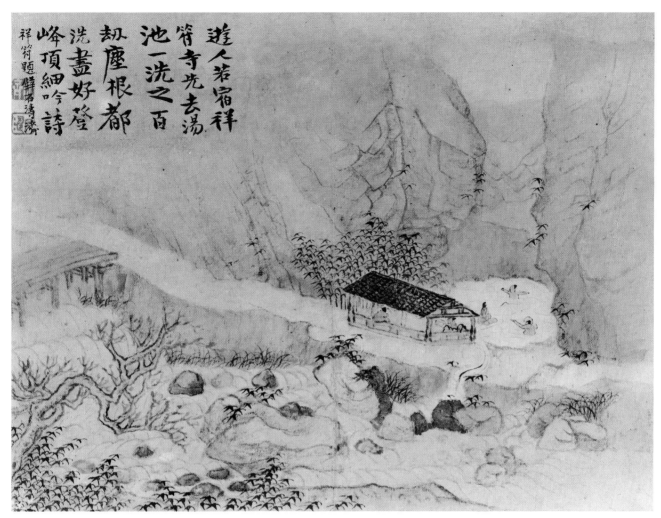

遊人若宿祥
符寺先去湯
池一洗之百
劫塵根都
洗盡好登
峰頂細吟詩
祥符題

SHIH-T'AO The Hot Springs on Huang-shan, with People Bathing: album leaf, late 17th century *ink and light colors on paper*
Ōiso, Japan, *collection the late Sumitomo Kanichi*

ANONYMOUS Loquats: from "Treatise on the Paintings and Writings of the Ten Bamboo Studio," 1633 *color woodcut* $9\frac{7}{8} \times 11\frac{1}{2}$ *in.*
Boston, Mass., Museum of Fine Arts

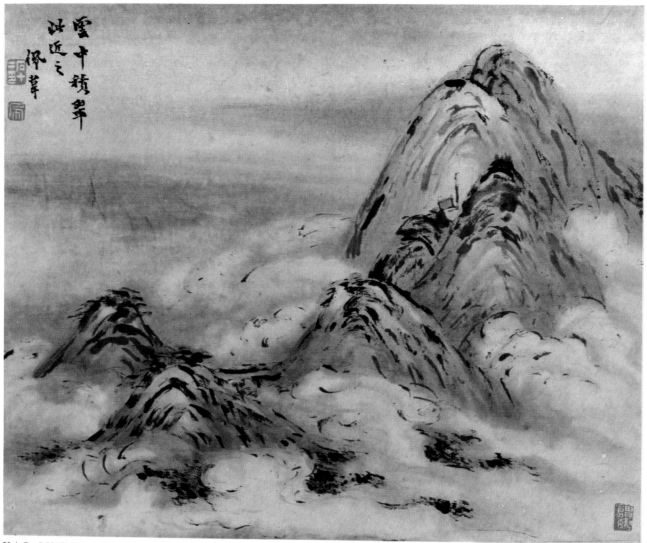

KAO CH'I-P'EI Landscape: album leaf, late 17th or early 18th century *finger painting, ink and colors on paper* $10\frac{5}{8} \times 13$ in.
Amsterdam, Rijksmuseum, Museum of Asiatic Art

HUA YEN Chrysanthemums: album leaf, 18th century *ink and colors on paper* $12\frac{1}{2} \times 14\frac{1}{2}$ *in.*
Lugano, Switzerland, collection Dr. Franco Vannotti

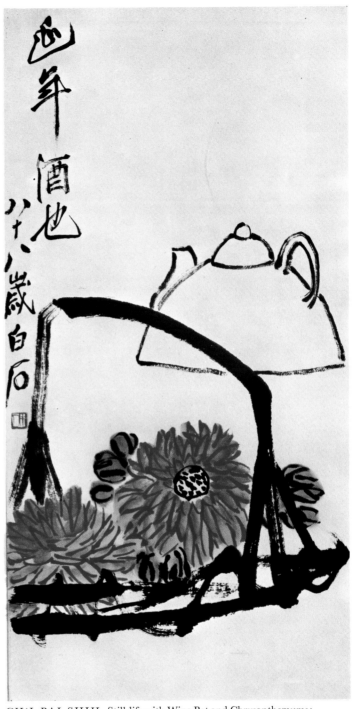

CH'I PAI-SHIH Still-life with Wine Pot and Chrysanthemums:
hanging scroll, 1951 *ink and watercolor on paper 25¼ × 13 in.*
London, Private Collection

LI K'O-JAN Two Scholars in a Wood, about 1940 *ink and color on paper* *height approximately 18 in.*
Honolulu, Hawaii, collection Madame Tseng Yu-ho

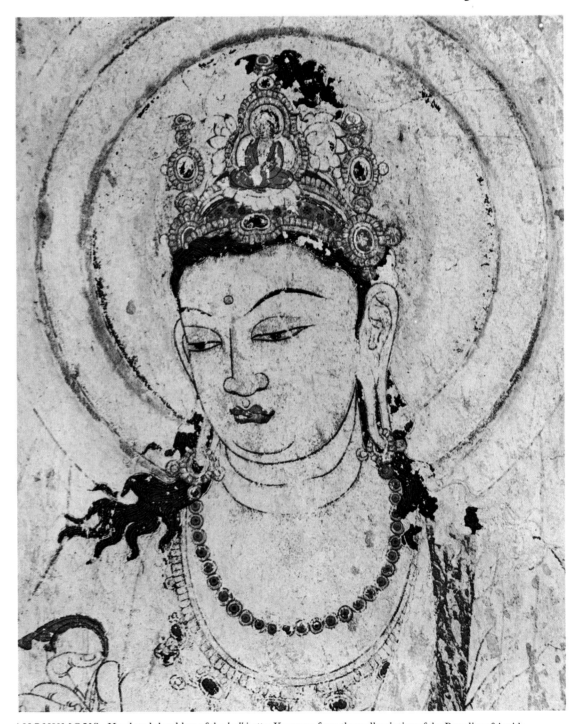

ANONYMOUS Head and shoulders of the *bodhisattva* Kannon: from the wall painting of the Paradise of Amida, about 700 A. D. *color on plaster 120 × 103 in.*
Nara, Japan, Hōryū-ji Museum

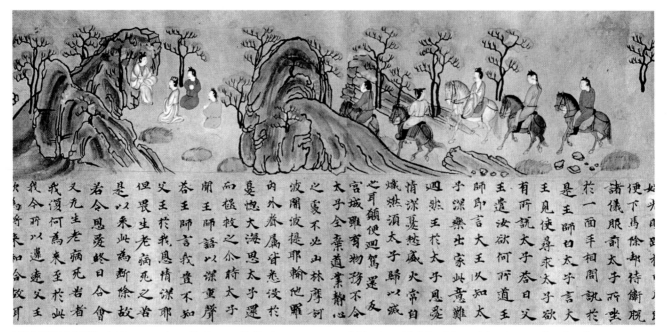

大我我若又若蒼但父苔而惆內波之太宮爐之漂迴子師玉王王王有是玉於便諸女
為今須令先是王王王王掘憔大開懷王子城溉耳溶深深即使遣見所於皆一下儀為人
将所何先生以王於師師枝大海提不全雖但顧求太太言欲汝太太說諸面當羽
天以為老老米於我恩語以海思太耶必藥有願便子子大出太于太于子師手相服日跣
知遣來病病此我恩死我謀思太子輪山道物駕駕深家王家子深於白相間訊脫
合速至死死為恩死情不除業子還他林業務還還恩此意道王答此父白扫於坐

ANONYMOUS A Messenger from Shākyamuni's Father comes to recall him from his Life of Austerities: from an Ingakyō Sūtra
handscroll, mid-8th century *colors on paper height 11 in.*
Japan, formerly collection Tarō Masuda

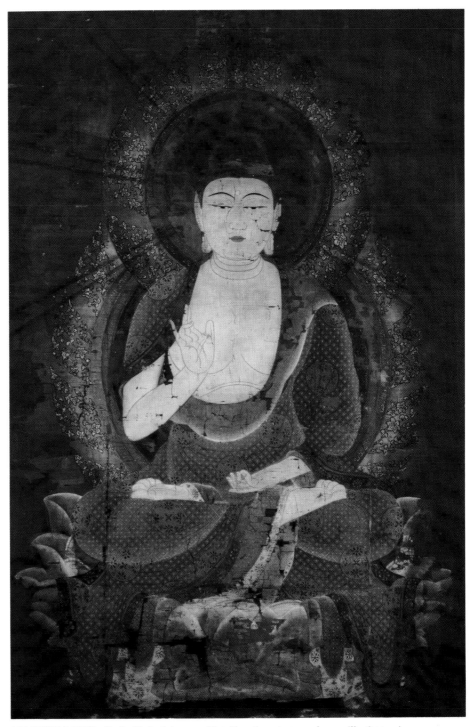

ANONYMOUS Shaka Nyōrai: banner (detail) 12th century *colors on silk 62 × 34 in.*
Kyoto, Japan, Jingō-ji

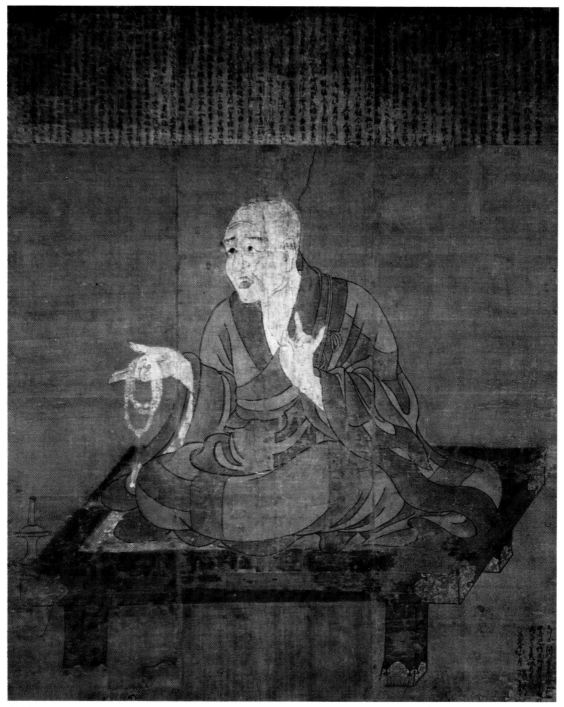

ANONYMOUS Portrait of the Shingon Patriarch Gonzō: hanging scroll, 11th century
ink and colors on silk 66 × 54 in.
Wakayama, Japan, Mount Kōya, Fumon-in

HOGEN EN-I Pictorial Biography of Ippen Shōnin: handscroll (detail) 1299 *ink and colors on silk* $14\frac{1}{8} \times 315\frac{3}{4}$ *in.*
Tokyo, National Museum

ANONYMOUS Michizane in Exile: from a Kitano-tenjin-engi handscroll (detail) about 1219 *ink and colors on paper* *20¾ × 318½ in.*
Kyoto, Japan, Kitano Shrine

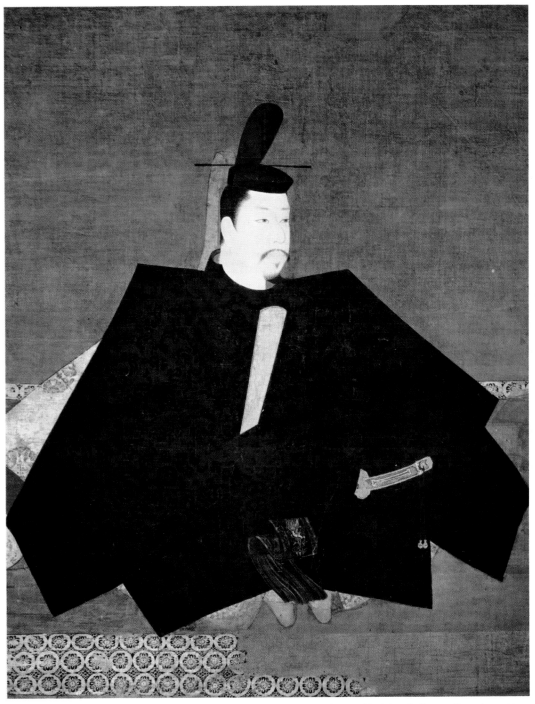

FUJIWARA TAKANOBU Portrait of Minamoto no Yoritomo, about 1188 *ink and colors on silk* $54\frac{7}{8} \times 44\frac{1}{8}$ *in.*
Kyoto, Japan, Jingō-ji

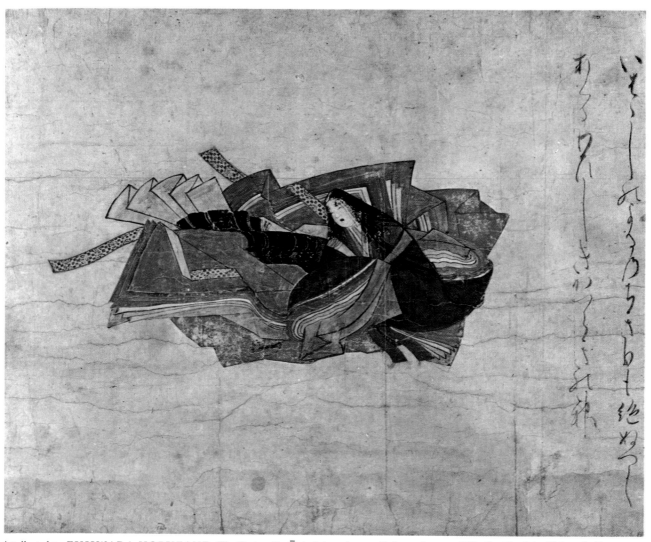

Attributed to FUJIWARA NOBUZANE The Poetess Ko Ōgimi: hanging scroll, formerly part of The Scrolls of the Thirty-six Poets, 13th century *ink and colors on paper* *14 × 23½ in.*
Nara, Japan, Museum Yamato Bunkakan

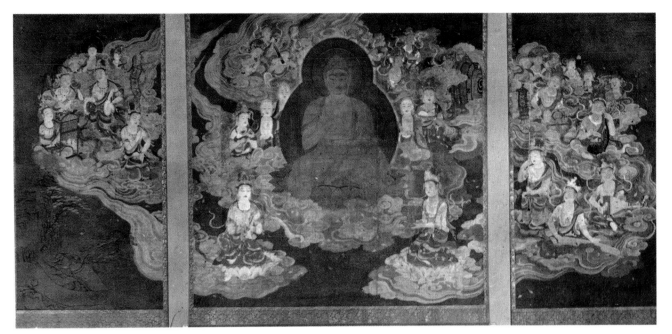

ANONYMOUS Amida Raigō (Amida Coming to this World): hanging scrolls, late 11th century
colors on silk center 83 × 83 in.; side panels 83 × 41 in.
Wakayama, Japan, Mount Kōya, Daien-in

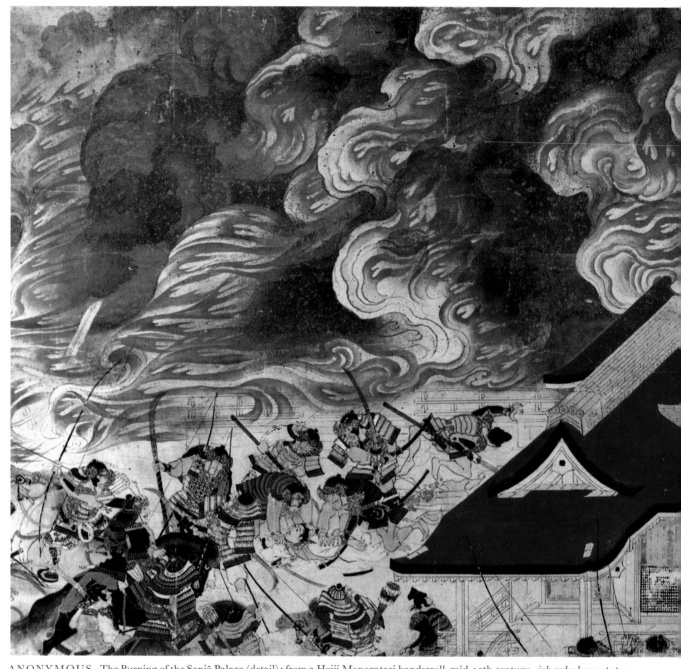

ANONYMOUS The Burning of the Sanjō Palace (detail): from a Heiji Monogatari handscroll, mid-13th century *ink and colors on paper*
16¼ × 274⅞ in.
Boston, Mass., Museum of Fine Arts

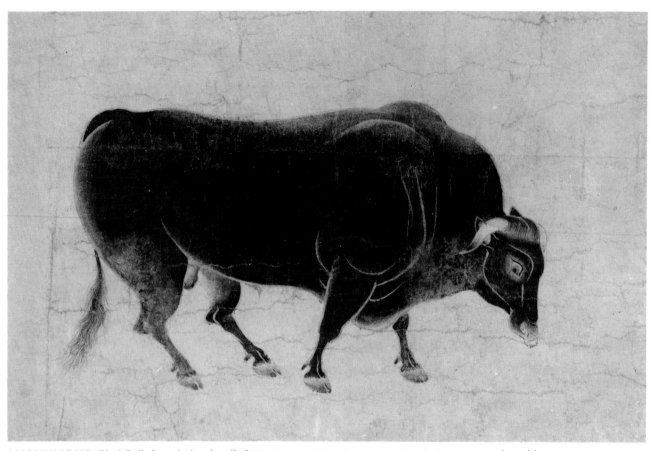

ANONYMOUS Black Bull: from the handscroll of Ten Famous Bulls, about 1300 *ink and color on paper* $10\frac{5}{8} \times 12\frac{1}{4}$ *in.*
Seattle, Wash., Art Museum, Gift of the late Mrs. Donald E. Frederick

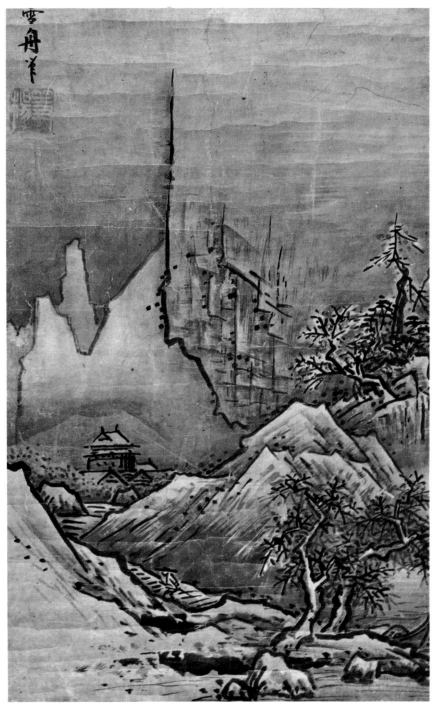

SESSHŪ TŌYŌ Winter Landscape: hanging scroll, 15th century
ink on paper 18¼ × 11½ in.
Tokyo, National Museum

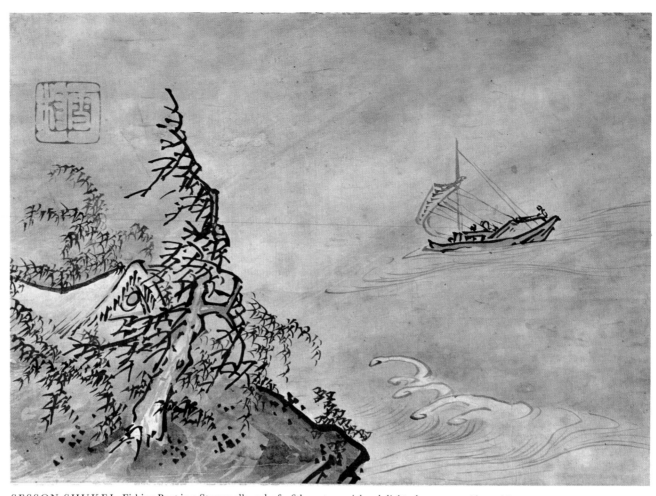

SESSON SHUKEI Fishing Boat in a Storm: album leaf, 16th century *ink and slight color on paper* $8\frac{3}{4} \times 12\frac{3}{8}$ *in.*
Kyoto, Japan, collection Nomura Fumihide

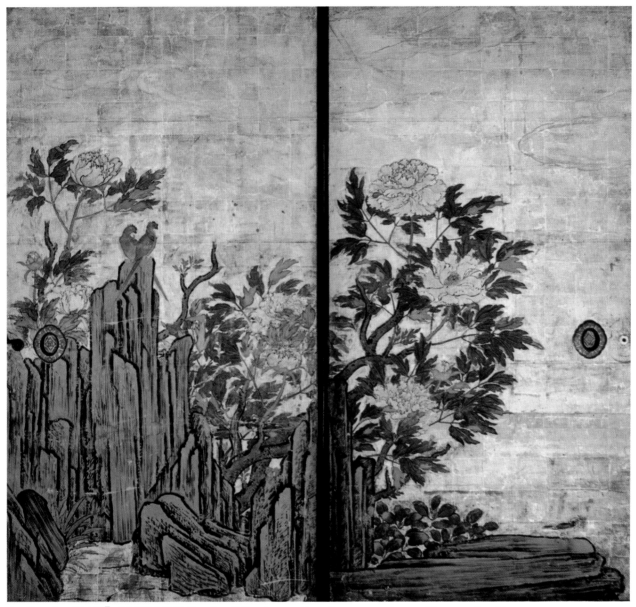

Attributed to KANŌ SANRAKU Peonies: sliding doors, early 17th century *colors on gold paper* *72½ × 78 in.*
Kyoto, Japan, Daikaku-ji, Shin-den

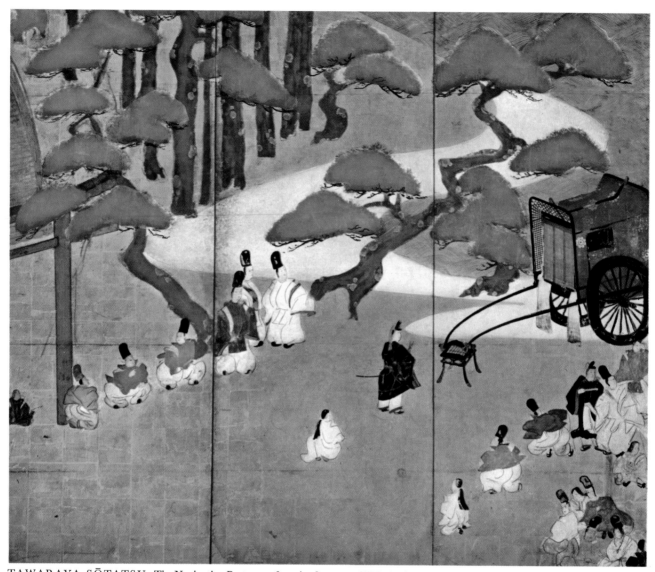

TAWARAYA SŌTATSU The Navigation Post: one of a pair of screens of "The Tale of Genji" (detail) early 17th century
ink and colors on paper 61¾ × 103½ in.
Tokyo, Seikadō Collection

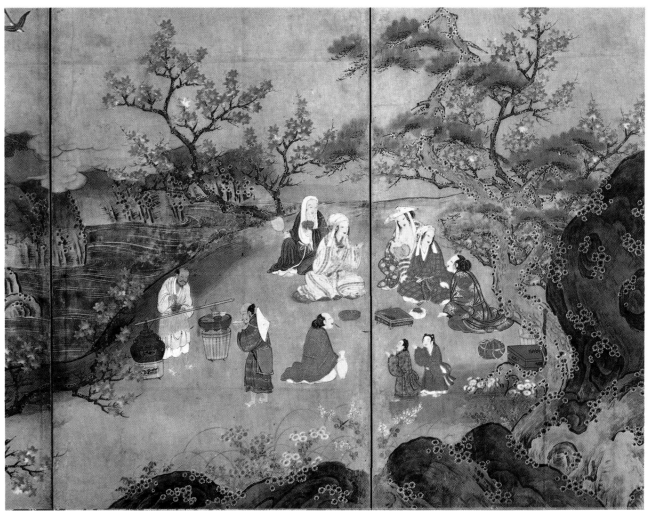

KANŌ HIDEYORI Maple Viewers at Takao (detail): from six-panel folding screen, mid-16th century *ink and colors on paper $58\frac{4}{8} \times 143\frac{1}{4}$ in.*
Tokyo, National Museum

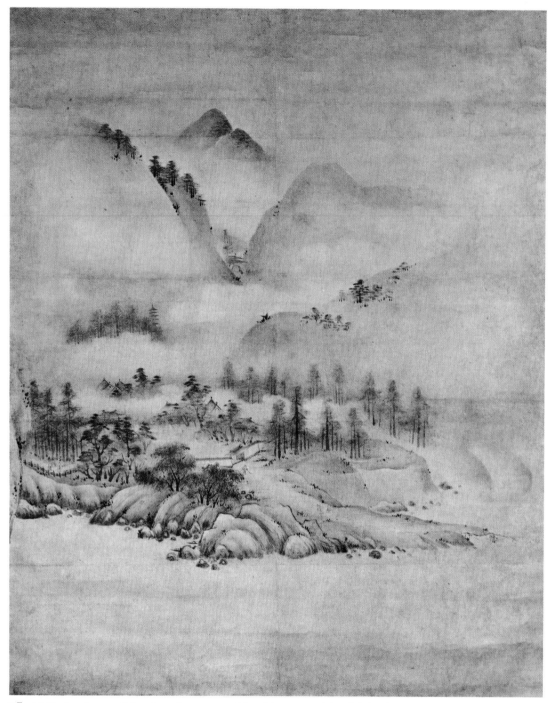

SŌ-AMI Landscape: sliding door, first quarter of the 16th century *ink and slight color on paper* *69 × 48 in.*
Kyoto, Japan, Daitoku-ji, Daisen-in

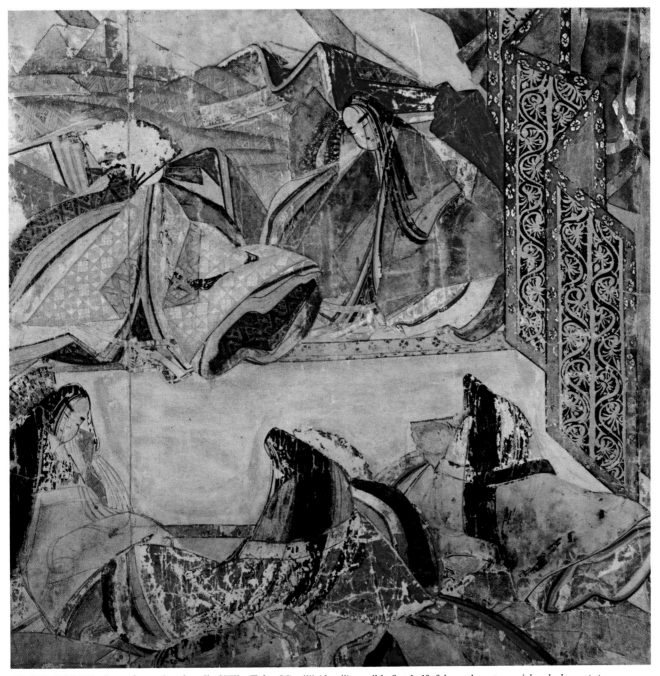

ANONYMOUS Scene from a handscroll of "The Tale of Genji" (detail) possibly first half of the 12th century *ink and colors on paper*
height approximately 8⅝ in.
Nagoya, Japan, Tokugawa Art Museum

URAGAMI GYOKUDŌ Landscape after SHIH-TʻAO: album leaf *ink and colors on paper*
Kanegawa, Japan, collection Umesawa Hikotaro

Attributed to KANŌ TAKANOBU Men Playing Chess: one of four doors of The Four Enjoyments
ink and colors on gold paper 68½ × 55 in.
Seattle, Wash., Art Museum, Eugene Fuller Memorial Collection

225

OGATA KŌRIN Waves: from a folding screen, before 1716 *colors on gold paper 58×65 in.*
New York, Metropolitan Museum of Art, Fletcher Fund, 1926

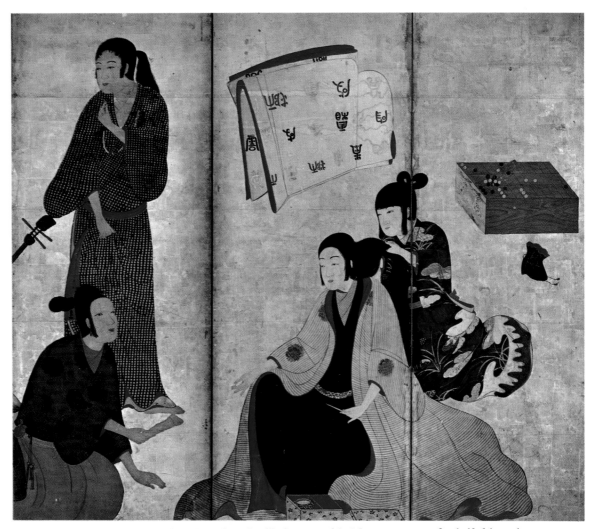

ANONYMOUS Women Amusing Themselves (detail): from one of the Matsu-ura screens, first half of the 17th century
ink and colors on gold paper 60¼ × 206 in.
Nara, Japan, Museum Yamato Bunkakan

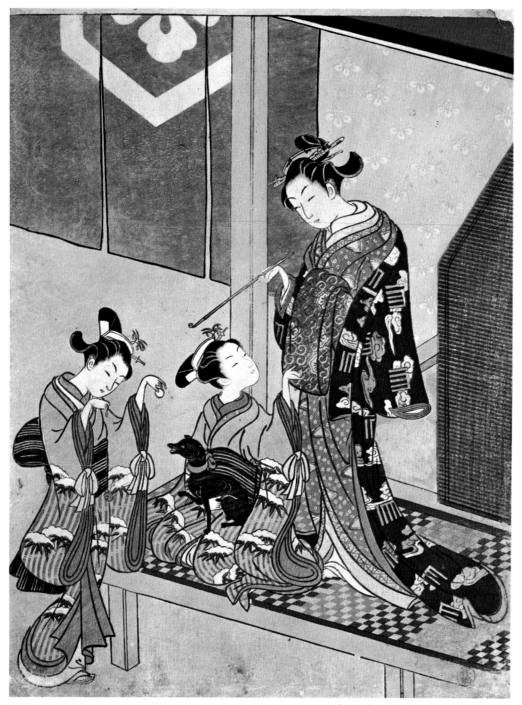

SUZUKI HARUNOBU Courtesan with Attendants, about 1770 *color woodcut on paper*
Tokyo, National Museum, et al.

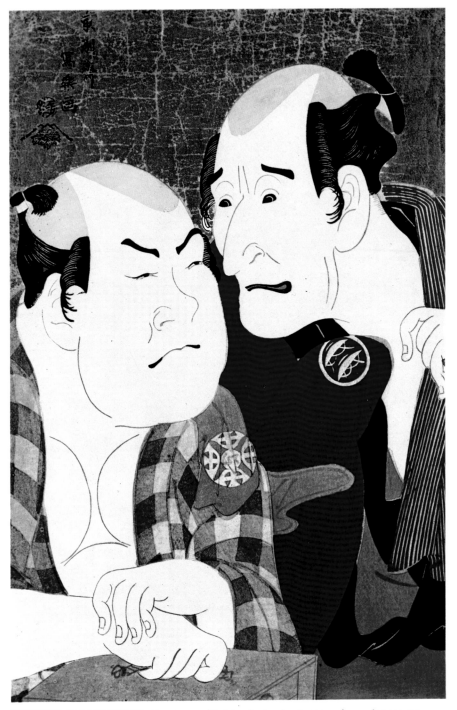

SUZUKI HARUNOBU Courtesan with Attendants, about 1770 *color woodcut on paper*
Tokyo, National Museum, et al.

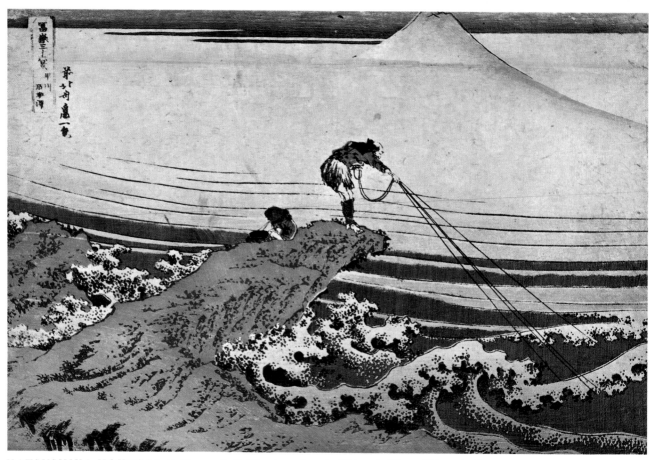

KATSUSHIKA HOKUSAI Kajikazawa in Kai Province: from the Thirty-six Views of Mount Fuji, 1823-29
color woodcut on paper $9\frac{7}{8} \times 14\frac{5}{8}$ in.
London, British Museum, et al.

Monochrome Plates

CHINESE

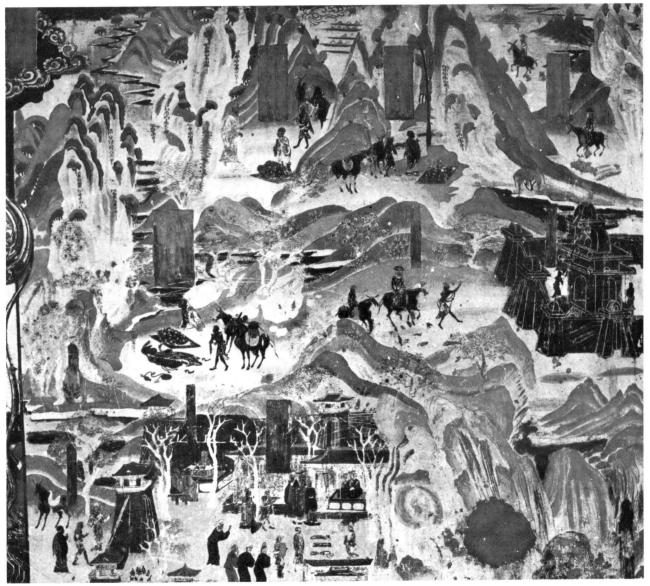

ANONYMOUS Landscape (detail): wall painting from Cave 217, early 8th century
Kansu Province, China, Tunhuang Caves

ANONYMOUS Deer in an Autumn Forest: hanging scroll, 10th century
color on silk 52¼ × 28¾ in.
Taichung, Taiwan, National Palace Museum

234

Copy after SHIH K'O Patriarch and Tiger: hanging scroll (detail) 13th century
ink on paper height 17¾ in.
Tokyo, Commission for the Protection of Cultural Properties

CH'EN JUNG Nine Dragons Appearing through Clouds and Waves: handscroll (detail) 1244 *ink and slight color on paper 18¼ × 430 in.*
Boston, Mass., Museum of Fine Arts

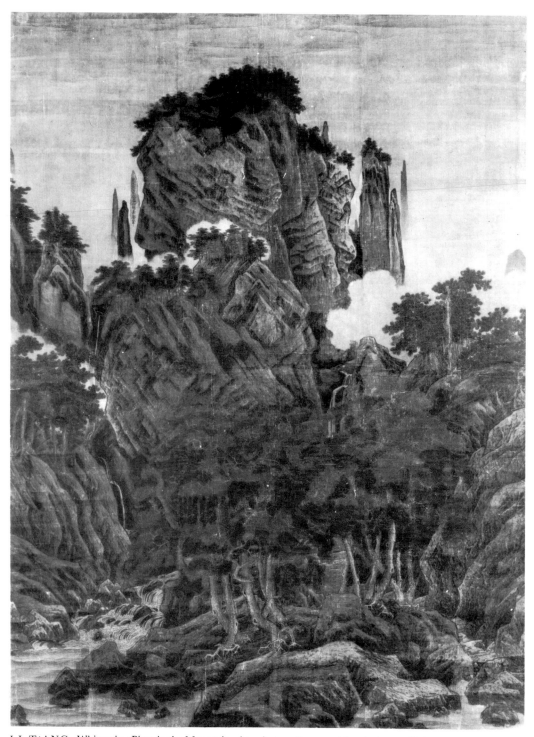

LI T'ANG Whispering Pines in the Mountains: hanging scroll, 1124 *ink and colors on silk 69×51¼ in.*
Taichung, Taiwan, National Palace Museum

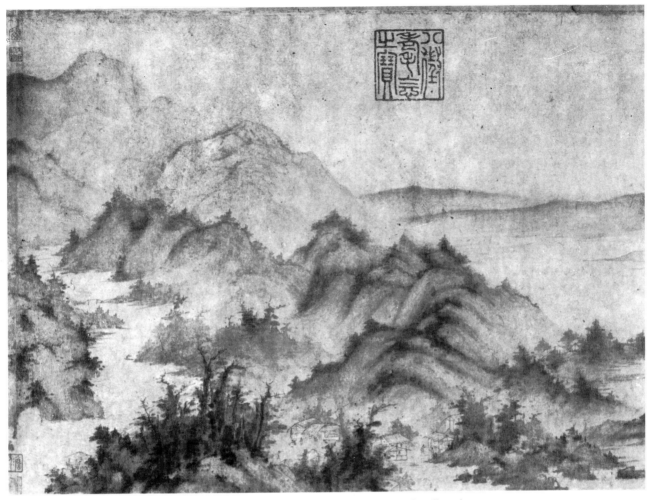

ANONYMOUS Traveling on the Hsiao and Hsiang Rivers in a Dream (detail): handscroll, 12th century
ink on paper 11¾×160¼ in.
Tokyo, National Museum

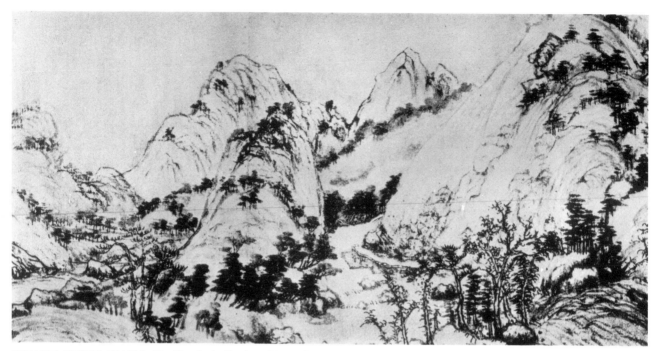

HUANG KUNG-WANG Dwelling in the Fu-ch'un Mountains: handscroll (detail) 1350 *ink on paper height 13 in.*
Taichung, Taiwan, National Palace Museum

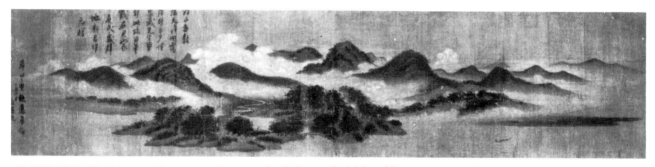

MI YU-JEN Cloudy Mountains: handscroll, 1130 *ink and colors on silk height 17¼ in.*
Cleveland, Ohio, Museum of Art

238

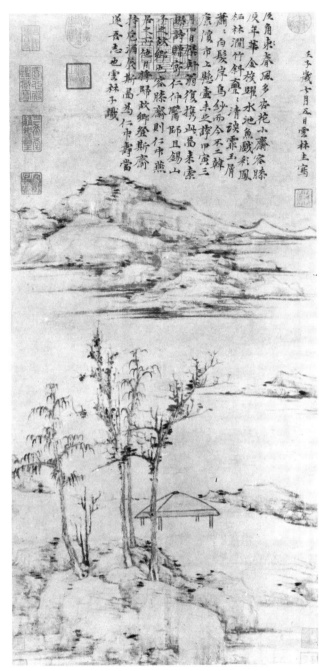

NI TSAN The Jung-hsi Studio: hanging scroll, 1372
ink on paper 28¾ × 14 in.
Taichung, Taiwan, National Palace Museum

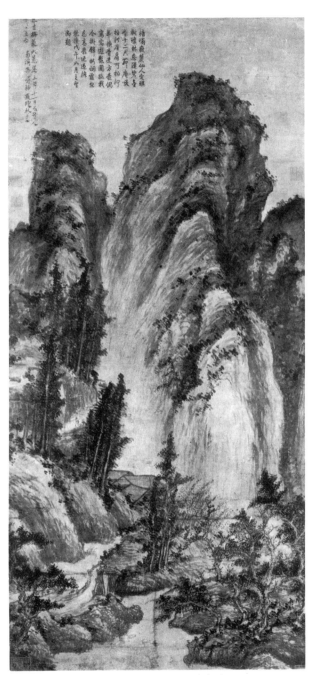

FANG TS'UNG-I Immortal Mountains and Luminous
Woods: hanging scroll, 1365 *ink and colors on paper 47⅞ × 22¼ in.*
Taichung, Taiwan, National Palace Museum

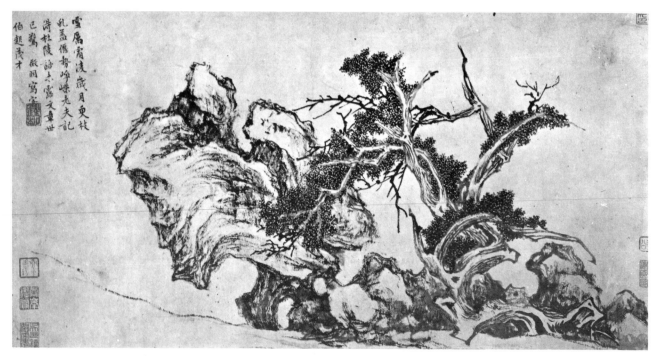

WEN CHENG-MING Cypress and Rock: handscroll, 1550 *ink on paper 10¼ × 19¼ in.*
Kansas City, Mo., William Rockhill Nelson Gallery of Art and Mary Atkins Museum of Fine Arts

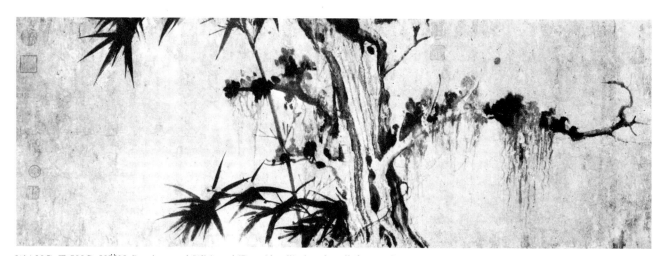

WANG T'ING-YÜN Bamboo and Withered Tree (detail): handscroll, late 12th century
ink on paper height 15 in.
Kyoto, Japan, Fujii Yūrinkan

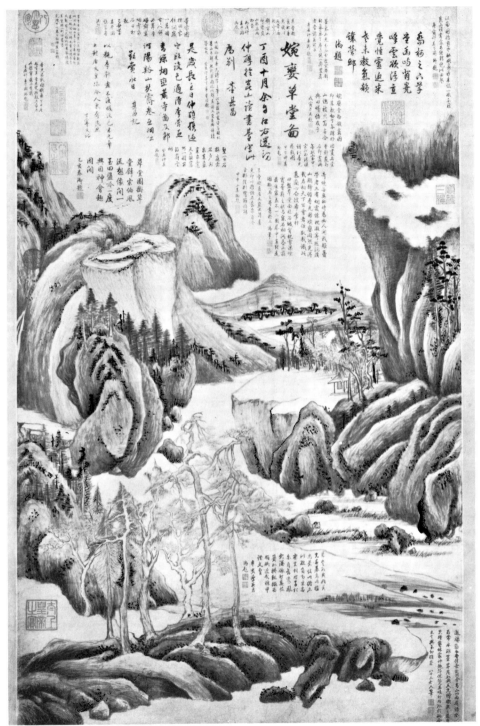

TUNG CH'I-CH'ANG Landscape with a Straw Hut: hanging scroll, 1597 *ink on paper*
New York, collection C. C. Wang

PA-TA SHAN-JEN Bird: album leaf, late 17th century *ink on paper 10 × 10 in.*
Stockholm, Museum of Far Eastern Antiquities

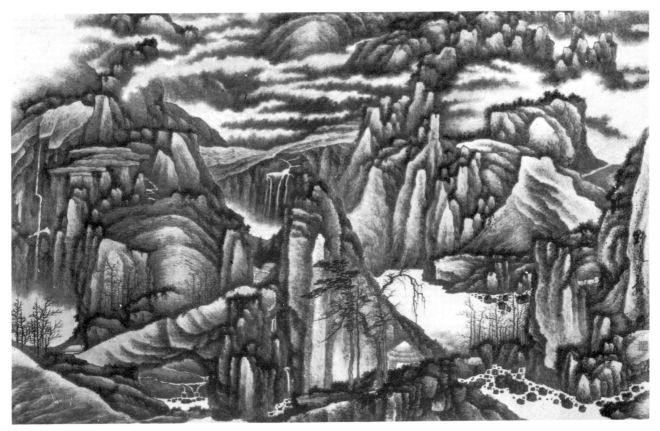

KUNG HSIEN Landscape: hanging scroll, late 17th century *ink on paper* *40 × 24 in.*
Zurich, collection C. A. Drenowatz

JAPANESE

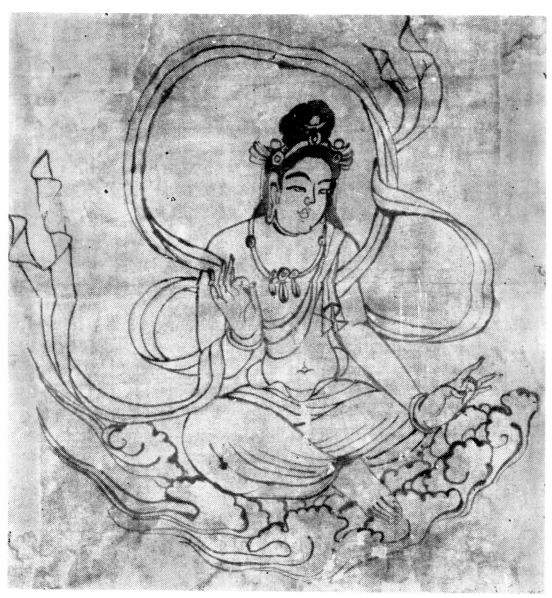

ANONYMOUS Bodhisattva Flying on a Cloud, 8th century *ink on hemp cloth 52 × 54 in.*
Nara, Japan, Tōdai-ji, Shōsō-in Repository

ANONYMOUS The Nachi Waterfall: hanging
scroll, 14th century *color on silk 63 × 23 in.*
Tokyo, Nezu Art Museum

SHINKAI Fudō Myō-ō: hanging scroll, 1282
ink on paper 46 × 17 in.
Kyoto, Japan, Daigo-ji

面水好山皆可廬
唯多竹更稱吾居
應言門於是嚴佳客
日課猶愁欠讀書
村菴靈彥

Attributed to SHŪBUN Reading in a Hermitage in a Bamboo Grove: hanging scroll, 1448
ink on paper 53⅛ × 13⅛ in.
Tokyo, National Museum

KANŌ TANNYŪ Chinese Gentlemen Playing Chess: wall painting (detail) 18th century
ink and color on paper
Nagoya, Japan, Nagoya Castle

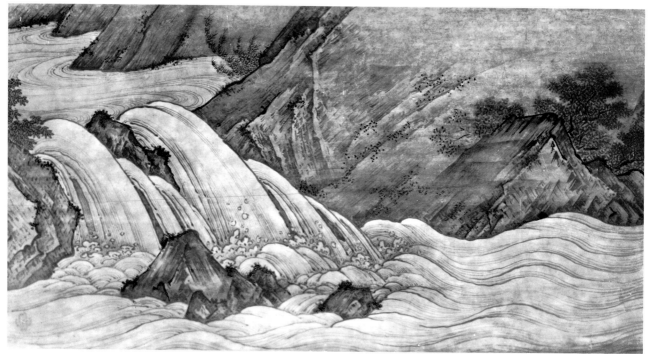

KANŌ MOTONOBU Waterfall, early 16th century *ink and color on paper* *18 × 34 in.*
Nara, Japan, Museum Yamato Bunkakan

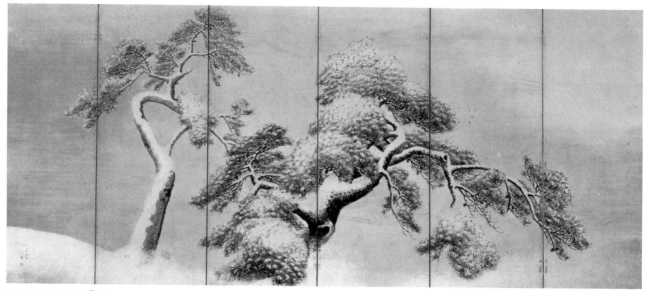

MARUYAMA ŌKYO Pine Trees in the Snow: one of a pair of six-panel folding screens, late 18th century *color on paper* *60 × 140 in.*
Tokyo, collection Takakimi Mitsui

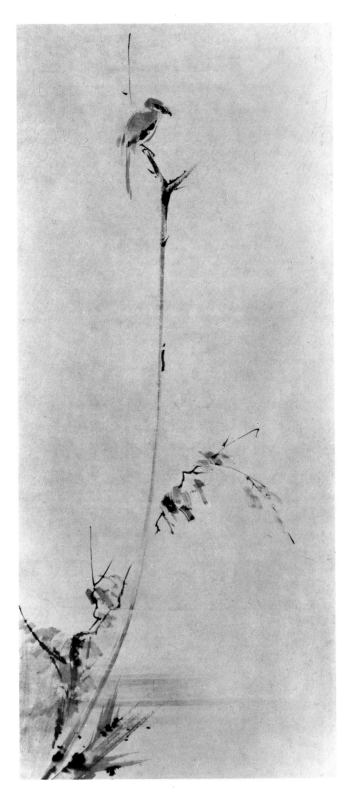

Influences and Developments

The essence of both Chinese and Japanese painting is the brushstroke. Whether the movement of the artist's hand is carefully controlled, or bold and free, it must express not only his own creative spirit but also his intuitive awareness of the life of nature around him.

For all its stark economy, this study of a shrike on a dead branch, by the Japanese painter Niten (1584-1645), is a brilliant expression of the Far Eastern genius for re-creating the forms of living nature through the vital energy and precise discipline of the brushstroke.

Niten
Shrike on a Dead Branch
ink on paper 50 × 21 in.
Formerly K. Nageo Collection, Tokyo

a

Nature and Art in China and Japan

People sometimes find it hard to believe that the fantastic mountain peaks of a Chinese landscape painting (b, e) could represent a real landscape. Yet such scenery is to be found in several places in China, notably in Kwangsi, in Honan (on the sacred mountain Hua-shan), and in Anhui (on Huang-shan; h). Peaks like these were being painted as early as the T'ang Dynasty (618-906), partly because they had ancient associations with Taoist myths, and partly because their shape seemed to embody the very essence of "mountainness" (a).

In the same way, Japanese painters have returned again and again for inspiration to the cool symmetry of Mount Fuji (c, d); also to the clean, spare lines of their architecture, and to the intimacy of their gardens (g).

Ideal, typical forms such as these, once discovered, influence the growth of a national pictorial language. Landscape painters tend to look for what seems typical in nature, and to reject the rest. In this way a tradition of "selective vision" is built up that gives their landscape art its national character. Today even photographers in China and Japan are influenced (f, h), if only unconsciously, by the selective vision that has been established through the centuries by landscape painters.

b

c

d

a Anonymous
Emperor Ming-huang's Journey to Shu: hanging scroll (detail) probably 12th century
ink and colors on silk
Taichung, Taiwan,
National Palace Museum

b Attributed to Li T'ang
A Myriad Trees on Strange Peaks: fan (detail)
ink and slight colors on silk
Taichung, Taiwan,
National Palace Museum

c Mount Fuji, Japan (Photograph)

d Hokusai
Fuji on a Clear Day with a Southerly Breeze: from the 36 Views of Fuji *wood-block print*
London, British Museum, et al.

e Li K'o-jan
Mountain Village
ink and color on paper
Location unknown

f Night Scene of Town amid Mountain Peaks, China (Photograph)

g The Moon-viewing Platform, Katsura Imperial Villa, Kyoto, Japan (Photograph)

h Huang-shan, China (Photograph)

e

f

g

h

a Design on inlaid bronze pole-end,
Han Dynasty
*Stockholm, collection H.M.
The King of Sweden*

b Design on inlaid bronze tube,
Han Dynasty
Tokyo, School of Art

c Figured silk fabric from grave-pit
at Loulan, Han Dynasty
London, British Museum

The Birth of Pictorial Art in China

Brush painting has a long history in China. The flowing movement of the brush can be seen in the earliest paintings on lacquer, an art practiced in the Warring States period (249-221 B.C.) and probably even earlier. In the Han Dynasty (206 B.C.-220 A.D.) this fluent, rhythmic movement was the basis of all decorative design. Expressed in whorls and spirals, it gave unity of style to the decoration of such different materials as bronze (a, b), lacquer (e), and textiles (c). Even landscape painting was affected by it: the sweeping, wavelike rhythm of the mountains on the side of a typical Han Dynasty hill-jar (d) persisted in the landscape paintings at Tunhuang (i, j), giving them a quality that is vitally alive and yet still somewhat abstract.

More naturalistic traditions seem to have developed (f, g) both in Szechwan and in central China around Changsha, the ancient kingdom of Ch'u, whence comes the earliest painting on silk yet discovered in China (h).

a

b

c

d

e

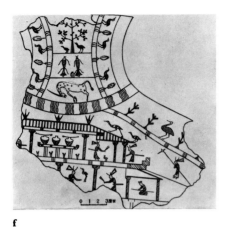

f

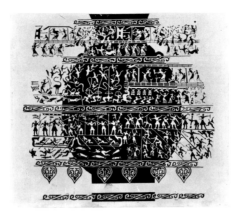

g

h

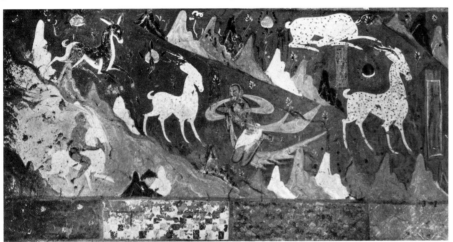

i

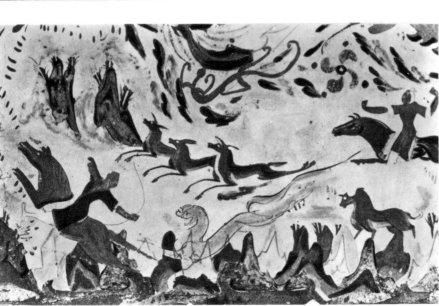

j

d The Hunt among Mountains:
relief on shoulder of glazed pottery
hill-jar, Han Dynasty
Stockholm, collection H.M.
The King of Sweden
(after Palmgren)

e Decoration on side of lacquer *lien*,
3rd century B.C.
excavated at Changsha

f Spout of engraved bronze ewer,
Warring States period
excavated at Ch'ang-chih
(redrawn)

g Designs engraved on an inlaid
bronze *hu*, Warring
States period (redrawn)
Peking, Palace Museum

h Anonymous
Woman, Phoenix, and Dragon,
Warring States period
painting on silk height 11¾ in.
Excavated at Changsha

i Anonymous The Buddha
Incarnate in a Golden Gazelle,
The Rūru Jātaka: wall painting
from Cave 257, about 500 A.D.
Kansu Province, China, Tunhuang Caves

j Anonymous
Fairy Landscape: ceiling of
Cave 249, Northern Wei Dynasty
Kansu Province, China,
Tunhuang Caves

253

The Language of the Brush

The technique of the Chinese landscape painter has four basic elements: the line, the ink wash, the texture-stroke (*ts'un*), and the dot (*tien*).

By the Han Dynasty (206 B.C.-220 A.D.), painters had learned to grade the tone of their ink washes. Control of the wash was further developed in the T'ang Dynasty (a), and achieved great subtlety in the Sung Dynasty in the art of Zen masters such as Mu-ch'i (d).

The line, at first smooth and even (b), was influenced by the free styles of calligraphy (see pages 266-267) during the Six Dynasties and the T'ang dynasty. In the 9th and 10th centuries it was freely broken and articulated (c)—a process that culminated in the dramatic technique of Hsia Kuei (e) and his followers.

About the 10th century, painters began to enrich the interior texture of mountains and rocks by means of *ts'un*. First came the simple "raindrop" *ts'un* of Li Ch'eng and Fan K'uan (f). From the "small ax-cut" *ts'un* of Li T'ang (g) was derived the "big ax-cut" *ts'un* of the Southern Sung academy (h). However, scholar painters preferred the long, more relaxed "hemp-fiber" *ts'un* of Chü-jan (i) and Huang Kung-wang (j), and added deftly placed *tien* (k) to give texture and accent to their rocks and mountains.

The Japanese made full use of these techniques only when painting in the Chinese manner. The brush language of their own tradition, the Yamato-e, is much simpler.

a

b

c

d

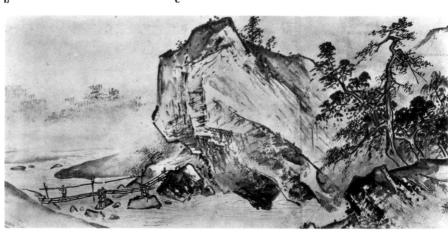

e

f

g

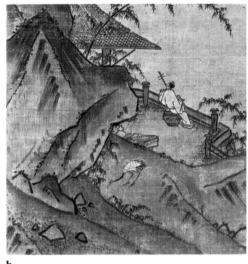

h

i

j

k

a Anonymous (from Tunhuang)
Landscape (detail) T'ang Dynasty
ink and colors on silk
London, British Museum

b Anonymous
Emperor Ming-huang's Journey to
Shu (detail): hanging scroll,
probably 12th century copy
ink and colors on silk
Taichung, Taiwan,
National Palace Museum

c Kuan T'ung
Travelers in the Mountains (detail)
10th century
Taichung, Taiwan,
National Palace Museum

d Mu-ch'i
Landscape (detail): from the
Scenes of the Hsiao and Hsiang
Rivers, mid-13th century
ink and slight color on paper
Tokyo, Nezu Art Museum

e Hsia Kuei
Pure and Remote View of Streams
and Mountains (detail):
handscroll *ink on paper*
Taichung, Taiwan,
National Palace Museum

f Fan K'uan
Traveling among Mountains and
Streams: hanging scroll (detail)
early 11th century
ink and slight color on silk
Taichung, Taiwan,
National Palace Museum

g Li T'ang
Whispering Pines in the Mountains
(detail) 1124
ink and slight color on silk 69 × 51½ in.
Taichung, Taiwan,
National Palace Museum

h Ma Yüan
Playing the Lute in the Moonlight
(detail)
Taichung, Taiwan,
National Palace Museum

i Attributed to Chü-jan
Seeking the way in the
Autumn Mountains (detail)
10th century *ink on silk*
Taichung, Taiwan,
National Palace Museum

j Huang Kung-wang
Dwelling in the Fu-ch'un
Mountains (detail):
handscroll, 1350 *ink on paper*
Taichung, Taiwan,
National Palace Museum

k Shen Chou
Landscape (detail) 1484
ink on paper 54½ × 24¾ in.
Kansas City, Mo.,
William Rockhill Nelson Gallery of Art

Chinese and Japanese painting may be looked upon as a visual language, perhaps the most subtle and expressive in the world. Its "vocabulary" consists of a repertory of typical forms, or "type-forms," representing a wide range of elements selected from nature.

For centuries painters have been enlarging this language of type-forms. By the 17th century in China it was so rich and complex that it became possible to compile "grammars" of it as guides for students. Nine of the illustrations (a-f, h-j) on these two pages are taken from the most famous Chinese handbook of art, the "Painting Manual of the Mustard Seed Garden," first published in 1679. Japanese painters later compiled their own painting manuals. Other handbooks provide amateurs with suggestions for themes and compositions (g).

Gifted painters have always used the repertory with a free hand, not merely adapting type-forms but even creating new ones as the need arises. On the other hand, by constant practice and strict adherence to the vocabulary and grammar of painting, an amateur of only average ability can also come to produce beautiful, if conventional, pictures.

a

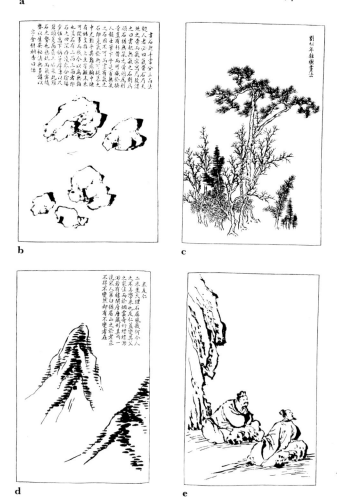

b

c

d

e

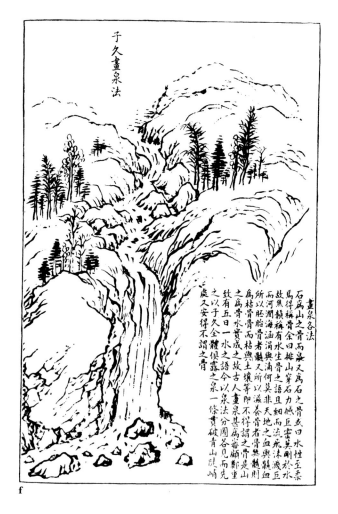

f

a-f, h-j
How to draw trees, rocks, mountains, figures, a waterfall, flowers, and birds: pages from the "Painting Manual of the Mustard Seed Garden" (19th-century line-block reprint)

g Suggestion for a landscape composition: from the "*Tien-shih-chai* Painting Collection," 19th century

g

h i j

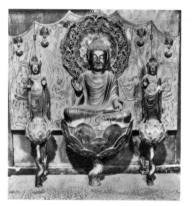

a

Symbolism in Chinese and Japanese Painting

Symbols play an important part in Chinese and Japanese art. A diagram (a) symbolizes the interpenetration of *yang* (male, light, high, and so on) and *yin* (female, dark, low, and so on); the eight trigrams surrounding it consist of combinations of unbroken —*yang*—and broken —*yin*—lines, which symbolize the forces of nature. The same *yang-yin* symbolism is indirectly implied in the mountains and valleys of a landscape painting.

Plants and animals, too, often have a symbolic meaning. The Buddha on a lotus growing from a muddy pool (b) stands for purity; the chrysanthemum (c) for autumn; the peach (d) for immortality. A tired, thin horse (e) is a symbol for the virtuous scholar official unappreciated and unemployed by a corrupt government. Paired water-birds (f) denote happiness in marriage; the leaping carp (i) that turns into a dragon, success in examinations and in an official career.

The dragon itself (g) was originally perhaps an alligator; probably it was worshiped as a river god, the bringer of water and rain, and hence of fertility. Always a benign creature, it became the symbol of the emperor, while the radiant phoenix (h) denotes both the sun and the empress.

In landscape painting, the tough yet pliant bamboo (k) suggests the integrity of the scholar whom fortune may bend but never break, while a gnarled pine tree is a symbol of the unconquerable spirit of old age. It is probably the birthday of the gentleman (l) to whom the deer is bringing a fungus, for both deer and fungus are symbols of long life. Even clouds welling up from a valley may be interpreted as the visible emblem of the *ch'i*, the cosmic spirit that animates all things. An especially meaningful symbolism (see page 117) pervades landscapes that, like the celebrated *Nachi Waterfall* (j), belong to the Dual Shintō movement in Japan.

b

d

e

f

c

g

h

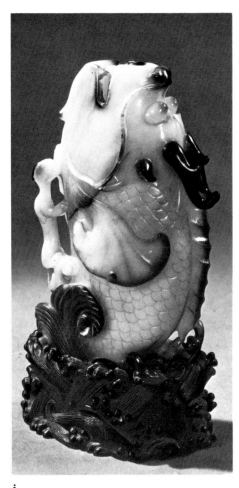

i

j

a The Yang Yin Symbol surrounded by the Eight Trigrams (drawing)

b Amida on the Lotus: from the Tachibana Shrine, 8th century
bronze
Nara, Japan, Hōryū-ji

c Vase with Chrysanthemum Decoration, Yüan Dynasty
height 12 in.
London, British Museum

d Water-dropper in the shape of a double peach: Yi-hsing ware, 18th century
London, British Museum

e Kung K'ai
The Emaciated Horse, late 13th century
ink on paper $11\frac{3}{4} \times 22$ in.
Japan, Private Collection

f Anonymous (from Tunhuang)
A Pair of Mandarin Ducks: banner, T'ang Dynasty *painted silk*
London, British Museum

g Dragon: rubbing from jade plaque from tomb of Wang Chien, 10th century
Chengtu, Szechwan Province, China

h Phoenix: rubbing from stone relief on Han Dynasty tomb
Szechwan Province, China

i Leaping Carp, Ming Dynasty *jade*
Taichung, Taiwan,
National Palace Museum

j Anonymous
The Nachi Waterfall (detail): hanging scroll, 14th century
color on silk 63 x 23 in.
Tokyo, Nezu Art Museum

k Attributed to Su Tung-p'o
Bamboo (detail) 11th century
New York, collection John M. Crawford Jr.

l Hsieh Shih-ch'en
A Scholar's Birthday (detail)
1556 *ink and color on silk*
Zurich, collection C.A. Drenowatz

k

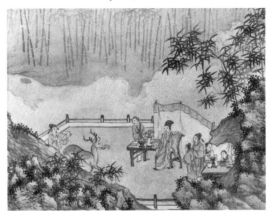

l

Composition

As brush technique became richer and more expressive, so composition developed.
The first step was to unite the early, isolated elements of landscape (a) into a
continuous composition. In the caves at Tunhuang, large wall surfaces were at
first decorated with separate horizontal strips of landscape painted one above the
other, like handscrolls laid out flat (c). During the early T'ang Dynasty the divi-
sions between these layers began to break down (d), leading to the coherent, all-
over design of Cave 217 (e).

The great landscapes of the early Sung achieved monumentality by means
of a central, dominating mass (f), which in the 11th century took on a well defined
S-curve (g). At the same time painters began to put this main mass to one side (h)
in order to open up deep vistas into the distance. The empty space thus created
was made poetically expressive by Ma Yüan (i) and Hsia Kuei.

With the sudden vision of some Zen painters of the late Sung Dynasty, formal
composition was abandoned almost completely, and all that remains is the artist's
intuitive sense of balance (b).

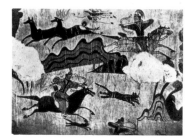

a

b

c

d

e

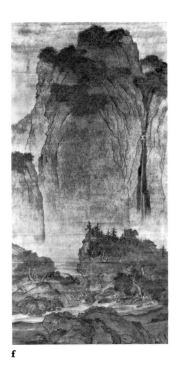

f

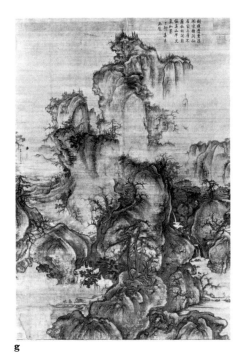

g

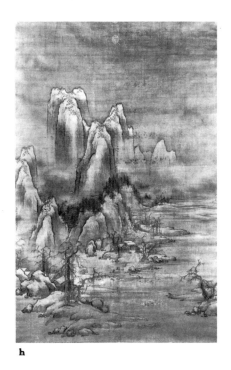

h

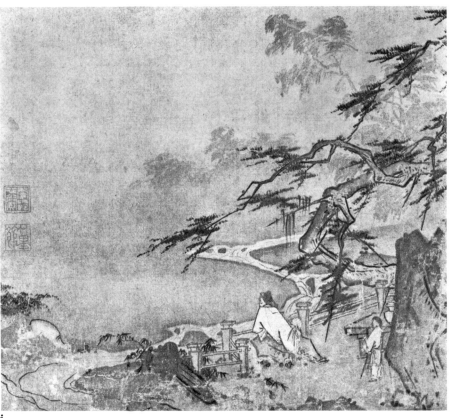

i

f Fan K'uan
Traveling among Mountains
and Streams: hanging scroll,
early 11th century
ink and slight color on silk
Taichung, Taiwan,
National Palace Museum

g Kuo Hsi
Early Spring: hanging scroll, 1072
ink and light color on silk
Taichung, Taiwan,
National Palace Museum

h Attributed to Hsü Tao-ning
Fishing on a Snowy River, Sung
Dynasty *ink and light color on silk*
Taichung, Taiwan,
National Palace Museum

i Ma Yüan
A Scholar and his Servant on a
Terrace: album leaf, 13th century
ink on silk
Cleveland, Ohio, collection
Mrs. A. Dean Perry

Perspective

It is often said that Chinese and Japanese pictures "have no perspective." Certainly they make no use of the one-point perspective of Western art. But Chinese and Japanese artists, who have always been acutely sensitive to pictorial depth, have evolved their own unique ways of suggesting it.

In general, objects are shown with one face parallel to the picture-plane (a). Receding parallel lines are drawn parallel and not, as in Western pictures (c), converging. The artist may even spread them apart so as to eliminate the illusion that they converge (b).

Reluctant to define too exactly the relationship between near and distant objects, because this would imply a fixed viewpoint, the Chinese or Japanese painter prefers to place objects (figures, mountains, rocks) in an enveloping atmosphere (water, mist, cloud) that both separates and unites them (d). Difficult junctures, where a Westerner would expect to see planes connected by a continuous ground-line, are often obscured by mist and cloud (e), which is also useful to suggest the life-breath (*ch'i*) that animates nature.

It was the same reluctance to define a viewpoint that led Chinese and Japanese painters to avoid one-point perspective. Instead they evolved "continuous perspective," in which the eye has a different optically correct view at every point in the picture. In a hanging scroll (f) the foreground, middle ground, and distant mountain-tops are each seen from their own level, or a little above it. As one moves through a handscroll (g) from right to left, one finds a constantly changing perspective like the view from a train or car window. Strategically placed paths, pavilions, and ferry boats help the viewer on his imaginary journey. It was the triumph of Chinese and Japanese art that it could weld such an infinity of viewpoints into a convincing whole.

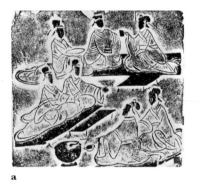

a

b

c

d

e

f

a Feasting Scene: rubbing from
tomb relief, Han Dynasty
Szechwan Province, China

b After Ku K'ai-chih
The Admonitions of the
Instructress to the Court Ladies
(detail): handscroll, 10th century
ink and light colors in silk
London, British Museum

c Carlo Crivelli
The Annunciation (detail) 1486
oil on panel $81\frac{1}{2} \times 57\frac{3}{4}$ in.
London, National Gallery

d Pa-ta Shan-jen
Fish and Rock (detail)
ink on paper
Cleveland, Ohio, Museum of Art

e Attributed to Li Ch'eng
Buddhist Temple in the Mountains:
hanging scroll,
probably 11th century
ink and slight color on silk 44 × 22 in.
Kansas City, Mo.,
William Rockhill Nelson Gallery of Art

f Wen Po-jen
Mountain Landscape: hanging
scroll, 1561
ink and color on paper $50\frac{3}{8} \times 15$ in.
Seattle, Wash., Art Museum,
Eugene Fuller Memorial Collection

g Sesshū
Landscape: handscroll (detail)
15th century
Yamaguchi, Japan,
collection Motomichi Mōri

g

Realism

Early Chinese art critics continually stressed the need for truth to nature, because only by accuracy in depicting the visible world could painters demonstrate that they understood and were attuned to the order that lay behind it.

Before the end of the Han Dynasty (220 A.D.), craftsmen in Szechwan were discovering how to suggest continuous depth (a), a process successfully mastered by the artists at Tunhuang (b). Some painters, such as Li Ch'eng, could portray buildings in a convincing "Western style" perspective, of which Tunhuang again offers examples (c). Shadows seemed to present the greatest difficulty. They were seldom attempted, and then only in illustrations to a poem or passage that specifically referred to them (d).

The climax of the trend toward realism can be seen in a remarkable handscroll painted about 1120 by an official, Chang Tse-tuan, and representing preparations for the Ch'ing-ming spring festival outside Kaifeng, the Northern Sung capital. Chang Tse-tuan here reveals an astonishing mastery of foreshortening and shading in his drawing of boats (e), a sedan chair (f), and interiors (g), when he does not hesitate to cut off the heads of his seated figures by the line of the eaves.

During the Southern Sung and Yüan Dynasties this promising path to realism was abandoned. Scholars lost interest in representational painting, and professionals and academicians were concerned to create only an ideal, artificial world. Although the Ch'ing-ming scroll was often copied by later artists, their renderings of it became more and more decorative and unnatural (h).

a

b

c

d

e

f

g

h

Calligraphy

a

According to a Chinese legend, the twin arts of calligraphy and painting had the same miraculous origin in ancient times. Certainly they have always been intimately related in China and Japan. The painter and the calligrapher (a) use essentially the same materials, their brush techniques have much in common, and both are judged by the same criteria, namely the strength and subtly accented rhythm of their brushstrokes.

From the pictograms (picture symbols) scratched on Shang Dynasty oracle bones (b), were developed the large and small seal characters (*chüan-shu*; c, e) of the early and later Chou Dynasty respectively. Improvements in the writing,brush under the Han Dynasty at least partly account for the powerful angularity of the *li-shu*, or clerk's hand (f), from which was evolved the more fluent but still formal *k'ai-shu* (g), which remained the standard script in China up to modern times.

The running script (*hsing-shu*; h) was a cursive development from the Han *li-shu*, and every orthodox style now has its cursive form. The draft script (*ts'ao-shu*; d, i) began in the Han Dynasty as a kind of shorthand, and first became fashionable, especially among Taoists, in the 3rd to 5th centuries.

The draft script reached a climax of fluent near-illegibility in the handwriting of some Japanese poets, painters, and calligraphers, in whose scrolls the writing and the painting are brilliantly balanced and combined (i).

b

c

d

e f g h

a The noted calligrapher Yang Ch'ao-hsien, aged 118, writing a scroll (Photograph, Singapore, 1955)

b Inscribed oracle bone: rubbing, Shang Dynasty

c *ta-chüan* (large-seal) characters: rubbing from stone drums, Chou Dynasty

d Attributed to Huang T'ing-chien (1045-1105): detail of Biographical scroll in *ts'ao-shu* (draft script) *New York, collection John M. Crawford Jr.*

e Wen Cheng-ming (1470-1559) *hsiao chüan* (small-seal) script: from "The Thousand Character Essay" *Taichung, Taiwan, National Palace Museum*

f *li-shu* (clerk's script): from "The Thousand Character Essay"

g *k'ai-shu* (standard script): from "The Thousand Character Essay"

h *hsing-shu* (running script): from "The Thousand Character Essay"

i Kōetsu and Sōtatsu *ts'ao-shu* (draft script: detail from Scroll of Painting and Calligraphy, 17th century *Kurashiki, Japan, Ohara Collection*

The Anatomy of the Scroll

Chinese and Japanese painters and calligraphers have their work mounted, in order to protect it while it is stored away, and show it to best advantage when it is unrolled. While mounting by a skilled craftsman will preserve and enhance the appearance of a hanging scroll (a) or a handscroll (b), careless work, such as the use of poor glues, can ruin it.

The chief elements in a mounting are the paper backing that strengthens the silk or paper of the picture, the wide border that protects the edges, and the roller. Great attention is paid to matching the materials used, and to proportioning the mount to the texture and shape of the painting. Japanese mounts are generally rather smaller than Chinese ones and make use of strongly contrasting brocades and leave the two bands (a. 2) hanging free.

The various parts of the hanging scroll (a) and the handscroll (b) are numbered and the names for these parts indicated in the chart below.

Hanging scroll (Chou)

1.	CHING-TAI	narrow vertical bands
2.	T'IEN	broad strip of paper
3.	CHIEH-LING	plain strip
4.	SSU-PIEN	framing silk
5.	YA-TZU	narrow strip of brocade
6.	HSIA CHIEH-LING	lower plain strip
7.	TI (EARTH)	bottom strip
8.	CHOU	roller
9.	CHOU	knobs of wood, ivory, porcelain, etc.

Handscroll (Chüan)

1.	TITLE	
2.	PAO-SHOU	protecting flap, of heavy ornamental silk or brocade
3.	TAI	band for winding round rolled-up scroll
4.	T'I	sheet for fortifying rolled-up scroll
5.	CHIEH-LING	plain strip
6.	T'IEN-TI	(Heaven-Earth): plain border
7.	CHE-PIEN	folded border
8.	PO (OR PA)	sheet(s) for added colophons or comments
9.	CHOU	roller

a

b

The Painting as a Document

A unique feature of a Chinese or Japanese painting is the amount of documentary matter it can carry (a, and color plate 178). This includes the artist's own inscription, signature, and seals (b, d, e,); inscriptions conveying the praises or the reflections of other prominent or scholarly men; and the seals of collectors and connoisseurs who once owned or admired the painting (c.). Inscriptions are naturally most numerous on pictures by the literary painters.

Genuine inscriptions and seals not only add much to the value and interest of a scroll in the eyes of Chinese and Japanese connoisseurs, but also make it possible to trace its history, and to check it against descriptions in the catalogs of great collections. The skillful placing of a few seals may actually enhance its beauty, but many famous paintings are partly obscured by the documentation accumulated through the centuries.

b

a

c

d

e

a Chao Meng-fu (1254-1322)
Autumn Colors on the Ch'iao and
Hua Mountains: handscroll (detail)
1295 *ink and colors on paper*
11¼ × 36¾ in.
Taichung, Taiwan,
National Palace Museum
Inscriptions and seals of the
artist and later collectors:
1. Artist's own inscription and
 seal
2. Emperor Ch'ien-lung (reigned
 1736-96)
3. Emperor Hsüan-t'ung (reigned
 1909-11)
4. Na-lan Hsing-te (1655-85)
5. Hsiang Yüan-pien (1525-90)
6. Chang Ying-chia (17th century)
7. Ou-yang Hsüan (1283-1357)
8. Wen P'eng (1498-1573)

b Wang Hui (1632-1717)
Date, signature, and seals, from
Landscape: hanging scroll, 1680
ink and color on paper *24½ × 15⅝ in.*
Honolulu, Hawaii, Academy of Arts
(See color plate 194)

c Seal of Mi Fu (1051-1107) in
chiu-t'ieh (ninefold) script

d Gourd-shaped seal of Kao Feng-han
(18th century)

e Seal of the Kanō painter Tanzan
(died 1719) including the mountain
element (*zan*) of his name

269

Copying; Painting "in the manner of"; Forging

By copying old masters (a), and studying their brushwork in detail (b), the Chinese or Japanese painter both trains his hand and learns the "vocabulary" of painting. These activities also bear witness to his respect for the tradition behind him. While copies made by academic painters are often very difficult to detect as copies at all (d), literary painters preferred to re-interpret the tradition, by painting "in the manner of" the artists they admired. When Shen Chou, for example, painted in the manner of Ni Tsan (c), he was not merely preserving the Ni Tsan tradition but even enriching it with his own genius. The landscape (e), long attributed to Li Ch'eng, is in fact probably an exercise in Li Ch'eng's manner by Wang Hui.

The Chinese attitude to tradition offers wonderful opportunities to the forger, who can acquire a *bona fide* copy, add forged signature, seals, and inscriptions, and sell it as an original. It is sometimes extremely difficult to discover such fakes. If we compare a genuine Shih-t'ao album leaf (f) and a fake one (g), we can see how the forger has captured all but the subtlety of Shih-t'ao. The faked Ch'ien-lung inscription (i), however, is virtually indistinguishable from the original (h).

a

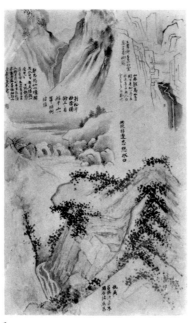

b

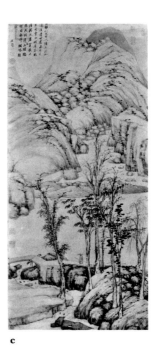

c

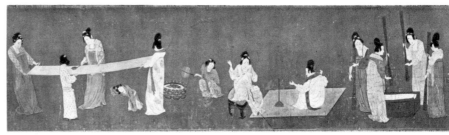

d

270

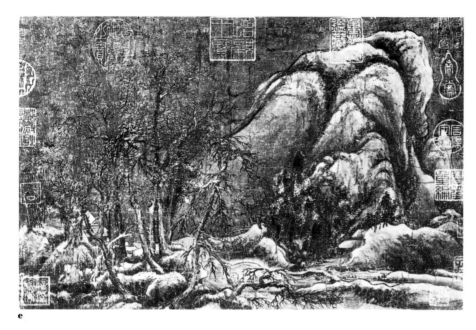

e

f

g

h

i

a Ch'en Yung-chih
Buddha under a Mango Tree:
hanging scroll after
Wei-ch'ih I-seng, about 1023
ink and colors on paper 82¾ × 28 in.
Boston, Mass., Museum of Fine Arts

b Ku Chien-lung
Copies of details of Ming
paintings, 17th century
ink and color on paper 14¼ × 11¼ in.
Kansas City, Mo.,
William Rockhill Nelson
Gallery of Art

c Shen Chou
Walking with a Staff: in the manner
of Ni Tsan, 15th century
ink on paper 62½ × 28¼ in.
Taichung, Taiwan,
National Palace Museum

d Attributed to Hui-tsung
Ladies Preparing
Newly-woven Silk:
handscroll after Chang Hsüan,
12th century
ink and colors on silk 14⅛ × 57 in.
Boston, Mass., Museum of Fine Arts

e Wang Hui
Winter Landscape (in 10th-century
style) with forged inscription of
Tung Ch'i-ch'ang, 17th century
Taichung, Taiwan,
National Palace Museum

f Shih-t'ao
Landscape: album leaf (detail) 1697
ink on paper
Princeton, N. J., Art Museum

g Anonymous
Copy of (f)
Osaka, Japan, Municipal
Art Museum, Abe Collection

h Emperor Ch'ien-lung
Inscription dated 1747 on
landscape by Chao Yüan
New York, collection C. C. Wang

i Anonymous
Copy of (h) on a painting
Hong Kong, Private Collection

How Paintings are Viewed in China and Japan

In Sung Dynasty China, landscapes were often painted on large standing, stretched-silk screens called *p'ing-feng* (c). Framed pictures hanging permanently on the wall were unknown in the Far East until modern times. Instead the reception rooms in a wealthy or middle-class Chinese house (b) would probably be hung with scrolls—a set of landscapes of the four seasons, perhaps, or an auspicious subject flanked by matching scrolls of calligraphy. Although these works of art lent dignity to a room, they were seldom of high quality.

A Chinese collector always keeps his more precious scrolls rolled up. When friends visit him he will bring them out and unroll them one by one for their inspection, while they drink tea or wine, talk, or write verses (a). The atmosphere is relaxed and informal.

The paper screens (*byōbu*; d) and sliding doors (*fusuma*) in big Japanese houses offer large unbroken surfaces to the decorative painter. And in a recess (*toko-no-ma*; e) in the Japanese livingroom or tearoom is hung some specially precious or appropriate scroll, accompanied by a discreet flower arrangement. In contrast to the Chinese, the Japanese tend to make something of a ritual of hanging and contemplating a work of art. Yet at the other end of the scale the young ladies of the Yoshiwara, the gay quarter of 18th-century Tokyo, were on very informal terms (f) with the artists who put them into so many pictures.

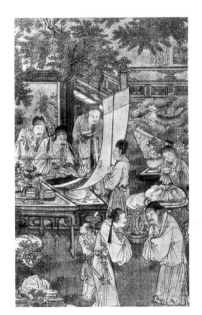

a

b

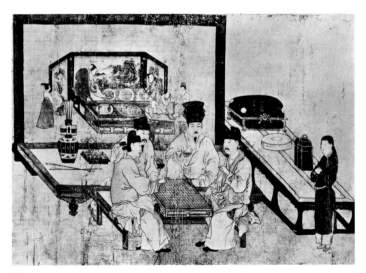

c

272

d

e

f

273

CHINA: Mainstreams in Chinese Painting

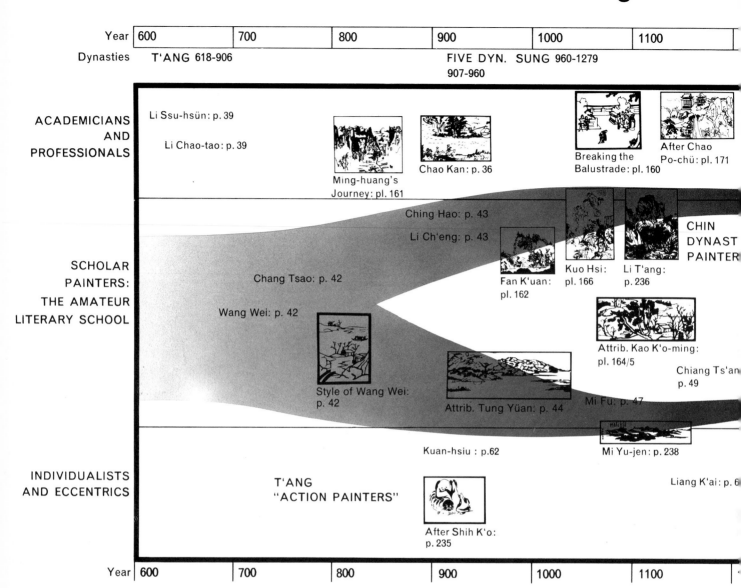

Year	600	700	800	900	1000	1100

Dynasties T'ANG 618-906 FIVE DYN. 907-960 SUNG 960-1279

ACADEMICIANS AND PROFESSIONALS

Li Ssu-hsün: p. 39
Li Chao-tao: p. 39
Ming-huang's Journey: pl. 161
Chao Kan: p. 36
Breaking the Balustrade: pl. 160
After Chao Po-chü: pl. 171

SCHOLAR PAINTERS: THE AMATEUR LITERARY SCHOOL

Ching Hao: p. 43
Li Ch'eng: p. 43
Chang Tsao: p. 42
Wang Wei: p. 42
Style of Wang Wei: p. 42
Fan K'uan: pl. 162
Kuo Hsi: pl. 166
Li T'ang: p. 236
CHIN DYNASTY PAINTER
Attrib. Kao K'o-ming: pl. 164/5
Attrib. Tung Yüan: p. 44
Mi Fu: p. 47
Chiang Ts'an: p. 49
Mi Yu-jen: p. 238

INDIVIDUALISTS AND ECCENTRICS

Kuan-hsiu: p.62
T'ANG "ACTION PAINTERS"
After Shih K'o: p. 235
Liang K'ai: p. 6

Year	600	700	800	900	1000	1100

This chart shows how the tradition has been transmitted through the three main schools of Chinese painting: the academic and professional; the literary and scholarly; and the individualist. Not every painter falls neatly into one stream or another. Some professionals such as Li T'ang and T'ang Yin had strong literary affiliations, while some scholar painters such as Mi Fu, Mi Yu-jen, and Kung

Hsien were sufficiently original in outlook and technique to be classed with the individualists. Strictly speaking, the latter did not form a school so much as a tradition that was reborn independently in the work of a number of isolated men of genius. Chao Meng-fu occupied a dual position, painting horses and figures in the academic style and ink landscapes in the manner of the scholars.

The chart shows a division in the literary school in the late 10th century. The powerful, angular style of Li Ch'eng was developed by Fan K'uan and modified by Kuo Hsi and Li T'ang, providing a basis for the technique of Southern Sung academicians such as Ma Yüan and Hsia Kuei. Thereafter it was popular only among court painters and professionals. Tung Yüan and Chü-jan,

274

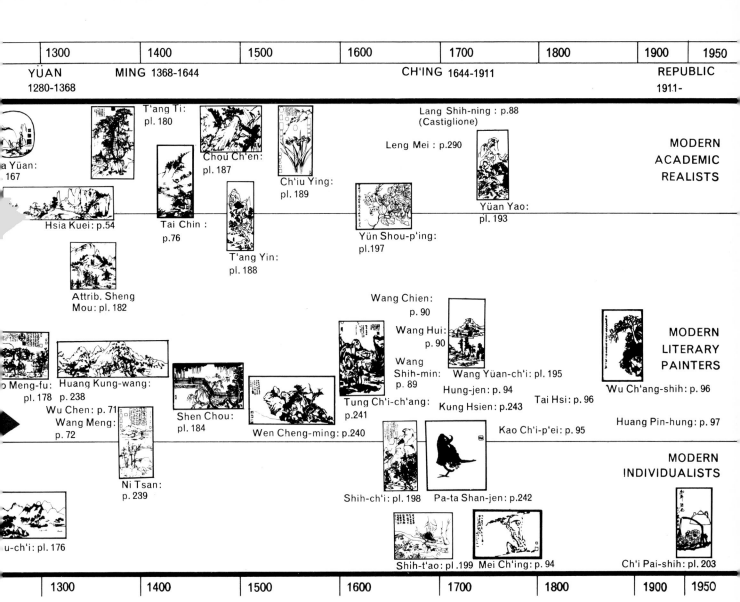

Timeline labels: Modern Academic Realists, Modern Literary Painters, Modern Individualists.

on the other hand, painted in a freer and looser manner more suited to the expression of poetic ideas. This became the basis of the scholarly tradition, the *wen-jen-hua*. As the chart shows, this style was never popular at court.

These painters, particularly the amateur scholar painters, did not merely follow the technique of their predecessors. They were fully conscious of their place in the tradition. Huang Kung-wang and Ni Tsan, for example, really felt themselves to be heirs of the style and outlook of Tung Yüan and Chü-jan; Shen Chou and Wen Cheng-ming were proud to uphold the spirit of the great literati of the Yüan Dynasty; the Ch'ing scholar painters firmly adhered not only to the style of painting, but also to the philosophy and way of life of the Yüan masters, as presented and interpreted for them by the Ming painter and critic, Tung Ch'i-ch'ang.

TRANSMISSION : CHINA-KOREA-JAPAN

500	600	700	800	900	1000	1100

SIX DYN.	SUI 581-618	T'ANG 618-906		FIVE DYN. 907-960	SUNG 960-1279	

CHINA

Only painters and schools that influenced Japan are shown

T'ANG PAINTING

Stone Sarcophagus: p.22

Style of Wu Tao-tzu?: p.30

Yen Li-pen: pl.157

Attrib. Chou Fang: pl. 158

Style of Wang Wei: p.42

After Shih K'o: p.235

SOUTHERN SUNG ACADEMY

Hsia Kuei: p.54

Ma Yü pl.167

ZEN INK PAINTING

KOREA

Bodhisattva Kannon: pl.205

Kichijō-ten: p.102

The Patriarch Gonzō: pl. 208

Amida Raigō: pl.213

Shaka Nyōrai pl.207

JAPAN

For the development of the Japanese tradition see next chart

Tamamushi Shrine: p.100

Bodhisattva: p.244

RISE OF THE YAMATO-E

500	600	700	800	900	1000	1100

	ASUKA 552-645	HAKUHO 645-710	NARA 710-794	HEIAN or FUJIWARA 794-1185		

This chart shows how Chinese art flowed in successive waves to Japan. First came Buddhist art, which reached the Nara region via Korea about 550 A.D. The style of Japanese Buddhist art during this first phase was essentially Korean.

Chinese influence on Japan was strongest and most direct in the 8th century, when the T'ang Dynasty civilization was at its height. Japanese architects,

sculptors, painters, and craftsmen copied Chinese models closely, thus helping to preserve the T'ang style of art and architecture, much of which has perished in China itself. Yet Japanese Buddhist art was already beginning to take on a national flavor.

After the middle of the T'ang Dynasty Chinese influence declined, but T'ang styles continued in the elegant and refined

court art of the Fujiwara period in Japan. Meanwhile, a true Japanese school of painting, the Yamato-e, was emerging. It found expression partly in brilliant narrative scrolls inspired by native legends, the lives of monks, or popular Japanese novels.

As the Yamato-e developed, a renewed interest in Chinese ink paintings was taken by Zen monks. From the Zen-

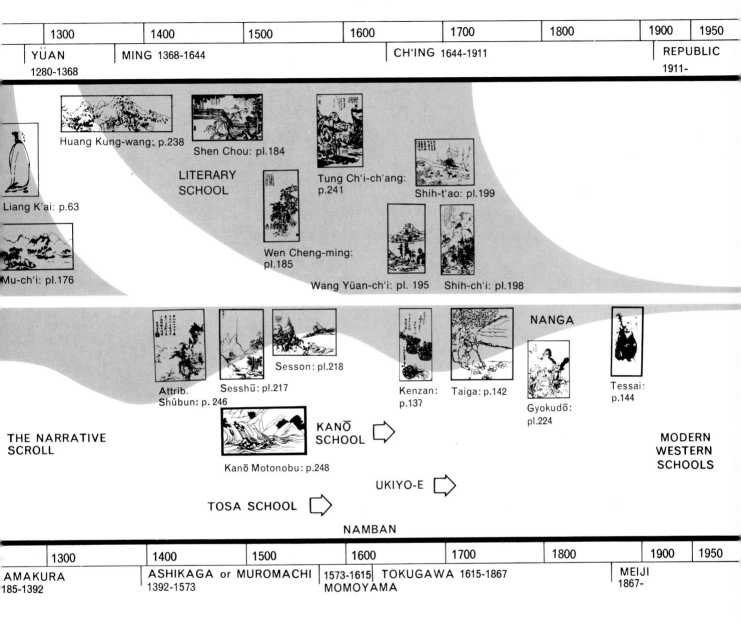

1300	1400	1500	1600	1700	1800	1900	1950

YÜAN
1280-1368

MING 1368-1644

CH'ING 1644-1911

REPUBLIC
1911-

Huang Kung-wang: p.238

Shen Chou: pl.184

LITERARY
SCHOOL

Tung Ch'i-ch'ang:
p.241

Shih-t'ao: pl.199

Liang K'ai: p.63

Wen Cheng-ming:
pl.185

Wang Yüan-ch'i: pl. 195

Shih-ch'i: pl.198

Mu-ch'i: pl.176

Attrib.
Shūbun: p. 246

Sesshū: pl.217

Sesson: pl.218

Kenzan:
p.137

Taiga: p.142

NANGA

Gyokudō:
pl.224

Tessai:
p.144

THE NARRATIVE
SCROLL

Kanō Motonobu: p.248

KANŌ
SCHOOL

MODERN
WESTERN
SCHOOLS

UKIYO-E

TOSA SCHOOL

NAMBAN

1300	1400	1500	1600	1700	1800	1900	1950

AMAKURA
185-1392

ASHIKAGA or MUROMACHI
1392-1573

1573-1615 TOKUGAWA 1615-1867
MOMOYAMA

MEIJI
1867-

inspired paintings of Liang K'ai and Mu-ch'i their eyes were drawn to the romantic ink landscapes of the Southern Sung academicians Ma Yüan and Hsia Kuei. Paintings by these artists were eagerly collected, not only in the Zen monasteries but also by the Shōguns Yoshimitsu and Yoshimasa.

The process of transforming the art of Ma Yüan and Hsia Kuei into a Japanese style was begun by Shūbun and Sesshū. The painters of the Kanō school founded by Motonobu completed the transformation. Motonobu's blend of realism, brilliant brushwork, and decorative splendor exactly suited the needs of the time.

The ink landscapes of the scholar painters of the Yüan and early Ming Dynasties, on the other hand, were quite unknown in Japan at this time. The scholarly tradition, or *wen-jen-hua,* was finally introduced into Japan by minor Chinese artists such as Shen Nan-p'in. It never become the art of an intellectual and social elite as it was in China, but remained simple a style, to be blended at will with other styles. Something of its true spirit was caught, however, by Taiga and Buson in the 18th century, Bunchō in the 19th, and Tessai in the 20th.

277

JAPAN : Development of the Tradition

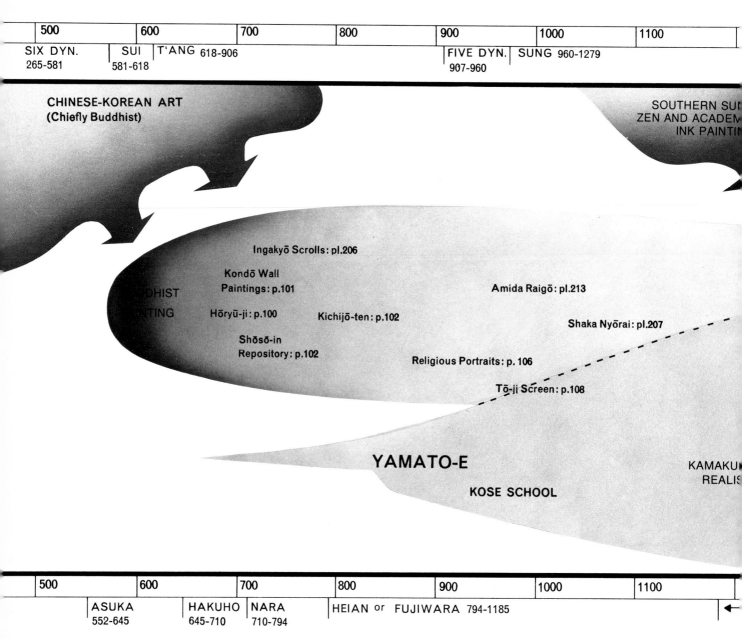

500	600	700	800	900	1000	1100

SIX DYN. 265-581 | SUI 581-618 | T'ANG 618-906 | FIVE DYN. 907-960 | SUNG 960-1279

CHINESE-KOREAN ART (Chiefly Buddhist)

SOUTHERN SU[NG]
ZEN AND ACADEM[Y]
INK PAINTIN[G]

[BU]DDHIST [PAI]NTING

Ingakyō Scrolls: pl.206

Kondō Wall Paintings: p.101

Hōryū-ji: p.100

Kichijō-ten: p.102

Shōsō-in Repository: p.102

Amida Raigō: pl.213

Shaka Nyōrai: pl.207

Religious Portraits: p. 106

Tō-ji Screen: p.108

YAMATO-E

KOSE SCHOOL

KAMAKU[RA] REALIS[M]

500	600	700	800	900	1000	1100

ASUKA 552-645 | HAKUHO 645-710 | NARA 710-794 | HEIAN or FUJIWARA 794-1185

This chart shows the development of the chief schools of Japanese painting, and the connections between them.

The Yamato-e, the main stream of Japanese tradition, gave birth to a number of schools, all marked by Japanese, as opposed to Chinese, subject matter, and the decorative use of color. Among these schools are the following: the Kose family painting for the Fujiwara court;

the realistic narrative and portrait painters of the Kamakura period; the Tosa school of courtly scroll and fan painting of the Ashikaga period; and the Ukiyo-e, the popular art movement that culminated in the color print of the 18th and 19th centuries. The huge decorative screens of Sōtatsu and Kōrin were the most spectacular achievements of the Yamato-e.

The Kanō school represents the growing influence of the Yamato-e upon the imported Sung Academy style. Within a hundred years between Masonobu and Tannyū, the Kanō painters transformed monochrome ink landscape painting into a realistic and decorative style that has remained popular up to the present day.

The Bunjin-ga, or Nanga, was Japan's belated response to the scholar painting

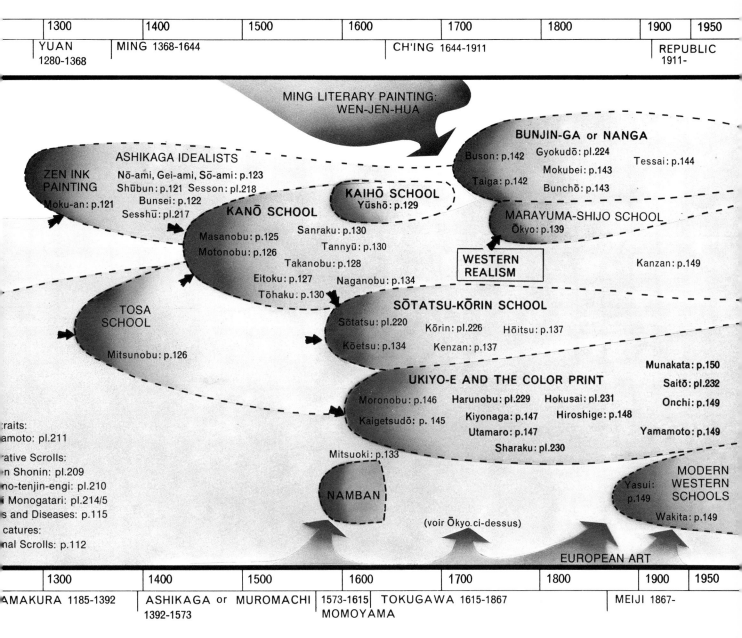

MING LITERARY PAINTING: WEN-JEN-HUA

BUNJIN-GA or NANGA
Buson: p.142 Gyokudō: pl.224 Tessai: p.144
Mokubei: p.143
Taiga: p.142 Bunchō: p.143

ASHIKAGA IDEALISTS
Nō-ami, Gei-ami, Sō-ami: p.123
ZEN INK PAINTING
Shūbun: p.121 Sesson: pl.218
Bunsei: p.122
Moku-an: p.121
Sesshū: pl.217

KAIHŌ SCHOOL
Yūshō: p.129

MARAYUMA-SHIJO SCHOOL
Ōkyo: p.139

KANŌ SCHOOL
Sanraku: p.130
Masanobu: p.125 Tannyū: p.130
Motonobu: p.126
Takanobu: p.128
Eitoku: p.127 Naganobu: p.134
Tōhaku: p.130

WESTERN REALISM

Kanzan: p.149

TOSA SCHOOL

Mitsunobu: p.126

SŌTATSU-KŌRIN SCHOOL
Sōtatsu: pl.220
Kōrin: pl.226 Hōitsu: p.137
Kōetsu: p.134 Kenzan: p.137

Munakata: p.150
Saitō: pl.232

UKIYO-E AND THE COLOR PRINT
Moronobu: p.146 Harunobu: pl.229 Hokusai: pl.231
Onchi: p.149
Kaigetsudō: p. 145 Kiyonaga: p.147 Hiroshige: p.148
Utamaro: p.147 Yamamoto: p.149
Sharaku: pl.230

raits:
amoto: pl.211
ative Scrolls:
n Shonin: pl.209
no-tenjin-engi: pl.210
Monogatari: pl.214/5
s and Diseases: p.115
catures:
nal Scrolls: p.112

Mitsuoki: p.133

NAMBAN

(voir Ōkyo.ci-dessus)

Yasui: p.149

MODERN WESTERN SCHOOLS

Wakita: p.149

EUROPEAN ART

of the Yüan and Ming Dynasties. It was not a traditional school in the sense that the Kanō was, but the art of poets and Zen-inspired individualists who were encouraged by the example of the Chinese literati to express themselves freely and spontaneously.

The Kaihō Yūshō school represents a partial return to Sung ideals. The Maruyama-Shijō school, on the other hand, was a blend of Kanō techniques with European realism.

The vitality of Japanese art in the 20th century, seen at its best in the modern color print, is largely due to the dynamic interplay between the imported art of Europe and China on the one hand, and the ever-living tradition of the Yamato-e on the other.

279

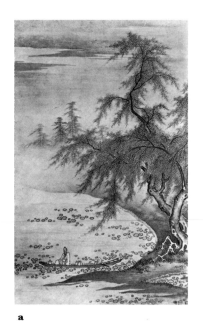

The Transmission of the Tradition in the Kanō School

Until recently, the sense of tradition was strong among all non-European artists; but it was strongest of all in the Kanō school of Japanese painters, who often turned their master-pupil relationship into that of father and son by the simple process of adoption. Yet the devotion of each painter to his teacher-father did not prevent outstanding personalities in the Kanō tradition making their own distinctive contributions to it.

The founder of the school, Masanobu (a), painted sober, Chinese-style ink landscapes. The work of his son Motonobu (b) is on a larger scale and has a more Japanese flavor. Motonobu's son Hideyori (c) was the first Kanō master to paint purely Japanese subjects. Hideyori's nephew, Eitoku (d), responded to the challenge of the great castle builders of his time with a new brilliance of color and hugeness of scale.

Eitoku's adopted son, Sanraku (e), continued the Kanō tradition in Kyoto; and one of his real sons, Takanobu (f), carried it to Edo, where he painted screens that cleverly combined Chinese ink brushwork with the Japanese feeling for decorative color. With the work of Takanobu's son Tannyū (g), the Kanō style was frozen into the decorative immobility that it has preserved ever since.

a Masanobu
Chou Mao-shu Admiring the Lotus
Flowers: hanging scroll (detail)
about 1530 *ink and slight color
on paper*
Tokyo, formerly Ogura Collection

b Motonobu
Stork on a Pine Tree: hanging
scroll, early 16th century
ink and slight color on paper
Kyoto, Japan, Myōshin-ji, Reiun-in

c Hideyori
Maple-viewers at Takao: screen
(detail) 16th century
colors on paper
Tokyo, National Museum

d Eitoku
Landscape with Flowers and Birds:
screen, about 1566
ink and colors on paper
Kyoto, Japan, Jukō-in

e Attributed to Sanraku
Pink Plum-blossoms: sliding doors
(detail) early 17th century
colors on gold paper
Kyoto, Japan, Daitoku-ji

f Takanobu
Chinese Gentleman Enjoying a
Painting: sliding door, about 1600
ink and color on gold paper
*Seattle, Wash., Eugene Fuller
Memorial Collection*

g Tannyū
Chinese Gentlemen Playing Chess:
wall painting (detail) 18th century
ink and color on paper
Nagoya, Japan, Nagoya Castle

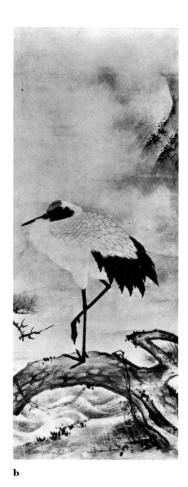

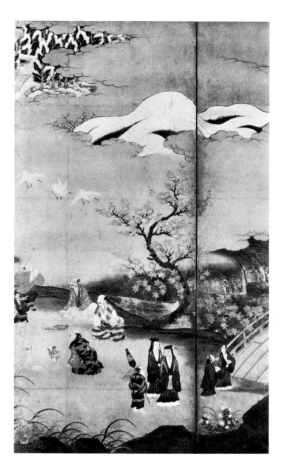

b

c

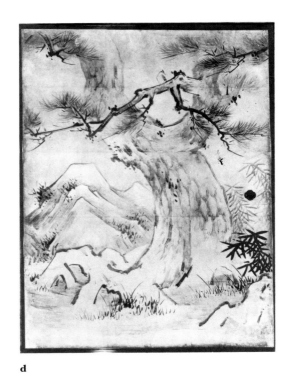

d

e

f

g

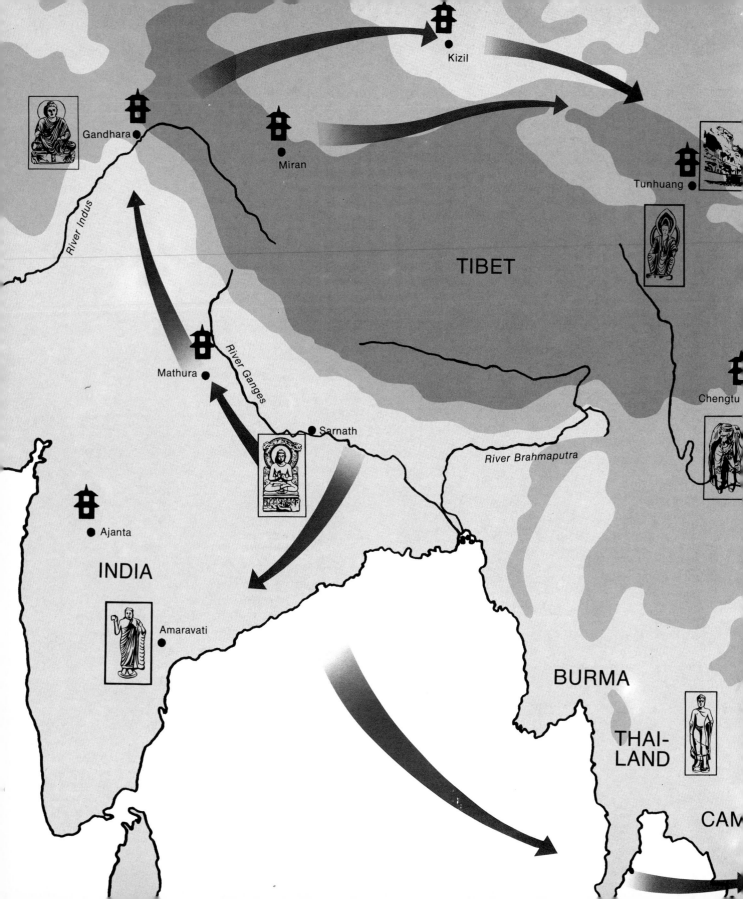

Kizil

Gandhara

River Indus

Miran

TIBET

Tunhuang

Mathura

River Ganges

Sarnath

River Brahmaputra

Chengtu

Ajanta

INDIA

Amaravati

BURMA

THAI-
LAND

CAM

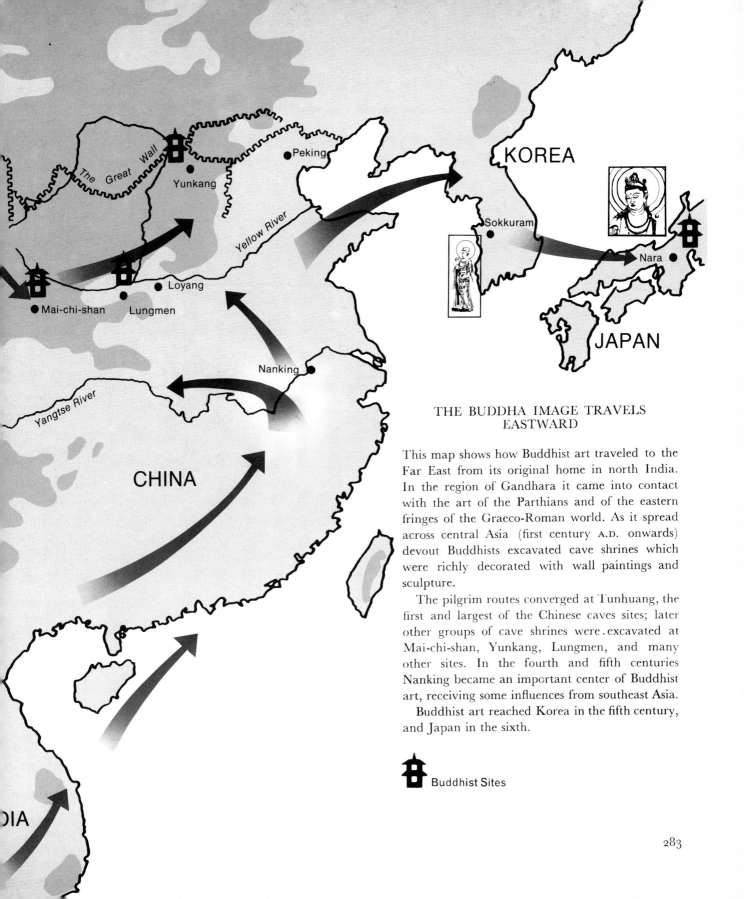

THE BUDDHA IMAGE TRAVELS
EASTWARD

This map shows how Buddhist art traveled to the Far East from its original home in north India. In the region of Gandhara it came into contact with the art of the Parthians and of the eastern fringes of the Graeco-Roman world. As it spread across central Asia (first century A.D. onwards) devout Buddhists excavated cave shrines which were richly decorated with wall paintings and sculpture.

The pilgrim routes converged at Tunhuang, the first and largest of the Chinese caves sites; later other groups of cave shrines were excavated at Mai-chi-shan, Yunkang, Lungmen, and many other sites. In the fourth and fifth centuries Nanking became an important center of Buddhist art, receiving some influences from southeast Asia.

Buddhist art reached Korea in the fifth century, and Japan in the sixth.

Buddhist Sites

The Relationship between Painting and Sculpture

a

Buddhist doctrines were illustrated in a unified language of architecture, painting, and sculpture (a). When Buddhism first reached China from India, native craftsmen found it difficult to reproduce the essentially sculptural quality of Indian images (b), for they were accustomed to express themselves in purely linear terms. But gradually the foreign sculpture was assimilated to Chinese taste, to produce the extremely painterly, even calligraphic, icons of the Northern Wei Dynasty (c), which are very close in style to wall paintings of the same period (d). Renewed Indian influence in 6th-century China resulted in a variety of styles, some synthetic, some more purely Indian (e).

Chinese craftsmen under the T'ang emperors achieved a successful compromise, in which an Indian style body could be clothed in, and enhanced by, the sweeping lines of the Chinese brush; and sculpture and painting became almost interchangeable (f, g). The methods of painters became more sculptural (h), those of sculptors more painterly (i). The final triumph of Chinese linear and pictorial feeling over Indian solid form was the painted wooden sculpture of the Sung Dynasty (j). Yet the influence of the painter over the modeler is just as clear in later centuries, in the almost liquid quality of 18th-century porcelain figurines, for example (k).

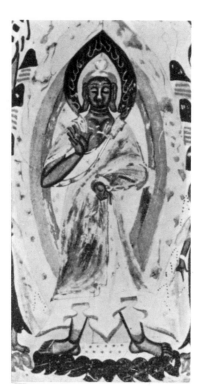

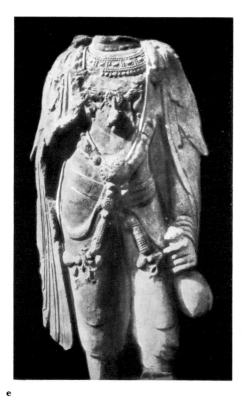

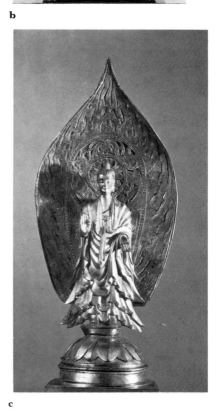

c

d

e

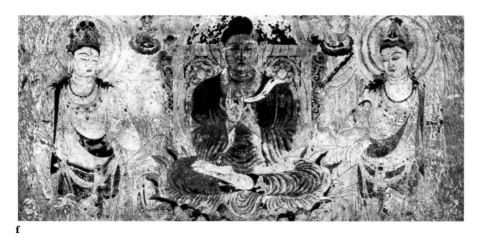

f

g

h

i.

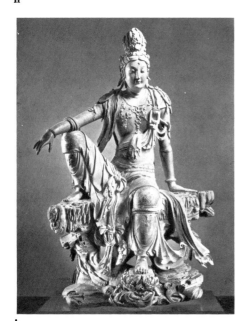

j

k

a Interior of the Buddha Hall, Upper
Hua-yen Ssu, dedicated 1140
Tatung, Shansi Province, China

b Seated Buddha, 4th century
gilt bronze
Cambridge, Mass., Fogg Art Museum

c Standing Buddha, 536 *gilt bronze*
Philadelphia, Pa., University Museum

d Standing Buddha Preaching the
Law: wall painting from Cave 249,
6th century
Kansu Province, China, Tunhuang Caves

e Kuanyin Bearing a Vase, first half of
T'ang Dynasty (excavated at
Wan-fo-ssu, Chengtu) *stone*
*Chengtu, China, Szechwan Provincial
Museum*

f Amida Triad (detail): wall
painting, about 700
colors on plaster 120 × 103 in.
Nara, Japan, Hōryū-ji, Kondō

g Buddha Triad, 8th century
bronze relief
Nara, Japan, Hōryū-ji

h Bodhisattva Flying on a Cloud,
8th century *ink on hemp cloth*
Nara, Japan, Shōsō-in Repository

i Seated Buddha: from Cave 17,
late 7th - early 8th century *stone*
*T'ien-lung Shan, Shansi Province,
China*

j Kuanyin, 12th-13th century
polychromed wood height 95 in.
Kansas City, Mo.,
*William Rockhill Nelson Gallery
of Art*

k Kuanyin, 18th century
white porcelain
*Wendover, England, collection
Sir Alan and Lady Barlow*

a

Sculpture as a Popular Art

Because it involves manual labor, sculpture has very rarely been regarded in China as a proper occupation for a scholar, and so has not been considered one of the fine arts (for an exception, see page 21). As a result great artists have not used sculpture to express the profound ideas they have conveyed in painting. China has had no Pheidias. But a true sense of sculptural form is to be found in the humbler arts of the bronze caster (a), the jade carver (b), and the maker of pottery tomb figurines (c, d). These figurines have a lively naturalism and an often sly humor. The beauty of a T'ang jar (e), unlike the static perfection of a Greek vessel, lies in its uplifting vigor of form, which seems to have sprung to life under the potter's hand. At this level the best Chinese sculpture is essentially a modeler's art, and its rhythms are flowing, lively, and natural.

In Japan there has been no such line of demarcation between the scholar painter and the craftsman, chiefly because there has been no class of scholar painters as such. Sculpture reaches into higher levels of society than it does in China, and the names of many great masters are known. While some worked in clay (f) or bronze, most Japanese sculpture is not the art of the modeler, but that of the carver in ivory (g), or wood (h, i) in which sheer planes and sharp angles proclaim the disciplined conquest of a tough, resistant material.

b

c

d

e

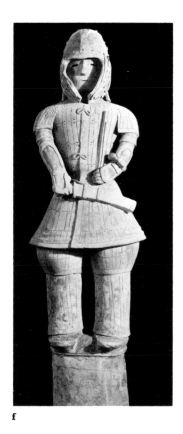

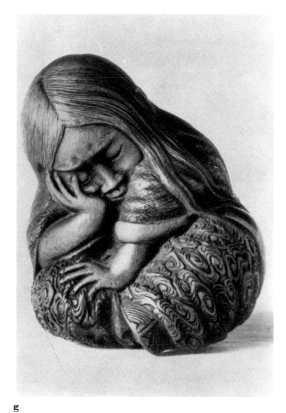

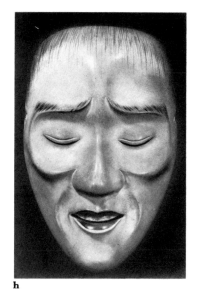

h

f **g**

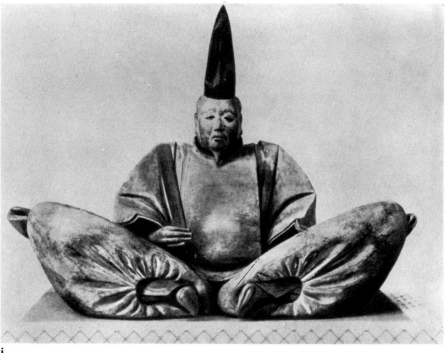

a Rhinoceros, 12th-11th century B.C.
bronze 8¼ × 14½ in.
San Francisco, Calif.,
M. H. de Young Memorial Museum,
Brundage Collection

b Recumbent Buffalo, Ming Dynasty
jade 5¾ × 12 in.
London, collection H. Tozer

c Camel, T'ang Dynasty
pottery height 17¾ in.
Stockholm, Museum of Far Eastern
Antiquities

d Seated Armenian Merchant,
T'ang Dynasty *pottery*
London, collection the late
Mrs. B. Z. Seligman

e Jar, T'ang Dynasty
white glazed porcelain
Wendover, England, collection
Sir Alan and Lady Barlow

f Warrior: *haniwa* tomb figure,
6th century *pottery*

g The Drunken Shojo, 18th century
ivory height 1½ in.
Hamburg, Museum für Kunst und
Gewerbe

h Japanese Nō Mask of a Blind Man,
17th-18th century
wood with color on gesso
Seattle, Wash., Art Museum,
Eugene Fuller Memorial Collection

i Portrait of Uyesugi Shigefusa,
13th century *wood*
Kamakura, Japan, Meigetsu-in

i

a

Portrait Painting

In the Far East the purpose of painting a portrait was to record not so much the sitter's features as the kind of man he was. In ancestral portraits (a), and in the work of painters at frontier posts whose job it was to note the features of travelers entering or leaving the country, the human face was depicted with a functional accuracy. But this was not considered art, and the great masters were concerned with deeper qualities. Yen Li-pen in his scroll of the Thirteen Emperors (b) sought to portray the idea of imperial dignity; another T'ang painter, perhaps Wang Wei, has painted the saintliness and dedication of an eminent scholar (d), and it matters little whether or not it is a true likeness. In his famous "portrait" of Li Po (c), Liang K'ai brilliantly evokes the moments of creative exaltation in the life of the long-dead poet. By contrast, the realism achieved in the 17th century by Tseng Ch'ing in portraits of scholars (e) and painters, whom he knew personally, is exceptional in China.

Japanese painters pursued the same ends as the Chinese, though their techniques have tended to be sharper and more disciplined. They have often attained a more penetrating realism (g), nor do they shrink from caricaturing themselves (h). Especially fine are the portraits of great Buddhist priests (color plate 208) and of military leaders (color plate 211), while in the idealized portrait of Kōbō Daishi as a child (f) discipline and sentiment are held in exquisite balance.

b

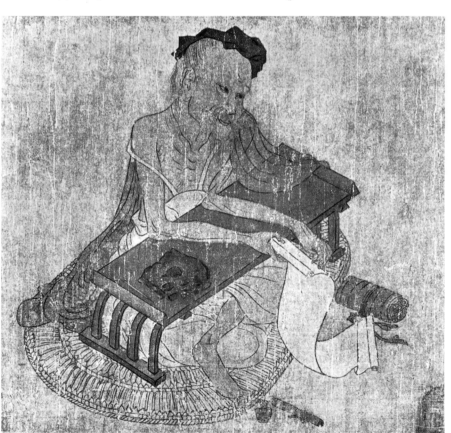

c

d

e

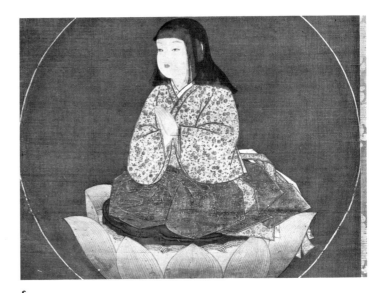

f

g

h

The Influence of Western Art on China

European art was brought to China in the 17th and 18th centuries chiefly by Jesuit missionaries. Under their influence some court painters attempted to adapt Western perspective and shading to Chinese techniques (a), but the scholar painters ignored Western methods, which they considered merely vulgar. It was only in the 20th century, when China felt an urgent need to modernize her whole way of life, that Chinese painters began seriously to study Western art.

About 1915, Cantonese artists started a movement to paint modern themes in the traditional Chinese ink medium (b). Then Hsü Pei-hung, trained in Paris, brought a new realism to the old brush technique (c); a more recent exponent of this synthetic style is Chiang Chao-ho (d). Meanwhile left-wing realists were adapting the technique of the Western wood engraver to ink painting (e). P'ang Hsün-ch'in, also trained in Paris, expresses an almost Western sense of form in terms of line alone (f), while more recently Huang Yung-yü has given the woodcut a new lyricism (g). Some of the most interesting experiments in fusing Chinese and Western vision and techniques have been made by Chinese artists living outside China (h).

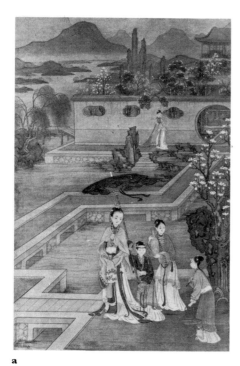

a

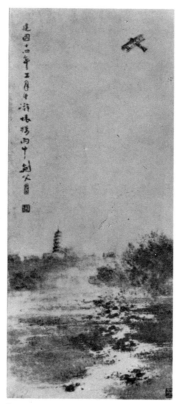

b

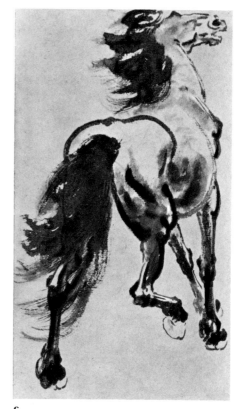

c

d

e

f

g

h

a

The Impact of the West on Japanese Art

Japan first learned of European art through traders and missionaries in the 16th century. Catholic devotional pictures were skillfully copied (a), and a few other European paintings and engravings inspired large decorative screens by artists of the Namban school (b). The Namban movement practically ceased when contact with Europe was broken in 1640. Nevetheless, Western books on figure drawing and perspective began to trickle into Japan. Maruyama Ōkyo makes an attempt (c) to give his clothed figures an anatomical foundation, while the landscape prints of Hokusai and Hiroshige reveal a knowledge of Western perspective. In some of Hiroshige's prints there are even convincing shadows (d).

Since the Meiji Restoration of 1868, every school of Western art has been promptly and eagerly imitated in Japan. Yamamoto Kanae's early woodcuts, notably *Breton Girl* (e), set the print makers free from their bondage to tradition and pointed the way to a new naturalism. At about the same time Shimomura Kanzan fused Western realism with the old themes and techniques of Japanese painting, as in his screen depicting a traditional character from a Nō play, the blind boy Yoroboshi (f). But it is the print makers who have been most successful in creating an original art, up-to-date and yet essentially Japanese (g).

b

c

d

e

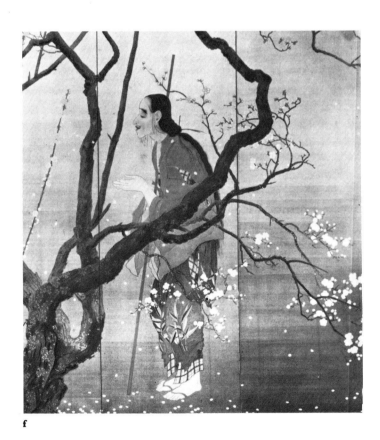

f

g

293

The Impact of China and Japan on the West

a

European merchants and missionaries in China in the 17th and 18th centuries knew nothing of the higher forms of Oriental art, but they sent home vast quantities of porcelain, lacquer, and silks, whose designs and motifs were adapted with playful charm but little understanding to European architecture and the decorative arts, and gave birth to the style known as Chinoiserie (a).

Oriental art created no response in European painting until the early French Impressionists. Japanese prints reached Paris by chance in the 1850's stirring up a wave of enthusiasm for all things Japanese. Their fresh, simple color harmonies and bold, clear design (d) were a revelation to painters like Manet, Degas, and Whistler who were struggling to free themselves from the authority of the Academy, while van Gogh copied Japanese prints in oils (b, c, e).

The more sophisticated 20th-century Western artists have looked beyond style to the meaning and methods of Oriental art (h). Chinese calligraphy (f) has its counterpart in Paul Klee's sensitive line (g); knowledge of Zen painting has encouraged the spontaneity of Action Painting (i); and the cool, disciplined forms of Japanese architecture (j) have, directly or indirectly, influenced Western architects and painters, such as Mies van der Rohe and Piet Mondrian (k).

b

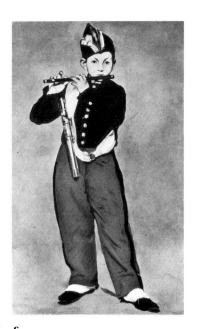

c

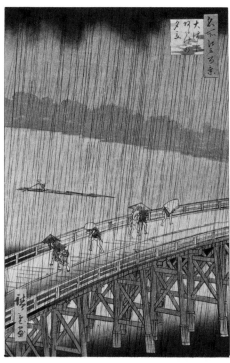

d

e

f

g

h

i

j

k

a Thomas Chippendale
English lacquered bed, 18th century
lacquered wood
London, Victoria and Albert Museum

b Edgar Degas
Aux Courses devant les Tribunes,
about 1879
oil on canvas $16\frac{1}{4} \times 24\frac{1}{2}$ in.
Paris, Musée de l'Impressionnisme

c Édouard Manet
The Fifer, 1866
oil on canvas $38\frac{1}{2} \times 23\frac{1}{2}$ in.
Paris, Musée de l'Impressionnisme

d Hiroshige
Ohashi Bridge in Rain, 1857
polychrome woodcut $14\frac{1}{2} \times 9\frac{3}{8}$ in.
Philadelphia, Pa., Museum of Art, et al.

e Vincent van Gogh
Copy after Hiroshige's woodcut,
about 1887
oil on canvas $28\frac{3}{4} \times 21\frac{1}{4}$ in.
Amsterdam, Stedelijk Museum,
V. W. van Gogh Collection

f Huai-su
Autobiographical Essay (detail)
T'ang Dynasty
Taichung, Taiwan,
National Palace Museum

g Paul Klee
More and More Signs, 1932
brush drawing $12\frac{3}{8} \times 7$ in.
Bern, Kunstmuseum, Paul Klee
Foundation

h Morris Graves
Ceremonial Bronze Taking the
Form of a Bird, 1947
watercolor
Seattle, Wash., Art Museum,
Gift of Mr. and Mrs. Philip Padelford

i Karel Appel
Personnages, 1961
oil on canvas
London, Gimpel Fils

j Detail of wall treatment, Katsura
Imperial Villa, Kyoto, Japan

k Piet Mondrian
Composition with Red, Blue,
and Yellow, 1935
oil on canvas
London, collection Mrs. Basil Gray

295

Oriental, or Western?

This brilliant sketch, set down in broad strokes with a wet brush, was made in 1962 by the Hong Kong painter Lui Shou Kwan (or Lü Shou-k'un). Although it is a spontaneous creation by an original artist, no art starts from nothing, and the sources of Lui's style are, on the one hand, the free "ink-play" of Chinese 17th-century Individualists such as Pa-ta Shan-jen (page 242), and on the other the broad, sweeping brush gestures of modern Western painters like Pierre Soulages and Franz Kline.

The 20th century is seeing the evolution of a new series of styles in art and architecture that transcend all frontiers and are truly international. Works such as this one suggest that the chief contribution of Far Eastern painters to the new international art is a vitally calligraphic use of the brush, and a feeling for nature revealed even in pictures that appear at first glance to be entirely abstract.

Lui Shou Kwan
Mountain, 1962
*ink on paper 18 × 15 in.
Woking, Surrey, England,
collection Major Geoffrey Barker*

296